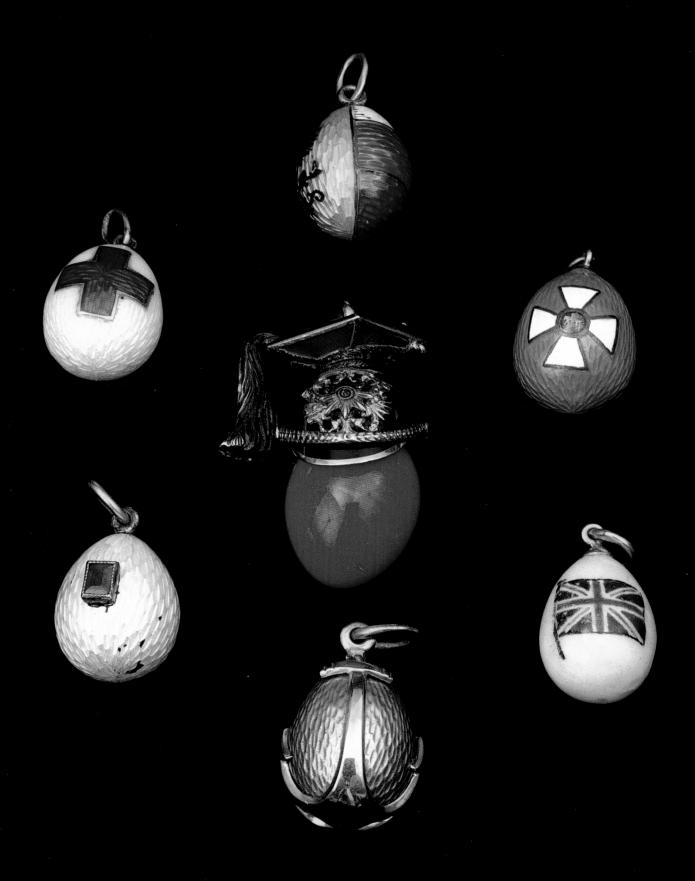

FABERGÉ

AND THE RUSSIAN

MASTER GOLDSMITHS

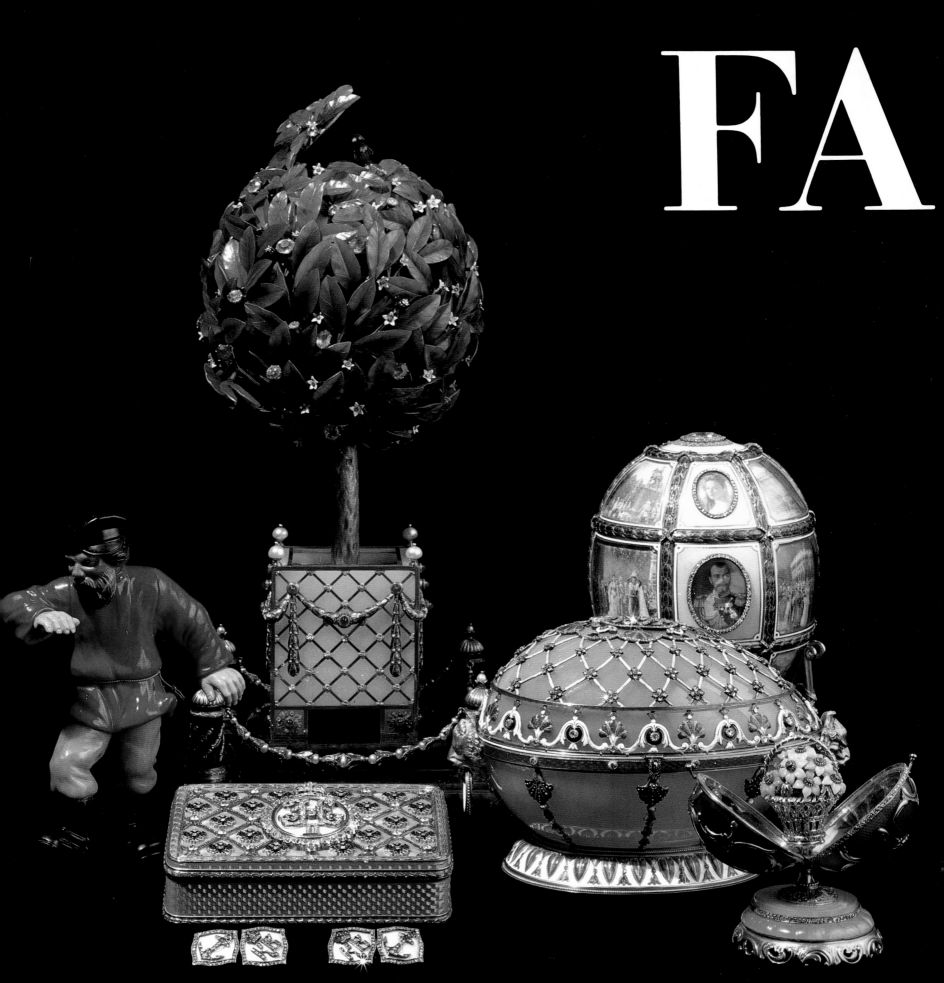

FA

BERGÉ

AND THE RUSSIAN

MASTER GOLDSMITHS

Edited by GERARD HILL

With introductions by Gerard Hill, G.G. Smorodinova,
and B. L. Ulyanova

HUGH LAUTER LEVIN ASSOCIATES, INC.

Distributed by Macmillan Publishing Company, New York

Copyright © 1989, Hugh Lauter Levin Associates, Inc.
Design by Philip Grushkin
Photo research by Ellin Yassky Silberblatt
Typeset by A & S Graphics, Inc., Wantagh, New York
Editorial production by Harkavy Publishing Service, New York
Printed in Hong Kong.
ISBN 0-88363-889-4

Contents

PETER CARL FABERGÉ (*plates 1—7*) 9

THE RUSSIAN MASTER GOLDSMITHS
(*plates 8—16*) 23

EGGS (*plates 17—73*) 54

FLOWERS AND
HARDSTONE CARVINGS (*plates 74—93*) 116

BOXES AND CASES (*plates 94—130*) 136

FRAMES AND CLOCKS (*plates 131—165*) 170

RELIGIOUS OBJECTS (*plates 166—179*) 206

TABLE ORNAMENTS
AND *OBJETS DE VITRINE* (*plates 180—251*) 220

OBJETS DE LUXE (*plates 252—275*) 290

Index 317

Photography Credits 320

(Left endpaper). Fabergé. **Seven Miniature Easter Eggs.** Heights ⅝″ to 1⅛″ (1.6 cm to 3 cm). *(Clockwise from top left)* **Navy-capped Egg.** Workmaster Alfred Thielemann. 1880–1910. *This gold egg is enameled translucent white over a crackled ground with a divider of rose diamonds and a navy-blue cap.* **Crown Egg.** Workmaster Michael Perchin, St. Petersburg. 1899–1093. *Yellow and white stripes form the background for a salmon-pink enameled crown set with diamonds on this gold egg.* **Green and Pink Egg.** Workmaster Alfred Thielemann. 1880–1910. *A basket-weave pattern forms the background for this green- and pink-enameled gold egg. As with the Navy-capped Egg, a divider of rose diamonds is used between the two enamel colors.* **Winter Egg.** Workmaster Henrik Wigström, St. Petersburg. 1899–1908. *This intricately detailed gold egg is enameled translucent pink enamel over a sunburst pattern. Underpainted in brown enamel is a design of wintery branches. A diamond band encircles the egg.* **Fleur-de-Lis Egg.** Maker unknown. Date unknown. *This tiny auburn-enameled gold egg has a gold fleur-de-lis in the center.* **Neo-Classical Egg.** Maker unknown. 1899–1908. *This neo-classical gold egg has a top and base of deep blue enamel with a white center. It is mounted with green-gold swags hung from red gold flowers.* **Cannon Egg.** Workmaster probably Alfred Thielemann. Date unknown. *On top of this tiny rhodonite egg is a silver soldier behind a cannon.* The Forbes *Magazine Collection, New York.*

(Right endpaper). Fabergé. **Seven Miniature Easter Eggs.** Heights ⅝″ to 1⅛″ (1.6 cm to 3 cm). *(Clockwise from top left)* **Red Cross Egg.** Workmaster August Hollming, St. Petersburg. 1880–1915. *This gold egg has a deep ruby-red cross on a background of white enamel. Alexandra and her four daughters were actively involved with the work of the Red Cross after the outbreak of the war.* **Eagle and Banner Egg.** Workmaster Feodor Afanassiev. Date unknown. *One half of this gold egg has a yellow background with the black imperial double-headed eagle. The other half is enameled with a white, blue, and red banner, the colors of imperial Russia.* **Cross of St. George Egg.** Maker unknown. Date unknown. *This gold egg has a white Cross of St. George enameled on a lime-green ground.* **Union Jack Egg.** Workmaster G. Lundell, Odessa. 1899–1908. *Acknowledging the imperial family's ties to Great Britain, this red, white, and blue Union Jack is enameled against a white background on this gold egg.* **Anchor Egg.** Workmaster Erik Kollin, St. Petersburg. 1899–1908. *A pair of gold anchors form the perimeter of this pale blue-enameled egg.* **Square Ruby Egg.** Maker unknown. Date unknown. *One of the simplest of the small gold Easter eggs, this white-enameled egg is set with a ruby.* **Helmet Egg.** Maker unknown. Date unknown. *A purpurine egg is surmounted by a gold and enamel helmet of Her Imperial Majesty's Guard Lancers. A silver tassel hangs from the right side of the helmet.* The Forbes *Magazine Collection, New York.*

(Title page). Fabergé. **Dancing Moujik, Imperial Orange Tree Egg, Imperial Fifteenth-Anniversary Egg, Imperial Renaissance Egg, Imperial Spring Flowers Egg, Imperial Crown Cuff Links, Coronation Box.** *These items are further represented in the book, with the exception of:* **Imperial Crown Cuff Links.** 1887–1917. Height ½″ (1.3 cm). *Imperial initials and anchor design are rendered in diamonds on a white enamel background.* The Forbes *Magazine Collection, New York.*

ACKNOWLEDGMENTS

It is my pleasure to thank the publisher, Hugh Levin, for making this volume possible, and his able assistant, Ellin Yassky Silberblatt, for her expert management of the necessary photo research and for her coordination of the entire project. Thanks are also due to Susan Cutrofello and Dale Ramsey of Harkavy Publishing Service, who as copyeditors successfully wrestled with many unfamiliar names and constructions, and to Philip Grushkin, for his sterling performance as the designer of this book.

I would also like to thank George Ginsburg for his photographs from the Soviet Union, as well as VAAP, the Soviet Copyright Agency. Margaret Kelly and Mary Ellen Sinko of the *Forbes* Magazine Collection provided enormous help in facilitating the use of so many of the objects from the *Forbes* Collection. Lastly I thank all the museums and collectors who cooperated so willingly in enabling the assemblage of such an impressive variety of works from the hands of the Russian master goldsmiths.

G. H.

Peter Carl Fabergé

Peter Carl Fabergé (1846–1920) stands as a representative of a vanished age: the age of the Czars and the fabulously rich imperial court in Russia. It was an age of empires and European monarchies that was brought to an end forever by the Great War (1914–1918). The production of luxury goods ceased completely in Russia as the war dragged on, ushering in decades of hardship and dramatic changes in the social system within which the imperial court had flourished. Today, long after the 1917 Bolshevik Revolution, the name Fabergé conjures images of Russian imperial grandeur. In recent years museum exhibitions and publications of his work have been greeted with tremendous interest. Who was Fabergé, and what accounts for this reputation?

Carl Fabergé was Russian-born of French lineage, his ancestors having left France in the late seventeenth century. His father, Gustav, was born in Pernau on the Baltic Sea and moved to St. Petersburg, where he opened a jewelry shop in 1842. In 1870, at the age of twenty-four, Carl took over his father's modest business and began to turn it into an establishment of international renown. His business came to be patronized by the Czars and imperial court as well as other royal houses and aristocracy of Europe. He went from the production and sale of routine gold and silver jewelry, to an output of *objets d'art*, an almost limitless variety of accessories for the lady or gentleman of the day, for personal use—cufflinks, parasol handles, tie pins, and the like—as well as for the desk top or dinner table. He brought a strength of design and execution to even the smallest of his creations, such as pencil holders and bonbonnières. Fabergé relied on creative design and exquisite enameling for the success and appeal of his products, rather than on the carat weight of stones or the lavish gold settings that had been the opulent norm in the third quarter of the nineteenth century. Fabergé later conceived such *objets de fantaisie* as carved hardstone animals and hardstone-and-gold flowers.

In a foreword to H. C. Bainbridge's book on Fabergé, Sacheverell Sitwell wrote: "Why, and how is it, that so simple an object as a cigarette case can speak to us with a Russian accent?" And again: "When you touch and hold a Fabergé object, you are in contact with something, coming down to you, not only from the era of the Tsars, but of an ancestry far more ancient; for it is typical of all the Imperial courts there have ever been."

Concerning Fabergé's "Russianness," it can be said that there is something about a Fabergé silver or gold cigarette case that is distinguishably Russian in feeling as well as distinguishably Fabergé. Perhaps it is a particular Russian flamboyance, or perhaps it is simply the heavy weight that Russian silver and gold objects tend to have. In his latter remark, Sitwell seems to be referring not just to the category of *objets de luxe* associated with the courts of kings and emperors, but also to the element of imperial patronage that allowed for wide artistic freedom. So, for example, when the Czar commissioned Fabergé to produce an egg at Easter as a surprise for the Czarina, the goldsmith was not constrained with exhaustive specifications, either artistic or fiscal.

Carl Fabergé trained as a young man in Frankfurt am Main, apprenticed to the goldsmith and jeweler Friedman. In 1860, when Carl was fourteen years old, the Fabergé family had moved to Dresden from St. Petersburg, and it is quite likely that Carl had stayed behind for a time to be trained under his father's manager Hiskias Pendin. (Gustav Fabergé had retired and left his shop in St. Petersburg under the supervision of Pendin.) Before Carl apprenticed in Frankfurt, he attended commercial school in Dresden. He also undertook the customary European "Grand Tour," not only to round out his general education but also to obtain more specific familiarity with European works of art, particularly those of the goldsmith and the jeweler. He visited Paris and London, and in

Florence he visited the Opificio delle Pietre Dure, the workshop for hardstone cutting and carving founded by the Medicis. In Dresden he had been inspired by the treasures of the Grünes Gewölbe (Green Vaults), the Saxon collections of precious objects from the hands of such famous goldsmiths as Johann Melchior Dinglinger—for example, carved rock crystal cups mounted in gold, jewels, and enamels dating to the sixteenth and seventeenth centuries.

Carl returned to St. Petersburg in 1870 to take over the firm, and two years later he married Augusta Jacobs, daughter of a foreman at the Imperial Furniture Workshops. In 1882 he was joined in St. Petersburg by his twenty-year-old brother Agathon, who was to make an important contribution to the firm as a jewelry designer.

Thus, Carl Fabergé, the goldsmith and jeweler of St. Petersburg, was active at the end of an era that had begun with Peter the Great in the early eighteenth century. Peter built his city of St. Petersburg (renamed Petrograd in 1914 and then Leningrad in 1924) near the mouth of the river Neva on the Gulf of Finland as a "window to the West." Western architects such as Tressini and Rastrelli were instrumental in giving the city its European flavor. Built on marshy land and incorporating a series of canals, Peter's city came to be known as the "Venice of the North." During the eighteenth century the rulers of Russia continued the westernizing begun by Peter. The goldsmiths and silversmiths that came to St. Petersburg were frequently of foreign birth. From Germany, Finland, France, and Switzerland they came to satisfy the demands of the imperial court for silver candlesticks and Parisian-style gold snuff boxes.

Such European-born goldsmiths as Jean-Pierre Ador, J. Pauzie, and members of the Kolbe family worked in St. Petersburg during the latter part of the eighteenth century. During the nineteenth century, the well-known firm of Nicholls and Plincke specialized in high-quality table silver in the much admired English style; their establishment was known as the "English Shop." (One of the partners was English, in fact—namely, Charles Nicholls.) The firms of Sazikov (founded in 1793) and Ovchinnikov (founded in Moscow in 1853 and in St. Petersburg in 1873) produced silver ware more in the Russian national style.

Fabergé was inspired by the styles and design of eighteenth-century and early nineteenth-century France, from rococo to Empire, but his imagination roamed far and wide and even drew from Japanese sources (not unlike his contemporaries, such as Tiffany and Company of New York). Interested in Japanese art, Fabergé acquired a substantial collection of netsuke, the small, carved-ivory toggles used in conjunction with a Japanese man's kimono sash. One can detect the strong rococo influences upon the creations of Fabergé's workmaster Michael Perchin in particular, but later the crisp neo-classical style came to play a major role. Perchin's successor, Henrik Wigström, excelled as a master interpreter of the styles of the Louis XVI period. But in the final analysis, it can be said that Fabergé's style was original and modern; in fact, some of his more linear designs anticipate trends of the 1920s, like the Art Deco movement. Some of his later works incorporate an abstract quality that was a decade ahead of its time.

In understanding Fabergé's turn-of-the-century Russia, the differences between Moscow and St. Petersburg should be borne in mind. St. Petersburg, the modern, Western-oriented city was the new capital of the empire and home to the imperial court. Moscow, with its ancient Kremlin and brilliant multicolored Russian architecture, was the old capital and seat of the aged traditions of Russian culture and art.

Fabergé branched out from St. Petersburg in 1887 to establish a shop in Moscow, where he produced work in the "Old Russian" style as well as large quantities of everyday table silver. The 1913 tercentenary of the Romanov dynasty gave rise to widespread production of pieces in the Old Russian style, which harkened back to seventeenth-century pre-Petrine Russia. Such objects frequently incorporated the State coat of arms, with its double-headed eagle, and thus took on a rather robust Russian flavor.

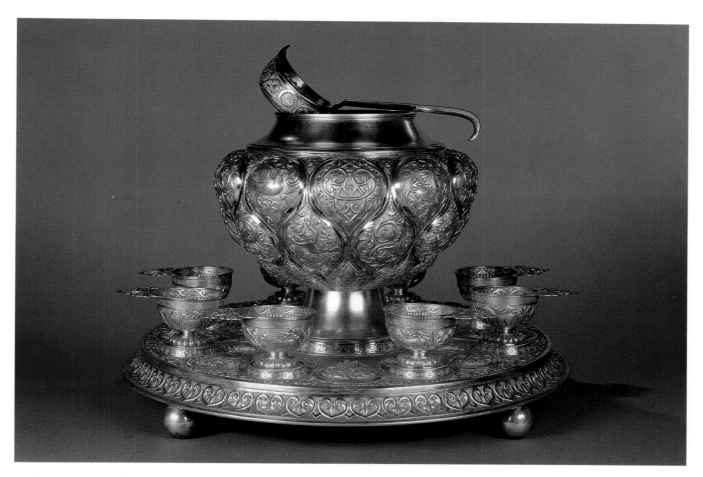

1. Ovchinnikov. Moscow. **Silver-gilt Punch Set.** ca. 1889. Diameter of stand 16¾″ (42.8 cm). *The set comprises a punch bowl, a stand, a ladle, and eight charkas. The bowl is lobed and chased with birds, satyrs, and foliage. It was a presentation to the artist Bilibin and is inscribed, "For Ivan Ivanovich Bilibin on the Twenty-Fifth Anniversary of his work from the Members of the Registration Committee, Moscow, 9 July 1889." The State Historical Museum, Moscow.*

There was a difference in the organization of the St. Petersburg and Moscow establishments. In St. Petersburg, there were a number of discrete workshops, each headed by a separate master goldsmith or jeweler known as a workmaster. Fabergé's Moscow branch was managed as a more or less unitary workshop. In St. Petersburg, there were more than twenty workmasters whose marks can now be identified on products from the house of Fabergé. The leading workmaster of the workshop overall, and the executor of the most important commissions, was the head workmaster. Michael Perchin was the head workmaster from 1886 until his death in 1903, when he was succeeded by his chief assistant Henrik Wigström. These two workmasters were responsible for almost all the imperial Easter eggs. Erik Kollin, a Finn, was head workmaster from 1870 to 1886 and produced gold jewelry, including pieces in the Scythian style (the Scythian treasure had just been discovered at Kertch in the Crimea). Other workmasters, also mostly Finns, were August Holmström—who had been appointed head jeweler by Gustav Fabergé in 1857—Anders Nevalainen, Carl Gustav Hjalmar Armfelt, Johan Victor Aarne, Feodor Afanassiev, Andrei Gorianov, August Hollming, Karl Lundell, Anders Mickelson, Gabriel Niukkanen, Knut Oskar Pihl, Wilhelm Reimer, Philipp Theodore Ringe, Eduard Schramm, Vladimir Soloviev, Alfred Thielemann, Stephan Wäkevä and his son Alexander Wäkevä. Julius Rappoport was head silversmith.

The cloisonné enamels sold by Fabergé were almost all made by Feodor Rückert, a Russian-born

silversmith of German ancestry. He did not, however, supply Fabergé exclusively. Some of his output was handled by other firms such as Ovchinnikov's. Rückert worked in the Old Russian style, but with a delicacy surpassing that of almost all his contemporaries working in the cloisonné technique. Mention should also be made here of two workmasters with the initials A.T., whose marks, or work, should not be confused. One was the Fabergé workmaster Alfred Thielemann, referred to above, who produced small jewelry pieces. The other was Alexander Tillander, who worked for the firm of Hahn, producing larger objects in the style of Fabergé. Note should also be made of the artels. These were cooperatives of jewelers and goldsmiths who marked their wares with their artel numbers (the 3rd Artel, for instance). There were more than thirty of these artels functioning during Fabergé's time, and we know that Fabergé commissioned work from the First Silver Artel. The Cyrillic mark 1CA (1SA in Roman letters) stood for the First Silver, or Serebriannaya, Artel and is found in conjunction with Fabergé's mark on large silver objects.

Fabergé himself did not spend his days behind a silversmith's bench. Rather, he was the guiding inspiration for the entire production. By best estimates, there were about five hundred persons employed by Fabergé at the height of the firm's success in the early years of this century. There was, of course, a division of labor in the workshops between designers, enamelers, and so on. Many pieces were therefore a collaborative effort of many talented individuals.

Fabergé had an association with Carl Woerffel's hardstone workshop, which later became part of the Fabergé firm. This is where most of the carved hardstone figures, flowers, and animals were produced and where the hardstone carver Derbyshev worked. We also know that hardstone objects were commissioned by Fabergé from the Imperial Hardstone Workshops in Peterhof.

Fabergé opened branches in Odessa in 1890 and in Kiev in 1905. There, some minor work was carried out, but the bases of production remained St. Petersburg and Moscow.

The origin of Fabergé's greatest success and fame can be traced to the eggs he supplied to the Czar each Easter as gifts for the Empress. This custom apparently originated in 1885 when the first

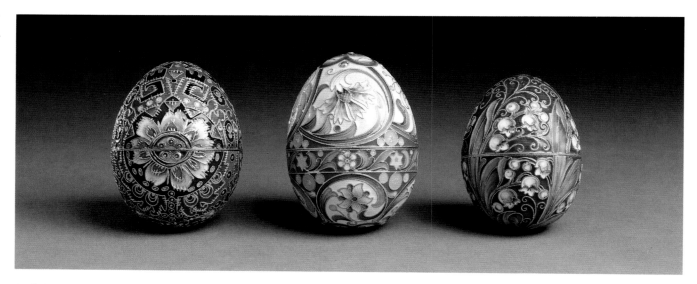

2. **Silver-gilt and Shaded Enamel Easter Egg.** Ovchinnikov. Moscow. ca. 1900. Height 2½″ (6.4 cm). *Bordered in Chinese-red with enameled stars and foliage, this egg is enameled with flowers on grounds of pink and cream.* **Silver-gilt and Shaded Enamel Easter Egg.** Feodor Rückert. Moscow. ca. 1910. Height 2½″ (6.4 cm). *This egg is enameled with stylized foliage and geometric designs in muted tones of blue, green, and brown.* **Silver-gilt and Shaded Enamel Easter Egg.** Feodor Rückert. Moscow. ca. 1900. Height 2¼″ (5.7 cm). *This egg is enameled with lilies-of-the-valley on a Chinese-red ground. Copyright 1989, Sotheby's, Inc., New York.*

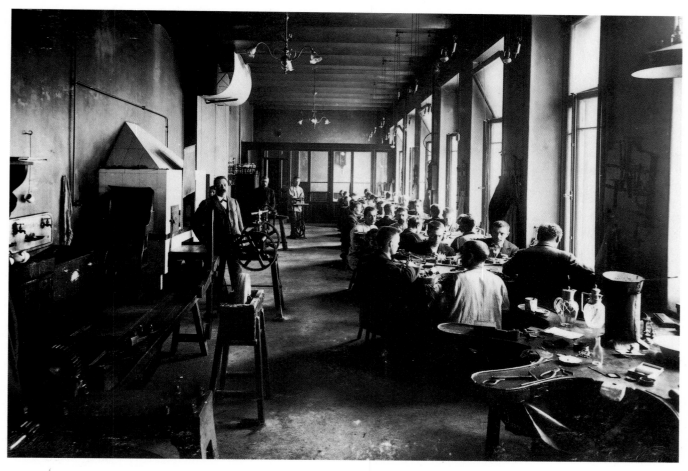

3. *Interior of Michael Perchin's workshop in St. Petersburg, ca. 1900. Courtesy Wartski, London.*

egg was commissioned from Fabergé by Czar Alexander III for Empress Marie Feodorovna. He was so pleased by the result that henceforth Fabergé was given orders for a similar egg each Easter. After the death of Alexander III in 1894, his son Nicholas II continued the custom. He now ordered two eggs each Easter, one for his mother the Dowager Empress and the other for the new Czarina, his wife Alexandra Feodorovna.

As symbols of creation and of new life, eggs have been exchanged at Easter, the central feast of both the Eastern and Western Christian churches, for hundreds of years. Throughout Europe natural eggs were colored and given as gifts. During the eighteenth century, the practice of creating eggs out of glass, porcelain, wood, papier-mâché, and precious metals and jewels was begun. Fabergé would naturally have been acquainted with such eggs. According to tradition, the first imperial egg, the Hen Egg, was ordered to remind the Empress Marie of home. She was born a Danish princess, daughter of Christian IX, and a very similar eighteenth-century hen egg was in the collection of the Danish royal family. Over the years the eggs became more elaborate as Fabergé's imagination (and resources) soared. Each egg contained a surprise. Between 1900 and 1911, six automaton eggs were produced (though not all were imperial commissions), the first being the imperial egg of the year 1900, the so-called Cuckoo Egg. In this egg the surprise is a singing bird which rises at the press of a button from the top of an egg-shaped gold, enameled, and jeweled table clock. Other surprises contained within these eggs ranged from miniatures of the imperial family (the Red Cross Egg with Portraits) to a model train in precious metals (the Trans-Siberian Railway Egg).

It would seem that a total of fifty-four such imperial Easter eggs were produced by Fabergé

between the years 1885 and 1917. Of the forty-seven eggs known to survive today, thirty-eight are distributed as follows: In the Kremlin Armory Museum: the *Pamiat Azova* Egg, 1891; the Madonna Lily Egg, 1899; the Trans-Siberian Railway Egg, probably 1901; the Clover Egg, 1902; the Uspensky Cathedral Egg, 1904; the Alexander Palace Egg, 1908; the Standart Egg, 1909(?); the Alexander III Equestrian Egg, 1910; the Romanov Tercentenary Egg, 1913; and the Steel Military Egg, 1916.

In the *Forbes* Magazine Collection, New York: the first Hen Egg, 1885; the Resurrection Egg, ca. 1889; the Renaissance Egg, 1894; the Rosebud Egg, 1895; the Coronation Egg, 1897; the Lilies-of-the-Valley Egg, 1898; the Spring Flowers Egg, before 1899; the Cuckoo Egg, 1900; the Orange Tree Egg, 1911; the Fifteenth-Anniversary Egg, 1911; and the Cross of St. George Egg, 1916.

In the collection of H. M. Queen Elizabeth II: the Colonnade Egg, 1905, and the Mosaic Egg, 1914.

In the Pratt Collection at the Virginia Museum of Arts, Richmond, Virginia: the Egg with Revolving Miniatures, 1896; the Pelican Egg, 1897; the Peter the Great Egg, 1903; the Czarevich Egg, 1912; and the Red Cross Egg with Portraits, 1915.

In the Matilda Geddings Gray Foundation, New Orleans, Louisiana: the Caucasus Egg, 1893; the Danish Palace Egg, 1895; and the Napoleonic Egg, 1912.

In the Marjorie Merriweather Post Collection at the Hillwood Museum, Washington, D.C.: the Silver Anniversary Egg, 1892, and the Cameo Egg, 1914.

In the Walters Art Gallery, Baltimore, Maryland: the Gatchina Palace Egg, ca. 1902, and the Rose Trellis Egg, 1907.

In the India Early Minshall Collection, Cleveland Museum of Art: the Red Cross Egg with Resurrection Triptych, 1915.

In the Maurice Sandoz Collection, Switzerland: the Swan Egg, 1906, and the Peacock Egg, 1908.

Two are known only from photographs, and another seven are in American and European private collections.

A. Kenneth Snowman, in *The Art of Carl Fabergé*, writes that for any parallels to these treasures one might consider Johann Melchior Dinglinger's creations for the Elector of Saxony or James Cox's collection of mechanical clocks, which he made for Qianlong's imperial palaces in Beijing, Yuan Ming Yuan, and Jehol.

Eggs of such grandeur were made by Fabergé for only a handful of customers apart from the imperial court. Among those few were the industrialist Alexander Kelch and Dr. Emmanuel Nobel, the Swedish petroleum magnate and nephew of Alfred Nobel, the founder of the Nobel Prizes. Dr. Nobel lived in Russia and was a major Fabergé customer who had a special fondness for the carved hardstone animals and figures.

The Serpent Clock Egg, 1887, modeled on a smaller imperial egg, was made for the Duchess of Marlborough, *née* Consuelo Vanderbilt, when the Duke and Duchess of Marlborough visited Russia in 1902. Now known as the Duchess of Marlborough Egg, it was later owned by Ganna Walska, the Polish-born opera singer who was married to Harold McCormick of Chicago. Consuelo Vanderbilt had divorced the Duke of Marlborough in 1920 and sold her egg at a charity auction in Paris in 1926. Ganna Walska in turn consigned the egg to auction in 1965 at Parke-Bernet Galleries in New York, where it was purchased by Malcolm Forbes for $50,000. It had carried a presale estimate of $10,000 to $12,000, and by more than quadrupling its estimate opened a new era in Fabergé prices.

Other pre-Revolution foreign visitors to St. Petersburg and customers of Fabergé included J. P. Morgan, Jr., of New York and Henry Walters of Baltimore. Walters sailed his yacht to St. Petersburg and filled it with Fabergé treasures. Some years later, under different circumstances, Marjorie Merriweather Post sailed in on the 350-foot *Sea Cloud* and returned with a similar bounty.

Imperial patronage, followed by the interest of British and other European royalty and aristocrats, spread Fabergé's fame widely. The interrelationship of Europe's royal houses facilitated

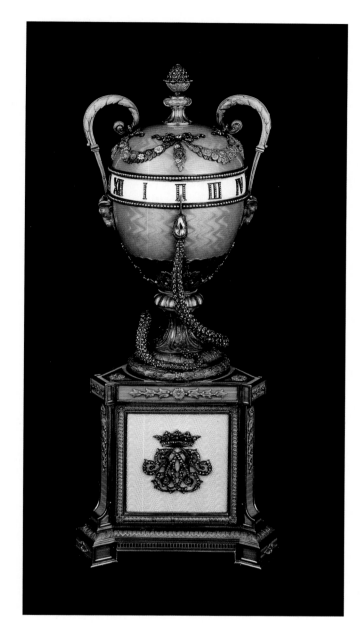

4. Fabergé. Workmaster Michael Perchin, St. Petersburg. **Duchess of Marlborough Egg.** 1902. Height 9¼" (23.5 cm). *This egg was made for the Duchess of Marlborough when the Duke and Duchess (formerly Consuelo Vanderbilt) visited Russia in 1902. It is enameled translucent pink over a guilloché ground. The egg is banded by a white enamel chaptering bordered by seed pearls on which the numbers of a clock are mounted in diamond-set Roman numerals. On the top are swags of flowers made from four-color gold and tied with diamond bows. A diamond-encrusted pine cone finial surmounts the egg. The handles on either side spring from red gold rams' heads and are topped with green gold foliage. A diamond-encrusted serpent, with a large oval diamond for its head, winds its way around and up the egg. His extended tongue indicates the time of day.*

The egg's three-sided base is pink enamel with white enamel panels over a moiré guilloché ground. On the main panel is the intricate monogram of the Duchess, "CM," topped with a coronet. The other two panels are applied with gold trophies. The Forbes *Magazine Collection, New York.*

this. For example, Alexander III of Russia and Edward VII of Great Britain were married to Danish sisters, daughters of King Christian IX: Alexander to Dagmar, who took the name of Marie Feodorovna, and Edward to Alexandra. Nicholas II, son of Dagmar, and George V, son of Alexandra, were therefore cousins (and they bore a striking resemblance to each other). Similarly, the German sisters, Elizabeth and Alix, daughters of Louis IV of Hesse-Darmstadt, married into the Russian imperial family: Elizabeth to Grand Duke Sergei, brother of Alexander III, and Alix, later Empress Alexandra Feodorovna, to Grand Duke Sergei's nephew, Nicholas II. In fact, the Russian ruling family was related to the majority of the rulers of Europe from Greece to Holland. The customary family exchange of gifts at Easter, Christmas, and name days thus combined with the imperial family's patronage of the house of Fabergé to spread Fabergé's creations and reputation across the face of Europe.

Another contribution to Fabergé's fame was his success at various European exhibitions. He won a gold medal at the Pan-Russian Exhibition in Moscow in 1882 and another in 1885 at Nuremberg. In 1897, following the Nordic Exhibition in Stockholm, Fabergé was appointed goldsmith to the court

of the king of Sweden and Norway. At the Paris Exposition Internationale Universelle of 1900, Fabergé exhibited *hors concours* (outside the competition) since he was a member of the jury. All the imperial eggs which Fabergé had hitherto made, as well as many other *objets d'art*, were shown in Paris at this time. As a result he was elected into the Légion d'honneur and was made a master of the Paris Goldsmith's Guild.

In 1903, Fabergé opened a shop in London. This was done in the interest of better serving his English clientele, mainly the royal family and Edwardian high society. At first, an office was opened by Arthur Bowe from Moscow in Berners Hotel, then in 1906 a shop was opened which was managed by Nicholas Fabergé, Fabergé's son, and Henry C. Bainbridge. In 1911, after some intermediate moves, premises were established at 173 New Bond Street, where business was apparently continued right up until the Revolution of 1917.

Leopold de Rothschild was a major customer of Fabergé's in London. As a coronation gift to George V and Queen Mary, he ordered from Fabergé a gold-mounted rock crystal vase engraved with the royal coat of arms. Henry Bainbridge has recounted how the gardener from the Rothschild house arrived on the morning of the coronation to collect the vase and fill it with flowers for delivery to Buckingham Palace. Leopold de Rothschild also bought quantities of objects from Fabergé to give as gifts, including various pieces enameled in his racing colors of deep blue and yellow. Bainbridge reports that "except in rare cases I never remember the Edwardian ladies buying anything for themselves: they received their Fabergé objects as gifts from men, and these gifts were purely for the psychological moment. When that had passed, i.e., the actual moment of the giving, they completed the mission for which they had been made."

In creating beautiful objects, Fabergé did not rely on large jewels and lavish settings, but emphasized design. He regarded himself as an artist whose media were jewels, precious metals, and enamels. When queried on this subject, he distinguished his work from that of other firms such as Tiffany, Boucheron, and Cartier, whom he characterized as "mere merchants."

Fabergé was associated with Mir Iskusstva ("World of Art"), a movement founded in 1898. Members of Mir Iskusstva took particular interest in the applied arts, as well as in eighteenth- and nineteenth-century Russian artistic movements. Prominent members of this association included Sergei Diaghilev, Alexandre Benois, and Leon Bakst.

Fabergé brought the art of enameling to technical perfection. The satisfaction of handling a flawlessly enameled, velvety smooth gold cigarette case, on whose invisible hinge the parts are perfectly aligned to snap tightly shut, was a pleasure shared by the last privileged classes of modern times. In the production of such a cigarette case Fabergé was following in the tradition of the great French goldsmiths of the eighteenth century who concentrated their skills on the manufacture of gold snuff boxes to be presented as gifts by the king; the snuff box came to represent the pinnacle of the goldsmith's achievement during that period. Fabergé, following a challenge by Czar Alexander III, reproduced a French box in the collection of the Hermitage. It was reported that the Czar was unable to distinguish the new from the old. Both boxes are now preserved in the collection of *Forbes* Magazine—the Paris snuff box by Joseph Etienne Blerzy and the Fabergé box with the mark of workmaster Michael Perchin.

The production of Fabergé's *objets de vertu* was highly labor-intensive. For example, many hours of hand-buffing were required to give an enamel object a velvety finish. The technique of enameling is an extremely delicate one involving firing the enamel (a compound of glass and metal oxides) at very high temperatures well over 1000°F. Also, an enamel object that combined different colors was fired in the kiln more than once, at different temperatures for different colors. The pleasing effect of translucent enamels was obtained by engraving a design on metal using a machine known as a *tour à guilloche*, then enameling over this design in translucent colors. Using this turning device, a variety of patterns called guilloche patterns could be engraved, the most popular being sunburst and moiré

designs. Fabergé also perfected the challenging technique known as enameling *en ronde bosse*—that is, enameling on curved surfaces. An enameling technique which Fabergé used only rarely is the champlevé method. Using this technique the design is engraved in the metal and the enamel is used to fill the depressions to make a smooth, decorated finish. In a way, the champlevé method is the opposite of the cloisonné method, in which wires are affixed to the surface of the metal to form compartments *(cloisons)* into which the enamel is poured.

Such carefully worked products were not inexpensive. A few years before the Great War, according to the London sales ledgers, a silver cigarette case cost in the range of £7 to £20 ($34 to $97) and a gold cigarette case £63 to £120 ($306 to $584). In comparison, according to the Baedeker guide of the time, a room at Claridge's or dinner at the Ritz cost about ten shillings. Therefore, it can be seen that a Fabergé gold cigarette case cost over one hundred times the price of an à la carte dinner at a top London restaurant or a room for the night at a five-star hotel. (It is interesting to

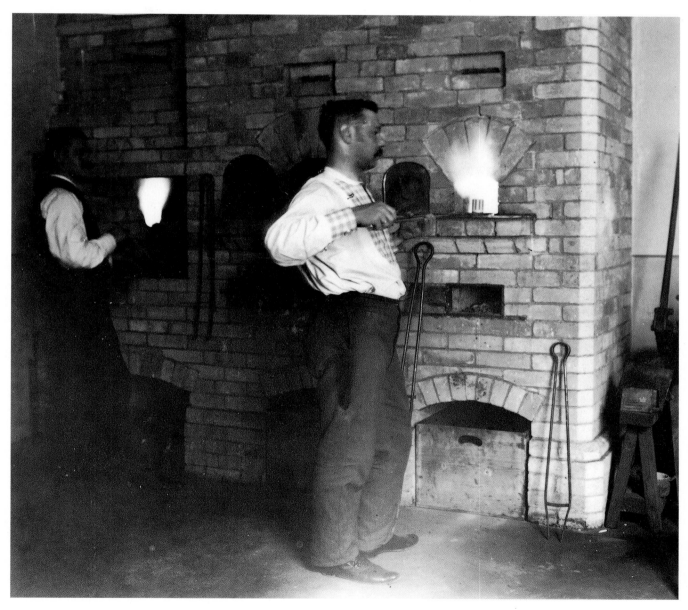

5. *Nicolai Petrov, son of Alexander Petrov, described by Bainbridge as "a somewhat rough character, fully absorbed by his work"* (Carl Fabergé, Goldsmith to the Imperial Court of Russia *by A. Kenneth Snowman, 1979). Courtesy Wartski, London.*

note that current auction prices show today's ratio between Fabergé and dinner to be comparable—about 100 to 1.)

Certain Fabergé pieces can be documented through the London sales ledgers. For example, we know that on 30 November 1915, a gold and enameled cigarette case was purchased from Fabergé in London by Lady Paget for the sum of £195. It was to be a gift to Lady Paget's close friend Queen Alexandra, widow of George V and sister of the Dowager Empress Marie Feodorovna. On 16 June 1988 it was again sold, this time at auction by Sotheby's in New York, for the astonishing sum of $154,000 (£86,000). The case is beautifully enameled using the champlevé technique in the style of an early nineteenth-century Geneva snuff box. The base is engraved with the crowned monogram A for Alexandra within a border of diamonds.

In the closing years of the last century and the early years of this century, Fabergé produced an almost endless array of *objets de luxe*: clocks, bell pushes, cigarette cases, scent bottles, parasol handles, frames, fans, paper knives, gum pots, calendars, thermometers, and even silver-mounted furniture. Fabergé did not limit himself to precious metals as a medium for his creativity. He felt free to use such materials as wood, steel, and sandstone, for example, and to choose those materials best suited to his purpose. Fabergé's stone carvings of animals were distinguished for their appropriate use of the various available hardstones and for a certain "psychologically interpretive" quality given to them, an accentuation of a typical characteristic, as in a pig's happy, well-fed look, as opposed to a formal, anatomical study. The particular qualities of various hardstones were skillfully utilized to best correspond to the animal being carved: pink chalcedony for the pig, for example, or obsidian for a penguin.

Fabergé was invited by Edward VII to create models of the domestic animals at Sandringham. Artists were dispatched from Russia to undertake the task. They returned to St. Petersburg with wax maquettes for the stonecutters to follow. The finished animals were then shipped to London for the king to approve and present to Queen Alexandra. She was, by all accounts, delighted. None of the queen's friends ever had to agonize over the question of selecting a gift for her: They needed only give her a creation by Fabergé.

Among the rarest of Fabergé's creations are the carved hardstone flowers, mounted in gold and placed in rock-crystal vases. Such flowers offered a reminder of summer during the long, dark St. Petersburg winters. One of the most famous of these flower studies is the basket of lilies-of-the-valley presented to the Czarina Alexandra Feodorovna as a coronation gift from the "Iron-works management and dealers in the Siberian iron section of the Nijegorod Fair." It is now in the collection of the Matilda Geddings Gray Foundation in New Orleans.

Objects which were produced in precious metals by Fabergé had to be "hallmarked" in accordance with the Russian State system of the time. As in other countries, this system existed, and still exists, to guarantee the fineness of the gold and silver being sold. (No marks existed for platinum at the turn of the century, for it was not highly regarded as a precious metal.) In general, for silver or gold objects produced in St. Petersburg by Fabergé, apart from the standard mark one can expect to find the workmaster's initials and, on objects from before 1899, the town mark for St. Petersburg (crossed anchors, with a scepter between; that is, the city's coat of arms), the date combined with the assay-master's initials, and, possibly but not necessarily, the mark in Cyrillic of Fabergé or K. Fabergé. After 1899, instead of the date and town mark, simply the numerical standard for the fineness of the metal (such as 84; see below) combined with a woman's head in profile and either the assay-master's initials (1899–1908) or a Greek letter-code for the town (1908–1917) will be found. For Moscow before 1899 the town mark was the city's coat of arms, St. George slaying the dragon; after 1899, the woman's head in profile was substituted (this was used throughout Russia after 1899). This mark of the woman's head is known as the *kokoshnik* mark, after the distinctive headdress worn by the woman. The maker's mark used by Fabergé in Moscow was simply

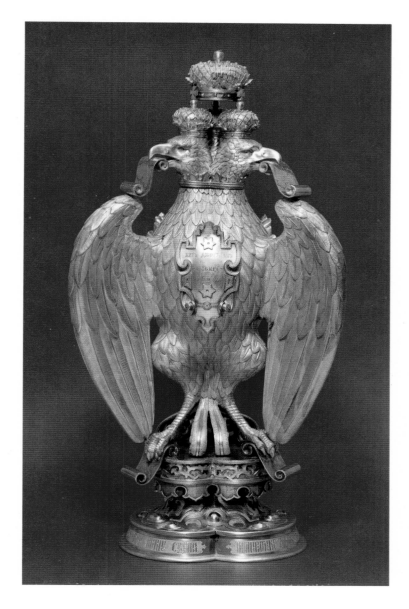

6. Sazikov. St. Petersburg. **Silver (Partly Gilded) Yachting Trophy.** 1851. Height 20¼″ (51.5 cm). *In the form of a three-headed imperial eagle, this trophy is realistically chased to simulate feathers. The slip-on cover is surmounted by a crown. The beaks of the eagle heads grasp scrolls upon which are engraved maps of Europe, Africa, and Asia, and the claws hold scrolls with maps of Russia, America, and the South Pacific. The body of the eagle is applied with three strapwork cartouches engraved in Cyrillic, "Yacht Georgian, F.K. Bird, 1 June 1851," and the base is inscribed around the border in Cyrillic, "Imperial Prize for Sea Race Between the Boats of the Imperial St. Petersburg Yacht Club." Copyright 1989, Sotheby's, Inc., New York.*

K.F. or K. Fabergé in Cyrillic, combined with the imperial warrant mark, since there was no system of workmaster's shops in Moscow. Pieces which were imported into England to be sold in London will be found with the maker's mark C.F. (for Carl Fabergé) in Latin letters, as well as a set of import marks added by the British authorities.

Fabergé was granted the imperial warrant, supplier to the imperial court, around 1885, presumably after delivery of the first Easter egg to Alexander III. The imperial warrant permitted Fabergé to use the state coat of arms of a double-headed eagle in conjunction with his own mark (as well as in his advertising). Various other silversmiths and jewelers of the time, such as Ovchinnikov and Khlebnikov, also held the imperial warrant; therefore, the double-headed eagle mark is found in conjunction with their marks also.

The various standards of fineness for silver or gold used in imperial Russia were calculated in zolotniks, 96 zolotniks being pure. The most common silver standard, 84, can be translated as 84 parts pure silver out of 96 parts total alloy (87.5 percent). Similarly, with gold the most frequently found standard of 56 can be translated as 56 parts out of 96 parts total alloy. This gold standard is equivalent to the Western standard of 14 karat, 24 karat being pure gold.

In 1910, Fabergé instituted a suit against Goldsmith's Hall in London in an effort to avoid the

necessity of hallmarking his delicate wares. The judgment, however, went against him, and he was thereafter obliged to import some pieces in an unfinished condition for hallmarking in London. Then they would be returned to St. Petersburg for completion. The sterling standard in use in England was 92.5 percent pure silver, so in order to comply with this requirement Fabergé's objects intended for sale in England were henceforth made using the Russian 91 standard, which was even finer than sterling (91 parts pure silver out of 96 parts total alloy equals 94.79 percent).

A cursory glance at the hallmarks will not suffice these days for ascertaining the authenticity of a work purported to be from the house of Fabergé. As when anything becomes sought after and collected, fakes will appear to trap the unwary. There are various categories of fakes. One category, for example, comprises old objects in the style of Fabergé produced around 1900 in either Russia, Vienna, or Paris, now to be found with pseudo-Fabergé marks. Fabergé's style was widely copied during his lifetime, both in Russia and in Europe, but his competitors were unable to match the essential balance and lightness of his designs. At the other end of the spectrum are to be found brand-new pieces bearing new marks. Between these extremes are those objects which may be said to be only partly genuine—for example, a napkin ring that has been changed into a box by the addition of a bottom and a cover, or a buckle that has been converted into a brooch.

A beginning collector would be well advised to make a comparative study of the field of Russian and European silver- and goldsmithing. One should be confident of deciding on the authenticity of an object based on the quality of the enameling, the style of chasing, and so on, before looking at the mark. The maker's mark should in that case serve merely to corroborate that opinion. If, on the other hand, the judgment is that the piece is not genuine Fabergé, a suspicious-looking shallow or shaky mark will serve to reinforce that opinion.

When the Revolution came, Fabergé's business in Russia ended and he left for Wiesbaden in Germany. In 1920, he moved to Lausanne, Switzerland, where he died on 24 September of that year. He had four sons, Eugene (1874–1960), Agathon (1876–1951), Alexander (1877–1952), and Nicholas (1884–1939). All worked for the firm during their father's lifetime. In 1924, following their father's death, Eugene and Alexander Fabergé opened a shop in Paris, where they carried on a moderately successful business under the name Fabergé et Cie.

In the 1920s and 1930s, a substantial number of Fabergé objects found their way to the West. Individuals such as Armand Hammer, Emanuel Snowman, and Alexander Schaffer brought Fabergé pieces out of Russia. Also, the Soviet Union, in great need of hard currency, held an auction in Germany and thus dispersed a sizable quantity of works of art. In fact, the new Soviet authorities had no great affection for the creations of Carl Fabergé, since he had been so closely associated with the last Czars of imperial Russia. They were happy to use his creations as a source of income.

Armand Hammer had gone to Russia in the early twenties and had begun trading with the new government. He had established a pencil factory there by the middle of the decade. When this business was appropriated by the government, he was allowed to take out antiques and works of art as compensation. He organized a traveling exhibition and sale at department stores in the United States from 1929 to 1933, starting at Scruggs Vandervoot in St. Louis, going to Marshall Field in Chicago, and ending at Lord and Taylor in New York. The traveling show was a big success in spite of the financial crash that began the Great Depression. At this time Lillian Thomas Pratt and Matilda Geddings Gray began what were to be their substantial Fabergé collections.

The art and antique dealers Emanuel Snowman and Alexander Schaffer went to Russia to purchase items for their shops in London and New York. In this way, many imperial Easter eggs left Russia to be sold to Western collectors. In fact, the only imperial egg to leave Russia with its original owner was the Cross of St. George Egg, taken by the Dowager Empress Marie Feodorovna to Denmark, via England, in April 1919. It was sold in 1961 by her grandson, Prince Vasili Romanov, at Sotheby's in London for £11,000.

7. *Carl Fabergé sorting through a parcel of loose stones, ca. 1915. Photograph by Hugo Oeberg, one of his designers in St. Petersburg. Photograph courtesy of Wartski, London.*

Marjorie Merriweather Post also built a substantial collection of Fabergé and Russian works of art in her lifetime, some pieces of which were acquired when she went to Russia with her third husband, Joseph E. Davies, in 1936. Davies had been appointed the United States ambassador to the Soviet Union, and Marjorie, heiress to the Post cereal fortune, used the opportunity to acquire a wide variety of Russian antiques and art. Some of these objects, at the time, were being offered in bulk or by the weight of the precious metal in exchange for much-needed foreign currency. Having begun collecting in the late 1920s, Post was already familiar with Fabergé and the wider field of Russian art by the time she went to Russia. The house she later built in Washington, D.C., is stocked with *objets d'art*, including two Fabergé imperial eggs. Now known as the Hillwood Museum, it is open to the public.

Another well-known American, the publisher Malcolm Forbes, has amassed a stunning collection of Fabergé works, all purchased in the West. His first major acquisition was the Duchess of Marlborough Egg in 1965. Within the next twelve months he acquired over two dozen pieces from the collection of the late Landsdell K. Christie, and in the years since he has built a veritable Fabergé museum. Christie was a New York shipping magnate whose well-known collection, prior to

his death, had been on loan to the Metropolitan Museum of Art in New York. From the Christie collection Forbes acquired the first Hen Egg, the Chanticleer Egg, the Rabbit Egg, the carved hardstone Dancing Moujik, the Basket of Lilies-of-the-Valley, the Coronation Box, the Nicholas II Nephrite Box, the Fire Screen Frame, and other treasures. Many of Christie's pieces had been owned by Jack and Belle Linsky, who had abandoned collecting Fabergé for other areas of acquisition in the 1950s on the advice of the then director of the Metropolitan Museum. Forbes's collection of almost three hundred pieces is publicly displayed at his publishing headquarters in New York City. Thus, there are now more Fabergé imperial Easter eggs to be found at 60 Fifth Avenue than in all of Russia—or anywhere else in the world, for that matter. Forbes surpassed the Kremlin in this regard in June 1985 with his purchase of the Cuckoo Egg for a record $1,760,000 at a Sotheby's New York auction. The auction of the Cuckoo Egg generated huge interest as the first auction in America of an imperial Easter egg. Similarly, museum exhibitions in recent times have met with long lines for admission, as, for example, when the Victoria and Albert Museum in London publicly exhibited the Royal Collection in 1977. As an indication of the current situation in Russia, it can be noted with pleasure that on 8 February 1989 a major exhibition of Fabergé's work was opened at the Yelagin Palace in Leningrad, the first such acknowledgment in the Soviet Union (that is, since the Revolution) of Fabergé's genius.

Much has been written about Fabergé and his creations in the past several decades. I would refer readers to the outstanding volumes by H. C. Bainbridge and A. K. Snowman. *Peter Carl Fabergé, His Life and Work*, by H. C. Bainbridge was published in 1949. In this work, Bainbridge, who managed the London branch of Fabergé's business, describes not only the conduct of the trade but also his personal experiences with Carl Fabergé. He relates some lively stories concerning famous Edwardian personalities as well. Bainbridge emphasizes Fabergé's "Russianness" as well as his originality; he located Fabergé securely within the framework of centuries of Russian history and tradition.

Published in 1953, *The Art of Carl Fabergé* by A. Kenneth Snowman, was the standard reference book on Fabergé for many years. Snowman has since updated his original work and published various monographs on aspects of Fabergé's production.

In view of the mass production of goods and the decline in workmanship throughout this century, the flawless works of the Russian master goldsmiths represent a care in conception and execution that is exceedingly difficult to find in the world today. It is hoped that this book, with its splendid assembly of widely dispersed creations by Fabergé and his greatest competitors, will sustain the wonder of their achievements and prolong the delight.

GERARD HILL

The Russian Master Goldsmiths

Through the ages an important role in the history of Russian culture has been played by the art of the goldsmith and the silversmith. With its birthplace in Kiev, this art has passed through many stages of development. In times of national ascendancy it rose to great heights, while in times of war and disaster its greatness waned. Little by little, unique types of ornamentation evolved, peculiar to Russian creations alone, both in materials and in form. The art reached its peak in the late nineteenth century, when the industrial manufacture of jewelry and *objets d'art* began in Russia. Having already acquired a national character, this art relived, as it were, the history of its previous development, beginning with the cloisonné enameling of Kiev, and went on to achieve worldwide recognition.

It was at this time that there came into being large firms with highly developed techniques for processing and ornamenting precious metals. The skilled use of these techniques made it possible not only to revive all the former styles but to introduce new forms of ornamentation as well. This greatly enhanced the expressiveness of the art and brought out new qualities in the materials themselves, many of which had been underutilized. Never before had such a wealth of materials been used or had smithing techniques known such success.

The Beginnings

The industrial manufacture of jewelry and *objets d'art* dates to the first half of the nineteenth century, when the first firms were established by I. Sazikov, C. Bolin, and I. Chichelyov. The mid-nineteenth century saw the establishment of the Gubkin, Orlov, Kuzmichev, and Semyonov companies. One of the largest Moscow firms was established by Pavel Ovchinnikov.

The number of large factories increased considerably after the abolition of feudalism in 1861. Those already in existence were enlarged, and many new ones were established, among them the firms of Adler, Shelaputin, Khlebnikov, and Klingert. Peter Carl Fabergé's establishment came into being in this period too. These factories also had retail shops, mainly in Moscow and St. Petersburg.

Some of the artisans and owners of the numerous small workshops in Moscow and St. Petersburg found it extremely difficult to compete with the rapidly growing, large-scale firms. Many preferred to work for the large firms and sell the work they produced through them, which accounts for why the articles are often marked with two names, those of the maker and of the firm.

At the turn of the century, and especially after the 1905 Revolution, goldsmiths in Moscow, St. Petersburg, and Kiev tended to combine in *artels*, or guilds. In Moscow alone, according to the data available, there were about thirty of these artels.

The increased production that took place in Russia after the 1861 reform led to an intensive development of joint-stock, manufacturing, and trading companies. In 1888 a joint-stock company was formed called I. P. Khlebnikov Sons and Co., Manufacturers of Gold and Silver Articles and

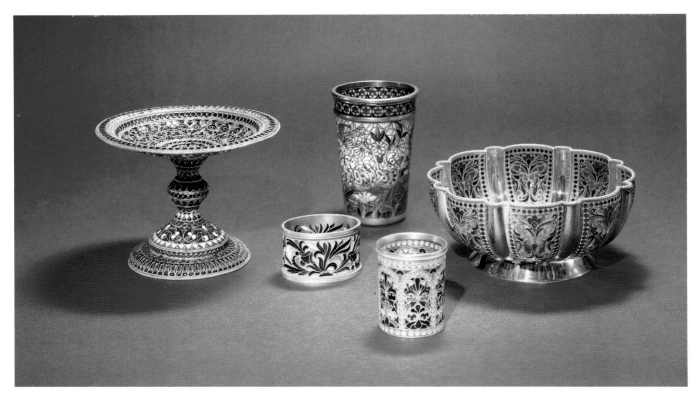

8. Various makers. Moscow. **Group of Silver and *Plique-à-Jour* Enamel Objects.** ca. 1890–1910. Heights 1⅜″ to 3⅞″ (3.5 cm to 9.9 cm). *These superb creations of* plique-à-jour *enameling were produced by various makers, including Ovchinnikov, Saltykov, and Khlebnikov. Copyright 1989, Sotheby's, Inc., New York.*

Jewelry. Its founders were Mikhail, Nikolai, and Alexei Khlebnikov and V. N. Suvorin, Merchant of the First Artel. The stated purpose of the company was "to maintain and extend the activities of I. P. Khlebnikov's manufactory of diamond, gold, and silver articles."

The statute of the manufacturing and trading firm of P. I. Olovyanishnikov and Sons was registered in 1901. The company owned a foundry in Yaroslavl for casting church bells and a factory in Moscow for producing church plate. In 1902 a manufacturing and trading company was formed by the successors of N. V. Nemirov-Kolodkin, a well-known manufacturer. And in 1916 one of the largest joint-stock companies in the trade was founded by O. P. Kurlyukov.

At the turn of the century there were many traders, among them the Makarov Brothers, I. S. Morozov, Baylin and Son, Nikolai Linden, F. I. and F. F. Köchli, and the Frolov Brothers, who owned large shops where they sold gold and silver articles they had acquired from individual artisans (whom they themselves frequently provided with raw materials). They also owned their own factories and workshops.

Some of these dealers would take orders from larger firms. For example, Baylin and Son made gold cigarette cases for Fabergé, and their workshop, for fifteen years, supplied Paul Buhré, a famous dealer in timepieces, with gold chains, accessories for gold wristwatches, diamond coronets, and diamond eagles. The same workshop also made gold cigarette cases for I. Marshak, a manufacturer in Kiev. Another example is Galkin Brothers, dealers who manufactured icons with silver repoussé covers "at your discretion" for the Lubavin firm in St. Petersburg and the Kurlyukov and A. Postnikov firms in Moscow.

The rapidly growing production in Moscow and St. Petersburg and the development of railroads, which contributed to the expansion of domestic and foreign trade, led to a gradual decline in the

craft in traditional centers like Novgorod, Pskov, Yaroslavl, Vologda, and Veliky Ustyug, for they were unable to compete with the large metropolitan firms. In 1911 Moscow and St. Petersburg produced 61 percent of all the silver work in Russia.

In the 1870s a number of assay offices in Oryol, Tver, Perm, Tobolsk, Novgorod, and Kishinyov closed down, their insignificant income insufficient to cover their expenses. The few who continued to work in these localities were obliged to have their work marked in towns where assay offices still functioned. Thus, from Novgorod they went to St. Petersburg, and from Tver they went to Moscow.

The gentry and merchants in the provinces now placed their orders in Moscow or St. Petersburg rather than with the local silversmiths. This explains why icon covers for the Yarmoroch (Marketplace) Cathedral in Nizhny Novgorod were made by a Moscow silversmith in 1846, by a St. Petersburg craftsman (Verkhovtsev) in 1856, and by the Moscow Nemirov-Kolodkin firm in 1899.

This process intensified still further at the beginning of the twentieth century. According to reports sent to the central assay office in St. Petersburg from provincial offices, in 1908 only one workshop in Tobolsk and two in Krasnoyarsk were engaged in producing gold and silver articles. By the beginning of the twentieth century there remained just one artisan in Veliky Ustyug familiar with the traditional methods of making niello.

However, while the craft had practically died out in some parts of the country, there were other places where the production of silver objects rose to a higher level. One of these was Rybnaya Sloboda, in the Lanshev District, Kazan Province. It was there that national ornaments had been produced in the nineteenth century for Tatars, Khirgizi, and Chuvashi. In 1891 there were nearly ninety silversmiths there, and by 1895 the number had increased to 140. They sold their wares at the Nizhny Novgorod Fair, mostly to professional buyers, from whom they bought the materials they needed for their work. That is how such articles found their way to Central Asia, Turkestan, the Kirghizi Steppe, even to Western Europe and the United States.

In the latter half of the nineteenth century there was a sharp increase in the production of small silver articles in villages in Kostroma Province. The center of this activity was the village of Krasnoye, where, at the close of the century, the inhabitants numbered around 3,000. In 1893 silver objects worth over three million rubles were produced there. They included small images of saints, pendants in the shape of crosses, icon covers, brooches, earrings, bracelets, chains, rings, and small vessels, all chased and stamped, with engraving, enamel, and semiprecious stones.

In 1897 a class in drawing was opened in Krasnoye; in 1904 it was converted into a workshop for the training of gold- and silversmiths, directed by S. G. Monastyrsky, who taught engraving on metal, and later by V. M. Anastasyev, who taught drawing, watercolor, the history of applied arts, and the techniques of the trade. V. A. Apukhtin taught pictorial enameling, and M. A. Morozova led classes in filigree and cloisonné enameling. These and other teachers had earned a Master of Graphic Arts degree at the Stroganov School of Industrial Art and their teaching was on a very high level.

The workshop trained the students to make tableware and jewelry; it taught them chasing, engraving on silver and steel, and filigree and enamel work. By 1915 there were ninety-three students attending courses in the school. Some of these Krasnoye artisans moved to larger towns. Archives show that many Moscow and St. Petersburg silversmiths of this period came from peasant stock—a large proportion of them from families in Kostroma Province.

Developments in Work with Precious Metals

In the second half of the nineteenth century the rapid technological and economic developments of the industrial revolution led to radical changes in the structure of society, including changes in the manufacture of jewelry and *objets d'art*. They were now produced on a mass scale, as the number

and range of buyers grew considerably. This growth inevitably affected the nature of the products themselves.

Nineteenth-century goldsmithing was strongly influenced by new techniques in processing precious metals and by a gradual increase in the use of machinery. In the 1840s galvanic gilding was introduced, and it very soon replaced the use of mercury fire-gilding, a practice highly detrimental to the health of the gilder. By about 1850 machinery was very largely used in the production of gold and silver objects.

Machine stamping became widespread, especially in making inexpensive silver ware, such as charkas, cutlery, and inexpensive jewelry for ladies. The stamps were made by engravers at the Mint. In 1879, for instance, a factory owner named Grachev placed an order with the Mint for "eight stamps for the manufacture of handles for tablespoons."

A wide variety of ornaments made of rolled metal were introduced at this time. The products of the best goldsmiths, including Fabergé, were frequently decorated with small ornamental bands winding around various parts of their smooth, polished surfaces.

Much in vogue was guilloche patterning: a machine-made, delicate carving of concentric circles,

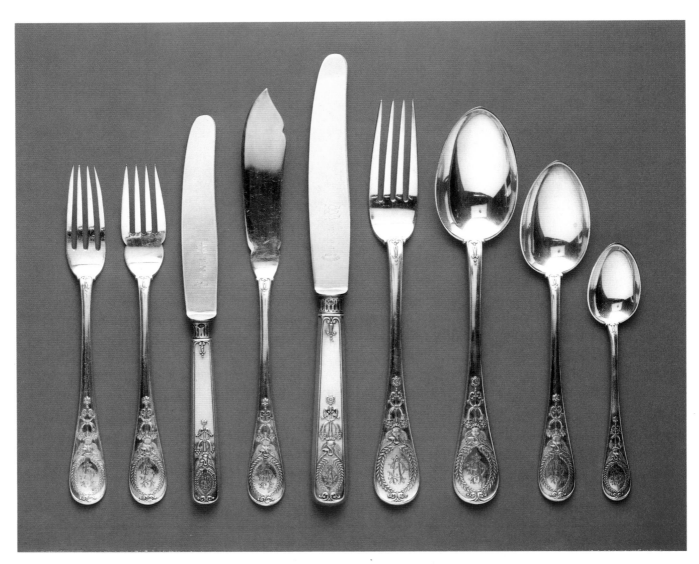

9. Fabergé. Moscow. **Silver Flatware Service.** ca. 1910. *This is a sample of a 132-piece service for twelve, with spatulate handles decorated with cornucopia and swans. Copyright 1980, Sotheby's, Inc., New York.*

26

fishscales, rays, or stripes on metal. This technique was used to ornament the lids of pocket watches, cigarette cases, and icon covers. The *guilloché* metal ground was also frequently coated with colored transparent enamel.

Although machine processing had gained considerable ground by the mid-nineteenth century, handmade pieces were still widely produced. This can be explained in part by the fact that there were processes that could not be accomplished by machinery: the complex twisting of filigree wire, the casting and chasing of designs and pictures, gold mosaic, niello engraving, and enameling in all the colors of the rainbow.

The large factories had staffs of specialists in every branch of goldsmithing. For instance, among the employees of the St. Petersburg factory owned by the Galkin Brothers in 1904 were nine enamelers, sixteen engravers, seven filigree workers, four chasers, eighteen mounters, thirty-one polishers, and three stampers. And the Ovchinnikov factory had separate workshops for chasing, enameling, and engraving.

The manufacture of small sculptures in silver was characterized by brilliant casting and chasing techniques and a great variety of themes. This art thrived up through the early twentieth century, along the way absorbing all the trends of contemporary art. Separate figures or sculptural groups cast in silver and scrupulously chased were often produced in connection with important historical events. They either served purely decorative purposes or were parts of other objects: sets of tableware, desk sets, candelabra, or clocks.

One of the first artisans to turn to sculpture in silver was I. Sazikov. A characteristic feature of his early work (1847–1848) was the production of tea sets overlaid with sculptured heads of cavaliers and ladies. In the 1850s Sazikov created sculptures on allegorical, historical, and genre themes. This style was immediately adopted by other well-known firms: Nicholls and Plincke, Ovchinnikov, Khlebnikov, the Grachev Brothers, and Fabergé.

Another common type of ornamentation was work in relief, made by chasing and characterized by an intricate compositional structure and a skillful rendering of texture and perspective. It was used to decorate jugs, cups, desk sets, albums, clocks, vases, and many other objects. A fine example is found on an 1871 Khlebnikov cup in the collection of the State Historical Museum. Ornamented with a chased scene of the founding of St. Petersburg, showing Peter I standing on the bank of the Neva, holding the plan of the city he was to build and surrounded by his comrades-in-arms and church dignitaries, the cup was probably made to mark the bicentenary of the birth of Peter I.

In the late nineteenth century—especially during the years 1860–1880—a new note was sounded in the chasing of silver. Possessing a true mastery of all the subtleties of their trade, artisans began to imitate in silver the texture of various materials: fur, wood, linen, birchbark, and leather.

The use of filigree in Russia dates back to very early times when jewelry was made partially or entirely of gold or silver wire. Russian filigree was a fine, delicate art, with designs that were always clear, rhythmical, and easy to follow. By 1900 the majority of jewelry firms, workshops, and artels produced objects in filigree: boxes, children's money boxes (in the shape of cups or little houses), icon covers, earrings, bracelets, belts, scissor and needle cases, bottle labels, and pen holders. These firms were located mainly in Moscow, Zhitomir, and Novocherkassk, but they were a rarity in St. Petersburg.

At the beginning of the twentieth century the art of filigree underwent considerable changes. The manufacture of open-work practically ceased, to be replaced by a fashion for handbags and purses made of a kind of chain-mail filigree that looked like iridescent cloth. These articles were produced in numerous workshops in Moscow and St. Petersburg.

The second half of the nineteenth century saw a revival of an exceptionally lively interest in enamel work. It was in this branch of the applied arts that the desire to revive early Russian traditions in form and ornamentation was most strongly felt. In the 1860s and 1870s enameling

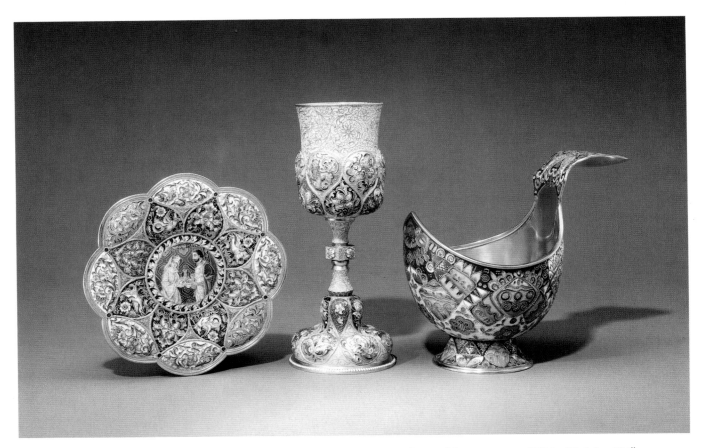

10. **Silver-gilt and Shaded Enamel Standing Cup.** Feodor Rückert. Moscow. ca. 1910. Height 9¾″ (24.9 cm). *The lobed body is enameled with teardrop panels which enclose a lion, an eagle, and a gryphon separated by multicolored flowers. The lower lobes are enameled with foliage on grounds of olive green, purple, and cobalt blue. The lobed base is decorated with sea creatures.* **Silver-gilt and Shaded Enamel Dish.** Feodor Rückert. Moscow. ca. 1900. Diameter 7½″ (9 cm). *This dish is of octafoil shape. It is lobed and enameled with birds inhabiting scrolling foliage and with panels of flowers on varicolored grounds. The center is enameled with a boyarina presenting a tray with a carafe and cup to a boyar, inscribed "Dear Guest" in Cyrillic.* **Silver-gilt and Shaded Enamel Kovsh.** Fabergé. Moscow. ca. 1910. Length 9¼″ (23.5 cm). *Of globular form, this kovsh is enameled with multicolored foliage and geometric forms in the Old Russian style. Copyright 1989, Sotheby's, Inc., New York.*

became the favorite method of ornamentation and, as in the seventeenth century, it was a very important feature of work with gold and silver. Once again the enameler's craft had become inseparable from that of the filigree worker, the carver, and the chaser; earlier in the century, enamel designs had been made on separate metal plates and artisans had simply added miniatures as part of the ornamentation.

From this era up to 1900 there was a blossoming of artistry in the use of enamel. It was produced in an unprecedented wealth of colors, and new techniques for combining it with metal, as well as many forms of ornamentation, were developed. There also reappeared long-forgotten ways of using enamel: cloisonné, champlevé, Limoges, *plique-à-jour* (known to Benvenuto Cellini), vitreous, and guilloche—not to mention the newly created enamel varnish and matte enamel.

The leading firms in the production of enamels were Ovchinnikov, Khlebnikov, Olovyanishnikov, Postnikov, Kurlyukov, and Rückert in Moscow, and Fabergé, the Grachev Brothers, Hahn, Tillander, and Britzin in St. Petersburg.

The most widespread use of enamel, especially in Moscow, was cloisonné, which covered most of

the surface of the object, leaving a piece of ground uncoated. The uncoated part was then often chased with fine patterns.

Sometimes both ornament and ground were completely coated with enamel, leaving nothing but a pattern of gilded, plaited filigree wire. This technical device was used by the Moscow firms of Klingert and Rückert and became a distinctive feature of their styles. Klingert was awarded a bronze medal for his enameled articles of silver at the 1893 International Exposition in Chicago.

Another widespread type of enamel work was champlevé, a technique wherein a design or inscription was cut into the surface of the metal and then filled with Limoges enamel. The designs often resembled such motifs of folk art as embroidery and wood carving. A tea service made in 1890 at I. Saltykov's Moscow factory was ornamented in an extremely original way: with a geometrical design made to look like a cotton print, in white and blue champlevé enamel.

Since ancient times one of the favorite ways of decorating precious-metal objects has been carving or engraving, a preference that continued up to the early twentieth century. There are many works from this period with carved ornaments and inscriptions that had lost the grandiose style of the sixteenth and seventeenth centuries. What had become popular was a fanciful figured medallion containing an inscription stating that the object was a gift or a souvenir. Or the medallion might be engraved with a coat of arms or a monogram. These medallions might then be cleverly worked into the general ornamentation of silver or gold cigarette cases, tableware, albums, or blotters. In Fabergé's Moscow branch there were eight engravers working on the carving of monograms alone. Special engraving establishments were even opened in Moscow and St. Petersburg at the turn of the century to fill orders for these engraved objects.

Many carved pictures of landscapes and architectural monuments made in the late nineteenth century were very accurate copies of prints. Some of them were views of the Kremlin, like the one carved on a canister by F. Yartsev, a Moscow artisan. A brilliant example of such carving is a cigarette case in the State Historical Museum, made in 1857 by an unknown Moscow artisan, that was also carved with a picture of the Kremlin against a background of the rays of the setting sun.

The forms of *style moderne*—often seen in book and magazine illustrations of the era—also influenced carving techniques, which frequently involved the use of colored gilding.

A technique very closely connected with metal carving is niello. It was the desire to make a carved ornament or design more forceful that led to the appearance of niello, an alloy of sulfur, silver, copper, and lead used to fill the incised lines of a metal carving and then fired. It was only in Russia, where it was used as early as the tenth century, that niello developed on an extensive scale.

Niello articles were produced to a greater or lesser extent by all the Moscow workshops in the late nineteenth century. Niello ornamentation varied widely, from delicate leaf patterns—somewhat altered revivals of characteristic sixteenth- and seventeenth-century forms—to engravings of urban scenes, mainly of Moscow and St. Petersburg.

There is a fine example in the State Historical Museum of the decorative qualities of niello: a tray produced in 1884 by Ovchinnikov, a firm that rarely employed the technique. On the tray three round medallions show the Grand Kremlin Palace, the Spassky Tower, and the Cathedral of St. Basil the Blessed. The clear contours of the delicate drawing on the silver ground are set off by an encircling relief of niello tendrils.

Another well-known Moscow firm, that of Khlebnikov, made a broader use of niello. It displayed a large number of niello articles at the Exhibition of Industrial Art held in Moscow in 1882. A prominent work was a cigarette case with a delicate ringlike design. Also in the State Historical Museum is a small tray made in 1862 with the maker's mark of A. Fuld (a Moscow factory owner well known between 1862 and 1917), that has a niello representation of a *rayoshnik*, or wandering storyteller, joker, and entertainer (a very popular figure in those days). It was a very accurate reproduction of a drawing printed in the 1858 illustrated almanac *St. Petersburg Zarechny*.

Vasiliy Semyonov's Moscow factory, established in 1852, occupied an important place in the manufacture of niello. The other large firms employed a great variety of methods for processing precious metal: chasing, casting, filigree, enameling, carving, and niello. Semyonov was an exception, for he worked almost exclusively in niello. The articles produced by his firm were equal in quality to those of the more powerful firms, such as Ovchinnikov or Khlebnikov, and even surpassed them in the precision of their execution.

Semyonov began displaying his work at Russian and international exhibitions of industrial art in 1867, winning general recognition. In 1870 he was awarded a silver medal in St. Petersburg (where niello was not very popular) for the clear-cut quality of his work in silver with niello and for the beauty of his designs. Semyonov's factory produced a variety of objects, among them dinner and tea services, cigarette cases, and snuff boxes; their ornamentation was in the spirit of the times, reflecting the general trends in applied art to revive old Russian forms. This can be seen in an 1869 goblet in the State Historical Museum that repeats the form of seventeenth-century goblets with globular stems; it carries the inscription "a silver goblet from which to drink to your health."

The Making of the Artisans

The increasing rivalry among manufacturers, the diversity and complexity of new artistic styles, and the creation of new manufacturing techniques made it essential that specialized training be developed for artisans. The owners of large firms organized specialized classes or schools in drawing, which gave rise to the appearance of splendid master jewelers. As early as 1895 Sazikov created a special department at his factory to serve as a "hothouse" for the expert training of eighty artisans.

One of the first specialized art schools was set up by the manufacturer Ovchinnikov for 130 people. It offered a five- or six-year training course, primarily for goldsmiths and silversmiths, but there were also general subjects: draftsmanship, singing, and gymnastics. Modeling in clay and in wax, drawing, and calligraphy were taught to the extent needed for "technical applied art, as used by silver- and goldsmiths."

Ovchinnikov's factory school was awarded a silver medal at the 1882 national Russian exhibition of industrial art for "objects exhibited related to modeling in clay and inscribing in enamel, and for drawings and compositions by the pupils themselves."

Ovchinnikov called upon all manufacturers producing valuable *objets d'art* to follow his example. In 1881 he published a book about the necessity to arrange special classes and to found special educational establishments at factories, so that "the factory owner [could] provide himself in advance with good employees in order to put the factory's output on a firm, sound basis."

A smaller training school for artisans that opened at Postnikov's factory in 1870 was awarded a second-grade diploma at the 1882 exhibition. There was also a specialized art school for seventy-five students at Khlebnikov's factory. Several firms limited themselves to arranging drawing classes, among them the Moscow factories owned by Gubkin and by Maria Adler.

Training schools were also opened under auspices other than factories. For instance, the St. Petersburg Society for the Encouragement of the Arts set up specialized workshops for arts and crafts, with a curriculum including practical work. In 1870 this society inaugurated a permanent art exhibition at which products of all the fine arts, including works by students, were offered for sale year-round. In 1897 A. V. Lobanov opened a small school, the first Russian practical school for gold and silver work, to produce artisans well trained in technique and in art. With the assistance of the Stroganov School of Industrial Art, the management of the Moscow assay offices arranged a class in technical drawing in 1900 "with a bias towards silver and metal work generally."

An event of great significance in the history of art education was the 1895 reform of the system to

make compulsory the inclusion of drawing as applied to the trades in the curricula of the principal schools: the School for Industrial Drawing of the Imperial Society for the Encouragement of the Arts and Baron Stieglitz's Central School for Technical Drawing. The effect of this reform can be judged by the fact that the collections of drawings and models from industrial-art schools were given a place of their own at the national exhibition of industrial goods held in 1896 in Nizhny Novgorod. The most important school for drawing, however, was the Imperial Stroganov School of Industrial Art, which specialized in training graphic artists and teachers of drawing and calligraphy.

The 1895 regulations for school curricula were aimed at orienting the educational system toward the development of the arts and crafts by training the specialists needed in domestic industry. The models of the Stroganov School that were sent to the 1900 International Exposition in Paris had great success, amazing everyone with the novelty of the Russian motifs in objects of applied art.

The 1902 charter of the Stroganov School established the principle that it was necessary to combine theoretical and practical training. A diploma was introduced conferring the title of Specialist in Applied Art on all who completed a course in general education, along with a course of study of the arts and crafts, in every one of the eighteen newly formed workshops. In 1902 the Stroganov School opened casting, chasing, mounting, and enameling workshops, where particular attention was paid to objects made of precious metals: kovshes (ladles), wine bowls, ornamental dishes, blotting pads, and albums.

A very high level of achievement was required to obtain the diploma. In 1904, the first graduation year, only four of the 1,500 graduates were awarded the Specialist in Applied Art diploma; the rest had to be content with the title Graphic Artist.

The compulsory part of the curriculum required preliminary sketches in various styles, including contemporary ones, and the copying of paintings and works of decorative applied art. The collection in the State Historical Museum includes several of these works from the Stroganov School. Among them are a copy on silver plate of a sketch of a boy by A. Ivanov and an Easter egg coated with transparent enamel on a *guilloché* ground with a picture of the Virgin and Child in enamel. (In 1904 a studio attached to the Stroganov School was opened for painting icons and religious pictures.) These works were not exactly copies, for they were executed with different techniques and on different materials, but the purity of the colors, the clear-cut lines, and the compositional skill indicate the high level of professionalism of the students.

An important factor in the emergence of highly skilled artisans was the institution of a system of contests, both in the Stroganov School and in honor of Fabergé. In 1905 the Stroganov School announced a contest for drawings of a majolica vase in silver or bronze, a silver coffee service for two, a silver altar Book of Gospels, and a cross. Over 150 sketches were submitted to the Fabergé contest in 1913, most of them by artists and jewelers working at large factories.

The development of the production of art objects gained a great deal from the organization of national exhibitions of industrial artware and textiles and of products of the arts-and-crafts industry, both in the new style and in historical styles. These exhibitions were held in Moscow, St. Petersburg, Nizhny Novgorod, and Kiev. Many of them had a great historical and artistic impact on the cultural life of Russia, with their display of the latest achievements in the processing of precious metals, methods of decoration, and the latest trends in art.

In addition, Russian artisans often exhibited their wares at international exhibitions of industrial art, beginning with the very first exhibition, in London in 1851. These artisans were very successful and often were awarded major international prizes. Russia contributed to practically every exhibition of this kind: in London (1851, 1862), Paris (1867, 1878, 1900), Vienna (1867, 1873), Philadelphia (1876), Amsterdam (1883), Antwerp (1885, 1894), Copenhagen (1888), Chicago (1893), Stockholm (1897), and Glasgow (1901). Nearly all the reports of these exhibitions were full of praise for the work of the Russian goldsmiths.

At the turn of the century international exhibitions were frequently held in Moscow and St. Petersburg, and nearly all the art schools displayed their works at them. They were represented not only by pictures but by objects of decorative applied art as well. Russians who went to see these exhibitions were able to familiarize themselves with the technical skill of the exhibits from abroad, as well as with the forms and types of their art. There were also international exhibitions devoted to work in gold and silver: a jewelry exhibition in 1901, an exhibition of works of gold, silver, and leather in 1902, an exhibition of articles of metal and stone in 1903, and so on. Gold and silver works were foremost in both quality and quantity in the 1904 exhibition of *objets d'art* held in St. Petersburg.

Aspects of Style

The industrial production of gold and silver objects necessitated new forms of art and ornamentation that would blend naturally with precious metals and the other materials with which they were used. In the second half of the nineteenth century the leading manufacturers invited sculptors, architects, graphic artists, and researchers into Russian history and art to help them create models. These specialists would often take subjects and forms from monuments or from easel art and use them for work in gold and silver. Ovchinnikov, Fabergé, and Khlebnikov paid their graphic artists between six and ten thousand rubles a year in order to have a permanent supply of new designs unavailable to their competitors.

Some workers at Sazikov's firm made a paperweight depicting a troika according to a model by the sculptor Nicholas Liebericht, and this paperweight was displayed at the 1862 International Exposition in London. The same firm also exhibited a silver horse, several figurines, candelabra, and vases executed according to models by Klodt, Lanceray, Spiess, and Reimer.

At the national exhibition of 1882 in Moscow, the Sazikov firm displayed an album encased in silver and decorated with pictures based on designs by E. Sabaneyev, a member of the Academy of Architecture. The exhibition also included works from the Ovchinnikov firm: an allegorical group on a historical theme; "a memorial to the liberation of the Slavs," executed according to a drawing by M. Mikeshin; models by the sculptors Lanceray and Ober; and works based on drawings by the artists S. Komarov and L. Dahl. Khlebnikov displayed many things, among them a sculpture of a little girl with a setter and a tipsy peasant, based on models by Liebericht.

In art of the nineteenth century, particularly in the latter half, many nonclassical cultures became sources of new forms that blended organically with those of contemporary art. There was no other European country where the problem of national style was as acute as it was in Russia. The crucial question of how to preserve the specifically Russian features of culture was uppermost in everyone's mind, which explains the keen interest taken in the problem of "the Russian style" that arose in the 1850s and 1860s and took final shape in the 1870s.

The source of this preoccupation can be traced to many archaeologists, restorers, art critics, architects, and artists who made great contributions to the study of art, history, and cultural life and asserted the importance of the Russian people in the history of world culture.

It was at this time that two new societies were organized: the Society of Russian History and Antiquities in Moscow, and the Society of Early Russian Art in St. Petersburg. And several new museums were also opened: the Public Museum, the Rumyantsev Museum, the Academy of Arts Museum of Early Russian Art, and the Museum of Orthodox Eastern Church Iconography. These institutions published numerous studies of early Russian art—such as *The History of Russian Ornamentation from the Seventh to the Fifteenth Centuries According to Ancient Manuscripts*—that paved the way for the revival and development of the Russian style in all the arts.

V. I. Butovsky, director of the Stroganov School Industrial Art Museum, wrote in a book entitled *The Application of Aesthetic Education to Industry in Europe and Especially in Russia*: "Our factories and trades cannot be kept up by using foreign models and drawings and copies of foreign works. This perpetual borrowing is a weakness of ours and is wholly contrary to our technical conditions. . . . We can find original forms and drawings in our own land that, for taste and grace, are in no way inferior to those in the West." Thus, to restore the natural course of development artisans turned to the heritage of Russia from the era prior to Peter I.

Beginning in the mid-nineteenth century, Russian artisans responded to the need for a national art by fashioning ethnographic reproductions of various objects, copying ornamentation, and using certain historical motifs in producing original works. In creating articles from precious metals, they often engraved views of towns, historical monuments, and subjects from Russian history. They also created wine bowls with seventeenth-century ornamentation or inscriptions of proverbs; silver salt cellars imitating birchbark baskets or linen bags, ornamented with the figure of a peasant or a cow; cigarette cases imitating the texture of a leather mitten; inkwells shaped like tree stumps with grass around them in relief (an axe stuck into the stump serves as a handle); cups engraved with a scene of people hunting, plowing, sawing firewood, making hay, or other depictions of peasant life. This was the first time in the history of Russian art that peasant life became a subject for ornamentation.

The question of national themes and forms in decorative art for articles produced on an industrial scale acquired special significance at the turn of the century, when it became the subject of a series of measures taken officially by the state. In the course of this process several societies were set up, among them the Society for Aid to Labor, the Russian Industrial Art Society, and the Society for the Revival of Russian Artistry. The *Collection of Acts Legalizing Institutions of Industrial Art* was published, museums were opened and exhibitions arranged, and a multitude of illustrated publications were issued.

It was recognized that if a national Russian art industry were to come into being—one that could combine historical forms with contemporary developments—it would require coordination of the work of experienced technicians with the creativity of artists having a knowledge of history and familiarity with this type of art. This led to the creation of many fine works of applied art by some of Russia's great painters—Roerich, Vasnetsov, Vrubel, and others—who elaborated the Russian style using a range of approaches from the archaeologic-historical to the neo-Russian romantic.

The enthusiasm in the workshops of the Stroganov, Abramtsev, and Talashkina schools for the revival of the applied arts, together with the arrangement of special exhibitions of industrial art, handicrafts, and amateur art, provided evidence of the great aesthetic changes. Art—which up to this time had been considered the sole province of museums and the drawing rooms of the wealthy—now became democratized, and its creators were faced with the task of bringing art and beauty to the people, of making it part of everyday life.

Le style moderne, which had established itself in Europe at the turn of the century, had stylistic variations in each country. In Russia the interaction of *style moderne* with national motifs led to the neo-Russian style. Based on early Russian art and ornamentation, with its imaginative treatment of proportion and rhythm, enriched by illustrations drawn from history, folklore, and literature, the neo-Russian style developed with greatest intensity in Moscow.

The first goldsmith to borrow themes from Russian history and the fine arts was Pavel Feodorovich Sazikov, owner of a small Moscow workshop first heard of in 1793. By 1810 he already owned a factory producing a variety of articles of silver, and in 1842 he opened a branch in St. Petersburg. His business passed on to his son Ignaty, one of the most outstanding artisans of the mid-nineteenth century. Ignaty, in turn, was succeeded by his children, Pavel, Sergei, and Valentin, and Valentin's son Pavel. No mention of the firm is found after 1896.

Proof that the Sazikov firm was one of the best in the middle of the nineteenth century is found

in its many awards, certificates of merit, and medals, including gold medals from exhibitions of industrial art in 1835, 1849, 1853, 1861, and 1865. It also won the Grand Gold Medal at the International Exposition in London in 1851 and the Order of the Legion of Honor at the Paris exhibition of 1867. From 1846 onward Sazikov bore the title Jeweler to the Court.

At the 1851 display in London, Sazikov's collection of nineteen objects—silver goblets, milk jugs, and paperweights—decorated with themes from Russian peasant life was a complete departure for what previously had been an expensive, elitist art. The depictions were simple, realistic, and varied in subject: There was a dancing bear with his master (dancing bears were great favorites at fairgrounds), a Cossack girl playing a bandura, an Okhotsk dairymaid next to a wooden barrel with a cat creeping along the handle, and the like.

The firm's most important piece of work, however—one that earned it a gold medal—was a large silver candelabrum made in the form of a sculptured group of figures on the subject of the victory at Kulikovo Field. It was about three meters high and weighed 130 kilograms. In the center, Dmitri Donskoy lies at the foot of a fir tree, surrounded by boyars, high-ranking army officers, a standard-bearer, and a man on horseback, who are discussing the victory. The candelabrum was made by the sculptors Vitali and Klodt, under the supervision of a historian, Solntsev, who helped them achieve strict accuracy in all the details of dress and armor. The novelty of style, the beauty of design, and the brilliant execution made Sazikov famous throughout Europe. The sculptured group could stand comparison with the work of the best artisans in the West. Thus, for the first time, a Russian firm began to receive orders from foreign countries.

The press likened Sazikov to a Russian Benvenuto Cellini for the fine quality of his engravings and drew attention to the fact that his works were nearly all Russian—in idea, design, and modeling.

In the predominant techniques of casting and chasing, Sazikov approached perfection. With his mastery of form and technique, he was able to convey the textures of fur, pelts, feathers, and various kinds of cloth. The entire output of the factory evidenced a constant search for new subjects and a careful study of the achievements of the world's foremost artisans—as demonstrated in their copy of a Cellini masterpiece shown at the 1870 exhibition in St. Petersburg.

The themes Sazikov chose for the ornamentation of paperweights, goblets, cups, vases, jugs, cigarette cases, and other silver objects were either historical events or everyday genre subjects, executed in a realistic manner, with splendidly modeled forms and the decorative qualities of the silver fully expressed. Among the many Sazikov compositions were Czar Mikhail Feodorovich hunting, men on horseback, peasant girls performing a folk dance, boar hunting, a three-horse sleigh with driver, peasant children tobogganing, and armed warriors.

The Sazikov firm also created religious works. The 1861 exhibition in St. Petersburg contained a shrine and a communion cup that were made for the court church. A copy of the ancient chapel on the Pereyaslavl Road, the cup was a result of a study of early Russian architecture. There is a remarkable icon in the collection of the State Historical Museum—a picture of the Virgin and Child in a silver-gilt frame decorated with a scrolling stalk of transparent blue enamel. The icon had belonged to Alexander II.

The last exhibitions in which Sazikov participated were the exhibitions in Moscow in 1882 and in Nizhny Novgorod in 1896. The finest of the firm's 1882 exhibits were an album decorated with a portrayal of Hercules overcoming Hydra, a vase in Renaissance style, and a dish with a salt cellar shaped like the dome of Uspensky Cathedral in Moscow—all created by using the techniques of engraving, carving, and enameling. These objects were cited by the press as showing the desire of Pavel Sazikov's heirs to uphold the reputation of the firm.

Sazikov's example was followed by another Moscow firm, one that had been established in 1842 by Ivan Semyonovich Gubkin and carried on by his sons Sergei and Dmitri. This firm was assisted by I. Bornikov, a great connoisseur of Russian ornamentation and himself a graphic artist, who had

11. Sazikov. Moscow. **Icon of the Smolensk Mother of God.** 1854. 9¾ × 7⅞″ (25 × 20 cm). *The silver oklad has a border enameled in blue with scrolling foliage and is set with three sapphires. The halos of the Virgin and Christ are set with cabochon rubies. The back of the icon carries a presentation inscription in Cyrillic which reads, "Holy Icon of the Smolensk Virgin, Donated with Ardent Zeal by the Smolensk Boyars and Wives of Merchants for Prayers of Blessing from Bishop Timofei of Smolensk to His Imperial Highness, Czarevich Alexander Nikolaevich in Reverential Hope for the Crushing of the Arrogance of the Enemies of Our Faith, Our Czar and Our Fatherland." This icon was presented to Czarevich Alexander Nicholaevich, later Czar Alexander II, while he commanded troops defending St. Petersburg during the Crimean War. The State Historical Museum, Moscow.*

devoted himself for over ten years to a study of styles and ornamentation and their specific applications to gold and silver work. The firm became widely known in 1852, its success being largely due to Bornikov, and it was granted the right to call itself Court Jeweler in 1855.

The Gubkin firm was one of the first to produce articles that imitated textures. Among the exhibits that aroused admiration at the 1861 exhibition in St. Petersburg was a small silver-gilt bread container (designed by Bornikov) made to resemble a wickerwork basket with a napkin thrown negligently over it. It was so skillful an imitation that one had an involuntary desire to touch it, all the more so because a fly rested on it!

Gold and Silver Work in Moscow

In the early years of the nineteenth century St. Petersburg was the only center of art in Russia; it decreed fashion in this sphere that artisans followed slavishly. It was here that the best artists worked; and it was here that the Academy of Arts, an establishment with immense authority, was located. All this changed later in the century when an independent art culture sprang up in Moscow, one with its own traditions, based on a study of early Russian history and art, and one running counter to the aesthetic views of St. Petersburg Academy of Arts.

Despite the general art trends of this era, there always remained a tangible difference between the art schools in Moscow and those in St. Petersburg and between the kinds of art they produced. In Moscow, with its age-old traditions, the adoption of national forms of art underlined its cultural independence of the "new" capital in St. Petersburg.

In Moscow's artistic circles a key role was played by merchants, especially the Tretyakov Brothers, the Shchukin Brothers, Naidyonov, Ryabushinsky, and Mamontov, who did so much for the development of Russian culture. As early as 1856 M. Pogodin said, "with the breadth of their charity, their activities as collectors, and their support of all kinds of initiatives, they faithfully serve the welfare of Russia."

The development of the Russian style—a lively, realistic depiction of scenes from everyday life, views of the Moscow streets, and old monuments—was hailed by people from all walks of life and gained many patrons among the wealthier merchants.

The period from the mid-nineteenth century onward was economically and culturally outstanding in Moscow: numerous art schools were founded, new museums opened, and the city acquired a beautiful appearance. In all branches of the arts, including industrial art, there was a search for original forms, inspired by Vasnetsov, Mamontov, Polenova, and others, whose attitude toward Russian antiquity was not merely that of archaeologists and restorers but of creators of a new art, too.

It was Moscow that took the first steps toward reviving nationalistic art in Russia and mastering the characteristic features of the ornamentation found in early Russian art. And it was the two best Moscow firms, those of Ovchinnikov and Khlebnikov, that were the foremost adherents to this new trend in gold and silver work. One could say that they fell under the spell of the beauty of historical Russian art—an art that had been forgotten and replaced for nearly two centuries by imitations of Western European forms—and they were able to restore it to its rightful place in their creations.

The firm owned by Pavel Akimovich Ovchinnikov had been founded in Moscow in 1853. In 1868 it bore the title of Court Jeweler, and the business was carried on by Pavel Ovchinnikov's sons Alexander, Pavel, and Nikolai in Moscow and Mikhail in St. Petersburg. In an official report of the 1882 Russian Industrial Art Exhibition in Moscow, it is stated: "Mr. Ovchinnikov's name is known to practically the whole of Russia; he created this renown himself, by his personal energy, his work, and his talents. He himself began as a craftsman, and in the course of twenty years enhanced his skill to a high degree of perfection."

The Ovchinnikov firm first attracted attention at the 1865 exhibition in Moscow, where it received a gold medal. From then on, it was always the central firm at Russian and world exhibitions, where entries received numerous awards for the progressive improvement of every aspect of its work in gold and silver, the continual introduction of new ornamental elements, and the excellent operation of its school. The firm used models by well-known architects, sculptors, artists, and designers, among them Borovsky, Bornikov, Lanceray, and others. In fact, a permanent employee of Ovchinnikov's was the artist-sculptor A. Zhukovsky.

From the 1870s to the 1890s Ovchinnikov made full use of the beauty and unlimited possibilities of Russian design. Ornaments found in illuminated manuscripts, in the illustrations of *Antiquities of the Russian State*, and in publications on early Russian art and ornamentation were all utilized to decorate various objects: icon covers, triptychs, sets of liturgical plate, dishes, blotters, and boxes.

The firm developed Russian themes in ornamentation, using the same casting and chasing techniques that Sazikov had employed. Ovchinnikov created many realistic genre scenes, such as small boys stealing watermelons while little girls fight over another watermelon (this on two bowls), and a boy striking a bell and waking another boy (on a candelabrum), in 1873; and, in 1878, a kitten playing with a ball of wool, a woman resting with her child (on a personal grooming case), and a nobleman and a lady playing blindman's buff (on a vase). These and many other works were displayed at exhibitions in Vienna, Paris, and St. Petersburg.

The firm's works on historical themes were often reviewed in the press. For instance, a desk set that won a silver medal at the 1867 Paris exhibition was described as "a worthy memorial of the great cause of liberation of the serfs." The set was ornamented with the sculptured figure of a peasant crossing himself before sowing his own land for the first time, as well as with pictures in relief of the emancipation of the serfs being declared, and of the principal events in the reign of Alexander II.

There were other items of interest too. One was a dish, displayed at the 1878 exhibition in Paris, on which appeared a series of medallions with pictures in relief of the coronation of Mikhail Feodorovich, the envoy sent by the people of Nizhny Novgorod to Prince Pozharsky, Patriarch Hermogene receiving the deed from Sigismund III, and other scenes from the Times of Trouble. These pictures were planned by Pavel Ovchinnikov himself, drawn by Chichagov, and modeled by Opekushin.

Experts both in Russia and abroad were unanimous in saying that everything produced by Ovchinnikov was remarkably executed and splendidly chased, with perfect technique; that the depictions were true to life and artistic; and that the forms were beautifully modeled.

Ovchinnikov developed further the imitation of textures that had originated with Gubkin. In 1873 in Vienna there was general amazement at the silver dish on which the bread-and-salt of welcome were presented to Czar Alexander III as he entered the Russian *izba* (peasant's cottage). On this dish lay a beautifully embroidered silver towel, an icon of the Savior in filigree, rye bread, and a

12. Khlebnikov. Moscow. **Silver Basket.** ca. 1885. Length 11¼″ (28.4 cm). *This partly gilded silver basket is chased to imitate basket weave. There is a plain silver section chased to simulate a linen napkin. The State Historical Museum, Moscow.*

13. Ovchinnikov. Moscow. **Large Silver and *Plique-à-Jour* Enamel Beaker on Foot.** ca. 1910. Height 8″ (20.4 cm). *This is an outstanding example of the technique of* plique-à-jour *enamel. The beaker has three oval figural reserves with a surround of red scalework. The borders are decorated with stylized plants and stars.* Copyright 1989, Sotheby's, Inc., New York.

salt cellar. The crown princess was presented with a silver cup and saucer in the Russian style, with a patterned enamel towel. At the same exhibition, the King of Italy acquired a silver basket, across which was thrown a silver napkin "made with such skill that [it] looked as though it were made of linen rather than metal."

The Ovchinnikov firm earned special fame for their use of multicolored enamel on designs in filigree, and they also used champlevé, cloisonné, and vitrail enamels and enamel varnish. The art of enameling flourished as a result of the labors of archaeologists and students of early Russian culture, as well as of Pavel Ovchinnikov, who was able to enlist their cooperation in the creation of original objects in gold and silver.

These creations were highly commended at the 1870 exhibition in St. Petersburg, where Ovchinnikov displayed an encasement for a Book of Gospels, a set of silver plate for the liturgy—in the Russo-Byzantine style, with turquoise enamel—and icon covers in cloisonné enamel. The State Historical Museum contains blotters, albums, boxes, icon covers, and dishes he made at the time, decorated with cloisonné, champlevé, and pictorial enamel. The rich coloring and abundance of ornamentation, the organic connection between the object itself and the use to which it was to be put, and the excellent quality of execution are truly remarkable.

At the 1882 exhibition Ovchinnikov displayed a Book of Gospels for the altar in a silver encasement with enamel pictures of evangelists and prophets painted from drawings by Dahl. It was made for the Church of Christ the Savior, and it was considered by contemporaries to be the most artistic plate in the church. For this Book of Gospels he used cloisonné enamel, which had originally come to Kiev from Byzantium and was lost during the Tatar-Mongol invasion. It was Ovchinnikov who revived this artistic device, not only for Russia, but for Europe as well.

An interest arose at this time in the nature of the materials themselves—silver and enamel—and in the techniques for treating them to bring out their full beauty. It is especially noteworthy in objects with a thin coating of transparent enamel varnish. Ovchinnikov took the initiative in producing this kind of work, too: In 1882 he exhibited a jug made with this technique having a Japanese design of grasses against a background of deep crimson glazing. The State Historical Museum, the Hermitage, and museums in other countries have tea services and other objects made in this style, ornamented in red lacquer depicting golden flowers, insects, sculptured lizards, and tortoises in relief.

Toward the end of the nineteenth century Ovchinnikov branched out into transparent *plique-à-jour* enamel, which, when held up to the light, looks like stained glass. It was used for small wineglasses and vases, and looked especially beautiful in icon lamps lighted from the inside, where all the wonder of the multicolored design can be seen at its best.

The firm of Ivan Petrovich Khlebnikov was also prominent in the development of national forms in the art of gold and silver work, and it produced articles in all the principal styles of the period: historical Russian, neo-Russian, and *style moderne*.

Khlebnikov's first factory was founded in St. Petersburg in 1867, followed by a second factory in Moscow in 1870–1871. His factories possessed all the latest equipment for producing every type of art object in silver, gold, and diamonds. In 1873 the firm received the title of Court Jeweler. In addition to the factory itself—which had design and sculpture studios and a workforce of 300 people—there were specialized workshops with more than 1,000 workers.

The first exhibition to include Khlebnikov's work after he became Court Jeweler was in Vienna in 1873, where his creations attracted the attention of experts and earned him two medals. The display consisted of numerous articles in the Russian style. The leaves of a triptych that aroused great admiration were ornamented with enamel and were said to be "permeated with the atmosphere of the olden days"; Khlebnikov was praised for his "serious elaboration of the style of the past of his native land." A samovar and a tea service captivated everyone with their originality of form: The samovar stood on a rooster's feet, and its handles were shaped like roosters' heads. Other items of interest were a massive wine bowl with six charkas, in enamel and precious stones; a copy of a wine bowl belonging to Czar Alexei Mikhailovich; and a cup with scenes from the life of Dmitri Donskoy in relief, with a bust of him on the lid.

Like all the large firms of the time, Khlebnikov's was famous for its engravings and "chamber" sculptures in silver on peasant themes. One of these—remarkable for the poetic way in which it was executed and for its similarity to Venetsianov's manner of depicting women—is an 1873 representation of dancing peasant girls on a cup (now in the collection of the State Historical Museum).

The themes of Khlebnikov's engravings are taken not only from history but from literature and nature. At the 1878 exhibition in Paris he displayed bas-relief pictures, one of which was a scene from the life of Peter I, overlaid on a silver album, and another was a dish depicting a winter landscape. In 1882, in Moscow, he exhibited silver-plate portrayals of St. Sergei Radonezhsky blessing Dmitri Donskoy before battle and the feast from Mikhail Lermontov's poem "Song of the Merchant Kalashnikov." The work of Puchkov, an engraver in Khlebnikov's firm, was praised highly, for Puchkov possessed an ability to express in silver the properties of any cloth and the softness of the human body.

Khlebnikov was most famous, however, for his enamel work. The State Historical Museum's collection contains a fine wine service of his made in 1875. It consists of a decanter in the shape of a rooster and charkas in the shape of chickens, ornamented with champlevé enamel. The originality of the conception, the popularity of the rustic subject, the kinship of the ornamentation to folk art, the richness of the colored enamels, and the perfect execution all combined to create a beautiful work of living folk art.

Khlebnikov employed every popular enameling technique of the day, and the richness and originality of the works he displayed at exhibitions was always noted by the press. At the 1882 exhibition Khlebnikov alone was able to rival Ovchinnikov in the number and variety of articles displayed. He showed a silver sculpture, several chased and enameled flower vases and fruit bowls, ornamental dishes in honor of the coronation of Alexander III, a triptych and church silver in the Byzantine style, and various other enameled articles. The press noted particularly a large tea service and a samovar with crimson cloisonné enamel, made according to a drawing by Balashov, who designed many of the firm's products.

There were two novelties at this exhibition: One was an album in a silver case with an enameled picture inscribed "Hawk hunting," the other a Book of Gospels in the Russo-Byzantine style, ornamented with cloisonné enamel—again from a drawing by Balashov—that, according to a contemporary, "was remarkable for its motif and color scheme."

Another large, prominent firm of this era, that of A. M. Postnikov, was founded in 1826 as a silver workshop. By 1868 it had grown to become a factory producing various articles in gold, silver, and bronze, and in 1877 it was granted the title Court Jeweler. Postnikov took part in many national and world exhibitions, where he displayed filigreed, enameled, and carved objects. Experts usually praised the restrained aestheticism of the simple color schemes of their enamel ware. One example of this enamel ware shown at an 1882 exhibition was glasses worked in red-and-black cloisonné. The firm also copied a Peter Paul Rubens painting by engraving on metal, and it manufactured many articles for churches, including repoussé covers for icons and crosses.

The desire to revive national forms of art can be seen in the work of a gold- and silver-ware factory owned by N. Nemirov-Kolodkin (1872–1917). He incorporated not only traditional materials when processing precious metals but also used pearls and carved stones—for example, he ornamented icon covers with the pearl embroidery that was fashionable in the seventeenth century. In addition, he made very successful use of intaglio in a picture of the Mother of God for a panagia (a medallion depicting the Mother of God and Christ).

In 1880 Y. F. Mishukov founded a workshop to produce silver items. It passed on to his wife in 1900 and then to his son, Feodor Yakovlevich, who headed the firm from 1912 until 1917. It specialized in producing articles for churches, and its silversmiths were exceptionally skillful in using historical Russian ornamental forms. They also possessed a command of the subtleties of such techniques as basma, filigree, and chasing with which they re-created early Russian silver and gold works. Their censers, communion silver, stials, and icon covers excelled in quality and in the feeling they gave of being handmade. The Mishukov workshop won a high place in the Fabergé contest for their drawings of crosses.

A large firm whose products clearly demonstrate the evolution of Russian style from historical to neo-Russian was Orest Kurlyukov's silversmithing firm (1884–1917). The works of this firm varied widely in type, form, and materials. It produced glass and crystal vases bordered with silver, desk sets of onyx and silver, repoussé covers for icons, cigarette cases, dinner and tea sets, kovshes, and wine bowls.

A kovsh and a wine bowl made by Kurlyukov at the end of the nineteenth century, now in the State Historical Museum, were executed in the tradition of the Russian historical style. The kovsh was ornamented with a medley of intricate decorative devices used in the sixteenth and seventeenth

centuries: multicolored cloisonné enamel; stylized leaves or fish-scale patterns resembling sixteenth-century basma; and contrasting silver, gilt, and multicolored surfaces. The large wine bowl is similar to the kovsh in style. It is ornamented with chased *lozhkas* with interwoven spirals and fantastic birds and beasts in relief, similar to those seen in manuscript illuminations.

The firm of P. I. Olovyanishnikov, bearing the title of Court Jeweler, was one of the oldest in Russia. The first mention of it that we find was in 1766. Early in the twentieth century Olovyanishnikov began to make extensive use of the drawings of S. Vashkov, an artist who contributed greatly to the revival of national art forms. It was largely his originality that led to the success of the firm's products. Vashkov strove to achieve the simplicity that had been a feature of early art: He subtly stylized early Christian symbols, and he created variations on the dominant themes of Russian art, the art of Kiev and Vladimir-Suzdahl, and the schools of art in Moscow, Novgorod, and Pskov, all of which he succeeded in combining with contemporary art forms. His work is emotional by association, and its simplicity of silhouette is matched by its refined ornamentation.

Olovyanishnikov's firm mainly produced church plate, but it also created a certain number of secular articles, among them furniture, candlesticks, boxes, and lamps. The firm's church plate was often worked in cloisonné enamel. For instance, it combined cloisonné and pictorial enamel in depicting the Passion of Christ on pendants hanging from mitres (now in the collection of the State Historical Museum). The mitres are embroidered with mother-of-pearl beads and covered with precious stones and figured silver medallions decorated with filigree and enamel. They display a refinement of execution, a delicate graphic stylization, and a sensitive choice of enamel colors.

A repoussé cover for an icon of the Virgin is interesting for the unusual form of its leaf ornamentation and its range of enamel colors—like those of the Solvytchegodsk icon made in the sixteenth century—with subtle gradations of shades of green, blue, white, and yellow. The neo-Russian style is also found on crosses for the altarpiece, with their characteristic entwining leaves and insertions of pictorial enamel. There are examples of these in the State Historical Museum.

Feodor Rückert's workshop (1887–1917), which employed around forty artisans, specialized in skillfully producing cloisonné and pictorial enamel ware, and they carried out orders for some of the best firms: Fabergé, Kurlyukov, and Marshak (in Kiev). Much of the silver work produced in the workshop—boxes, cigarette cases, covers for icons, etc.—was overlaid with multicolored cloisonné enamel, as a rule in the neo-Russian style. These objects often had insertions of colored pictures, such as a view of the Kremlin, a copy of a picture by Makovsky called *A Boyar's Wedding*, and a copy of a picture by Vasnetsov called *Czarevich Ivan and the Gray Wolf*. The variety of subjects and styles of these works encompasses many of the trends of Russian art at the turn of the century.

There is a small kovsh from Rückert's workshop in the collection of the State Historical Museum that is very original in ornamentation and in its delicate color scheme of mauve and blue, with a pinkish-white sheen. Its decorative structure, described as having an "illusory indistinctness of color," is akin to contemporary art, especially that of the "Blue Rose" artists. Rückert's individuality can be seen not only in his style but in his execution. The entire surface of the kovsh was coated with a smooth layer of multicolored enamel over a dainty design in plaited filigree, flush with the surface.

Because of the influence of the trends in painting and the graphic arts of the day, the style of enamel ornamentation underwent a change at the turn of the century, especially in Moscow. The surface of the article to be decorated came to be regarded as a kind of panel on which to paint. These compositions were often asymmetrical and included both traditional leaf motifs and the entirely new forms of *style moderne* and the neo-Russian style. The ornamentation that had been built up over the centuries now yielded to a free structure, combining a variety of leaf and geometrical motifs with pictorial elements.

The color schemes acquired greater variety and complexity, ranging from rich, bright tones to

soft pastels. And filigree played a more prominent decorative role—no longer was it used as a mere framework for an enamel design. Traditional filigree ornaments were complemented by tiny circles of tightly twisted spirals, small chains like those in chain mail, fish scales, fans bordered with silver grains, or conventional geometrical forms gradually becoming more abstract. This greatly enhanced the decorative possibilities in ornamenting objects of precious metal.

In addition to factories and workshops, there were also jewelers' artels engaged in the production of enamel ware. On the one hand, they produced kovshes, wine bowls, pots, salt cellars, and the like in the traditional national style, with its wealth of decorative elements; and on the other hand, they produced twisted napkin rings and glass holders with convoluted *style moderne* handles.

The State Historical Museum collection contains articles made in Moscow artels, of which the most notable is a serving set for cruchon (a type of rum) made by the 20th Artel, consisting of a large kovsh, a smaller kovsh-charka, and a ladle. The form of the ladle is made more complex by small embossed *lozhkas*, a lip shaped like the head of a rooster, and a large handle. The kovsh is abundantly decorated with cloisonné enamel, silver grains, and cabochons of semiprecious stones in the neo-Russian style. The combination of brilliant coloring and sculptured forms produces an impression of fabulous treasure.

The Moscow branch of the celebrated Fabergé firm opened in 1887 with the assistance of the brothers Allan, Arthur, and Charles Bowe and was later headed by Fabergé's son Alexander. There was a general difference between the Moscow and St. Petersburg branches: The Moscow branch produced more silver articles and tableware that were intended for the upper middle class in the main, while the St. Petersburg firm was mainly engaged in filling the orders of the imperial court and those connected with it.

Interesting information can be gained by reading the Moscow branch's price list for 1899. It contains illustrations of diamond necklaces, brooches, rings, and earrings; silver dinner and tea services, vases, salt cellars, tableware, and sculpture; and crystal jugs and vases made in many different historical styles. The illustrations are accompanied by the legend: "Each article, even though the price may be no higher than one ruble, is made with proper durability and care . . . and is frequently altered in accordance with the whimsical dictates of fashion."

Among the artists who designed for Fabergé's Moscow branch were Borin, Kozlov, Ivanov, Navozov, Lieber-Neuberg, and Klodt. Reports on the work of the then Imperial Russian History Museum for 1914 and 1915 say that Borin and Kozlov made a special study of the forms and ornamentation of silver ware in the Museum's collection.

A small silver box produced by Fabergé—possibly from Rückert's workshop—is a good example of the expressive work of the Moscow school. It is decorated with multicolored cloisonné enamel and combines ornamentation in the neo-Russian style and classical stripes of acanthus leaves, which was characteristic of the firm. A colored portrait of a boyar worked into the decoration of the surface lends special poignancy to the design.

The silver sculptures and vessels produced by the firm were distinguished by the fine quality of their casting and chasing and their originality of conception. The figures of an elk and a dolphin in the Historical Museum's collection are remarkable for the lovely modeling of their forms and the way the texture of the "skin" and even the characters of the animals are expressed.

Some small vases made by Fabergé at the end of the nineteenth century are also very artistic. Made in the shape of a water-lily leaf with a sculptured bud on it, they show an unexpected novelty that is shared by a silver sugar bowl made to look like a cabbage.

Like other firms, Fabergé produced works in silver and gold with pictures from Russian folklore and literature. For instance, there is a large cigarette case with motifs from "Morozko," a Russian folktale. The lid is engraved with a scene of snow-covered fir trees sprinkled with tiny rose diamonds, a bearded Jack Frost peeping through the branches, and a little girl curled up under a bush.

Among Fabergé works one also finds delicate designs in silver that stress the beauty of transparent crystal in vases, fruit bowls, and cruets. One of the crystal jugs in the Historical Museum's collection is adorned with dainty sprays of leaves and berries drooping over the crystal.

Gold and Silver Work in St. Petersburg

The age-old orientation of St. Petersburg toward Western European culture and art persisted up to the early years of the twentieth century. St. Petersburg collections possessed far more examples of art—including decorative applied art—from Western Europe than from Russia; this was true of the Hermitage, Baron Stieglitz's museums, the Academy of Arts, and the collection of the Society for the Advancement of the Arts. Furthermore, international art exhibitions were held there much more often than were Russian art exhibitions. It was in St. Petersburg that the artists' association Mir Iskusstva—The World of Art—arose, with its pronounced retrospective leanings and its aspiration to "Europeanize" Russian culture.

In gold and silver work these tendencies were linked to a tradition dating back to the era of Peter I, when collaboration with artists from other countries had been encouraged. There were now outstanding artisans from Europe working in St. Petersburg: Henrik Wigström, August Hollming, Stephan Wäkevä, Erik Kollin, Carl Hahn, and Frederick Köchli. Many works produced by Fabergé, Hahn, Tillander, Britzin, and the 3rd Artel bear a strong affinity to those made in Western Europe, especially to those of Cartier.

St. Petersburg gold- and silversmiths believed that historicism was important to their art, although many of them also responded to Russia's desire for national forms. These forms are to be found on a vase with sculptured portrayals of peasant children reaping (by Nicholls and Plincke), desk sets with themes from peasant life, an inkwell made to look like a driver on a horse-drawn sleigh (D. Smirnov), and glass holders in the shape of a log cabin or a fence (G. Weisenbaum and V. Viktorov). During this period Fabergé, Hahn, Britzin, and Köchli chiefly produced articles in the Western European style, rarely in the Russian style or in *style moderne*.

If we compare the Russian style in Moscow with that in St. Petersburg, we find the latter more subdued in form and coloring. In St. Petersburg a historical-archaeological approach to ornamentation prevailed, and very few articles were made in the neo-Russian style. The artisans preferred not to coat the entire object with a design in enamel, but rather to preserve the smoothness of the metal and decorate it with an ornamental band or a cartouche, which created an appearance at once more austere and more elegant.

The world-famous firm of Fabergé stood far above the others, not only in Russia, but in all of Europe. Based in St. Petersburg, the firm produced an extraordinary variety of articles, among them jewelry, boxes, clocks, dishes, sculpture, and toilet articles and other objects for daily use. It won renown for the valuable Easter eggs it produced: They were exceptionally skillfully made and striking in their imaginativeness, in the wide variety of methods used to make them, and in the color range of the precious stones and enamels. They are justly considered masterpieces.

Fabergé achieved its preeminent position in the art world due to the diverse ornamental motifs it used, its exceptionally profound knowledge and feeling for materials and their decorative possibilities, and a deep understanding of forms and the ways to express them with a broad range of jewelry materials.

Fabergé gathered all his most skillful artisans in the four-story building on Bolshaya Morskaya Street, which at the same time housed his family, a store, a large library, and a studio for the artists and modelers. More than twenty artists worked permanently in the studio, and Carl invited Benois, Schechtel, and Shishkin, very well-known artists, to work with him.

In 1890 Fabergé decided to expand the firm's activities by opening a new branch under Allan Gibson in Odessa (1890–1918). Twenty-five artisans worked there, among them Gabriel Niukkanen and Gustav Lundell. In 1905 a branch in Kiev with ten artisans was opened under V. Drugov but it lasted only about five years, after which it was amalgamated with the Odessa branch under Drugov. In 1903 the first foreign branch was opened in London (1903–1915) under Arthur Bowe; in 1906 its management fell to Carl's son Nicholas and H. C. Bainbridge.

In 1882 Carl Fabergé's brother, Agathon, joined the firm. Agathon was an artist, well acquainted with Benois and other members of "The World of Art," and he actively assisted his brother until his death in 1895. Occasionally one finds his mark on a Fabergé work.

In 1882 Carl took part in the Russian exhibition, where he was awarded a gold medal, and in 1884 he was presented to Alexander III to show him samples of his work, including a copy of a Sassanid bracelet and a diamond necklace called "Rucheyok" (Streamlet). He produced a favorable impression and was permitted to call himself Jeweler to the Imperial Court, which entitled him to use the state emblem.

In the same year, Alexander placed an order with Fabergé for an Easter egg to be presented to the Empress. Carried out in white enamel, with a crown decorated with rubies, diamonds, and roses, the present was so much admired that imperial orders for Easter eggs came to Fabergé annually. All in all, fifty-seven Fabergé Easter eggs were made, nearly all of them produced in the workshop of Perchin and his successor, Wigström. These Easter eggs represented a significant advance in goldsmithing in the number and variety of ornamental styles and the wealth of materials and technical devices employed. Many elements contributed to these works: Architecture, sculpture, painting, and applied decorative art as well, were all reflected in these original creations. In a way, they embodied the current desire in cultural circles to synthesize all types of art.

Carl Fabergé personally participated in the creation of his firm's works. He often made sketches for them and usually supervised their implementation. Each object was not only drawn and colored but modeled in wax as well. When the model was completed, all the stages of production commenced under the meticulous supervision of a group of specialists.

Carl Fabergé's son Eugene recalled many discussions at a big round table in his father's study about the materials to be used, the color and quality of the enamels, the firing temperatures—every minute detail. The final version was inspected by F. Birbaum, the firm's senior artist, and then submitted for approval to Carl Fabergé himself or, in the event of his absence, to his sons Agathon and Eugene Fabergé. Rumor had it that if Carl were dissatisfied with a finished article, he was capable of seizing a hammer and smashing it.

How famous and popular the Fabergé firm came to be can be deduced from the fact that a contest was named after him in 1913: The Carl Fabergé Competition for the best drawings for articles made of precious metal, sponsored by the Russian Industrial Art Society. The jury included Carl Fabergé himself, his sons Agathon and Eugene, and August Holmström, a jeweler with the firm. The first prize and a certificate of honor that year were awarded to Birbaum for drawings of a cross to be worn on a chain and earrings fashioned in the early Russian style, with precious stones, enamel, and filigree.

The Fabergé firm worked in all branches of decorative art, and in each of them it was superior to other firms. Its most typical work was enamel infused into a *guilloché* ground. Usually just one shade of enamel was used, transparent or semitransparent, which, combined with the delicate lines of the carved ground, was used to decorate very different objects: jewelry, clocks, cigarette cases, and so on. The firm had hundreds of shades of enamel colors at its disposal, making possible the most delicate transitions from shade to shade—these, in turn, intensified by differences in the direction and depth of incisions. Sometimes only small details of a design were enameled, which accentuated the beauty of the precious metals or jewels.

A large proportion of Russian decorative art consists of work in ornamental stone. The exquisite coloring and the variety of whimsical patterns with which nature has adorned these stones, as well as their capacity to be cut in various forms and polished, have made them invaluable material for the artisan. Many of the developments in lapidary art occurred in the Urals, where a large number of stones of every kind were to be found. The Yekaterinburg lapidary works was built in 1726 and was gradually surrounded by small lapidary workshops. Between 1880 and 1910, several thousand artisans employed therein produced a large number of vases, desk sets, boxes, candelabra, stamps, paperweights, and ashtrays, decorating them with figures of birds and beasts and representations of fruit and leaves. For the most part they were without any artistic value. Stone-cutting was also done at the Peterhof and Kolyvan lapidary works and in a workshop in St. Petersburg called Siberian and Ural Stones, owned by A. Sumin. This workshop, which is known to have existed from 1900 to 1917, produced small figures of animals.

Something quite new in lapidary art was produced by Carl Fabergé, who selected stones very skillfully and used them in original forms. The number and variety of stones he used exceeded that of any other artisan anywhere. Also famous for his personal collection of minerals, he made extensive use of semiprecious stones from the Urals, the Caucasus, and Siberia, frequently combining them with precious stones, enamels, and colored gold and silver. Among the stones he used were different shades of green jade, reddish-pink eaglestone with inclusions, blue-and-white lazulite, obsidian with a steel-like sheen, malachite (a great favorite with Russian artisans), and rock crystal. Jasper and agate were also used in large quantities because many of them have a natural pattern somewhat resembling a landscape.

At the end of the nineteenth century work with stones formed a relatively small proportion of Fabergé's activities, being on the whole limited to the Ural cutters in Woerffel's workshop in St. Petersburg and the Peterhof lapidary works. However, by the early twentieth century Carl Fabergé had his own stone-cutting workshop in St. Petersburg with about twenty employees. The first manager of the workshop was P. M. Kremnyov, a graduate of the Yekaterinburg art school, and the cutters were Svietshnikov and Derbyshev—both from the Yekaterinburg art school. Derbyshev was sent by Carl Fabergé to Lalique, one of the best *style moderne* artists, to develop his skills. In 1916 Birbaum was sent to Yekaterinburg in the Urals to study lapidary work on the spot.

The artisans in Fabergé's firm sought out stones that for durability, coloring, and pattern were most suited to the implementation of the artist's conception and that could at the same time reveal their natural beauty. A fine example of their judicious use is to be found in an agate cigarette case (in the State Historical Museum) ornamented with thin, barely visible stripes of gold with tiny diamonds and sapphires.

Julius Rappoport's workshop produced a large clock in the shape of a column on a round pedestal, made of malachite and copiously decorated with silver-gilt accoutrements of war and the sculptured figures of a mounted horse guardsman with a banner in his hand, two guardsmen on foot holding drawn swords, and ornamental bands of wreaths and garlands. The combination of deep-green malachite and golden ornamentation is in the best tradition of the conventional style of the early nineteenth century, when malachite was commonly used in such decorative objects.

Fabergé produced figurines of birds and other animals made of ornamental stones, to which were added diamond or sapphire eyes and ruby or gold and enamel collars or harnesses. These miniatures are amazing for the brilliance of their lapidary work and for their exceptionally apt forms and poses which bring out the most typical features of the animals depicted and make them come alive.

An extremely successful pose was found for a squatting monkey scratching its belly, made of gray agate, with lively, diamond eyes. The large collection of birds, beasts, and fish produced by the firm—frogs, little elephants, dogs, parrots, and the like, with their different shapes and characters—illustrate the wealth of beauty that comes from the earth and its infinite decorative potentials.

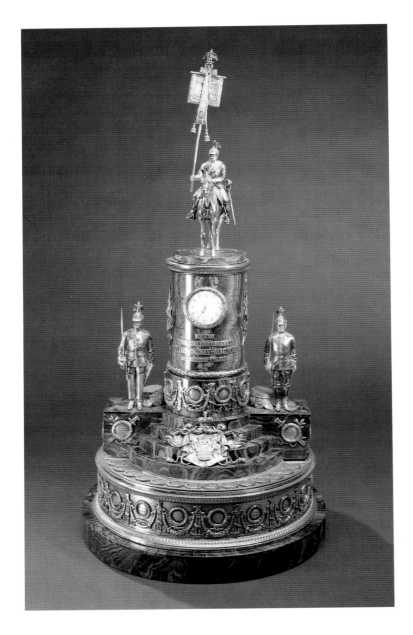

14. Fabergé. Workmaster Julius Rappoport, St. Petersburg. **Silver-gilt and Malachite Mantel Clock.** ca. 1901. Height 24½" (62.5 cm). *The malachite column is applied with a presentation inscription, "To Prince Nikolai Nikolaevich Odoevsky-Maslov from the Horse Guards." The column is surmounted by a silver-gilt figure of a mounted guardsman, and the column is flanked by guardsmen with drawn sabres. The base is applied with the arms of Odoevsky-Maslov. The State Historical Museum, Moscow.*

Fabergé's firm was also celebrated for its stone figurines of people. While porcelain figurines had been produced on a large scale in the eighteenth century, it was with stone that Fabergé was able to display his outstanding ability as an artist. Whether the figure was that of a policeman, a house painter, a peasant, or the famous singer Varya Panina, the characteristic facial expression of the person portrayed and the pose, clothing, and other details were expressed by means of a remarkably sensitive selection of stones.

The works in stone produced by Fabergé were valued highly by his contemporaries. The archives of the State Historical Museum contain an inventory of everything in the St. Petersburg house of the Yousoupov princes. Particular mention is made of jade and jasper boxes, a jade pig, a jade parrot, little dogs made of topaz and onyx, elephants of Siberian emeralds and jade, and hares made of rock crystal and nephrite—all products of Fabergé's firm.

Flowers made from stones, which gained great popularity at the beginning of the twentieth century, form a separate group in the firm's lapidary work. Narcissi and jasmine of white quartz, bilberries of lapis lazuli with leaves of jade or green jasper, sprays of rowanberries or wild strawberries with purpurine berries were placed in vases of rock crystal that created the illusion of

water. There are no two bouquets or vases alike. The vases were sometimes replaced by enamel pots that looked as though they were made of soil-filled earthenware or by gold wicker baskets. Some say that there was a special hothouse in the building where flowers were grown to serve as models for the artists. Sprays of flowers made of precious stones had been in vogue in the eighteenth century, but Fabergé introduced much that was new in this sphere. His sprays of flowers are striking in their simplicity, in the elegance of the motifs he chose, in the perfection of their clear-cut lines, in the exact, almost naturalistic way the forms of nature are conveyed—a kind of synthesis of the beauty of nature and the talent of a creative mind.

Sometimes enamel or gold was added to these sprays; sometimes they were made entirely of enamel and gold. The leaves and petals of some pansies in the Armory Museum are made of gold coated with delicately colored enamels. These flowers have a surprise hidden in them: If you press a button on the stalk, the petals open to reveal miniatures of the Czar's children, with narrow borders of small diamonds.

Fabergé's firm also worked with mother-of-pearl, out of which were made small articles, such as cigarette cases, holders, and boxes, ornamented with gold and precious stones. The collection of the State Historical Museum contains a beautiful mother-of-pearl cigarette case decorated with a network of baroque gold scrolls, made by Perchin.

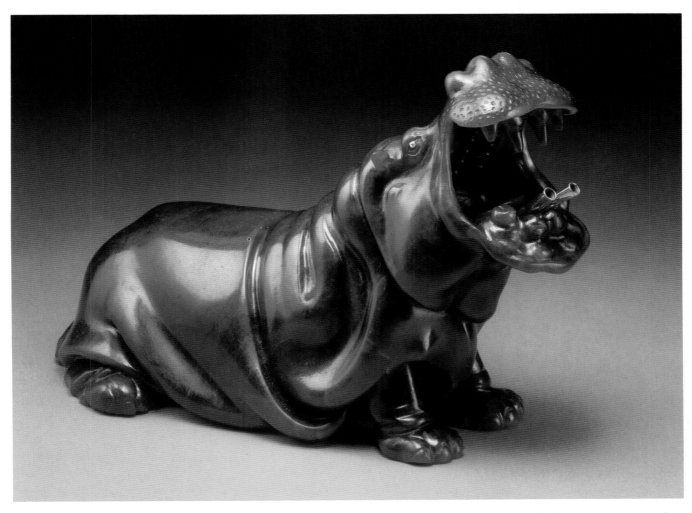

15. Fabergé. St. Petersburg. **Carved Nephrite Hippopotamus.** ca. 1910. Length 7¾″ (19.7 cm). *Carved from a uniformly colored block of nephrite, this hippopotamus, with head raised, is fitted as a cigarette lighter with silver-gilt mounts. The eyes are set with diamonds. Copyright 1979, Sotheby's, Inc., New York.*

The articles produced by Carl Fabergé's firm represent a singular event in the history of art. They reflect and synthesize the attempts to apprehend the best periods in its history, to revive historical forms, and to find new uses for them—for these reasons Fabergé's works remain masterpieces.

It was very difficult to compete with Fabergé and yet many factory and workshop owners, even artels, attempted to create the same kind of articles.

Worldwide recognition was achieved by the creations of a workshop belonging to Carl Hahn when it displayed its wares at the world exhibition in Chicago in 1893. The workshop had opened in St. Petersburg in 1880; at the end of the nineteenth century it bore the title Court Jeweler and filled the Czar's orders. Its best-known works were an 1896 copy of the Duval crown, with a diadem and a *kokoshnik*, a 1913 triptych in gold, diamonds, and enameled over a *guilloché* ground, and miniatures of the imperial family made for the tercentenary of the house of Romanov.

The distinctive features of works by Hahn's firm were their superb execution, the exquisite range of enamel colors, and elegance of form. In style of ornamentation they were similar to those produced by Fabergé. This can be seen from some gold boxes with enameled guilloche patterns and overlaid decorations with monograms made of precious stones, which in their whimsical patterns resemble eighteenth-century jewelry.

Among the finest enamel works of the late nineteenth century is a gold cigarette case with a miniature of the ship *Pamiat Azova* executed in pure, transparent enamels, with gentle color gradations, against a background of rays from the setting sun, done by the guilloche technique under a layer of opalescent enamel. This case is now in the State Historical Museum.

The works of the well-known workshops owned by Tillander, Köchli, and Britzin were known for the high quality of their work, the novelty of their expression of various styles, the variety of objects, and the manner of their ornamentation. In fact, Britzin even exported articles he manufactured to the United States and Great Britain. The works of these three workshops promulgated historicism in art, although the *style moderne* influence can be seen in the unusual contrasts in the types of materials used and in the colors: green jade combined with transparent red enamel over guilloche patterns, jade with rubies, and so on. This influence can also be seen in their use of the fashionable technique of producing a nugget-like surface and in their frequent use of enamel, usually an opalescent or colored, transparent enamel, over a *guilloché* ground.

The St. Petersburg 3rd Artel, having around thirty artisans, also deserves mention. It produced cigarette cases and picture frames, ornamenting them with guilloche patterns coated with enamel, and sprays of flowers made of colored gold. These were obviously imitations of articles produced by larger and more skilled firms.

In 1866 a large firm producing gold, silver, and electroplated articles was established by Gavrila Petrovich Grachev. Later it was taken over by his sons Mikhail and Simeon, and in 1893 it acquired the title of Court Jeweler. The firm won gold medals in 1889 and 1900 at international expositions in Paris, as well as a bronze medal in Chicago in 1893 for its works in enamel and filigree.

The Grachev Brothers' firm was engaged in the production of church plate, sculpture, tableware, tea services, and other objects of everyday use. Their dishes were usually decorated with classical and baroque elements. The firm was celebrated in St. Petersburg for its objects in the Russian style, in which were reproduced both the forms and the decorative motifs of early Russian household utensils and kitchenware.

The Grachevs used several enamel techniques, including vitrail and enamel-coated guilloche patterns. The State Historical Museum has a salt cellar of this kind in the shape of a small earthenware pot coated with semitransparent pink enamel. It is very tasteful in its coloring and has a light fish-scale design, which gives it quite a festive appearance.

Lyrical themes and a poetic portrayal of the common people were the general trend in artistic life in Russia during the last thirty or so years of the nineteenth century. A Grachev crystal vase (in the

State Historical Museum collection) from this era is a good example of this: the base of the vase is decorated with flowers and grass in relief and the figure of a peasant girl wearing a wreath of roses and holding a sheaf of wheat in her arms. She stands on a flowery knoll.

Andrei Stepanovich Bragin, the owner of a chasing workshop, was well known from 1851 to 1917. He did fine work in the historical style. A splendid example of his art, in the State Historical Museum collection, is a tea-and-coffee service, made in 1896, with a beauty of line and a combination of shining bands of "sloping lozhkas" with matte baroque cartouches, scrolls, and the Golitsin coat of arms. Another example of his work in the same collection is a small charka, made early in the twentieth century, with an embossed nude female figure on a dolphin against a background of waves, in expressive *style moderne* forms.

The New Century

The development of industrial art from 1900 on led to a transformation of interior decoration to include a much larger number of ornamental objects, including those made of silver and gold. Silver vases, kovshes, jardinières, boxes, frames, sculpture, and many other objects were placed on tables, whatnots, china closets, mantelpieces, and the like. They were expressions of a new century's style and outlook: a general desire of people to create an aesthetic atmosphere in their surroundings and to democratize art. The increasing number of kovshes and wine bowls that were now being used for cruchon and hot drinks—or simply as decorative ornaments—can be attributed to a nostalgia for the national images and traditions of early Russian art. These changes also affected the forms of tableware, which now assumed the shape of decorative sculpture.

Many firms, workshops, and artels in Moscow and St. Petersburg produced tableware with sculptural elements. This was a specialty of the 4th Artel in Moscow, which often employed themes that were characteristic of the Moscow school of art. Its work included a silver-edged crystal ship with a somewhat grotesque half-figure of a Vasnetsov warrior on the lookout, and a salt cellar with the figure of a seated peasant. In the State Historical Museum is a stand for a vase with a beautifully sculpted scene of a legendary hero vanquishing a winged dragon.

Casting and chasing techniques reached their peak around 1900. They revealed the wonderfully decorative properties of silver, which could convey splashing waves, snowstorms, the domains of water and plant life, and fairy-tale figures.

At the same time there arose a search for novel forms in decorative sculpture—in majolica, porcelain, semiprecious jewels, bronze, and silver. The ceramics workshop in Abramtsevo, the Stroganov School workshops, and the Moscow potters' artel were forming a new plastic language in art, a language of the forms and images of fairy tales and romance. The influence of Vrubel's paintings can be found in a silver tray with a molding of a figure resembling Princess Gryoza (Daydream) or Queen Volkhova. The fluidity and pliability of the silver is remarkable; it is slightly gilded and glitters in a way that is in complete harmony with the romantic image. This silver tray is in the State Historical Museum.

The desire at this time to breathe new life into artistic forms and ornamental themes is clearly expressed in articles for the toilet and in tableware. It is in this sphere of gold and silver work that *le style moderne* acquired its firmest hold. In silverware—such as dishes for sweetmeats, vases, tea and dinner services, and glass holders—there appeared new forms with specific structures and silhouettes raised to the level of rhythmic symbols. They were decorated with stylized ornamentations—inserted or cut—having smoothly flowing lines and embossed naturalistic details. These details were often quite unexpected—for instance, handles in the shape of birds, flower buds, or Baba-Yaga (a fairy-tale witch), or the devil—which somehow made them extravagant and poignant at the same time.

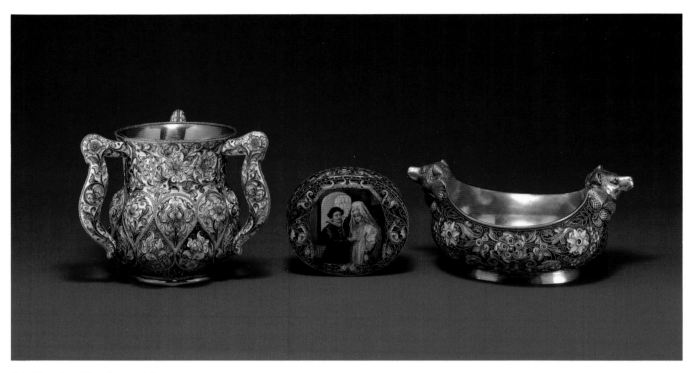

16. Feodor Rückert. Moscow. **Silver-gilt and Shaded Enamel Three-handled Cup.** ca. 1900. Height 4⅞″ (12.5 cm). *With lobed body, this cup is enameled with swans floating on ponds against grounds of Chinese red, blue, and olive green.* **Silver-gilt and Shaded Enamel Oval Box.** ca. 1910. Length 4″ (10.2 cm). *The center of the cover on this box is finely enameled* en plein *with a young boyarina and her groom.* **Silver-gilt and Shaded Enamel Bowl.** ca. 1900. Length 8″ (20.4 cm). *The handles of this bowl are in the form of realistically chased bear's heads with jeweled eyes. Copyright 1989, Sotheby's, Inc., New York.*

The fashion for smoking led to an increase in the use of cigarette cases. They were manufactured to suit all tastes by large firms, as well as workshops and artels. The artisans used all the techniques at their command, combining them with the cultural requirements of the time.

Not only cigarette cases, but glass holders and napkin rings were ornamented with all types of foliage or with the ultrafashionable themes of the underwater world, ladies bathing, portraits of Napoleon and Tolstoy, illustrations of Pushkin's "Snowstorm," and genre scenes. The genre scenes realistically portrayed hunting, plowing, birds, domestic or wild animals, or a peasant woman and her child. It was also common to depict legendary subjects as Ilya Mourometz, Prince Ivan and the gray wolf, or the Frog Queen.

Jewelry, the beauty and delicacy of which is, of course, for adornment of one's person, rose to great heights of technical accomplishment. Artisans exhibited great freedom in the manipulation of historical styles and newer styles of ornamentation, and in the abundant and quite complex use of precious materials. The new century attached great importance to personal ornamentation. Jewelry not only complemented one's clothing, but became an obvious symbol of the wearer's participation in the changing fashions and the spirit of the times. Jewelry reflected the new modernity, especially in the adoption of the out-of-the-ordinary, the item calculated to amaze people with one's inventiveness.

Design in this era acquired sinuous Art Nouveau–style lines, textured surfaces, and unusual new colors. There was a vogue for golden-green chrysolite and colored pearls; opalescent and soft pastel enamels; and tortoise shell, amber, coral, and ivory.

Style-moderne motifs acquired a greater range than ever after 1900, including elements of

mythology, landscape painting, and portraiture, and increasing the variety in the coloring of precious metals. One of the most notable developments in this trend was the use of the insect motif, under whose spell jewelry now seemed to fall. Brooches, pendants, and earrings were created in the shape of butterflies, dragonflies, beetles, and other creatures, studded with precious stones. The mysterious shimmering of opals, pearls, and mother-of-pearl and the brilliance of diamonds were extremely popular, for they reflected the romantic *fin de siècle* mood. The entomological theme is well represented in the State Historical Museum collection. Pins with the shapes of bees or flies, and earrings with tiny flies sitting on coral beads are among these delights.

The firms in Moscow and St. Petersburg that were most celebrated for their jewelry were those of Chichelyov, Bolin, Köchli, and Fabergé.

The most famous of the Moscow jewelry workshops was owned by Chichelyov, Merchant of the Second Guild. It had been well known since 1815. Bolin, who had received numerous awards in Russian and international exhibitions, owned a firm with both Moscow and St. Petersburg branches. These enjoyed an excellent reputation between 1810 and 1917. In 1870 the firm had been granted the highest honor—the right to use the state emblem. Bolin fulfilled numerous orders from the imperial family and the court; among the most popular of his productions were headdresses of diamonds and pearls, amethyst brooches, bracelets, and earrings of rubies, diamonds, and pearls. Köchli's workshop, which leaned toward historicism in its creations, specialized in jewelry and attracted notice at the 1900 International Exposition in Paris.

The jewelry produced by Fabergé's firm showed exceptional artistry in line, form, and color. The State Historical Museum has a gold *style-moderne* Fabergé brooch. It characteristically represents a spray of flowers enameled in soft golden-green tints and overlaid with diamonds.

Also, jewelry was manufactured at the beginning of the twentieth century at workshops belonging to the trading houses of Nicholas Linden and Baylin and Son. Many magazines advertised fashionable jewelry made of Bohemian garnets or Ural stones from the St. Petersburg jeweler Jan Reiman, as well as a wide range of diamond articles from Yakov Rimmer's workshop. In 1909 a jewelry workshop was opened in the Stroganov School that used all kinds of enamel, precious stones, horn, ivory, and other materials. It skillfully created whimsical necklaces, brooches, and pendants in the shape of female figures, birds, swans, grasshoppers, or spiders in their webs—all in the popular *style moderne.*

The State Historical Museum contains a gold locket that serves well as an illustration. It was made in Moscow at the beginning of this century by the First Jewelers' Guild. The locket was shaped to resemble the curves of a long, thin leaf, and it was decorated with a waterscape in semitransparent, bright blue-green enamel over a surface in relief, in imitation of ripples, and overlaid with three diamond and ruby flowers.

In expressing a love for nature, jewelers sought almost naturalistic precision in the conveying of its forms. On the one hand, the appearance of the naturalistic style in decorative applied art was influenced by Japanese culture, with its cult of plant themes, its whimsicality and sharpness of silhouette, its unusual types of ornamentation, and its asymmetrical compositions. On the other hand, the development of natural science that had begun in the mid-nineteenth century aroused considerable interest in artistic circles—so much so that many artists kept herbariums and had a good knowledge of botany and entomology. Art schools, including the Stroganov School, offered special drawing classes with live plants as models, as well as classes for devising ornaments from stylized plant forms. Jewelers often placed orders with botanists and entomologists for their drawings, to be used in making jewelry.

Le style moderne revived the fashion for cameos and intaglios, at the same time widening the range of colored stones used to make them. Artisans used coral, chrysoprase, jade, chalcedony, and tiger's eye, as well as banded sardonyx, onyx, and shells. Nontraditional subjects increased—

landscapes and illustrations of fairy tales and myths—and relief came to be used in a much more varied artistic manner, from the classical to the impressionistic. The settings of cameos became more varied, too. In addition to classical settings—which were thin and smooth, in flat relief, or in a filigreed twist—there now appeared more complex configurations produced in imitation of various textures or studded with garnets or turquoises.

In the work of all the Russian master gold- and silversmiths, the wide range of types, forms, and ornamental themes illustrates how interconnected were the various arts of the period. The stylized decorative manner that emerged from the desire to revitalize the expressiveness of art was an inseparable feature of all that was produced. The great possibilities of the art of goldsmithing that emerged from the multifarious materials and techniques—graphic carving, toning with colored gildings, colored pictorial enamel, filigree, high relief, precious and semiprecious stones—all unified according to the tendency of the culture of the period to synthesize many artistic styles.

G. G. SMORODINOVA

B. L. ULYANOVA

FABERGÉ

AND THE RUSSIAN

MASTER GOLDSMITHS

EGGS

Eggs as symbols of creation and new life have been exchanged at Easter for hundreds of years. Throughout Europe, natural eggs were colored and given as gifts. In the eighteenth century, the practice of creating eggs out of glass, porcelain, wood, papier-mâché, and precious metals and jewels was begun. The Russian goldsmiths and jewelers of the late nineteenth century mastered this art and created a variety of eggs in all sizes. Miniature eggs about half an inch long were made to be worn on a necklace and are found in an extraordinary variety of enameled colors and designs, frequently set with precious stones. Larger eggs, the size of chicken's eggs, were exquisitely enameled with flowers and foliage. Produced mainly by the Moscow gold- and silversmiths, such as Khlebnikov, Ovchinnikov, and Rückert, some of these eggs were fitted with small stands which screwed out from the interiors to enable each half of the egg to be converted into an egg cup. Others were made to enclose icons. The Easter eggs which Fabergé produced for the Czars were highly imaginative and ranged from the rather simple first imperial Easter egg to the complex creations of later years, such as the Orange Tree Egg of 1911.

17. Fabergé. Workmaster Erik Kollin (?), St. Petersburg. **Imperial Hen Egg.** 1885. Height 2½″ (6.4 cm), diameter of yolk 1⁵⁄₁₆″ (3.8 cm), length of hen 1⅜″ (3.75 cm). *This egg marks the beginning of the tradition of the imperial Easter eggs. About the size of a real egg, the white matte enamel egg opens to reveal a golden removable yolk that, in turn, opens to show a tiny hen. Made of four shades of colored gold, this hen has ruby eyes, and she rests on a nest of yellow-gold straw. When opened, the hen revealed a surprise (now lost), a replica of the imperial crown from which dangled another miniature ruby egg. The* Forbes *Magazine Collection, New York.*

18. Fabergé. Workmaster Michael Perchin, St. Petersburg. **Imperial Resurrection Egg.** ca. 1889. Height 3⅞″ (9.8 cm). *Given from Czar Alexander III to his wife Marie Feodorovna, this egg is one of the few eggs of religious subject created by Fabergé, remarkable for its simplicity and elegance. The egg, made of polished rock crystal, encloses a scene of Christ rising from the tomb flanked by angels. These enameled figures, exquisitely detailed, rest on an intricately enameled and jewel-encrusted stand of pearls, diamonds, and Renaissance-style enamelwork. A quatrefoil base of gold and white enamel gives rise to an arabesque of colors studded with diamonds. The* Forbes *Magazine Collection, New York.*

19. Fabergé. Workmaster Michael Perchin, St. Petersburg. **Imperial Blue Enamel Ribbed Egg.** Before 1899. Height 4⁵⁄₁₆″ (11 cm). *This egg was possibly a gift from Czar Alexander III to his wife, Marie Feodorovna. The blue enamel ground is overlaid with gold ribbing. The middle section has vertical gold bands which rest in a cup of gold acanthus leaves, supported by a swirled golden stem. The top portion of the egg has a gold crown set with diamonds and sapphires from which gold lilies-of-the-valley spray downward. Private collection.*

20. Fabergé. Workmaster Michael Perchin, St. Petersburg. **Imperial Spring Flowers Egg.** ca. 1890. Height 3¼″ (8.3 cm). *A gift from Czar Alexander III to the Empress Marie Feodorovna, this strawberry-red enameled egg with a guilloché, or engine-turned, ground, is laced with delicate neo-rococo gold*

54

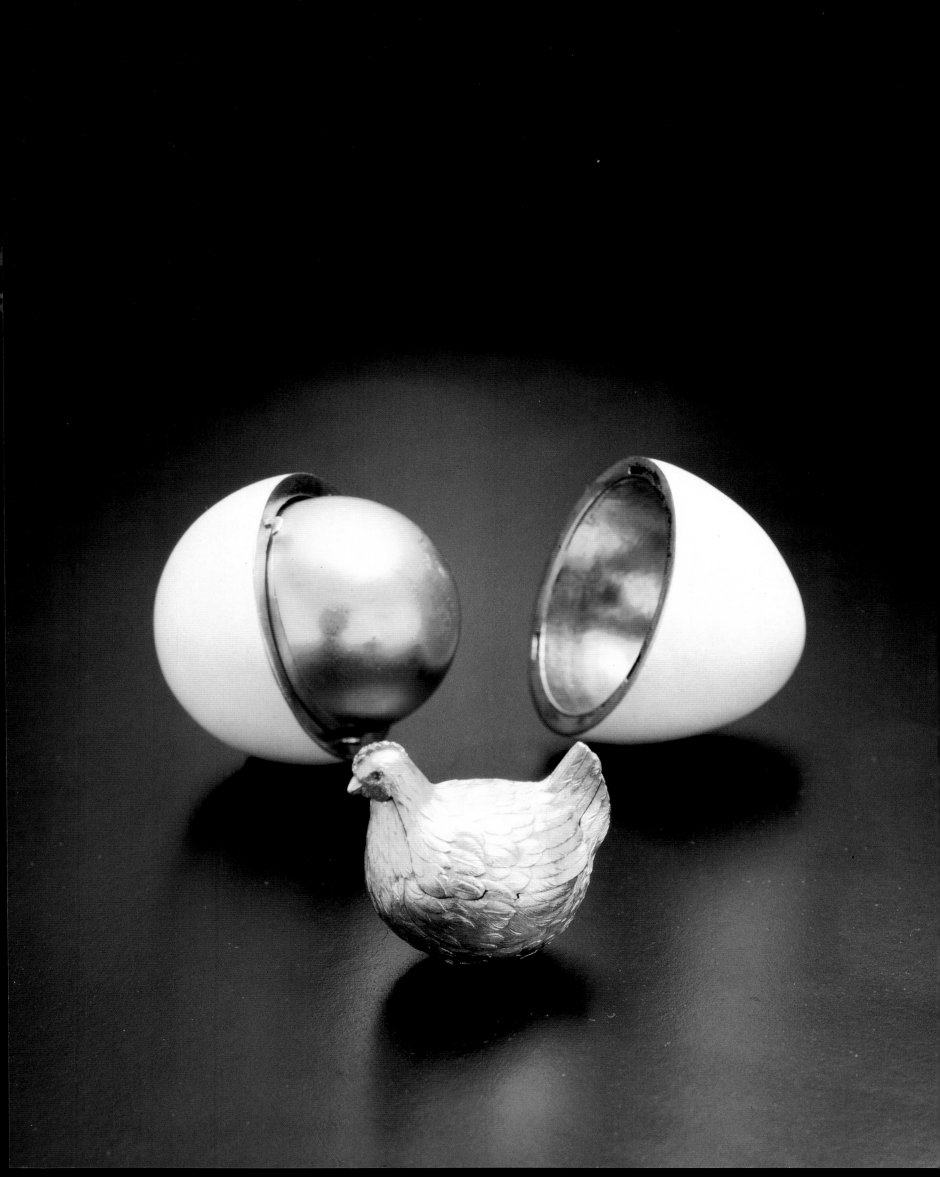

scrolls and stands on a diamond-studded bowenite cushion. The surprise inside is a diamond-studded platinum basket bursting with white chalcedony wood anemones and translucent green leaves. Demantoid garnets set in gold form the stamens of these tiny flowers. The Forbes *Magazine Collection, New York.*

21. Fabergé. Workmaster Michael Perchin, St. Petersburg. **Imperial Spring Flowers Egg** *(open)*.

22. Fabergé. Workmaster Michael Perchin, St. Petersburg. **Imperial *Pamiat Azova* Egg.** 1891. Height 3⅞″ (9.8 cm). *From 1890 to 1891, the future Czar Nicholas II, then heir to the throne, made a world tour aboard the vessel* Pamiat Azova. *This egg commemorates that voyage.*

 The egg is carved of jasper and is applied with diamond-set neo-rococo scrolls. Inside, a model of the ship, from the workshop of August Hollming, is wrought in gold and platinum with minute detailing, including gold rigging, anchor chains, life boats, and smokestacks. The ship rests on an aquamarine base. The Armory Museum, Moscow.

23. Fabergé. Workmaster Michael Perchin, St. Petersburg. **Imperial Caucasus Egg.** 1893. Height 3⅝″ (9.2 cm). *The surprise of this sumptuous egg is under four diamond- and pearl-encrusted panels on the outside. Translucent red enamel over an engine-turned basket-weave design forms the background for this egg. Behind the four "portals," each bearing one numeral of the date 1893, is a miniature, painted by Krijitski, of the imperial retreat at Abastouman in the Caucasus. Swags of varied shades of gold are held in place by diamond-studded platinum bows. A portrait of the Grand Duke George Alexandrovich is visible through diamonds at the top and bottom of the egg. Grand Duke George, brother of Nicholas II, spent most of his time at Abastouman for health-related reasons. Matilda Geddings Gray Foundation, on loan to New Orleans Museum of Art.*

24. Fabergé. Workmaster Michael Perchin, St. Petersburg. **Imperial Renaissance Egg.** 1894. Length 5¼″ (13.3 cm). *This was the last of the eggs ordered by Czar Alexander III for his wife Marie Feodorovna before his death in November 1894. Inspired by an eighteenth-century egg in the Grünes Gewölbe, Dresden, this gray agate egg is covered with a trelliswork of translucent white enamel dotted with rose-cut diamonds and rubies. A scrolled foliage pattern of red, white, green, and blue enamel form both the center band and the framing for the date, encrusted in diamonds and set on a red enamel oval. The two halves are divided by a red enamel band studded with diamonds. The bottom half, much simpler in design than the top, is trisected by three richly detailed blue fans, one of which serves as the clasp.*

 The egg rests on its side in a base of green palmettes and golden sheaths on a translucent white background. At both ends of the egg are gold lion heads with gold rings through their mouths. The Forbes *Magazine Collection, New York.*

25. Fabergé. Workmaster Michael Perchin, St. Petersburg. **Imperial Renaissance Egg** *(open)*.

26. Fabergé. Workmaster Michael Perchin, St. Petersburg. **Imperial Rosebud Egg.** 1895. Height 3″ (7.6 cm). *Presented by Czar Nicholas II to Czarina Alexandra Feodorovna, the Rosebud Egg, so called because of its surprise inside, is a red translucent enamel egg sparingly decorated with gold swags that are pendent from rose-cut diamonds. The top portion of the egg is adorned with gold laurel wreaths suspended from diamond-studded ribbons. Diamonds also form the central band of the egg as well as decorative vertical panel divisions. When opened, the egg reveals a yellow- and green-enameled rosebud which opens to display a diamond-and-ruby imperial crown. The* Forbes *Magazine Collection, New York.*

27. Fabergé. Workmaster Michael Perchin, St. Petersburg. **Imperial Rosebud Egg** *(open)*.

28. Fabergé. Workmaster Michael Perchin, St. Petersburg. **Imperial Danish Palace Egg.** 1895. Height 4″ (10.2 cm). *The egg is made of a delicate translucent pink enamel over a guilloché star-design ground. Gold palm leaf and diamond borders divide the egg into sections, and cabochon emeralds are set at each intersection. The top of the egg is set with a cabochon sapphire star mounted in rose-cut diamonds and*

set in gold. When the egg is opened, the surprise revealed is a screen of ten miniature mother-of-pearl panels, painted by Krijitski in 1891, which depict various palaces and residences of the Danish royal family and imperial yachts. The egg was given by Nicholas II to the Dowager Empress Marie Feodorovna. Matilda Geddings Gray Foundation, on loan to New Orleans Museum of Art.

29. Fabergé. Workmaster Michael Perchin, St. Petersburg. **Imperial Monogram Egg.** Before 1896. Height 3¼″ (8.3 cm). *The upper and lower halves of the Monogram Egg are each divided into six panels. Between each panel is a row of rose-cut diamonds with another row around the middle where the egg opens. Each panel contains a Cyrillic cipher in diamonds; of Alexander III in the lower half and of the Empress Marie Feodorovna in the upper half. On the top and bottom of the egg are large diamonds surrounded by smaller ones. The egg is of bright blue enamel with a design of red gold. There is a velvet lining for the surprise, which is now lost. The egg was possibly a gift for the Czar's twenty-fifth wedding anniversary in 1892. Courtesy of Hillwood Museum.*

30. Fabergé. Workmaster Michael Perchin, St. Petersburg. **Imperial Egg with Revolving Miniatures.** ca. 1896. Height 10″ (25.4 cm). *One of the largest imperial eggs, this rock crystal egg is inset with miniatures of royal residences associated with the life of Czarina Alexandra Feodorovna. The miniatures are attached to a central gold column topped with a cabochon Siberian emerald, which rotates inside the egg. A diamond band vertically circles the egg, which rests on an ornate base of champlevé enamel. Within the design are the adopted Russian and original German monograms of the Czarina, both crowned with diamonds. Virginia Museum of Fine Arts, Richmond, Virginia, Bequest from the Estate of Lillian Thomas Pratt.*

31. Fabergé. Workmasters Michael Perchin and Henrik Wigström, St. Petersburg. **Imperial Coronation Egg.** 1897. Height of egg 5″ (12.7 cm), height of carriage 3¹¹⁄₁₅″ (9.3 cm). *This is truly one of the most fanciful and well-known of all of the imperial eggs. Given by Czar Nicholas II to Czarina Alexandra Feodorovna on the first Easter after their coronation, the egg is a masterpiece of craftsmanship. Fabergé's expertise at enameling in the round is apparent, with yellow translucent enamel over a guilloché sunburst-pattern ground. On top of the egg, gold laurel leaf forms a trellis with a black imperial eagle, set with a central diamond, at every intersection. The top of the egg is crowned with a table-cut diamond which reveals the Czarina's Cyrillic initials "AF" in diamonds and red enamel.*

Inside the egg sits a coronation coach replica by George Stein. The coach, which took fifteen months to complete, is a creation of gold, platinum, diamonds, rubies, rock crystal, and blue and red enamel. Its doors, which bear the imperial emblem in gold and diamonds, have etched rock crystal windows. Steps drop from inside the carriage, which is articulated so that the front wheels, made of gold and rimmed in platinum, can turn realistically. The coach is topped with a diamond-set imperial crown. Missing from this masterpiece is an egg-shaped diamond which was once pendent from the ceiling of the interior. The Forbes Magazine Collection, New York.

32. Fabergé. Workmasters Michael Perchin and Henrik Wigström, St. Petersburg. **Imperial Coronation Egg** *(detail).*

33. Fabergé. Workmaster Michael Perchin, St. Petersburg. **Imperial Pelican Egg.** 1897. Height 4″ (10.2 cm). *Another in Fabergé's series of eggs with fold-out surprises, the Pelican Egg was a gift from Nicholas II to the Dowager Empress Marie Feodorovna. The exterior of the rose-gold egg is etched with imperial eagles and laurel motifs. The egg is engraved with the dates, 1797–1897, and the inscription "Visit our vineyards, O Lord, and we shall live in Thee" vertically bands the egg. On top, a gold, diamond, and enamel pelican sits in a nest feeding her young.*

The egg opens into eight panels creating frames for ivory miniatures, painted by Johannes Zehngraf, which depict institutions founded by the Empress Marie (wife of Paul I) in 1797. Virginia Museum of Fine Arts, Richmond, Virginia, Bequest from the Estate of Lillian Thomas Pratt.

34. Fabergé. Workmaster Michael Perchin, St. Petersburg. **Imperial Pelican Egg** *(open).*

35. Fabergé. Workmaster Michael Perchin, St. Petersburg. **Imperial Lilies-of-the-Valley Egg.** 1898. Height 5¹⁵⁄₁₆″ (14.9 cm). *One of three Art Nouveau eggs created by Fabergé (the others are the Pansy Egg, and the Clover Leaf Egg), this floral creation is a fantasy of nature. Translucent pink enamel over an engine-turned basket-weave ground is sectioned by vertical bands of rose-cut diamonds. In each section, lilies-of-the-valley made of pearls with diamond edges spray from green and gold leaves. The legs supporting the egg are naturalistic, curving down and upward, catching a pearl that seems to have fallen off.*

The surprise is a set of three miniature portraits of Czar Nicholas II and his two eldest daughters, Olga and Tatiana, surrounded by diamonds and painted on ivory by Johannes Zehngraf. These spring out of the egg when released by a pearl button and then fan open. Topping the portrait of the Czar are an imperial crown of diamonds and a cabochon ruby resembling the hilt of a sword. The Forbes *Magazine Collection, New York.*

36. Fabergé. Workmaster Michael Perchin, St. Petersburg. **Imperial Madonna Lily Egg.** 1899. Height 10½″ (26.7 cm). *This vari-colored gold egg, which serves as a clock, is enameled translucent yellow over a guilloché ground. The chapter ring is enameled opaque white, and the hours are set with diamonds. The base is set with the year 1899 in diamonds, and a bunch of carved hardstone, diamond-set Madonna lilies spring from the top. The Armory Museum, Moscow.*

37. Fabergé. Workmaster Michael Perchin, St. Petersburg. **Imperial Pansy Egg.** 1899. Height 5¾″ (14.6 cm). *The second in Fabergé's series of Art Nouveau eggs, the Pansy Egg is made of simply carved nephrite with five lavender pansies laden with rose-cut diamonds strewn across the egg. The base is a bold gilded silver swirl with diamond-set leaves.*

Inside, the surprise is a white enamel heart which rests on a multicolored gold easel bearing the date 1899, topped with a star made of diamonds. Enameled on the heart are eleven tiny oval red doors, each monogrammed, which cover miniature portraits of the imperial family. From left to right and top to bottom there are: Grand Duke George (younger brother of Czar Nicholas II), Grand Duke Alexander (husband of Grand Duchess Xenia, sister to the Czar), Czar Nicholas II, Grand Duchess Irina, Grand Duchess Olga (Nicholas and Alexandra's first child), Grand Duchess Tatiana (their second child), Grand Duke Michael (the Czar's youngest brother), Czarina Alexandra, Grand Duke Andrew (brother of Grand Duchess Irina), Grand Duchesses Olga and Xenia, sisters of the Czar. Private collection, U.S.A.

38. Fabergé. Workmaster Michael Perchin, St. Petersburg. **Imperial Cuckoo Egg.** 1900. Height 8⅛″ (20.6 cm). *A gift from Nicholas II to the Czarina in 1900. This playful egg served as a clock and a music box, the two elements working independently of each other. Outside, set on a translucent violet blue–enameled* guilloché *wave pattern, the baroque clock is decorated with multicolored gold cornucopias, tassels, and columns of translucent oyster enamel with burning golden pyres on top. The dial's Arabic numerals are set with diamonds. Diamonds dot the lace-like decoration beneath the clock, while leaves topped with pearls circle above it. The incurved sides of the base are enameled translucent lilac. When released by a mechanism, a rooster with real feathers pops up from a Moorish open-work screen and sings (by means of tiny bellows inside the egg) while its wings and beak move up and down with the music.* The Forbes *Magazine Collection, New York.*

39. Fabergé. Workmaster Michael Perchin, St. Petersburg. **Imperial Trans-Siberian Railway Egg.** Probably 1901. Height of egg 10¾″ (27.3 cm), length of train 15¹¹⁄₁₆″ (39.8 cm). *The debut of the Trans-Siberian railway in 1900 was a major event and was celebrated by the presentation of this egg from Czar Nicholas II to the Czarina Alexandra Feodorovna.*

A silver band around the middle of the egg is inscribed with "Great Siberian Railway, 1900" and engraved with the route of the line from Moscow to Vladivostok. The top and bottom of the egg are enameled translucent green, and the egg is topped with an imperial eagle. The base is formed by three gryphons, with arms extended, wielding shields and swords. The egg contains an articulated jewel-set gold and platinum replica of the train, which moves when wound with its gold key. The Armory Museum, Moscow.

40. Fabergé. Workmaster Michael Perchin, St. Petersburg. **Imperial Clover Egg.** ca. 1902. Height 3⅜″ (8.5 cm). *This Art Nouveau egg, probably a gift from Czar Nicholas II to Czarina Alexandra Feodorovna, is covered with* plique-à-jour *green enamel and diamond-studded clover leaves, tied with ruby-set ribbons. The surprise has been lost. The Armory Museum, Moscow.*

41. Fabergé. Workmaster Michael Perchin, St. Petersburg. **Imperial Gatchina Palace Egg.** ca. 1902. Height 5″ (12.7 cm). *The Gatchina Palace was the favorite residence of the Dowager Empress Marie, and it is celebrated in this delicate egg. The outside is made of opalescent white enamel over a moiré guilloché ground. Tiny seed pearls circumscribe the center and vertically band the egg, dividing it into sections. Each section is decorated with ribbon-tied swags of leaves from which are pendent symbols of the arts and sciences, favorite interests of the Dowager Empress. Inside is an exquisitely rendered miniature of the palace, created from four-colored gold, which is accurately detailed, right down to the flags waving in the wind. Walters Art Gallery, Baltimore, Maryland.*

42. Fabergé. Workmaster Michael Perchin, St. Petersburg. **Imperial Gatchina Palace Egg** *(open).*

43. Fabergé. St. Petersburg. **Imperial Peter the Great Egg.** 1903. Height 4¼″ (10.8 cm). *This egg of vari-colored gold and platinum is mounted with miniatures of Nicholas II and Peter the Great and with views of the Winter Palace and of the Wooden Hut of Peter the Great. It is set with diamonds and rubies. It contains a miniature bronze model of the statue of Peter the Great which was commissioned by Catherine the Great of the French sculptor Falconet and was erected in St. Petersburg in 1782. This miniature bronze rests on a block of sapphire and is surrounded by a gold fence. Virginia Museum of Fine Arts, Richmond, Virginia, Bequest from the Estate of Lillian Thomas Pratt.*

44. Fabergé. St. Petersburg. **Imperial Peter the Great Egg** *(open).*

45. Fabergé. **Imperial Uspensky Cathedral Egg.** 1904. Height 14½″ (37 cm). *Given by Czar Nicholas II to Czarina Alexandra Feodorovna, this egg, made of vari-colored gold and enamel, is a representation of the Uspensky Cathedral, within the walls of the Kremlin, where the Czars were crowned. Two of the Kremlin towers have clocks. A representation of the interior of the cathedral, including the high altar and icons, is visible through the windows. A hymn is played when the mechanism is wound with its gold key. The Armory Museum, Moscow.*

46. Fabergé. Workmaster Henrik Wigström, St. Petersburg. **Imperial Colonnade Egg.** Probably 1905. Height 11¼″ (28.5 cm). *This egg was a gift from Czar Nicholas II to the Czarina Alexandra Feodorovna to celebrate the birth of the Czarevich Alexei in 1904. Bowenite columns wrapped in multicolored gold garlands with two doves in the center form a classical Temple of Love. The pink enameled dome has a chapter ring of diamond-set numbers which revolve, passing a diamond-set pointer that indicates the hour. The top of the dome is crowned with silver-gilt Cupid, complete with arrows and quiver. The four cherubs at the base of the temple represent the Czarevich's four sisters. The Royal Collection, London. Collection of H.M. Queen Mary.*

47. Fabergé. Workmaster Henrik Wigström, St. Petersburg. **Imperial Rose Trellis Egg.** 1907. Height 3³⁄₁₆″ (7.7 cm). *Small enough to fit in the palm of one's hand, this 1907 egg was a gift to Czarina Alexandra Feodorovna. Its name refers to the "trellises" of diamonds that criss-cross its surface. The egg's "surprise" was probably an oval locket that has since been lost. Pink hardstone roses are interspaced upon a delicate green translucent enamel background. The detailing, especially of the tiny green rose leaves set amidst gold vines, makes this one of the most delicate of the eggs inspired by motifs from nature. The Walters Art Gallery, Baltimore, Maryland.*

48. Fabergé. Workmaster Henrik Wigström, St. Petersburg. **Imperial Standart Egg.** Probably 1909. Height 6⅛″ (15.5 cm). *A gold replica of the imperial yacht is contained within this rock crystal egg. The egg is supported on the tails of carved lapis-lazuli dolphins. The eagle-form grips on either side are also*

of lapis lazuli. The rock crystal base is gold-mounted and enameled in white, green, and blue. The Armory Museum, Moscow.

49. Fabergé. **Imperial Alexander III Equestrian Egg.** 1910. Height 6⅛″ (15.5 cm). *This carved rock crystal egg contains a gold copy of the Troubetskoy bronze sculpture of Alexander III and was presented to the Dowager Empress Marie Feodorovna by Nicholas II. The egg is mounted in platinum and set with diamonds. The Armory Museum, Moscow.*

50. Fabergé. **Imperial Fifteenth-Anniversary Egg.** 1911. Height 5⅛″ (13.2 cm). *This egg, shown full-size, commemorates the fifteenth anniversary of the coronation of Czar Nicholas II. The miniatures, painted on ivory and set on a background of oyster-colored enamel, were created by the artist Zuiev and depict Nicholas and Alexandra (for whom this was a gift), their children, and major events during the reign of the Czar. Each miniature is framed by green leaflike bands of enamel bordered in gold and bound by a line of diamonds. The Forbes Magazine Collection, New York.*

51. Fabergé. **Imperial Fifteenth-Anniversary Egg** *(detail).* 1911. Height 5⅛″ (13.2 cm). *Miniatures: (top) Grand Duchess Tatiana, (middle) Czar Nicholas II. The Forbes Magazine Collection, New York.*

52. Fabergé. **Imperial Orange Tree Egg.** 1911. Height 10¾″ (30 cm). *Presented by Czar Nicholas II to the Dowager Empress Marie, this egg bursts with the exuberance of spring. The tree is made of carved nephrite leaves dotted with white enamel blossoms with diamond centers. Oranges, formed of pink diamonds, citrines, and amethysts, peek through the leaves. The tree is planted in a white quartz gold trellised tub from which hang green enamel gold swags with cabochon ruby fasteners. The tub rests on a base of nephrite and is guarded by four nephrite posts topped by pearls. The surprise is a small song bird, with real feathers, which springs from beneath the upper leaves when a certain orange is turned. The Forbes Magazine Collection, New York.*

53. Fabergé. Workmaster Henrik Wigström, St. Petersburg. **Imperial Czarevich Egg.** 1912. Height 5″ (12.7 cm). *This ornate, lapis-lazuli egg is overlaid with gold tracery, in the style of a Louis XV cagework, of shells, scrolls, baskets of flowers, and putti. The top of the egg opens to reveal a diamond-studded Russian imperial eagle on a lapis-lazuli base, which serves as a frame for a miniature of the Czarevich Alexei Nicholaevich. Virginia Museum of Fine Arts, Richmond, Virginia, Bequest from the Estate of Lillian Thomas Pratt.*

54. Fabergé. Workmaster Henrik Wigström, St. Petersburg. **Imperial Napoleonic Egg.** 1912. Height 4⅝″ (11.7 cm). *On the occasion of the anniversary of the defeat of Napoleon at Borodino, this egg was a gift to the Dowager Empress Marie. The egg is of translucent green enamel over a sunburst-pattern guilloché ground. Military trophies fill each of the panels, which are framed by rose-cut diamonds and leafage. The egg contains a folding screen of six miniatures by Zuiev depicting the various regiments of which the Dowager Empress was honorary colonel. These are framed by a border of diamonds and green enameled laurel leaves. On the back of each panel is a green circular background, bordered by diamonds, which bears the diamond-encrusted Cyrillic monogram of Marie Feodorovna. Matilda Geddings Gray Foundation, on loan to New Orleans Museum of Art.*

55. Fabergé. Workmaster Henrik Wigström, St. Petersburg. **Imperial Romanov Tercentenary Egg.** 1913. Height 7⁵⁄₁₆″ (18.5 cm). *Celebrating three hundred years of Romanov rule, this gift from Czar Nicholas II to Czarina Alexandra Feodorovna is mounted with portraits painted on ivory of eighteen Romanov rulers. These small portraits are surrounded by gold imperial eagles and crowns which almost entirely cover the surface of the egg but leave traces of white enamel showing through. The egg contains a steel globe, one half of which depicts the territory of the Russian empire in 1613, the other half of which depicts the extent of the empire three hundred years later. The egg is mounted on a purpurine base. The Armory Museum, Moscow.*

56. Fabergé. **Imperial Mosaic Egg.** 1914. Height 3⅝″ (9.2 cm). *One of the most intricately worked of all the Easter eggs, this egg is created from a platinum mesh set with sapphires, rubies, emeralds, garnets, diamonds, topazes, and quartzes to resemble* petit-point *embroidery. Central medallions of roses are framed by half-pearls and joined by platinum-set diamonds. A band of diamond waves borders the egg at each end. A moonstone adorns the top of the egg and covers the Cyrillic initials of the Czarina Alexandra Feodorovna. Inside is an oval miniature of the five imperial children set on a pink ground, encircled with pearls and topped with a tiny diamond crown. The Royal Collection, London. Collection of H.M. Queen Elizabeth II.*

57. Fabergé. Workmaster Henrik Wigström, St. Petersburg. **Imperial Cameo Egg.** 1914. Height 4¾″ (12 cm). *This egg, made of four-color gold, has enameled panels painted by the miniaturist Vasiliy Zuiev after the eighteenth-century French artist François Boucher. The scenes are painted* en camaieu *in off-white monochrome on a pink translucent enamel ground. The front and back panels bear allegories of the arts and sciences, respectively. Four smaller panels contain putti which represent the four seasons. On the top is a portrait diamond with the cipher of Empress Marie Feodorovna. A portrait diamond on the bottom bears the date 1914.*

 This egg was a gift from Nicholas II to his mother, Marie Feodorovna. According to correspondence between Marie and her sister Queen Alexandra of England, the surprise, now lost, was a sedan chair in which sat Catherine the Great. Courtesy of Hillwood Museum.

58. Fabergé. Workmaster Henrik Wigström, St. Petersburg. **Imperial Red Cross Egg with Resurrection Triptych.** 1915. Height 3⅜″ (8.5 cm). *This egg was presented to the Czarina Alexandra by Czar Nicholas II. The outside is a simple translucent white enamel over a guilloché ground (austere in contrast to the eggs of the more opulent past), with two translucent red enamel crosses bearing portraits of Grand Duchesses Tatiana and Olga. The egg opens to reveal a delicately painted triptych of the Resurrection. On the left side of the interior are the Cyrillic initials of the Czarina Alexandra Feodorovna, and the right side bears the date 1915. The Cleveland Museum of Art, The India Early Minshall Collection.*

59. Fabergé. Workmaster Henrik Wigström, St. Petersburg. **Imperial Red Cross Egg with Portraits.** 1915. Height 3½″ (8.8 cm). *Similar to the Red Cross Egg, this piece, a gift to the Dowager Empress Marie, is somewhat more complex. The egg is enameled translucent opalescent white over a guilloché ground. Equilateral red enamel crosses on each side are surrounded by the dates 1914 and 1915. Cyrillic lettering around the center reads, "Greater love hath no man than this, that a man lay down his life for his friends." On the top of the egg are the crown and monogram of the Dowager Empress in silver, and at the bottom is a rosette. Inside is a five-part screen painted with miniatures by Vasiliy Zuiev. The frames are simple, white enamel designs with a small red cross in a roundel on top. Virginia Museum of Fine Arts, Richmond, Virginia, Bequest from the Estate of Lillian Thomas Pratt.*

60. Fabergé. **Imperial Cross of St. George Egg.** 1916. Height 3¹⁵⁄₁₆″ (9 cm). *This egg was given by Nicholas II to the Dowager Empress Marie. It is enameled opalescent white over a guilloché ground with a faint tracery of laurel leaves and with a white and red miniature Cross of St. George in each diamond pattern. A circular medallion on each side of the egg is pendent from the sash of the order. One medallion is decorated with the Cross of St. George, and the other bears the profile of Nicholas II; both are hinged to reveal a surprise underneath. Under the cross is a portrait of Nicholas II, and under the profile is a portrait of the Czarevich. The Forbes Magazine Collection, New York.*

61. Fabergé. Workmaster Michael Perchin, St. Petersburg. **Hoof Egg.** ca. 1890. Height 3¼″ (8.3 cm). *This simple, pale green bowenite egg is supported by four gold hoof-shaped legs. Gold swags tied with green gold are attached by pearls. A cabochon ruby forms the central knot of a diamond bow. When triggered, a round, framed portrait of Czarina Alexandra Feodorovna, dressed in court costume and wearing a tiara, springs from the center. The Forbes Magazine Collection, New York.*

62. Fabergé. **Seven Miniature Easter Eggs.** Heights ⅝″ to 1⅛″ (1.6 cm to 3 cm). *(Clockwise from top left)* **Swan Egg.** Workmaster Henrik Wigström. St. Petersburg, 1899–1908. *A woven gold basket forms the*

lower half of this egg, and the upper half is chased with a floating swan decorated with colored stones. **Hatching Chick Egg.** Maker unknown. Date unknown. *Deep blue enamel forms the background for this downy yellow-painted chick emerging from its shell.* **Scrollwork Egg.** Workmaster August Hollming, St. Petersburg. 1900–1915. *Emerald-cut pieces of crystal are intertwined in this open-scrollwork gold egg.* **Flower Egg.** Workmaster Michael Perchin, St. Petersburg. 1886–1903. *Six pastes form a flower on this gold egg.* **Fish Egg.** Maker unknown. Date unknown. *This small fish, with ruby eyes and a pearl mouth, has fins and a tail of gold.* **Pearl Trefoil Egg.** Workmaster Wilhelm Reimer (?). 1870–1898. *Three pearls with a central diamond form a trefoil on this gold egg.* **Perched Chick Egg.** Workmaster Feodor Afanassiev. Date unknown. *A quartz chick with diamond eyes sits on a gold perch.* The Forbes *Magazine Collection, New York.*

63. Fabergé. **Seven Miniature Easter Eggs.** Heights ⅝″ to 1⅛″ (1.6 cm to 3 cm). *(Clockwise from top left)* **Art Nouveau Egg.** Workmaster Michael Perchin (?), St. Petersburg. 1886–1903. *Made of green and red gold, the leaves on this naturalistic Art Nouveau egg are studded with rubies and sapphires.* **Ladybug Egg.** Workmaster Michael Perchin, St. Petersburg. 1886–1903. *This egg is enameled to resemble a ladybug in black and red with green and yellow gold.* **Oval-Frame Egg.** Workmaster Henrik Wigström, St. Petersburg. 1886–1917. *This white enameled egg is overlaid with gold leaf tips and is suspended within an oval frame enameled translucent russet.* **Imperial Colors Eggs.** Workmaster Michael Perchin, St. Petersburg. 1886–1903. *These are three tiny eggs, one white, one blue, and one red (the imperial colors).* **Mushroom Egg.** Workmaster unknown. No date. *This chased gold basket holds a small mushroom enameled ivory and speckled brown.* **Ribbon Egg.** Workmaster Michael Perchin, St. Petersburg. 1886–1903. *This blue enamel and gold and silver egg is set with a diamond and is surmounted by a diamond-set ribbon bow.* **Imperial Eagle Egg.** Workmaster Henrik Wigström, St. Petersburg. 1886–1917. *This rhodonite egg is surmounted by the double-headed eagle in silver.* The Forbes *Magazine Collection, New York.*

64. Grigori Pankratiev. Moscow. **Silver-gilt and Enamel Easter Egg.** ca. 1910. Height 3″ (7.5 cm). *This egg is enameled in red with a cross edged by blue and surrounded by multicolored, stylized scrolling foliage on a gilded stippled ground. The State Historical Museum, Moscow.*

65. Fabergé. Workmaster Michael Perchin, St. Petersburg. **Kelch Hen Egg.** 1898. Height of egg 3¼″ (8.4 cm), height of hen 1⅜″ (3.5 cm), height of easel 1⅞″ (5.6 cm). *This piece was created for Barbara Kelch, wife of Alexander Ferdinandovich Kelch, the Siberian tycoon. Based on the design of the first imperial egg, this egg on the outside is deep ruby-red translucent enamel over a basket-weave guilloché ground. A diamond band encircles the perimeter of the egg, with the catch bearing the date 1898. Inside, the gold egg contains an oval of matte white with a matte yellow yolk. The yolk opens to disclose a brightly enameled sitting gold hen, painted to highlight her brown and yellow feathers. She opens to reveal a tiny portrait, propped on an easel, of the Czarevich Alexis, bordered by diamonds.* The Forbes *Magazine Collection, New York.*

66. Fabergé. Workmaster Michael Perchin, St. Petersburg. **Gold, Enamel, and Jeweled Easter Egg.** 1899. Height 3½″ (9 cm). *This egg, encircled with a band of diamonds, is enameled translucent pink, and the borders are enameled with roses on a matte gold ground. At one end, under a portrait diamond, are the initials BK for Barbara Kelch; the other end has the date 1899, also under a diamond. This egg originally contained a surprise which is now lost. The Royal Collection, London.*

67. Fabergé. Workmaster Henrik Wigström, St. Petersburg. **Carved Nephrite Easter Egg Bonbonnière.** ca. 1910. Height 2¼″ (5.8 cm). *Mounted in gold, enamel, and diamonds with white enamel edges, this egg is carved of well-figured nephrite and is hinged at the center. The top has a gold border chased with leaf tips and set with diamond-set ribbon bows. Copyright 1987, Sotheby's, Inc., New York.*

68. Fabergé. Workmaster Henrik Wigström, St. Petersburg. **Bonbonnière Egg.** ca. 1900. Height 1⅞″ (4.8 cm). *The silver-gilt body of this egg is enameled translucent white over a guilloché ground. Beneath one of the outer layers of the enameling are painted wintery tree branches tied together with a bow.*

Chased gold laurel leaves divide the egg into quadrants, and trellised sections are set with diamonds. The cover has a thin, powder-blue enamel band with leaves and diamonds. The Forbes *Magazine Collection, New York.*

69. Feodor Rückert. Moscow. **Silver-gilt and Shaded Enamel Easter Egg.** ca. 1900. Height 3½″ (9 cm). *Enameled* en plein *with a winged infant holding a banner inscribed in Cyrillic, "Christ is Risen." This figure is flanked on one side by doves and by a nest holding three eggs on the other. The surround and back of the egg are enameled with colorful foliage on an avocado ground. Private collection, U.S.A.*

70. Maker unknown. Probably Feodor Rückert. Moscow. **Silver and Shaded Enamel Easter Egg.** ca. 1900. Height 2⅜″ (6.1 cm). *Finely enameled with flowers and leafage on a cream ground, this egg is set with colored hardstone cabochons. The State Historical Museum, Moscow.*

71. Fabergé. Workmaster Michael Perchin, St. Petersburg. **Gold and Agate Easter Egg Bonbonnière.** ca. 1900. Height 3¼″ (8.2 cm). *This egg-shaped bonbonnière opens at the center and is applied with gold neo-rococo scrolls and flowers in an eighteenth-century English style. Courtesy of Hillwood Museum.*

72. Fabergé. Workmaster Michael Perchin, St. Petersburg. **Pine Cone Egg.** 1900. Height 3¾″ (9.5 cm). *This egg is composed of overlapping disks enameled translucent deep blue over a guilloché ground with diamond-set borders. One end bears the date 1900, each of whose digits appears beneath a portrait diamond. The egg contains, as a surprise, a miniature elephant automaton mounted with a gold rug enameled translucent red and green and set with diamonds. A mahout is seated on the elephant's back. When wound with its gold key, the elephant walks with a swaying motion, swinging its tail and turning its head. Courtesy Christie, Manson & Woods International, Inc.*

73. Fabergé. **Travelling Boxes.** *The delicacy of Fabergé's creations necessitated elegant, yet practical boxes for their transportation. They were created from wood, silk, and velvet and were fitted to accommodate the treasures they carried. The* Forbes *Magazine Collection, New York.*

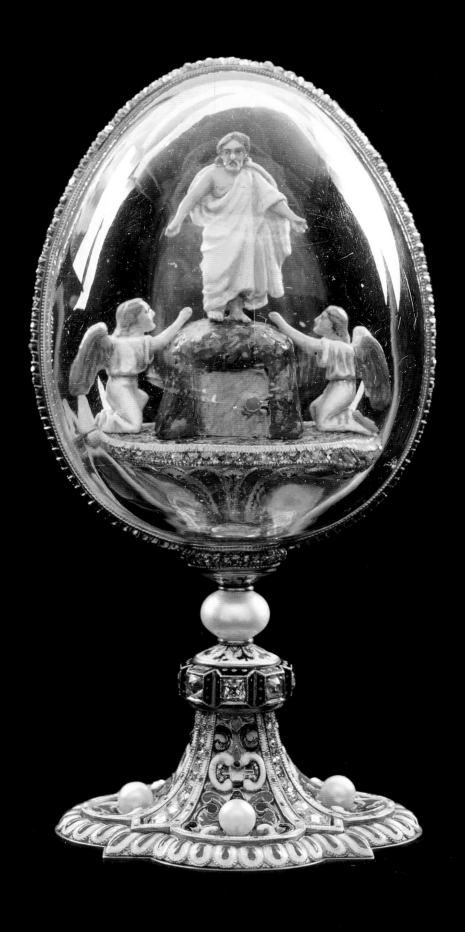

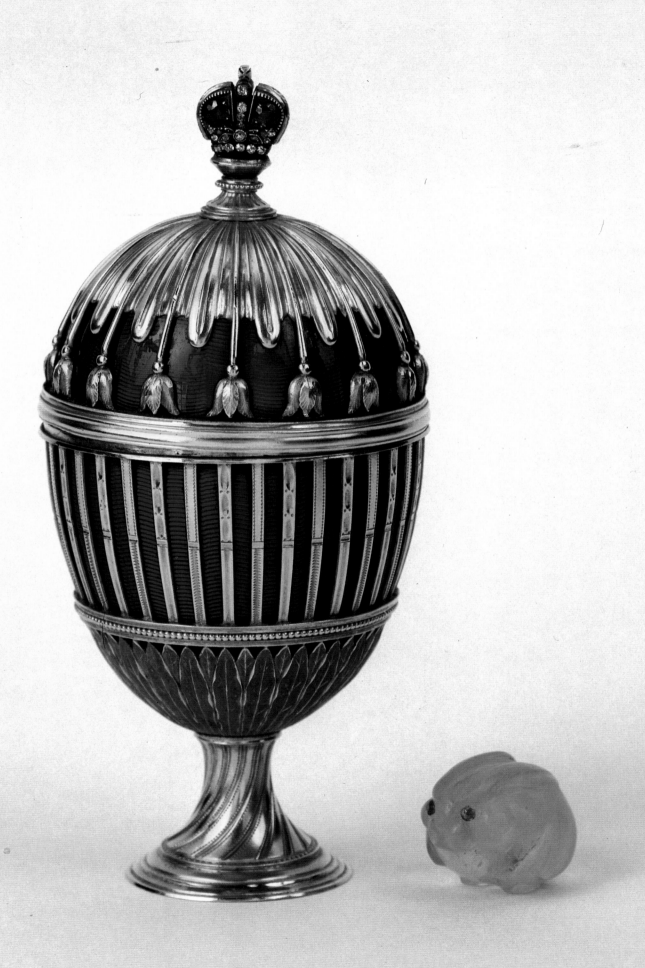

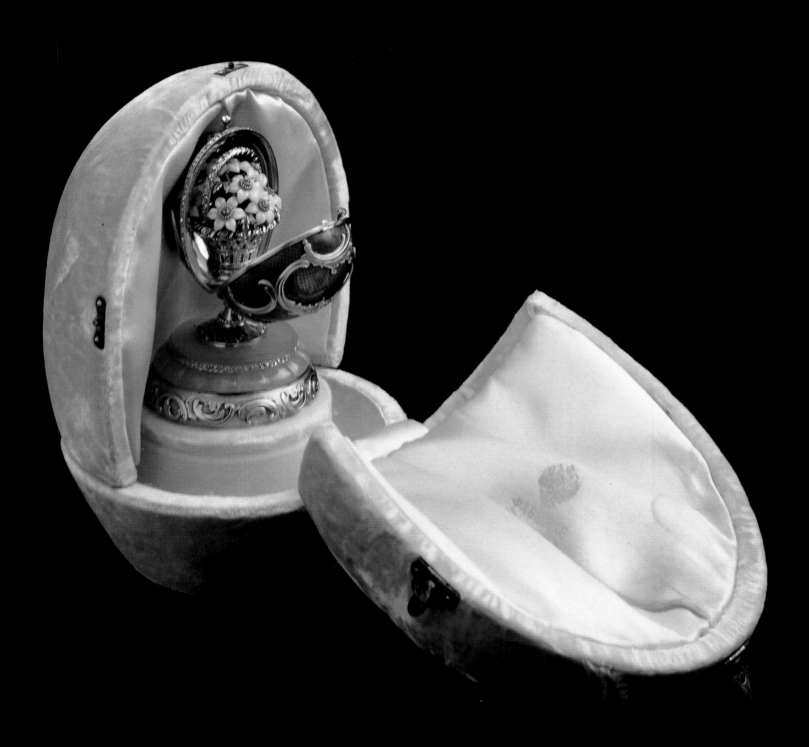

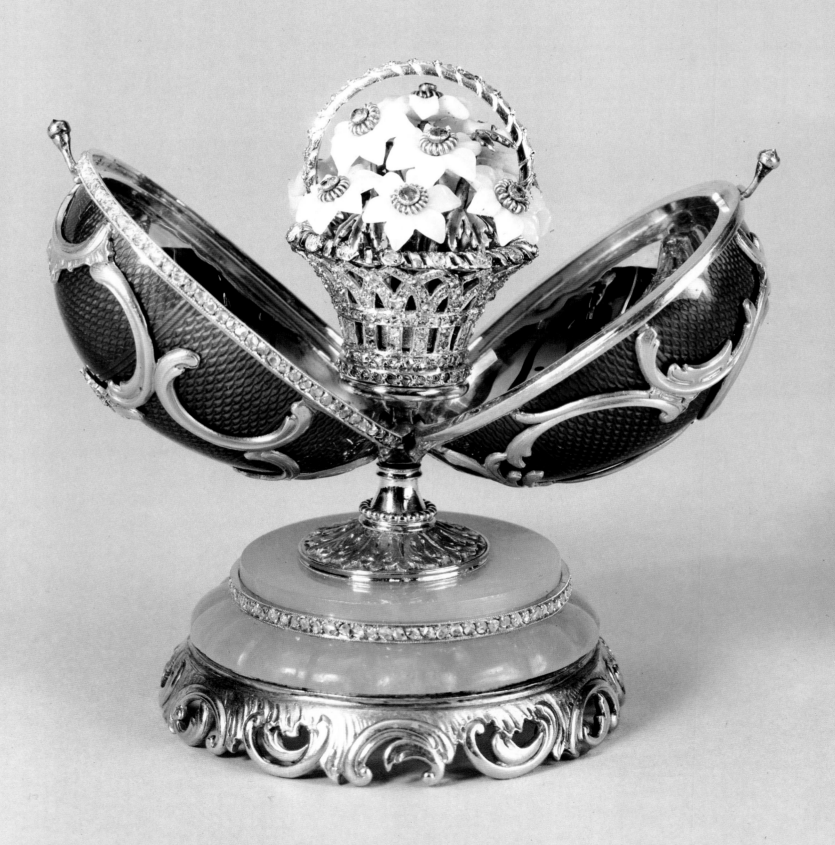

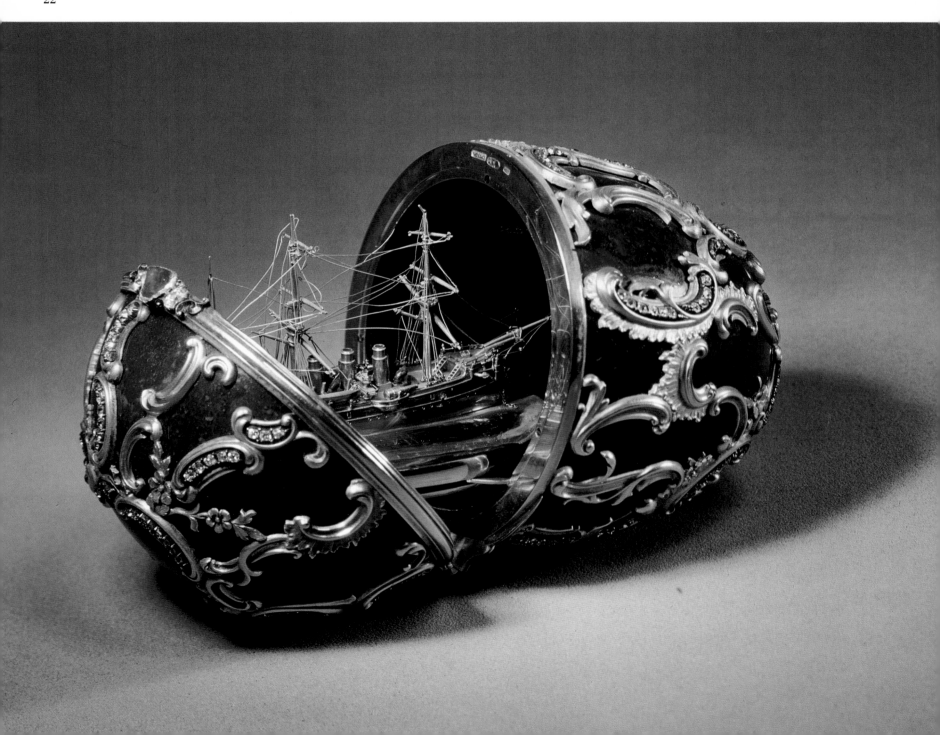

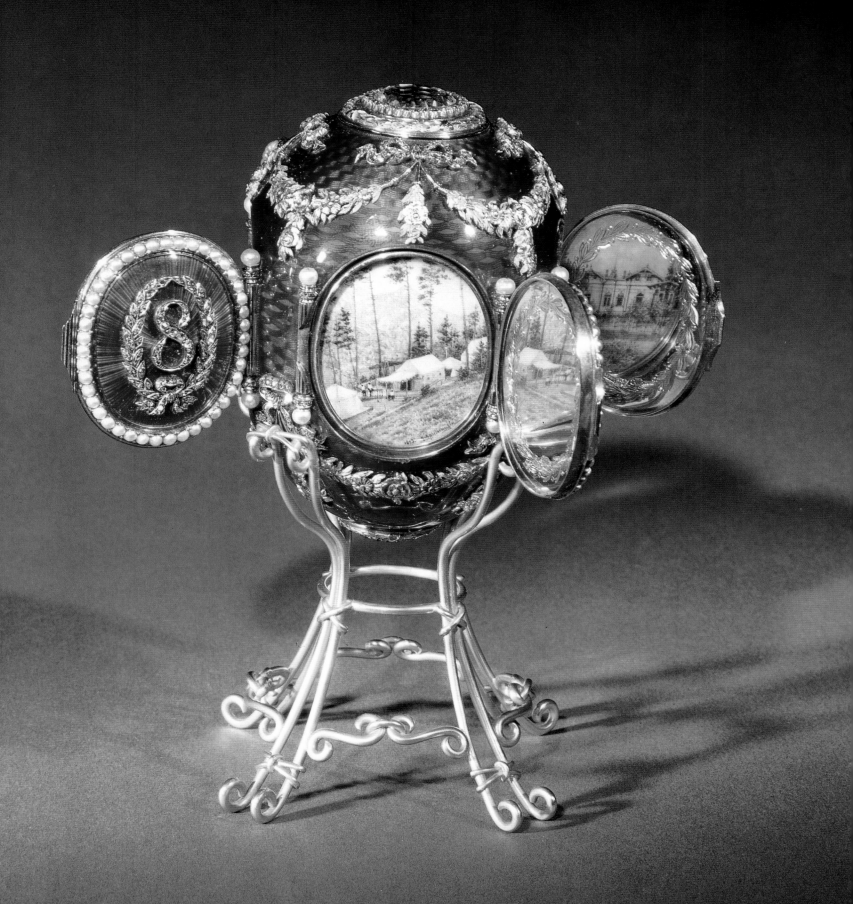

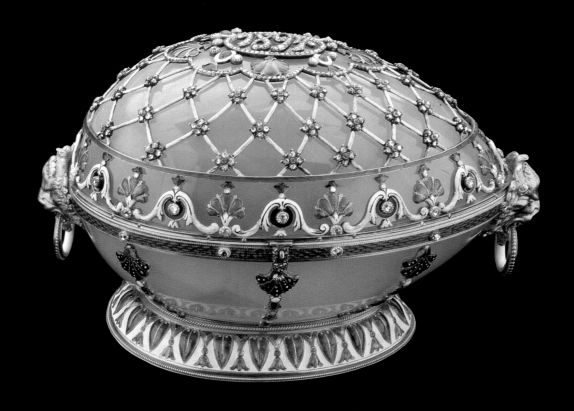

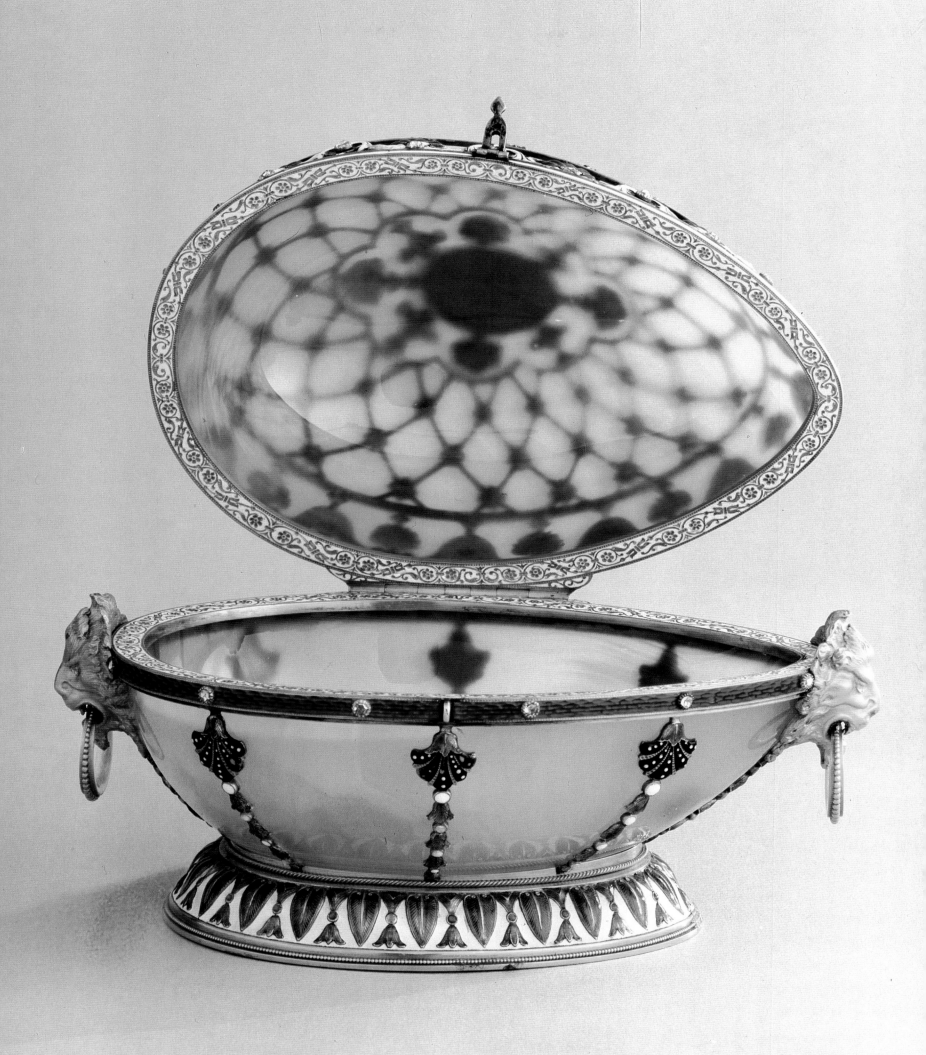

25

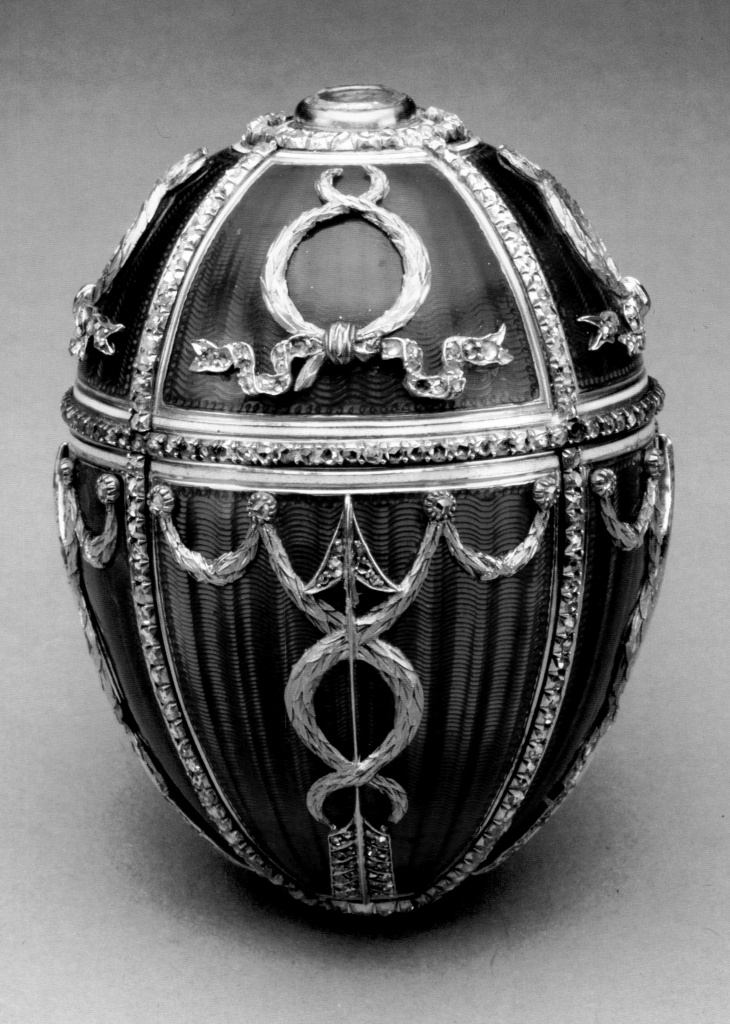

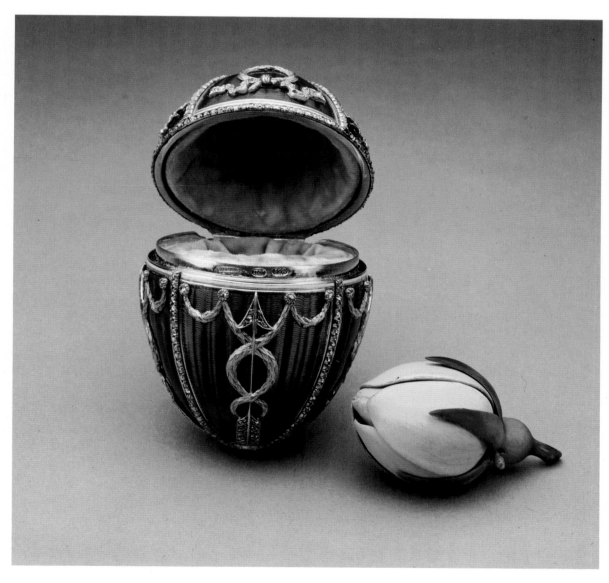

27

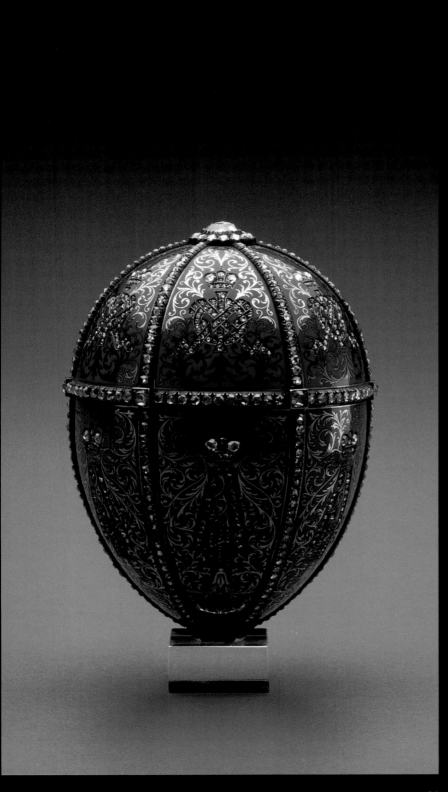

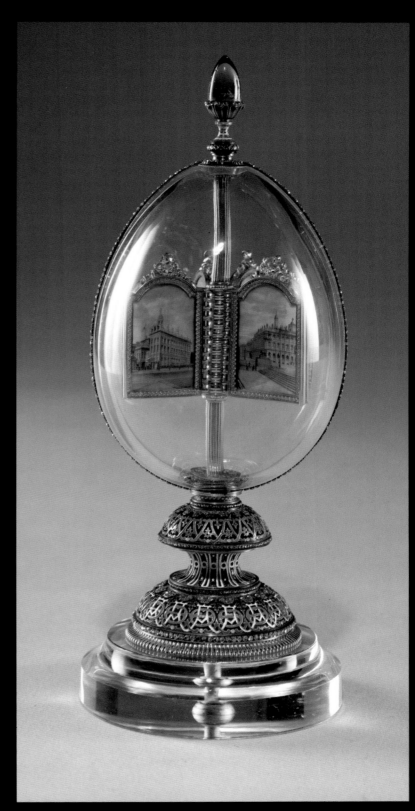

29

30

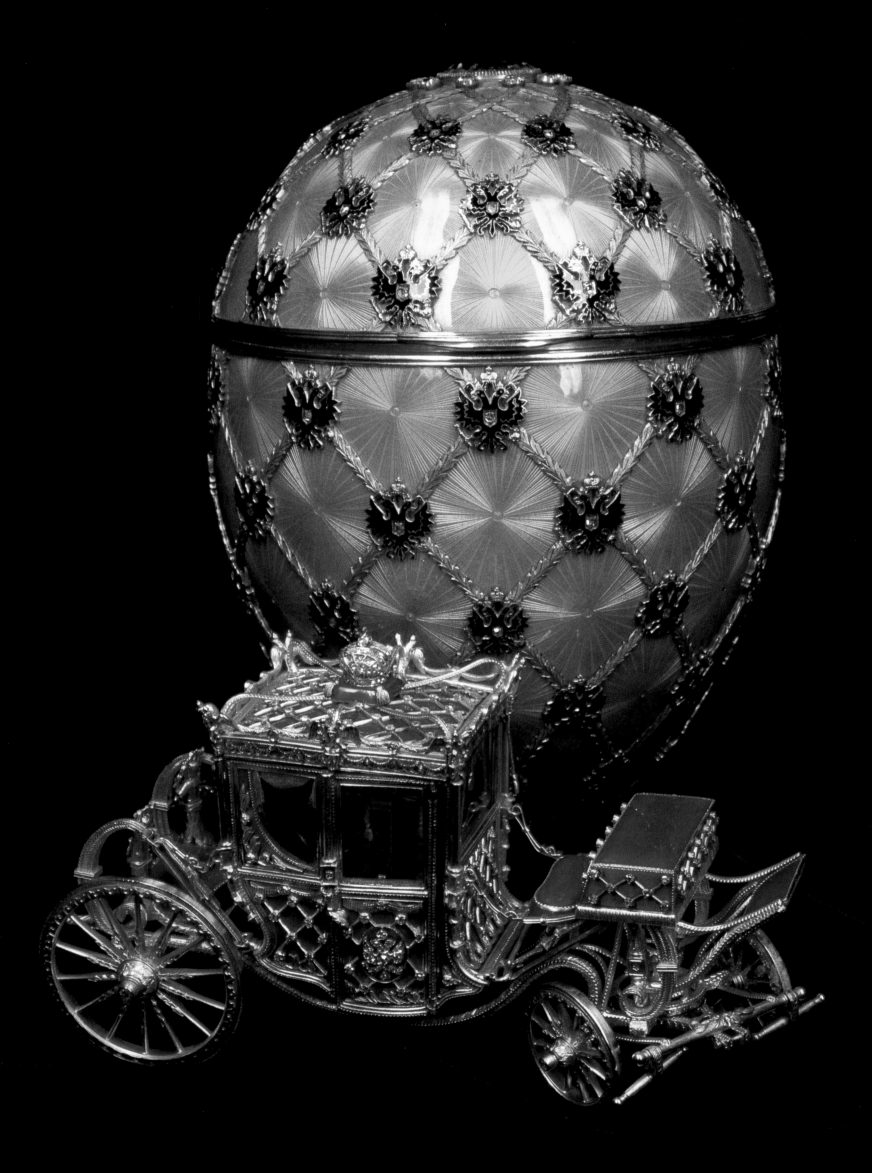

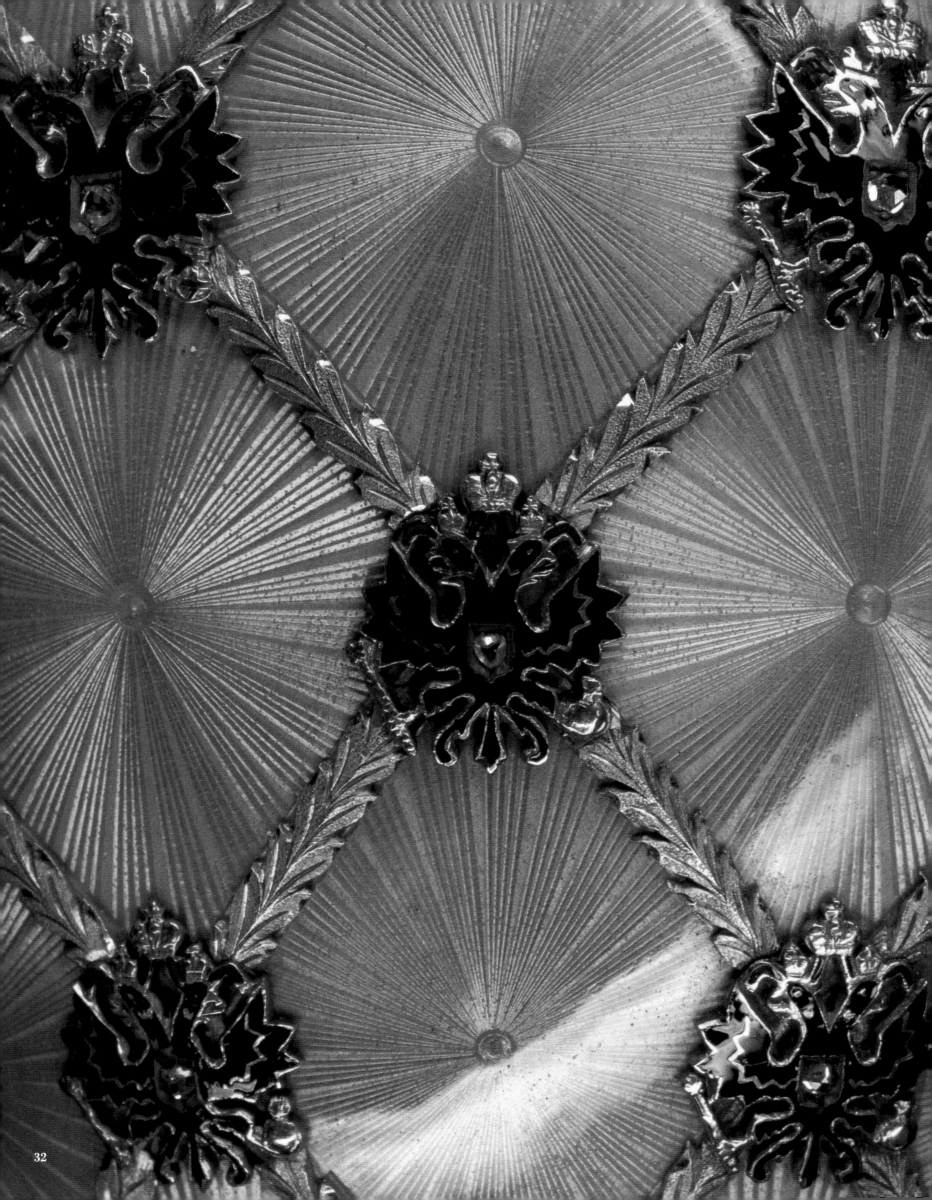

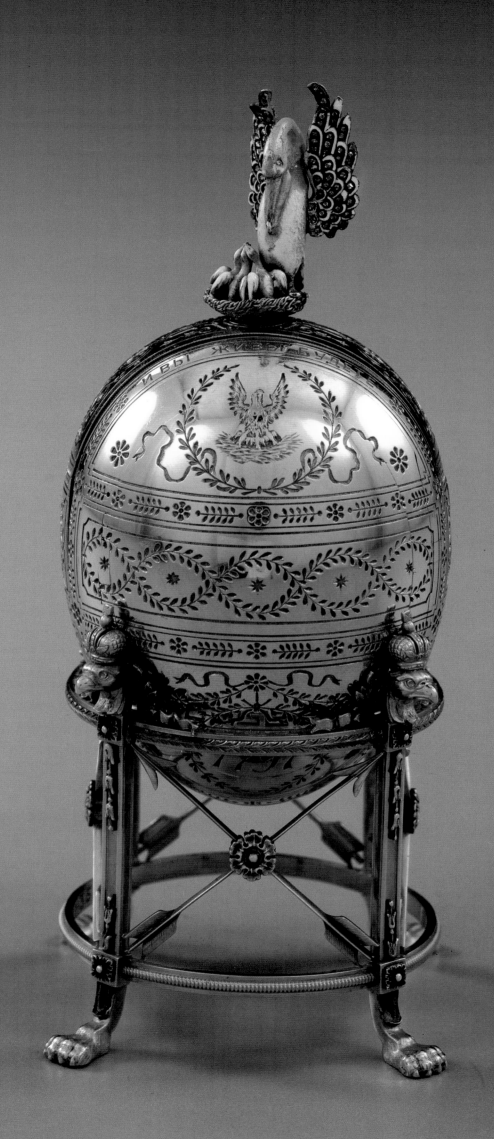

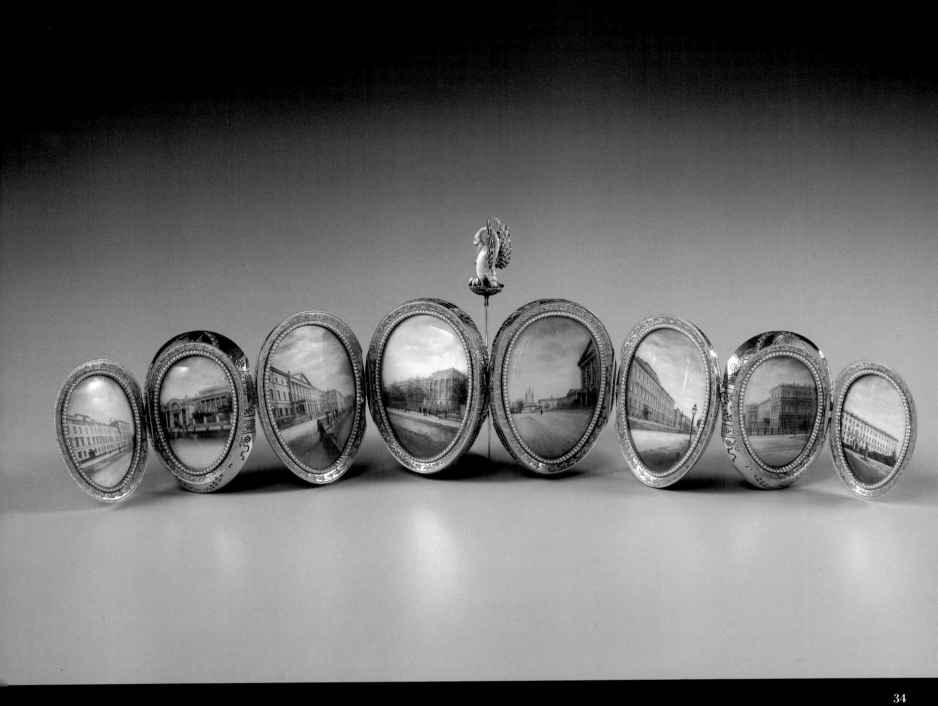

34

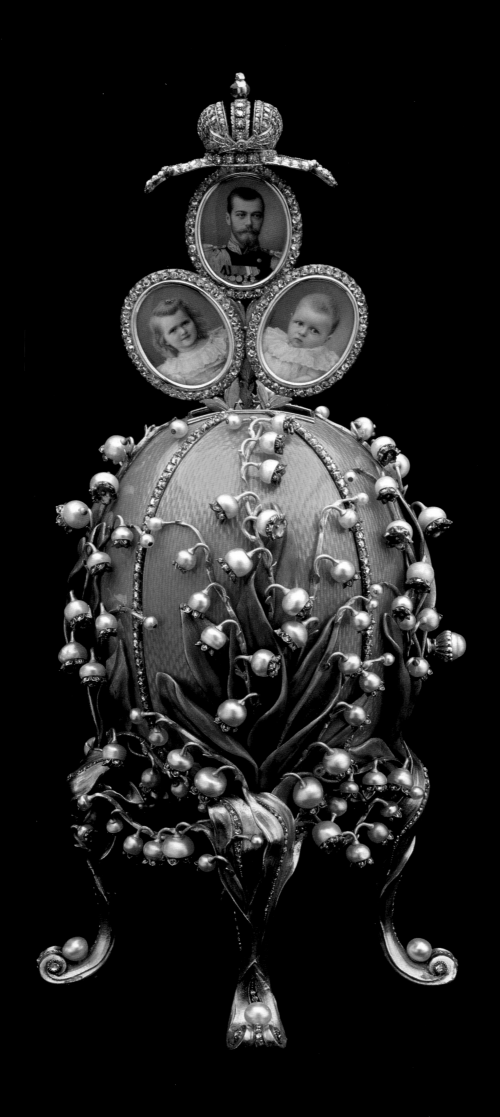

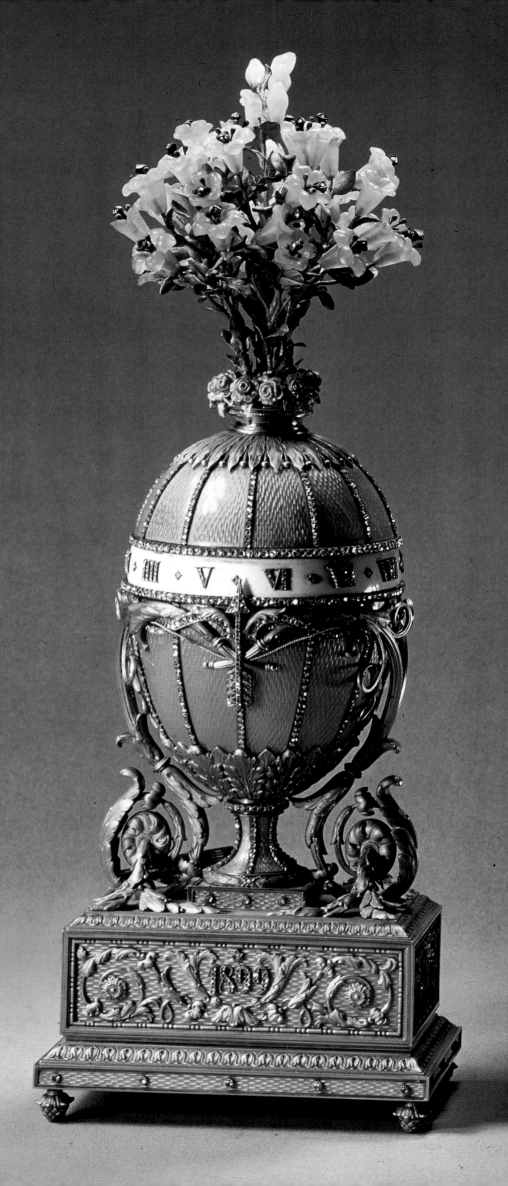

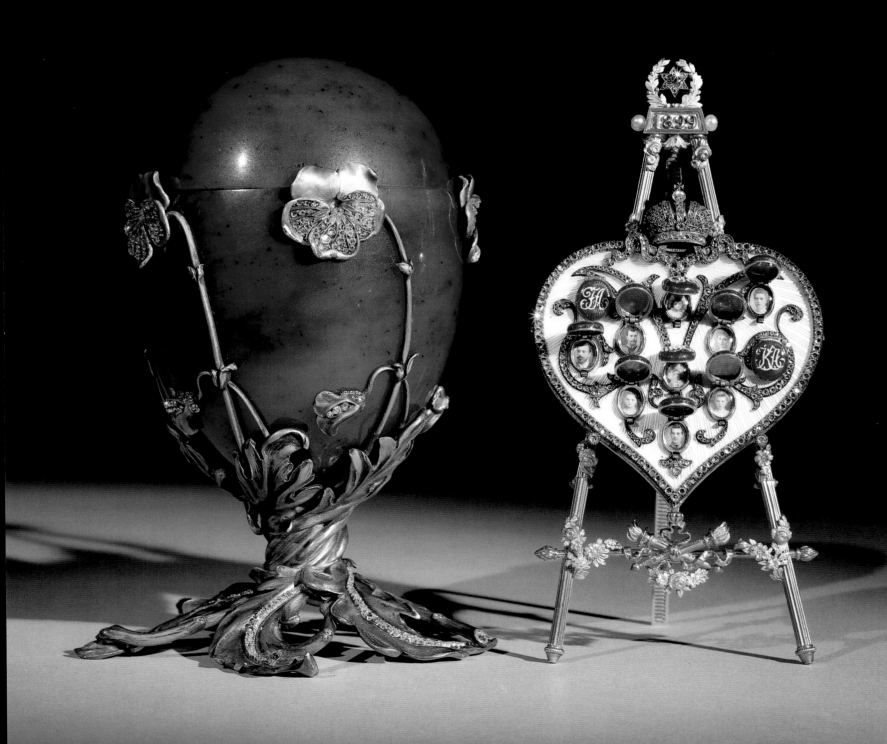

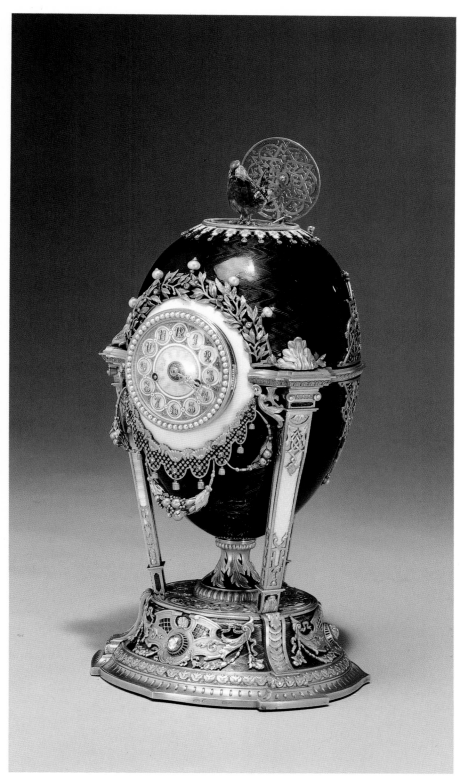

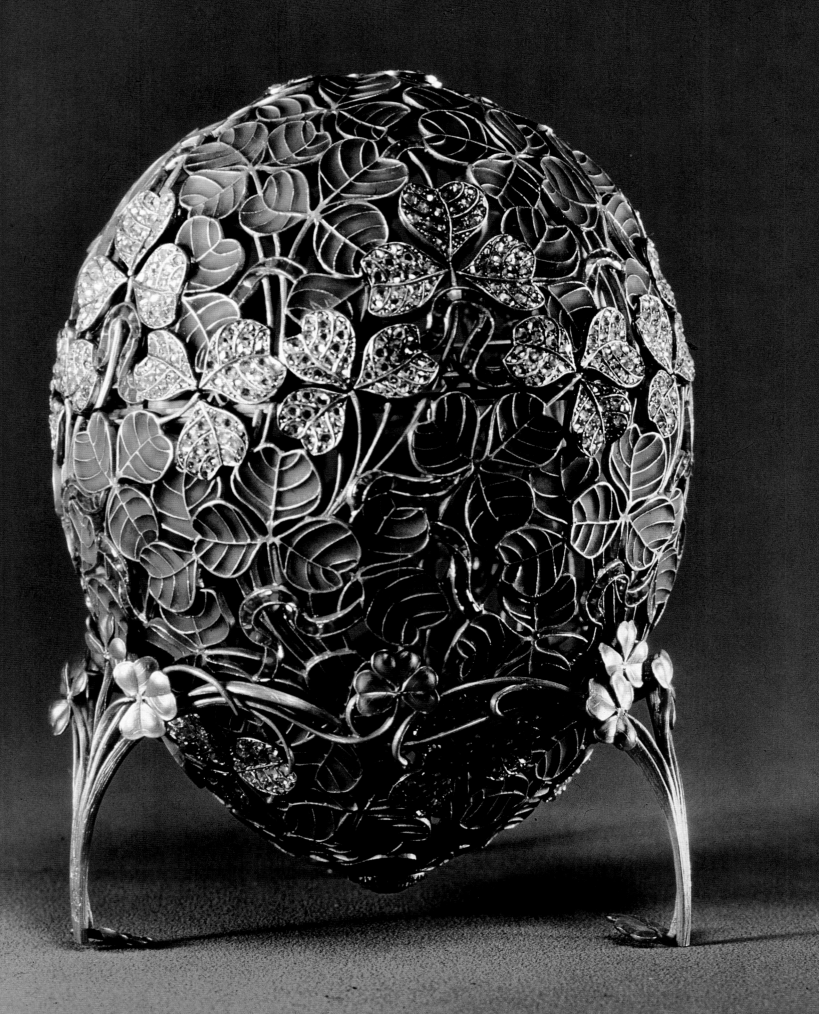

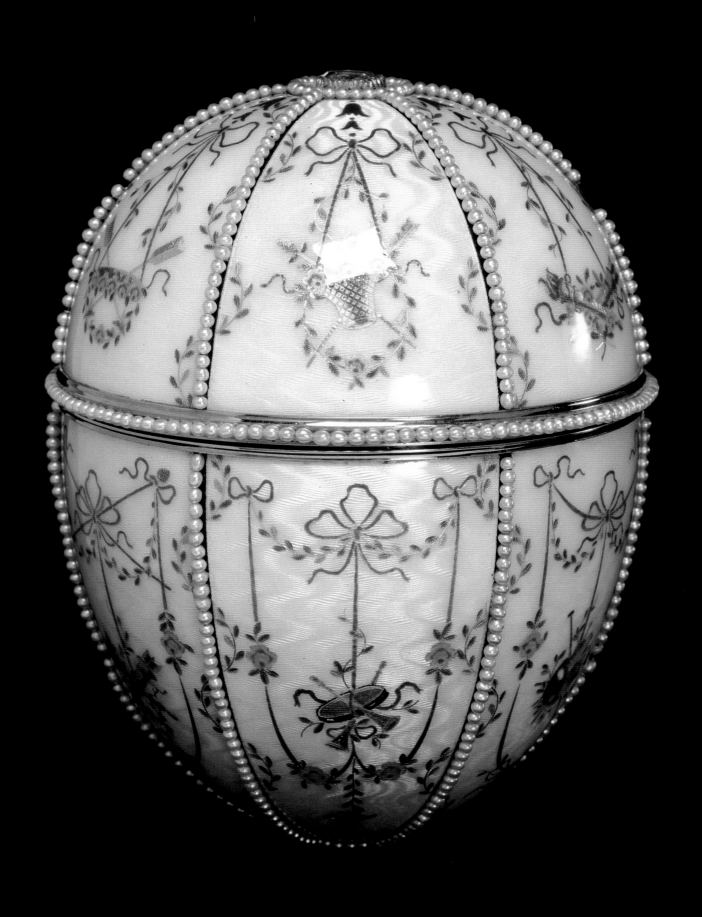

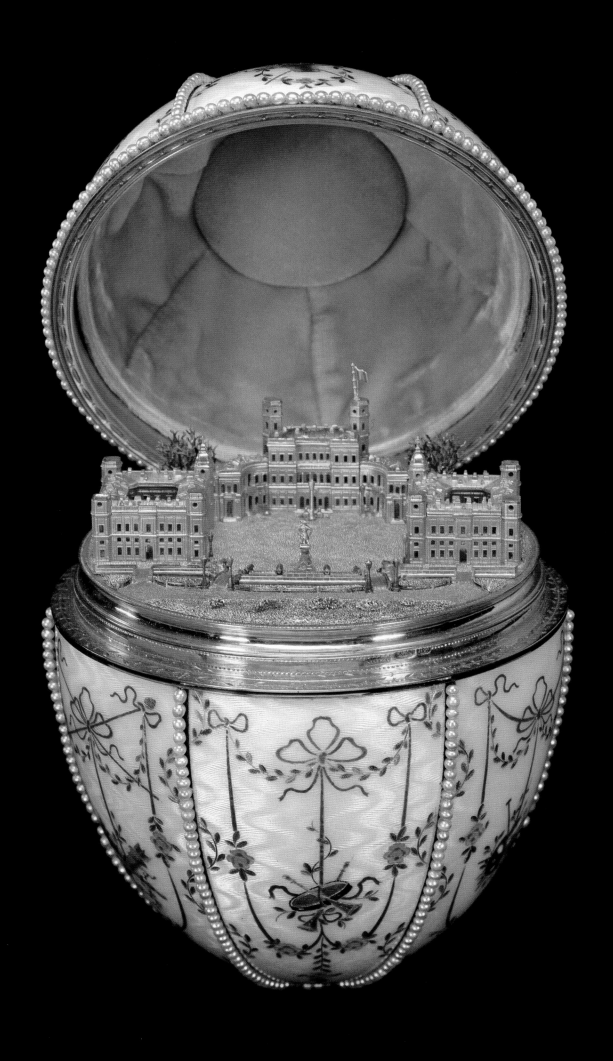

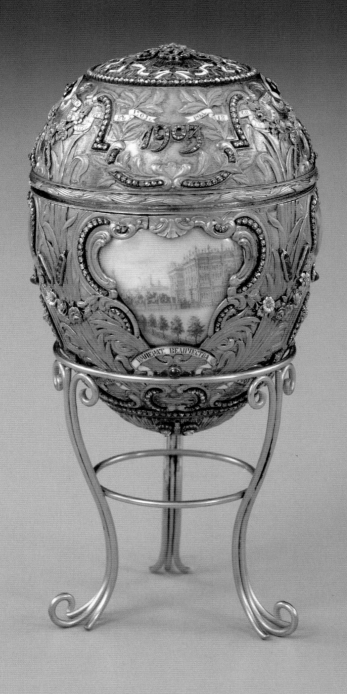

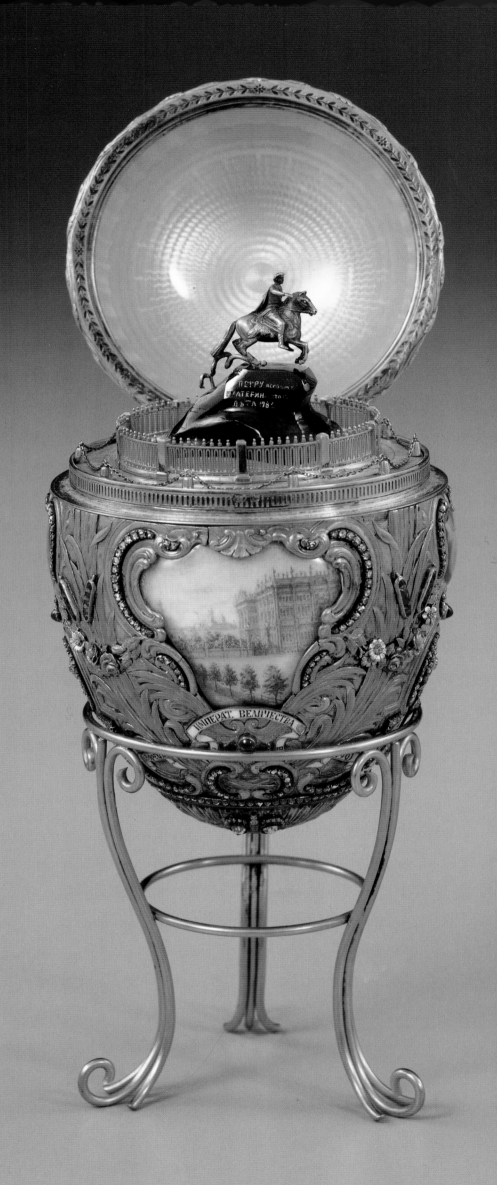

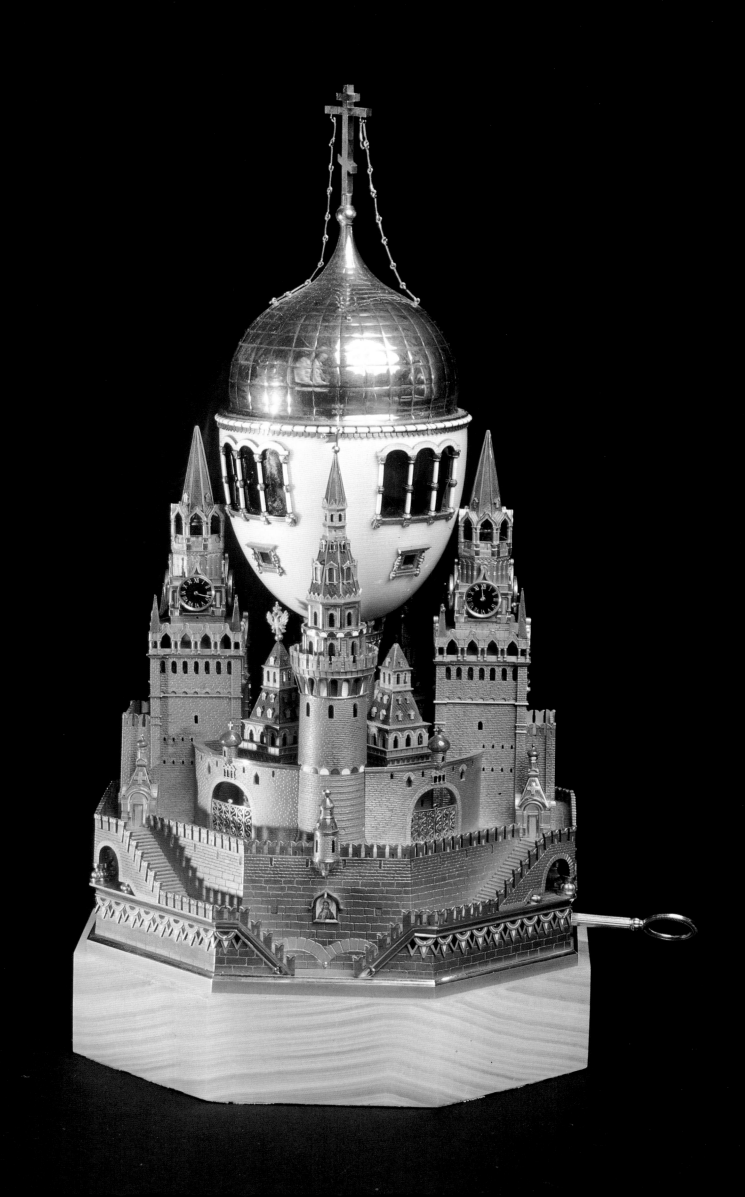

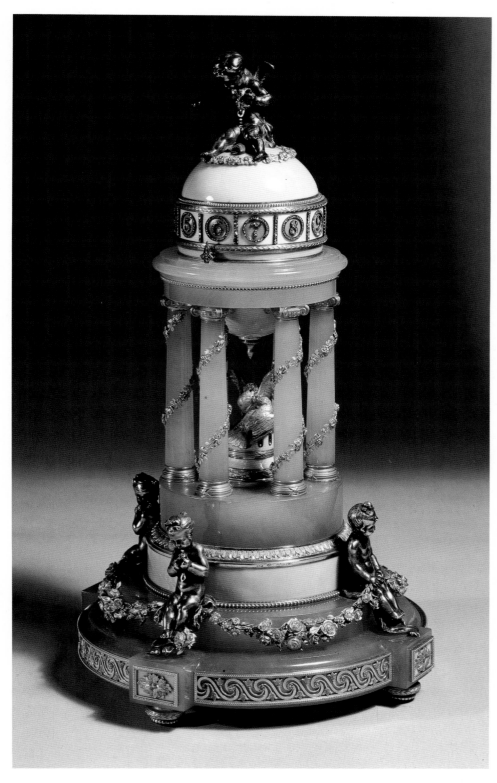

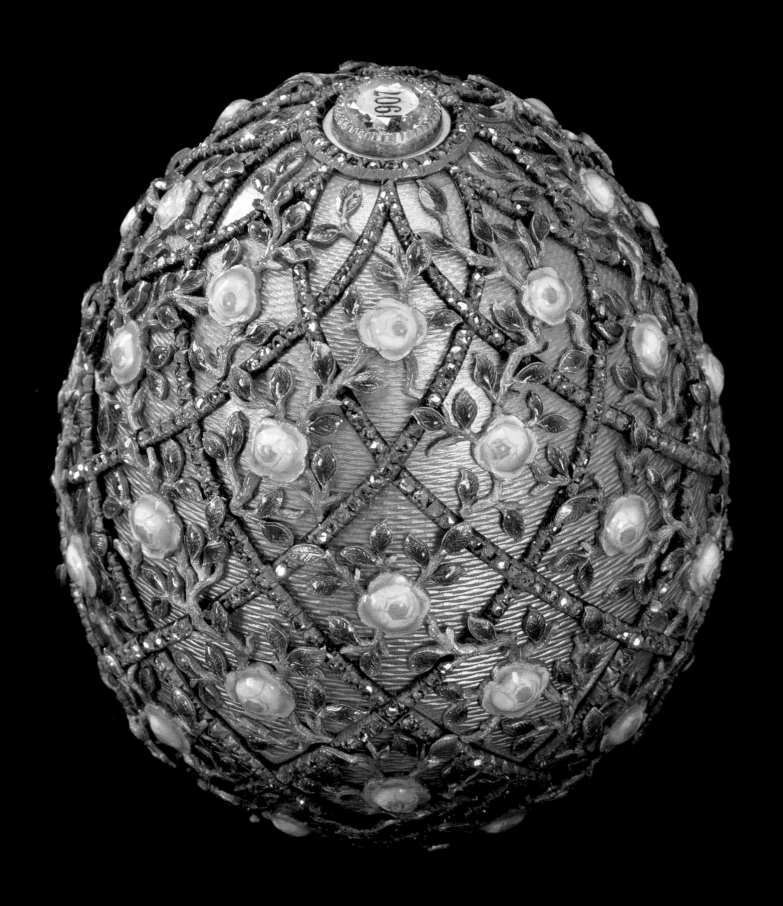

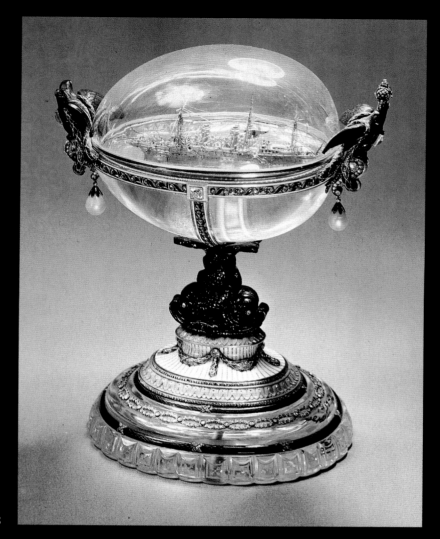

48

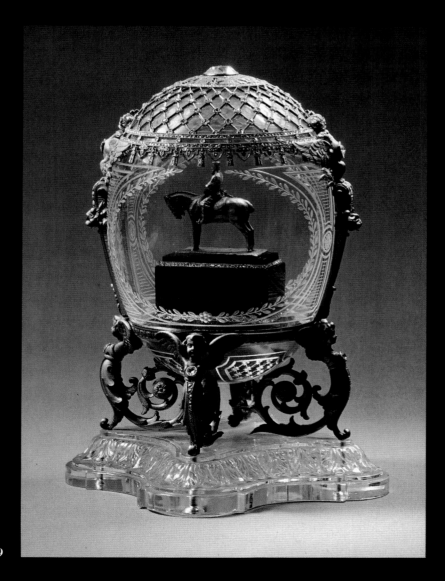

49

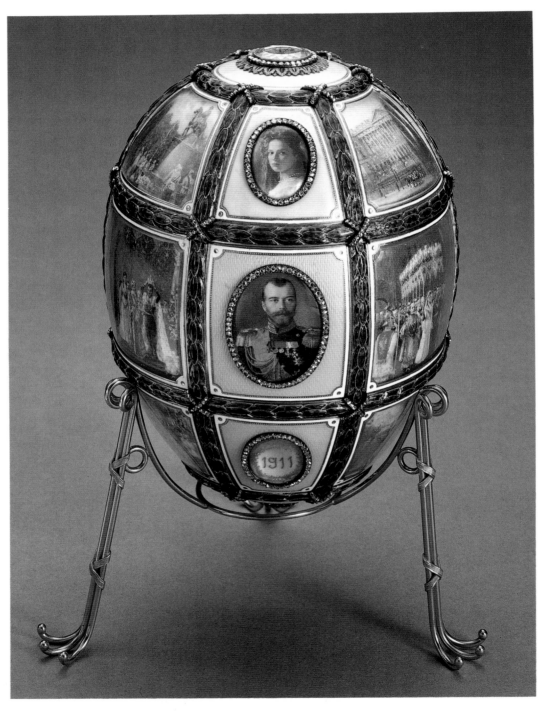

50

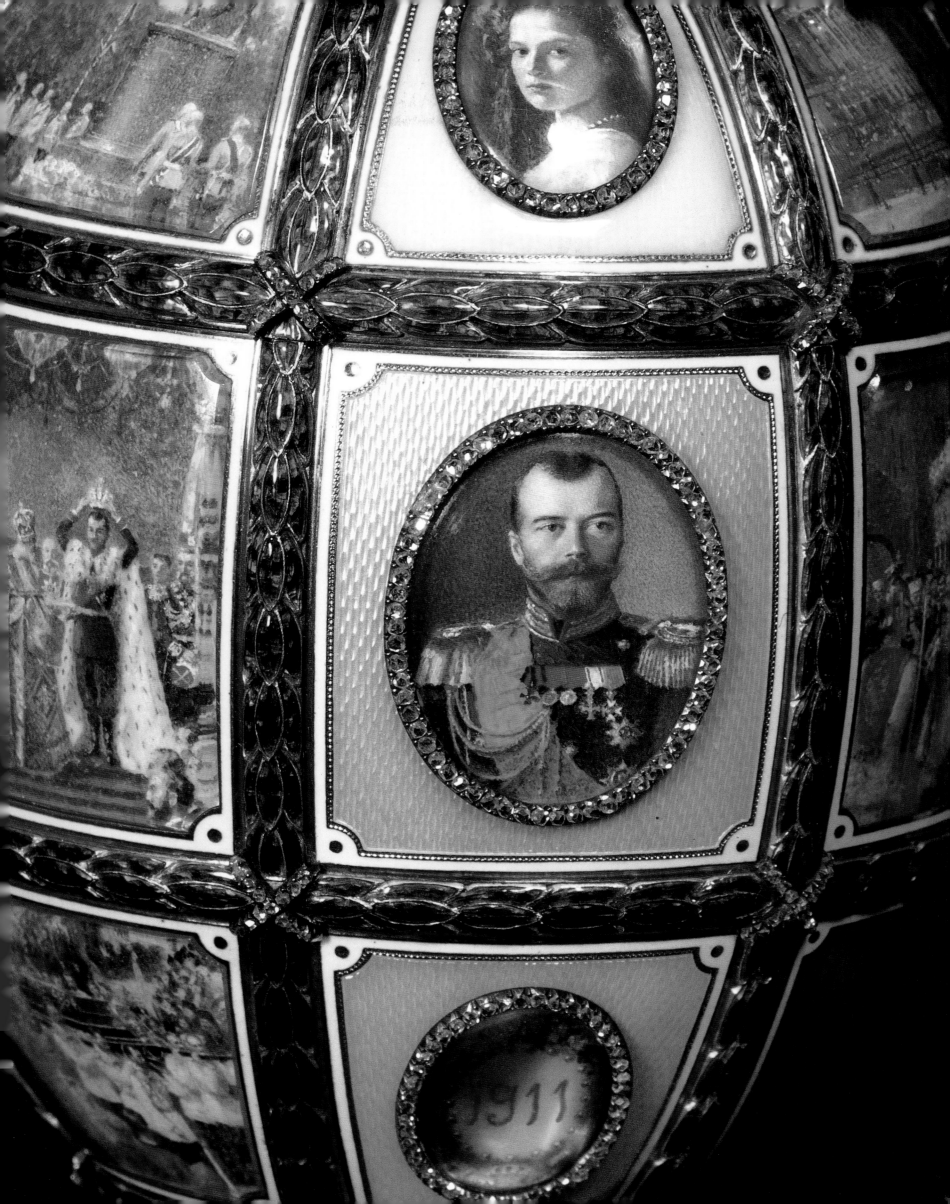

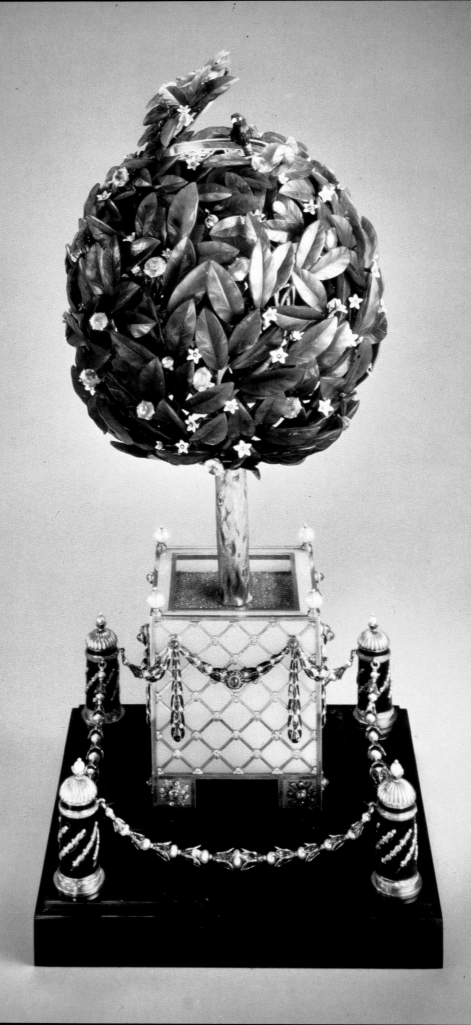

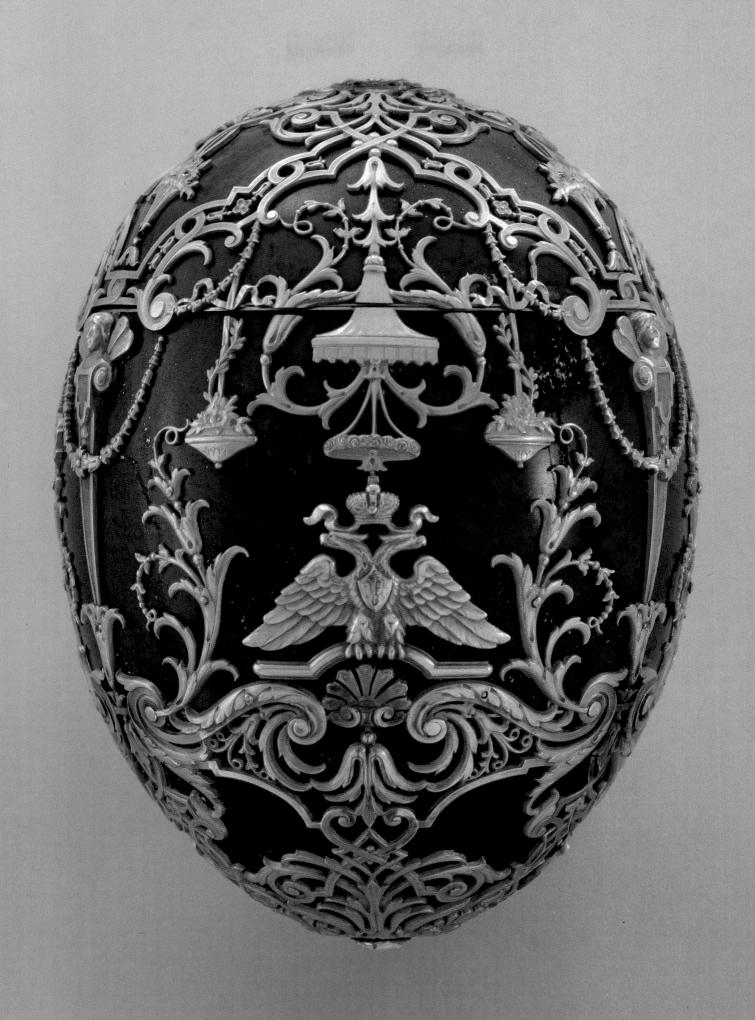

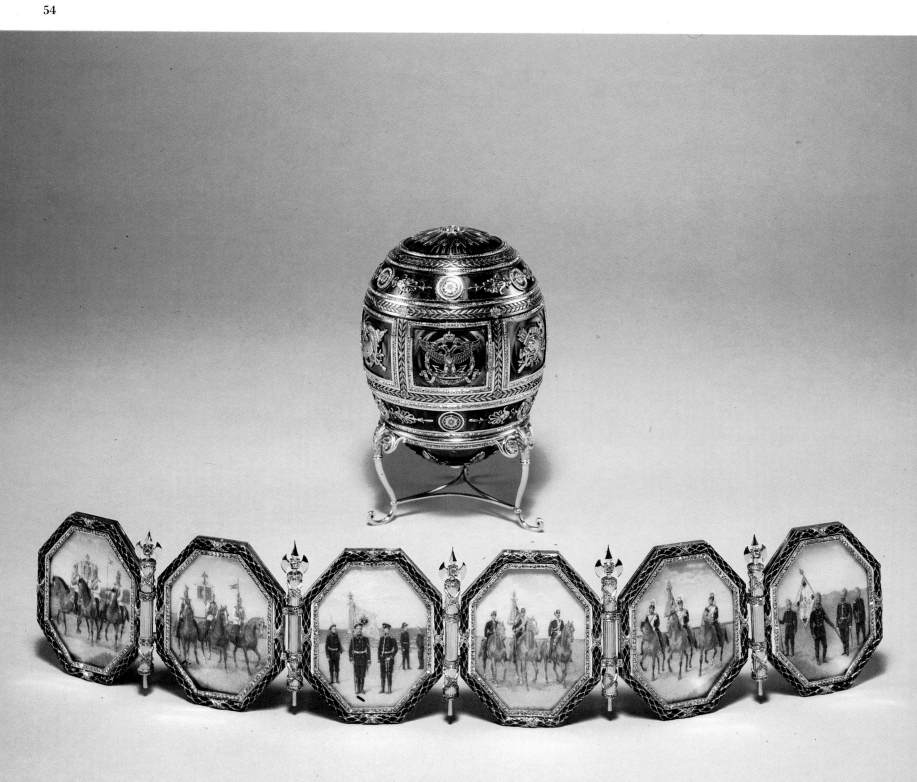

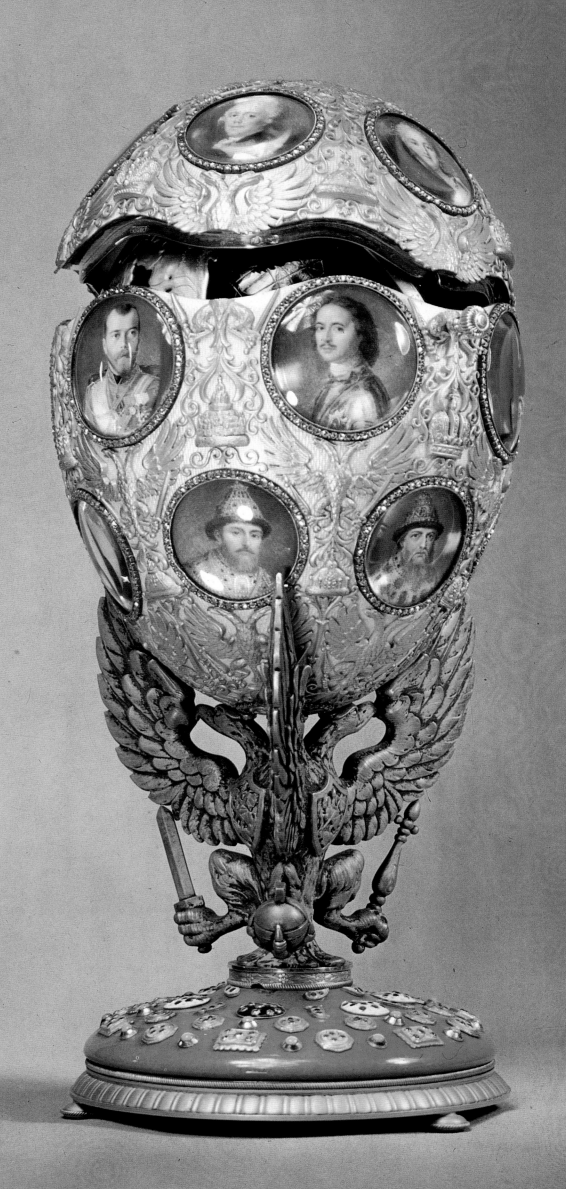

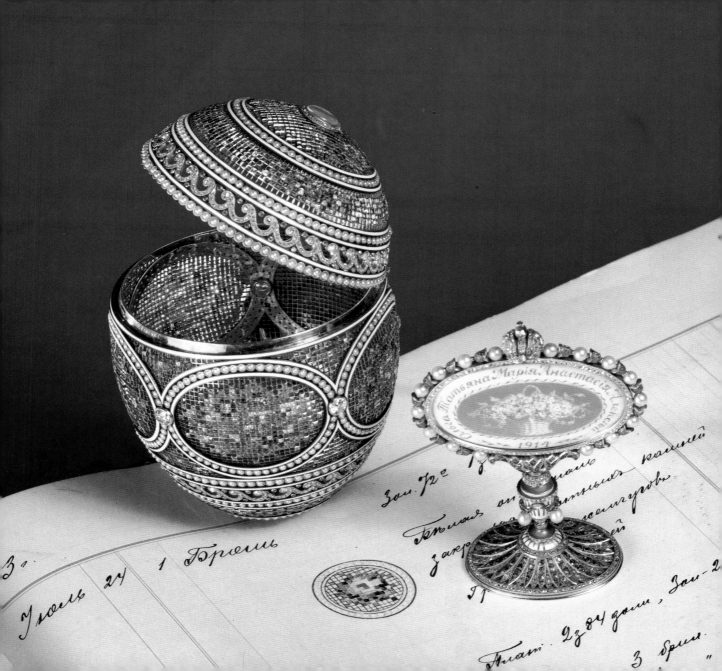

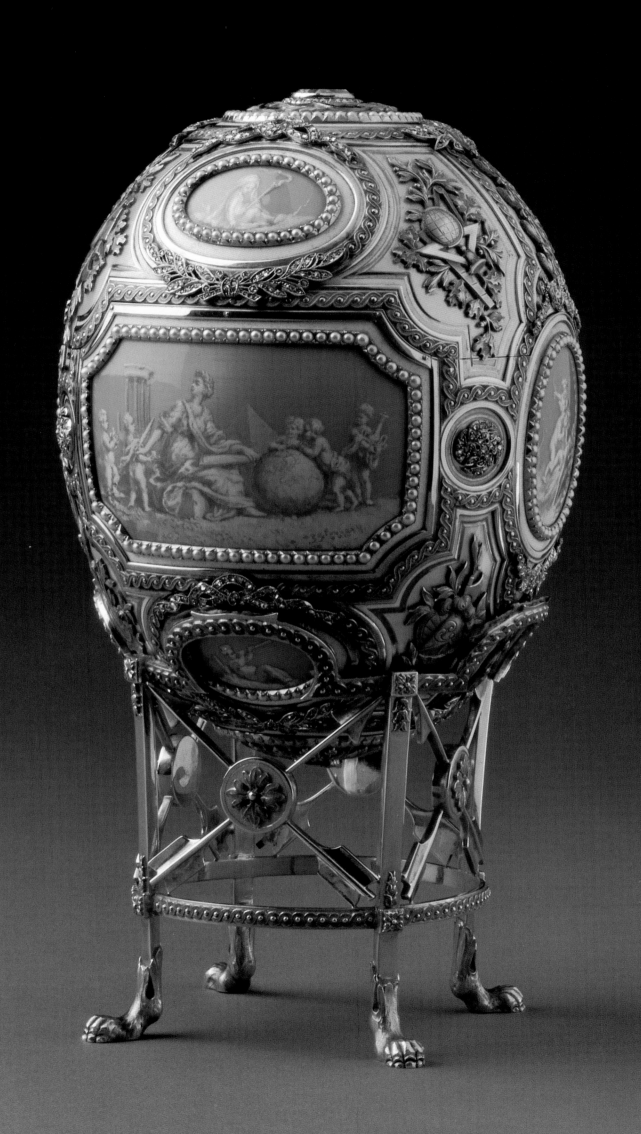

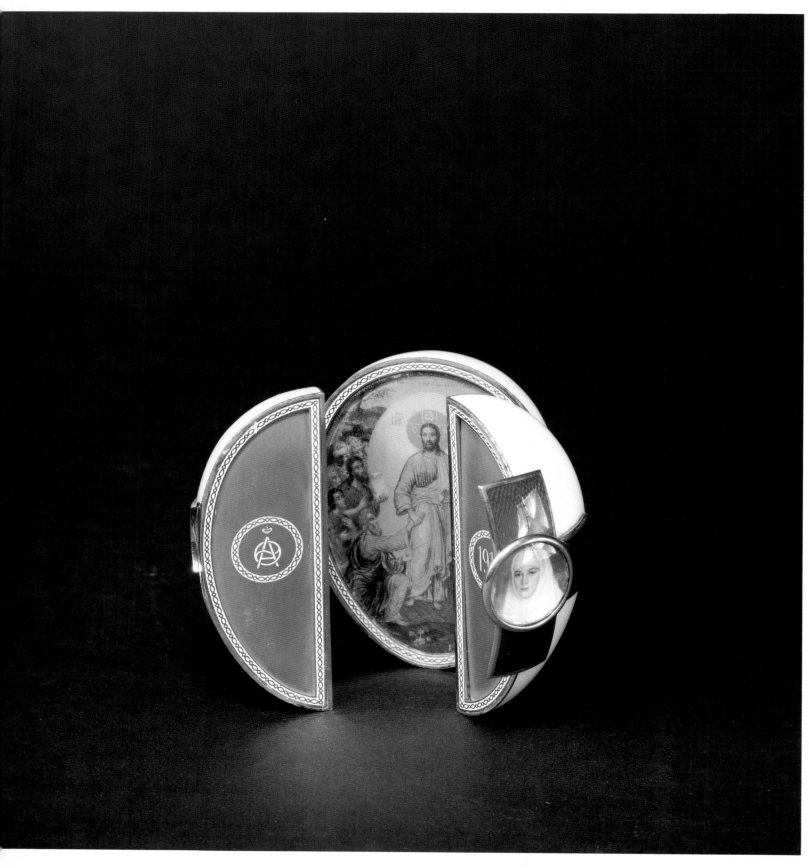

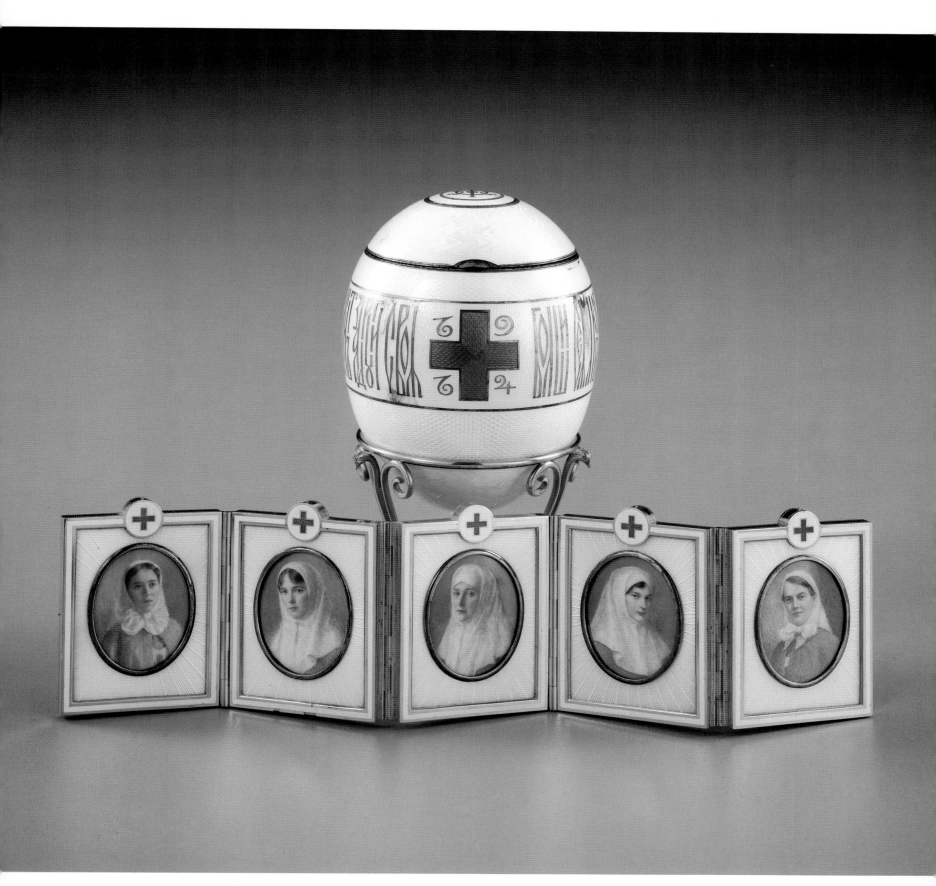

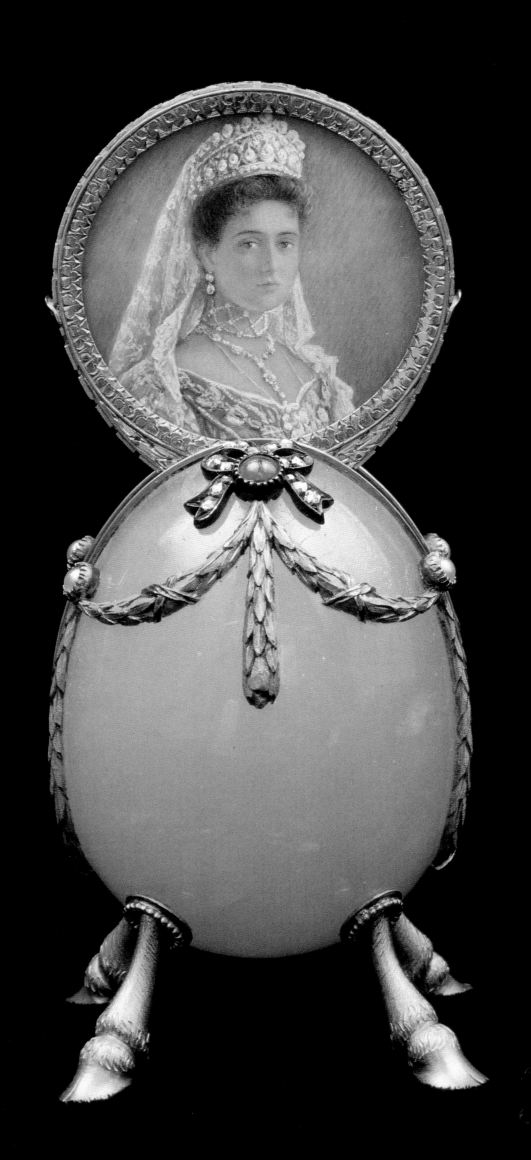

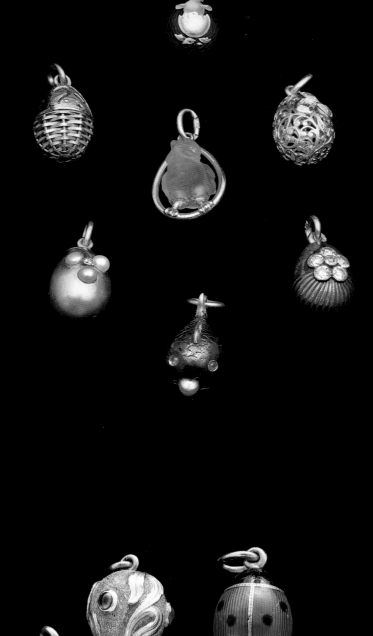

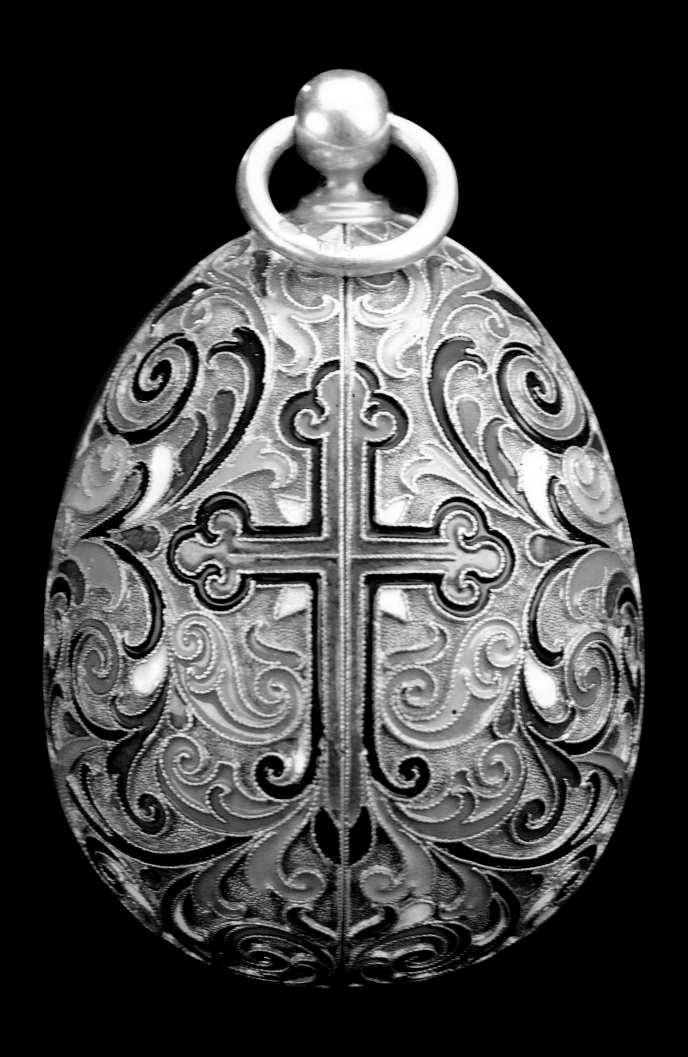

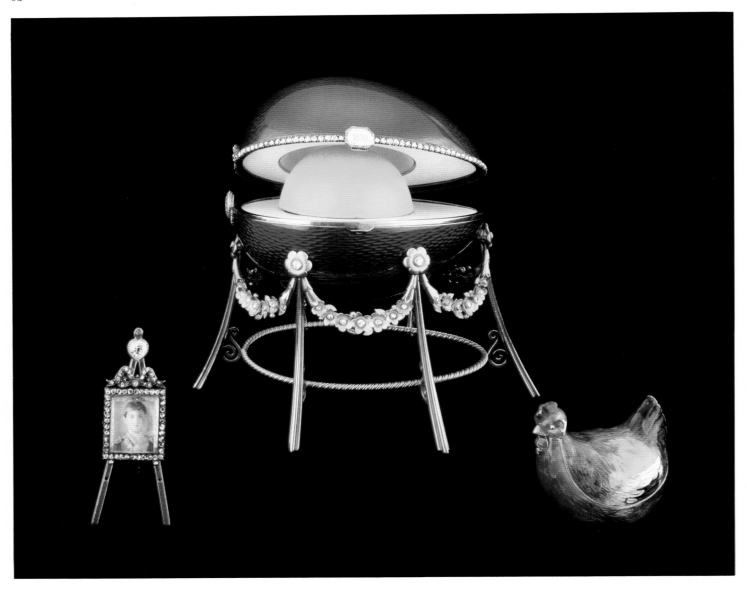

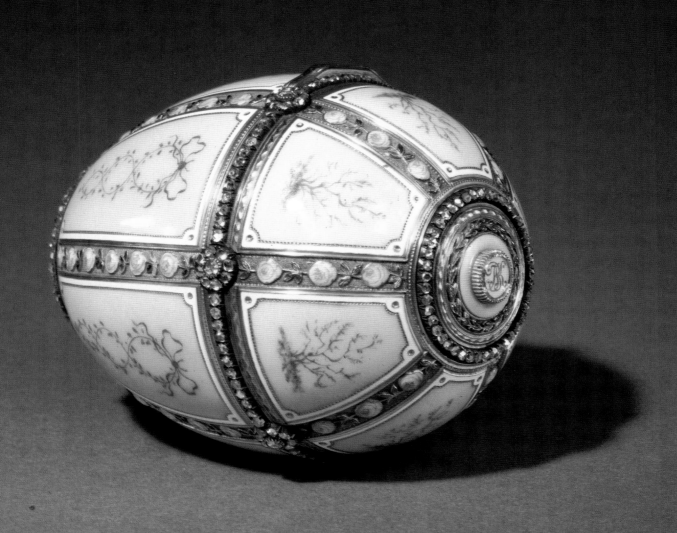

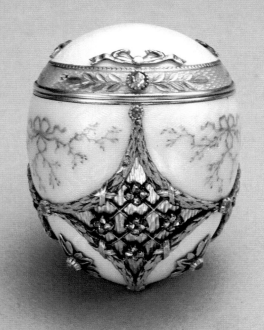

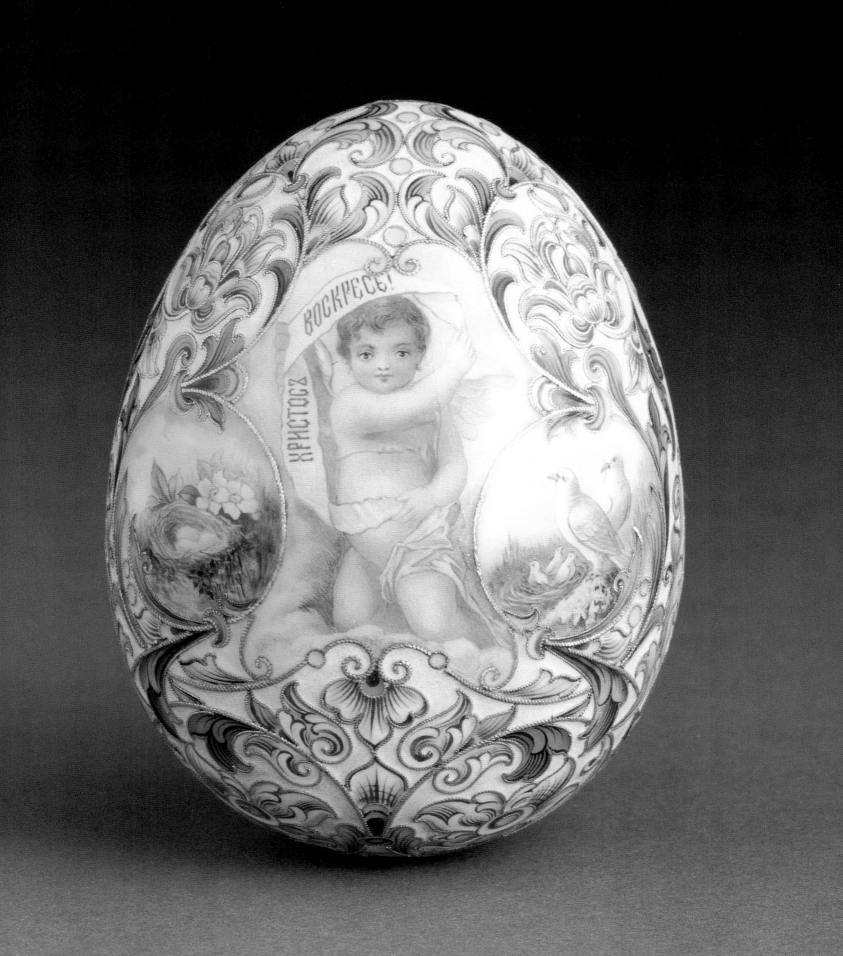

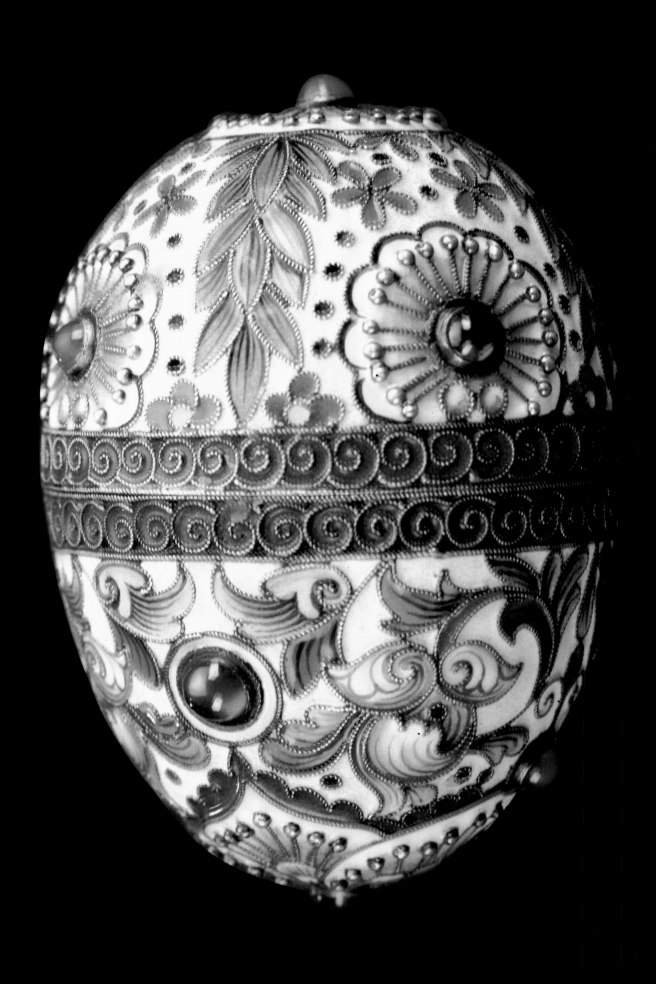

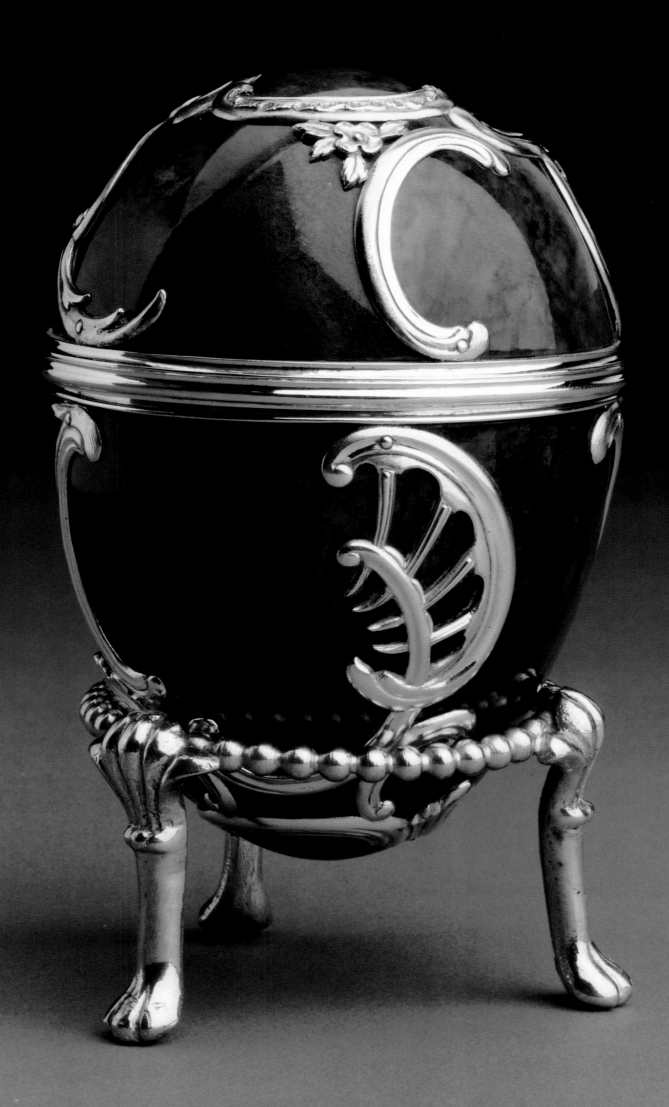

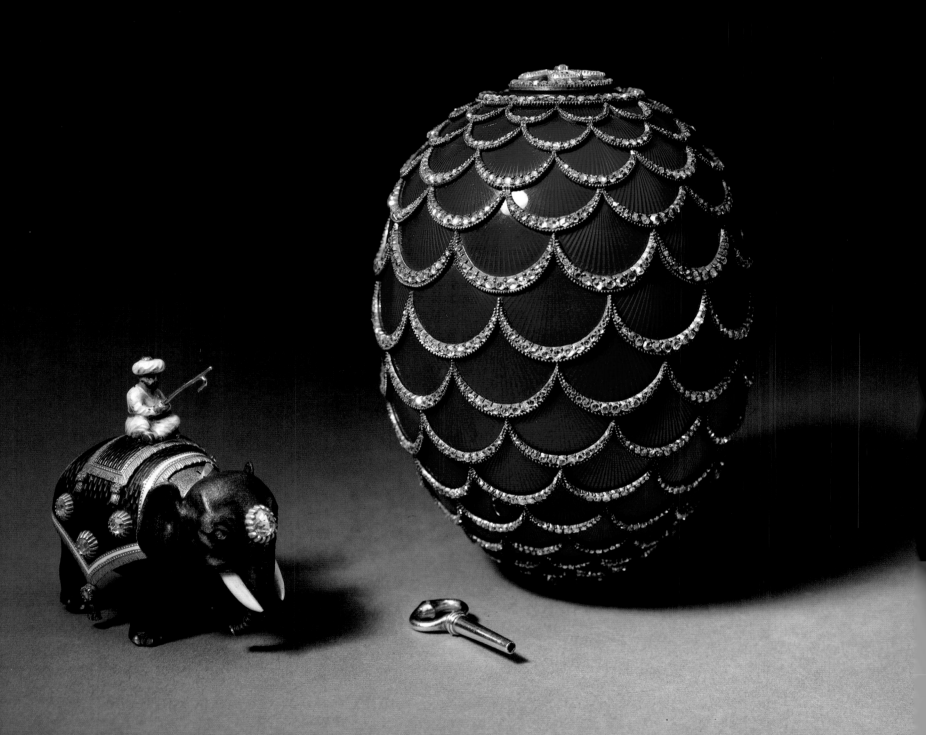

FLOWERS AND HARDSTONE CARVINGS

The tradition of the gold and carved hardstone flowers by Fabergé and others can be traced back at least to the eighteenth century. In the mid-eighteenth century, flowers were produced by Jeremie Pauzie, who then was working in the context of a broad European fashion for such flowers (these are now in the Hermitage). Fabergé also followed in this tradition in his production of such flowers. The magnificent basket of lilies-of-the-valley that was a gift to the Czarina Alexandra Feodorovna is one of Fabergé's best known works and possibly the earliest flower group created by him. Fabergé was no doubt inspired by the hardstone carvings preserved in the Grünes Gewölbe (Green Vaults) in Dresden. As a young man he had also visited the Opificio delle Pietre Dure in Florence, the hardstone cutting and carving workshop founded by the Medicis. Fabergé's hardstone carvings of animals are distinguished not only for a most appropriate use of hardstone—for example, the use of pearly-black obsidian for a penguin or milky-pink chalcedony for a pig—but also for the injection of "character." There was a certain "psychologically interpretive" aspect to Fabergé's animals: an accentuation of a typical characteristic, such as in a happy, well-fed pig. The hardstone human figures created by Fabergé utilized various materials seamlessly joined together to form the completed composition. These figures are reminiscent of the porcelain figures produced in the eighteenth and nineteenth centuries by the Imperial Porcelain Factory and by the Gardner, Popov, and other private porcelain factories.

74. Fabergé. St. Petersburg. **Cherry Sprig.** ca. 1900. Height 5″ (12.6 cm). *The cherries are made of purpurine, and the leaves are carved from nephrite. The stalk, sprouting from its rock crystal pot, is made of gold. Courtesy Wartski, London.*

75. Fabergé. Workmaster Henrik Wigström, St. Petersburg. **Gold and Hardstone Spray of Hawthorn.** ca. 1900. Height 5⁵⁄₁₆″ (13.5 cm). *On this spray of flowers, contained in a white chalcedony vase with a matching square base, the engraved gold stem has carved nephrite leaves and vari-colored berries. The ripe berries are formed of purpurine, and the unripe ones are formed of aventurine quartz and chalcedony. The gold interior of the vase simulates earth. Copyright 1985, Sotheby's, Inc., New York.*

76. Fabergé. Workmaster August Holmström, St. Petersburg. **Imperial Flower Arrangement of Lilies-of-the-Valley.** ca. 1896. Length 8½″ (21.5 cm). *This flower arrangement was presented to the Czarina Alexandra Feodorovna in 1896 on the occasion of the coronation. It consists of nine lilies-of-the-valley with gold stems, pearl blossoms, diamond petals, and carved nephrite leaves. The flowers are in a gold basket simulating basket weave, and the earth is made of wire-cut gold resembling moss. Underneath, the basket is engraved with a presentation inscription, "To Her Imperial Majesty, Czarina Alexandra*

116

Feodorovna, from the Management of the Iron Works and from the Dealers in the Siberian Iron Section of the Fair of Nijegorod, 1896." Matilda Geddings Gray Foundation, on loan to New Orleans Museum of Art.

77. Fabergé. **Group of Three Gold and Hardstone Flowers.** Height 5½ to 7¾" (14.1 to 19.7 cm). *The three flowers are, from left to right, a bleeding heart, a mock orange, and a catkins. They all have gold stems, nephrite leaves, and rock crystal pots. The Royal Collection, London.*

78. Fabergé. **Chelsea Pensioner.** ca. 1900. Height 4⁵⁄₁₆" (11 cm). *This figure wears a purpurine coat with black jasper boots and cap. His face and hands are of aventurine quartz, and his eyes are set with cabochon sapphires. The buttons are of gold and the medals are enameled with various colors. According to the London sales ledgers this figure was purchased by King Edward VII in 1909. The Royal Collection, London. Collection of H.M. Queen Elizabeth II.*

79. Fabergé. Workmaster Henrik Wigström, St. Petersburg. **Captain of the Fourth Harkovsky Lancers.** 1914–1915. Height 5" (12.5 cm). *This miniature military figure wears a lapis-lazuli uniform with an agate front and cuffs. The buttons, sash, and sword handle, as well as the double-headed imperial eagle on the figure's helmet, are made of gold. The boots are obsidian, and the hands and face are agate. The Forbes Magazine Collection, New York.*

80. Fabergé. St. Petersburg. **Dancing Moujik.** ca. 1900. Height 5¼" (13.3 cm). *The figure comprises various hardstones including agate, jasper, yellow chalcedony, and purpurine. The eyes are set with sapphires. The Forbes Magazine Collection, New York.*

81. Fabergé. **Carved Hardstone Figure of a Peasant Woman.** ca. 1900. Height 6⅛" (15.5 cm). *This figure wears a white chalcedony skirt and blouse and a scarf and dress of purpurine. Her face and hands are carved of eosite, and her eyes are set with sapphires. The underside of her foot bears the signature, "C. Fabergé." The Metropolitan Museum of Art, New York. Gift of R. Thornton Wilson, 1954, in memory of Florence Ellsworth Wilson.*

82. Fabergé. St. Petersburg. **Carved Hardstone Figure of an Izvoshchik.** ca. 1913. Height 5⅜" (13.6 cm). *The head of the izvoshchik, or coachman, is carved of green jade with a band of obsidian fur. His quartz face has a reddish jasper beard, and his eyes are made of sapphire. The skirt and boots are of green nephrite, the latter trimmed with dark brown jasper. The underskirt is made of eosite, and the gloved hands of mottled jasper. He wears a coat of lapis-lazuli with a green aventurine belt, and carries a gold riding stick, signed C. Fabergé, 1913. Copyright 1979, Sotheby's, Inc., New York.*

83. Fabergé. St. Petersburg. **Purpurine Model of a Seated Cat.** ca. 1900. Height 5" (12.8 cm). *This cat is one of the largest of the Fabergé sculptures. It is depicted with arched back and curled tail and is seated in an attentive posture. The rock crystal eyes are foiled with yellow and black enamel. Although purpurine had been known in the eighteenth century, it was rediscovered in the nineteenth century by a workman called Petouchov at the Imperial Glass Factory in St. Petersburg. Copyright 1982, Sotheby's, Inc., New York.*

84. Fabergé. Workmaster Henrik Wigström, St. Petersburg. **Carved White Mouse.** ca. 1900. Height 1¾" (4.4 cm). *This white mouse, shown actual size, is made of carved chalcedony. Its eyes are set with cabochon rubies mounted in gold, with silver ears and a diamond-studded tail. Copyright 1985, Sotheby's, Inc., New York.*

85. Fabergé. St. Petersburg. **Pig Miniatures.** ca. 1900. *Of the many hardstone animals created by Fabergé, this group of pigs is one of the most endearing. (From left to right)* **Seated Pig.** *Length 2⅛" (5.4 cm). Unmarked, made of pink and white aventurine quartz with cabochon ruby eyes.* **Sow.** *Length 2⅞" (7.3 cm). Unmarked, made of pink-brown chalcedony, with rose-diamond eyes.* **Standing Pig.** *Length*

2⅛″ (5.4 cm). *Unmarked, made of purpurine, with rose-diamond eyes.* **Seated Pig.** Length 2½″ (6.3 cm). *Unmarked, made of dark brown chalcedony with pale blue markings, with rose-diamond eyes.* **Four Piglets.** Length 2″ (5.2 cm). *Gold mark of fifty-six zolotniks (1899–1908). Made of different shades of chalcedony joined by gold mount.* **Seated Pig.** Length 1⅝″ (4.1 cm). *Unmarked, made of variegated agate, with rose-diamond eyes.* **Pig.** Length 2¾″ (7 cm). *Unmarked, made of pink-striped agate with yellow and gray markings, with olivine eyes. The Royal Collection, London. Collection of H.M. Queen Elizabeth II.*

86. Fabergé. St. Petersburg. **Carved Hardstone Group of Three Rabbits.** ca. 1900. Length 3½″ (9 cm). *Carved of obsidian, white chalcedony, and brownish agate, the rabbits are nestled together, two with eyes closed, the other with its eyes open.* **Carved Bowenite Frog.** ca. 1900. Length 2¼″ (5.7 cm). *This crouching frog's eyes are set with cabochon rubies.* **Carved Nephrite Hippopotamus.** ca. 1900. Length 3½″ (9 cm). *This model, carved of dark green nephrite, stands with its mouth open.* **Carved Smoky Quartz Mouse,** ca. 1900. Length 2″ (5 cm). *The mouse is in an attentive-looking position, with its ears back and its tail curled around its back. The eyes are set with diamonds.* **Carved Rhodonite Small Elephant.** ca. 1900. Length ⅞″ (2 cm). *This elephant stands with its trunk down.* **Carved Agate Cat.** ca. 1900. Length 2¼″ (5.7 cm). *The sleeping cat is modeled in grayish-brown agate. Copyright 1986, Sotheby's, Inc., New York.*

87. Fabergé. Workmaster Henrik Wigström, St. Petersburg. **Carved Agate Owl.** ca. 1900. Height 5″ (12.7 cm). *This is one of the largest of Fabergé's animal sculptures, made of mottled, multicolored agate, with eyes of gold-set citrine and claws of silver-gilt. Private collection. Photograph copyright 1980, Sotheby's, Inc., New York.*

88. Fabergé. St. Petersburg. **Chick.** ca. 1900. Height 1¹¹⁄₁₆″ (4.3 cm). *This tiny agate chick, with carved feathers, has ruby eyes and gold feet. The* Forbes *Magazine Collection, New York.*

89. Fabergé. St. Petersburg. **Group of Gold-mounted Carved Hardstone Birds.** ca. 1900–1910. Height 2″ to 4″ (5.1 to 10.2 cm). *These birds, carved of chalcedony and agate, include two storks, a flamingo, a hammerhead, an ostrich, and a kiwi. They are all mounted with gold legs and marked mostly by Henrik Wigström. The Royal Collection, London.*

90. Fabergé. Workmaster Henrik Wigström, St. Petersburg. **Table Seal.** ca. 1910. Height 3¾″ (9.5 cm). *The frog, made of nephrite with rose-diamond eyes, casually holds onto a column of silver enameled with opalescent pink over a moiré ground. The base has a border of laurel leaves made of green gold. The Royal Collection, London. Collection of H.R.H. The Prince of Wales.*

91. Fabergé. St. Petersburg. **Carved Agate Mandril.** ca. 1900. Height 3⅛″ (7.9 cm). *Modeled in a sitting position, this mandril has eyes set with diamonds. The Armory Museum, Moscow.*

92. Fabergé. **Shire Horse "Field Marshall."** Height 7″ (17.8 cm). *This animal is carved of aventurine quartz and has gold-mounted cabochon sapphire eyes. It was modeled after Queen Alexandra's champion shire horse at Sandringham in 1907 and given by Edward VII to Queen Alexandra for her birthday, on December 1, 1908. The Royal Collection, London. Collection of H.M. Queen Elizabeth II.*

93. Fabergé. Workmaster Carl Gustav Hjalmar Armfelt, St. Petersburg. **Carved Obsidian Bear.** ca. 1913. Height 5¾″ (14.5 cm). *In the form of the Yaroslavl coat of arms, this bear stands on a dish carved from red jasper. Around the center section a Cyrillic inscription is applied in silver, "the Yaroslavl Nobles, 1913." The State Historical Museum, Moscow.*

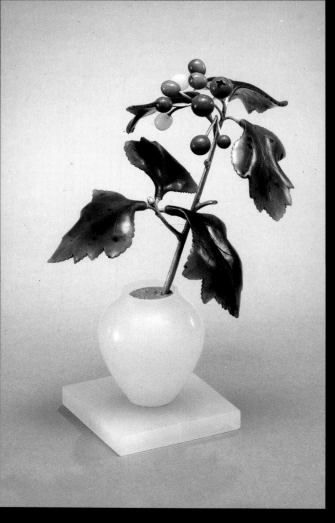

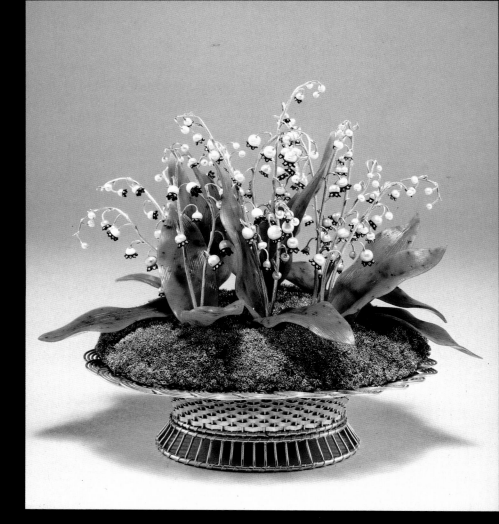

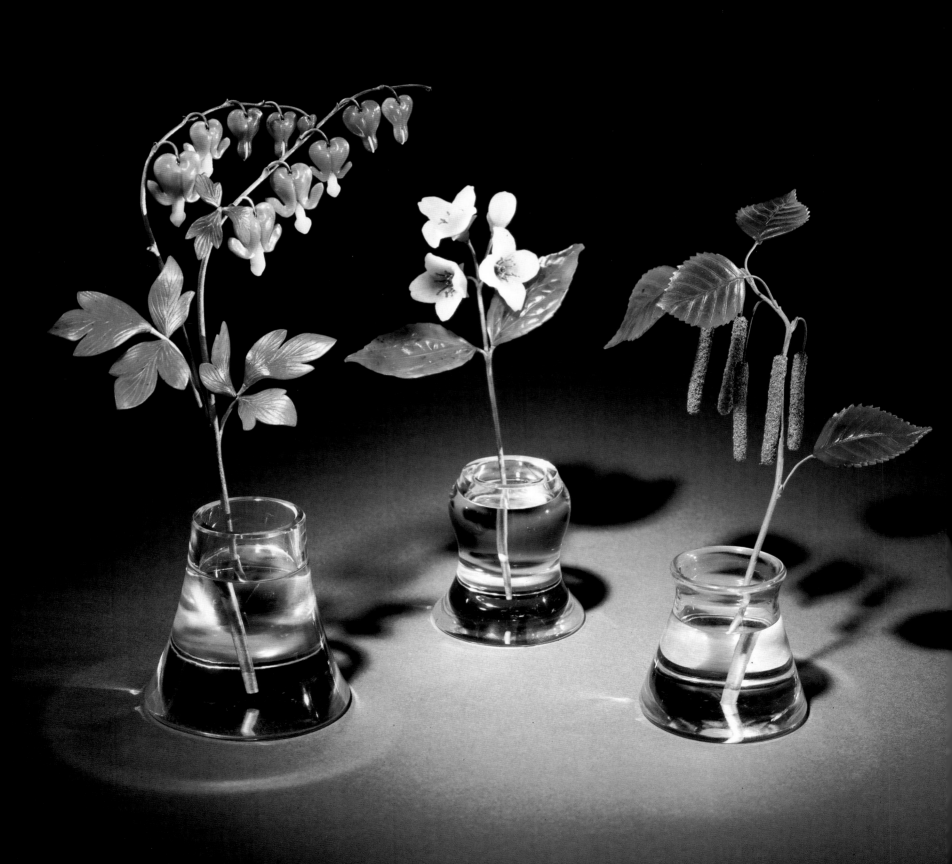

78

79

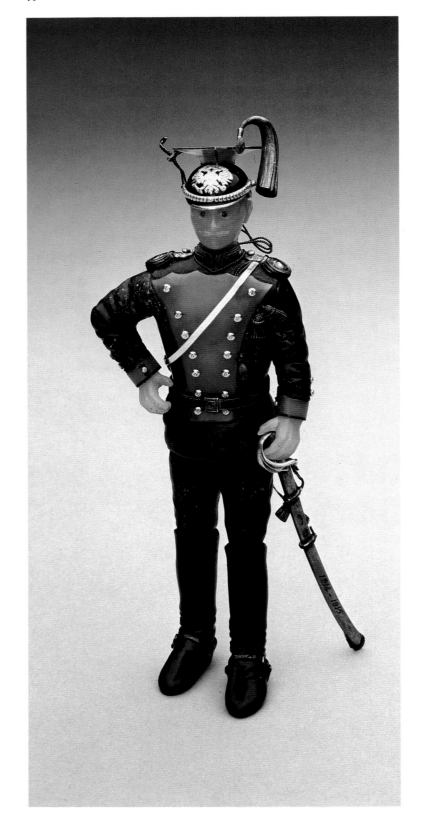

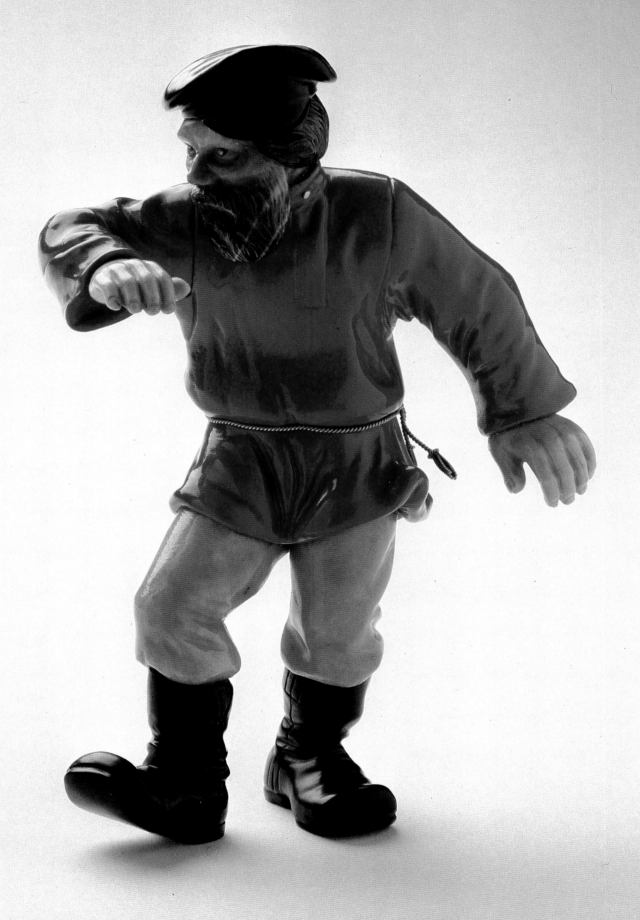

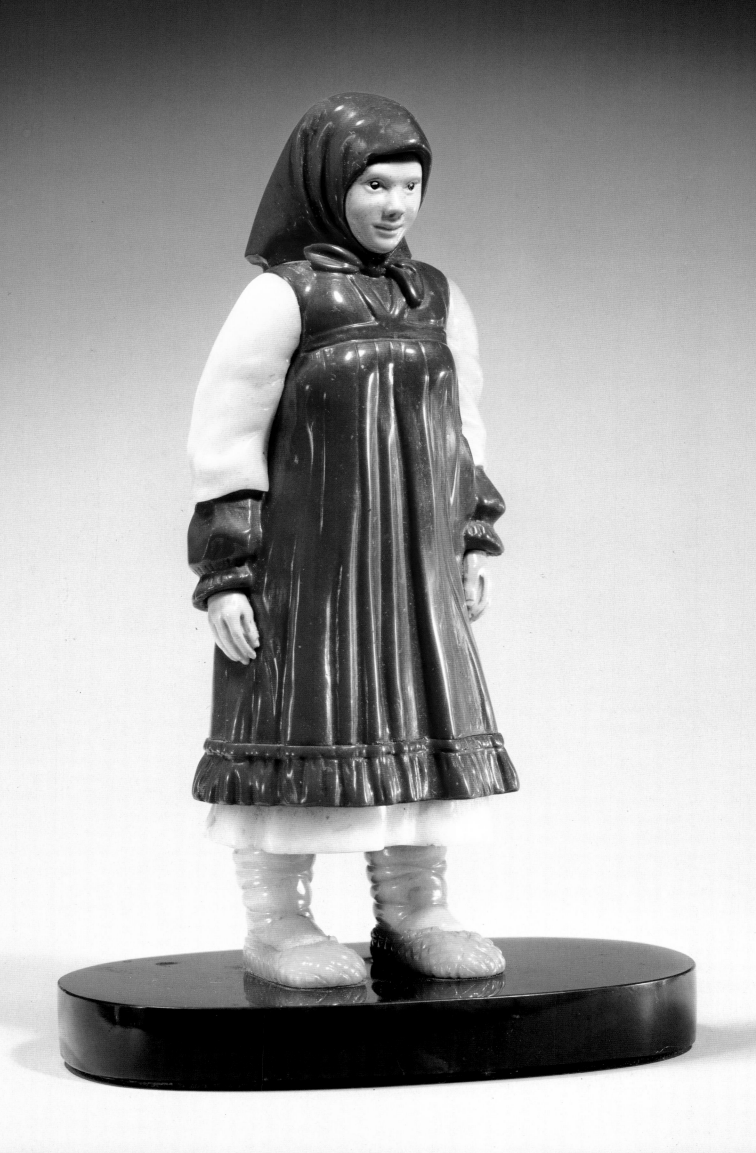

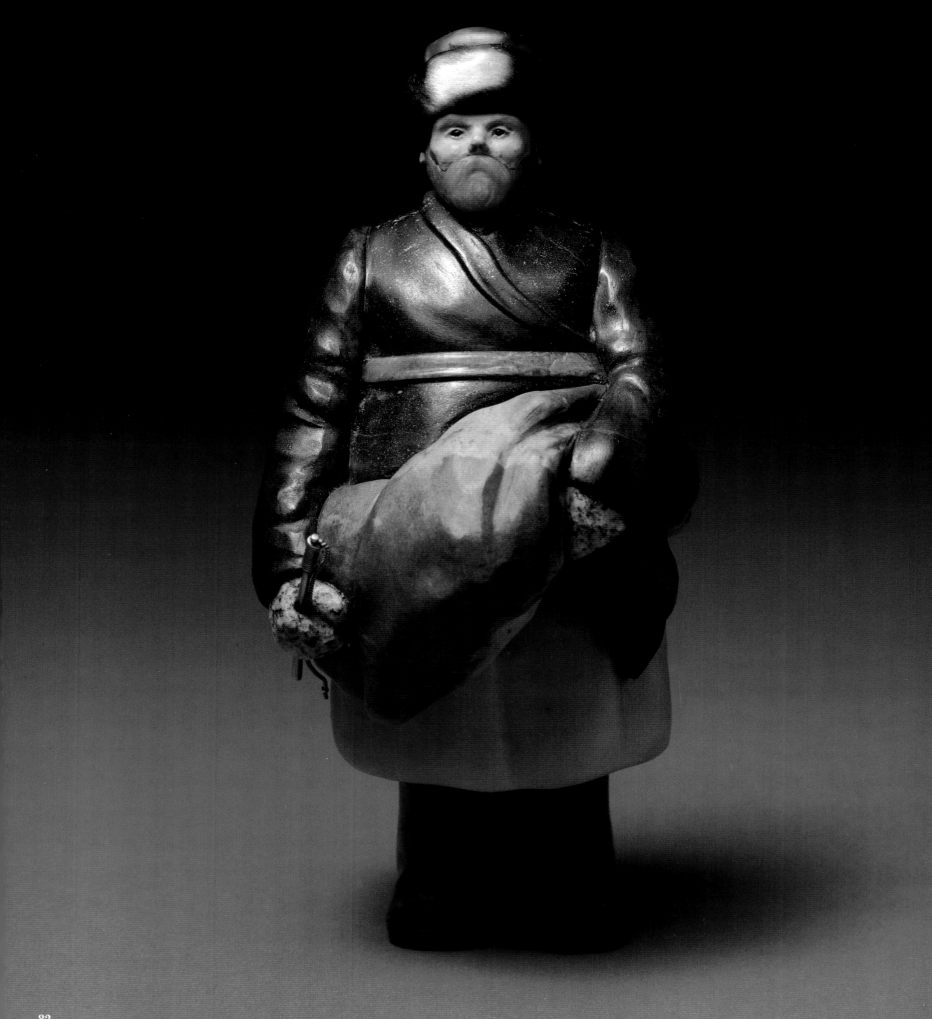

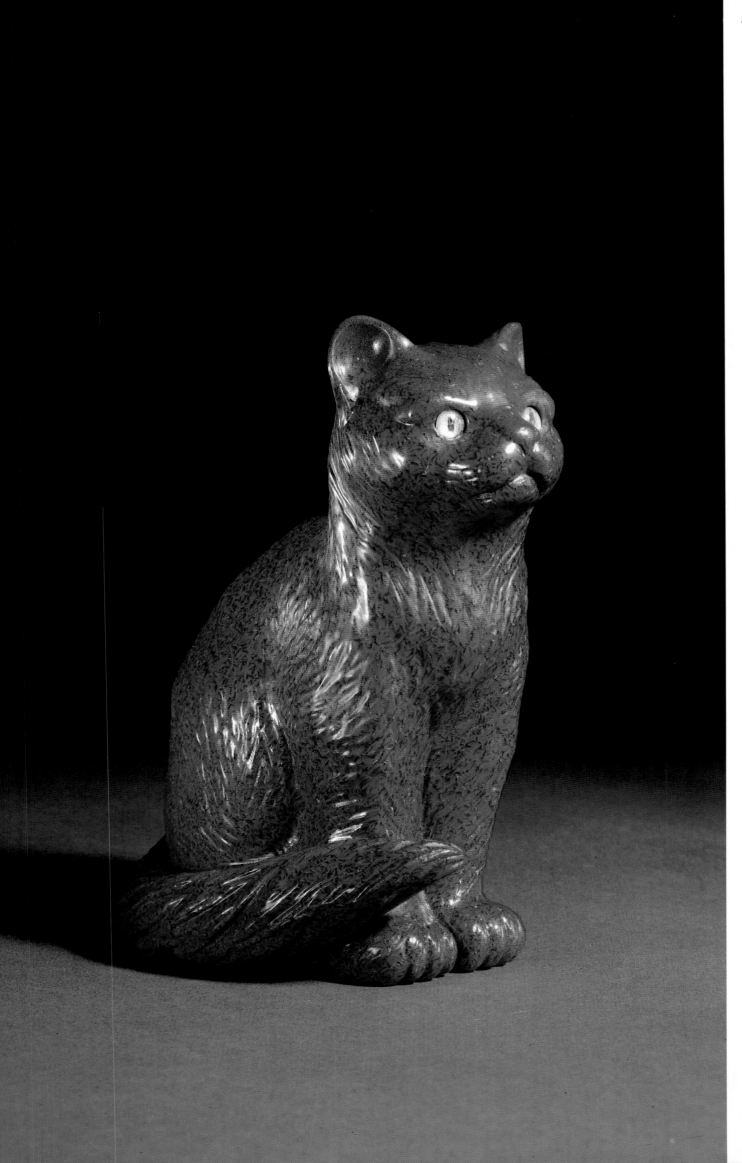

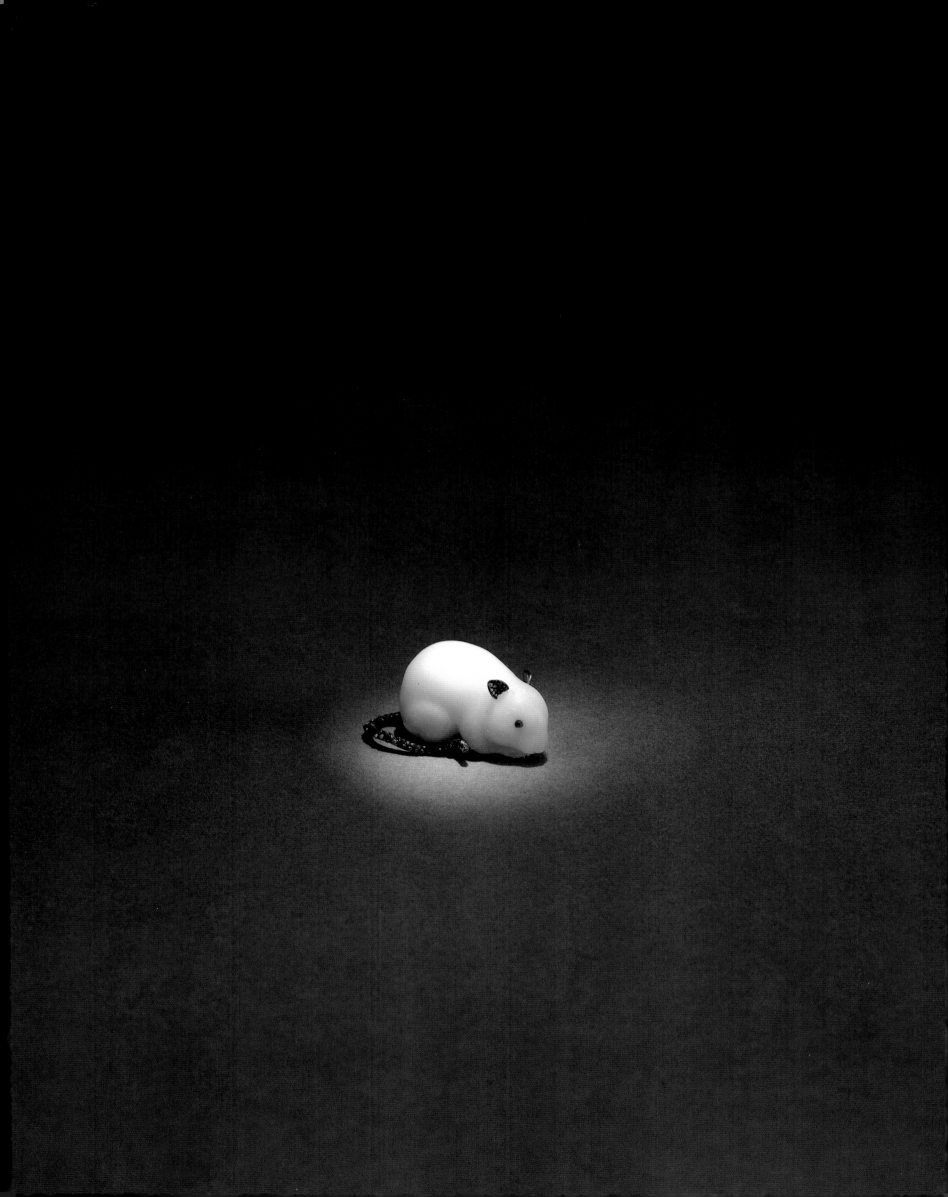

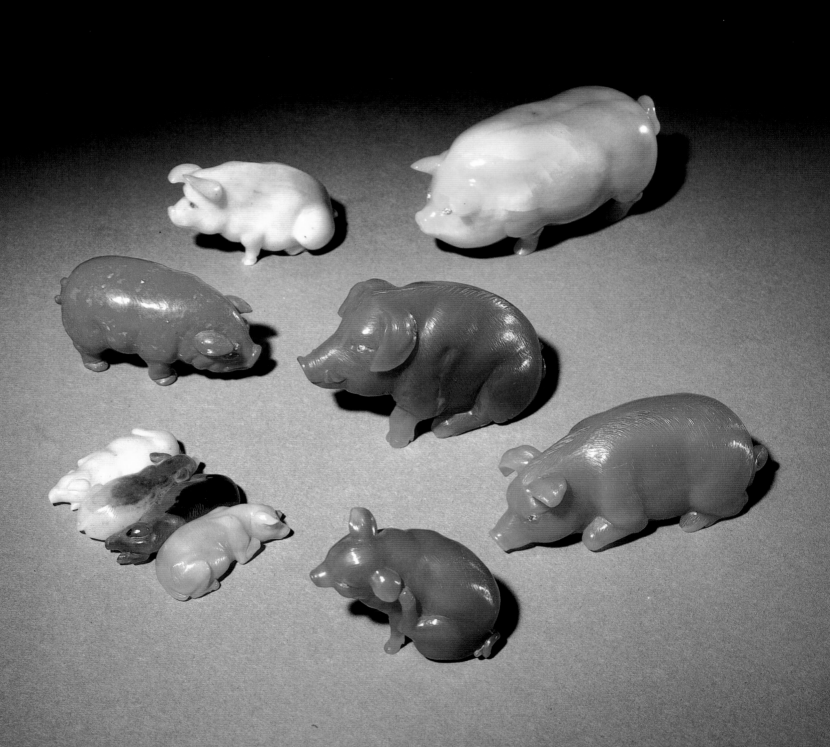

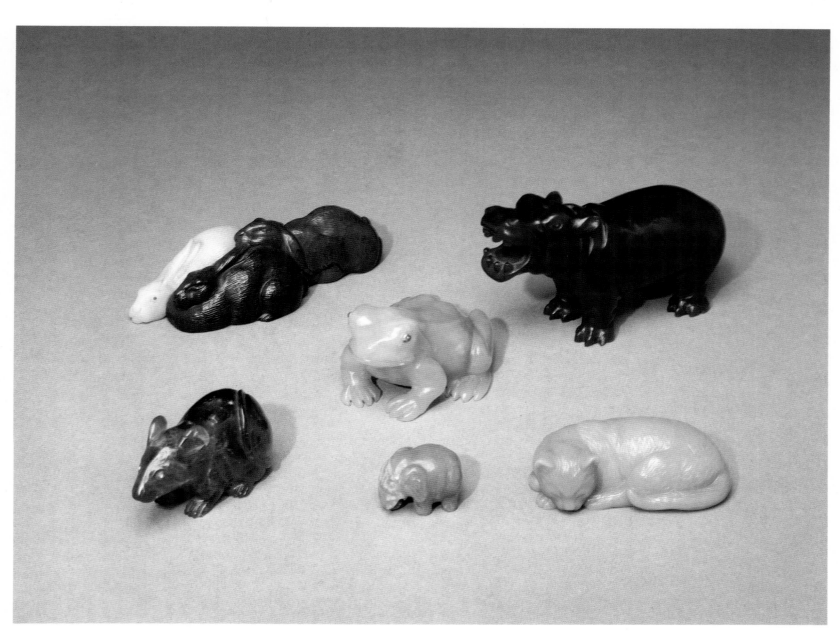

86

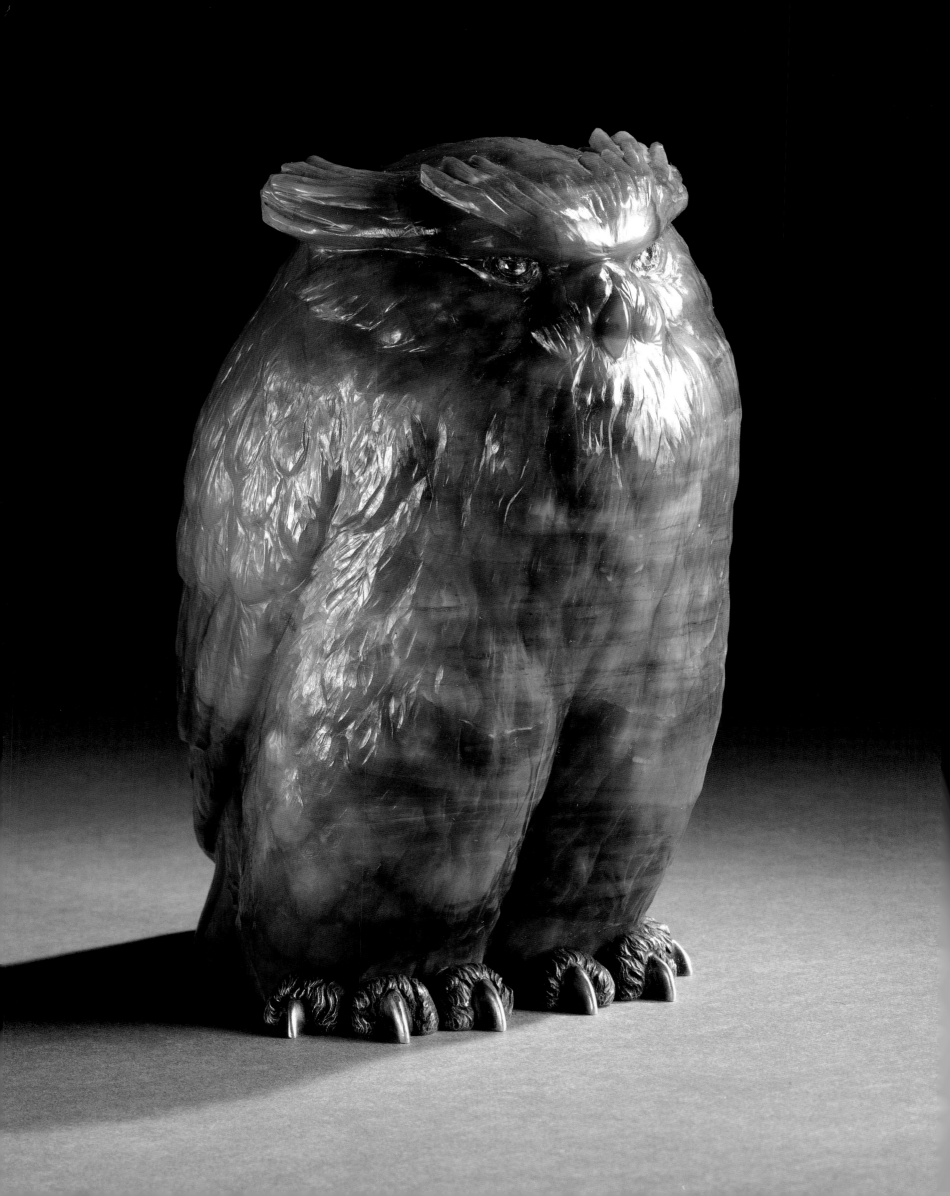

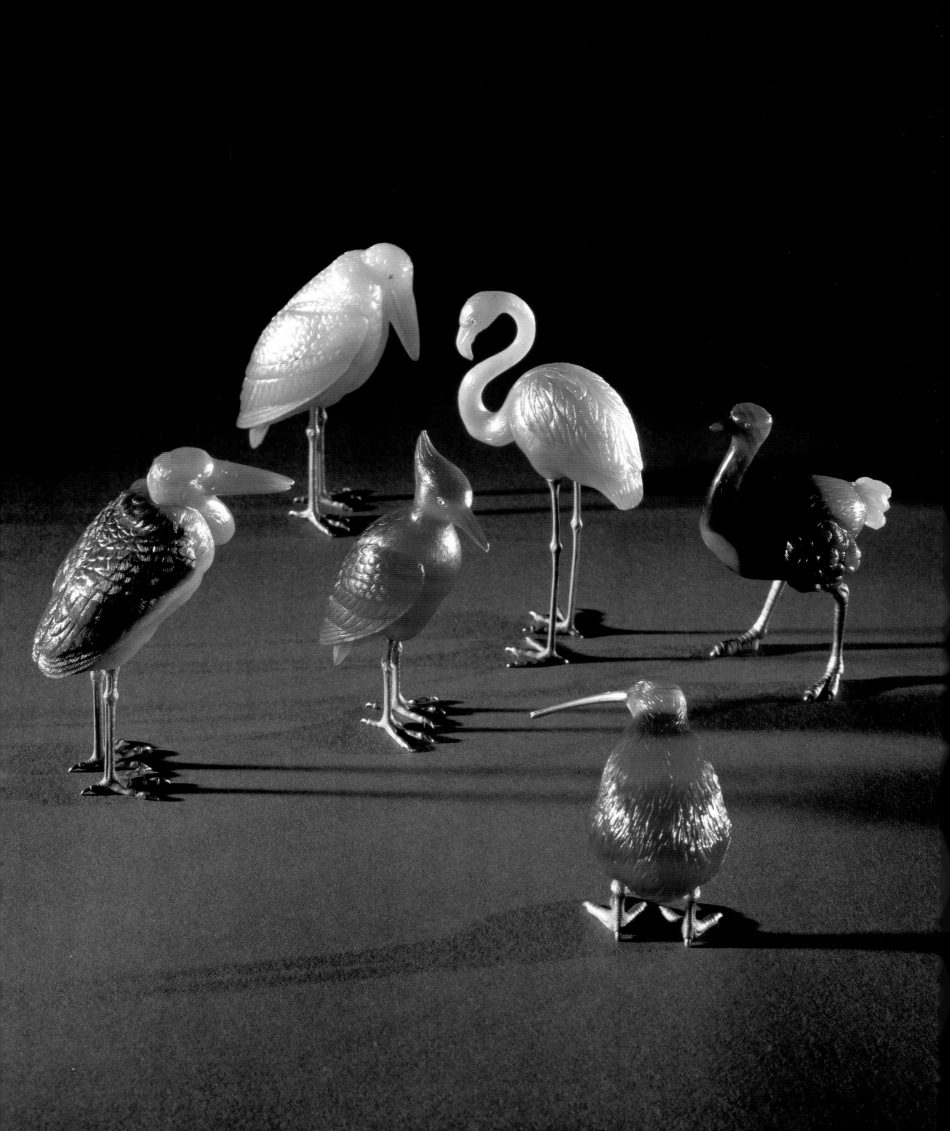

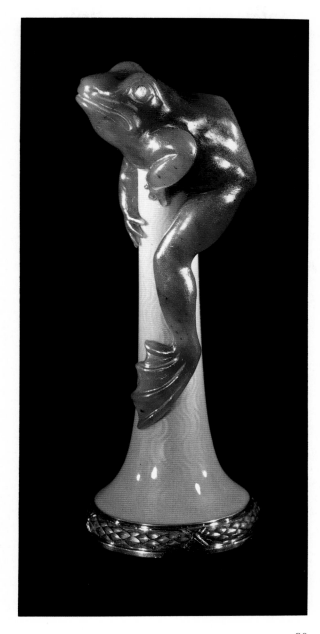

90

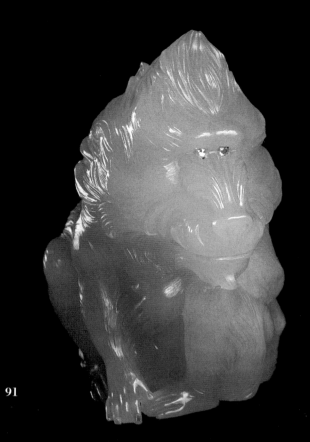

91

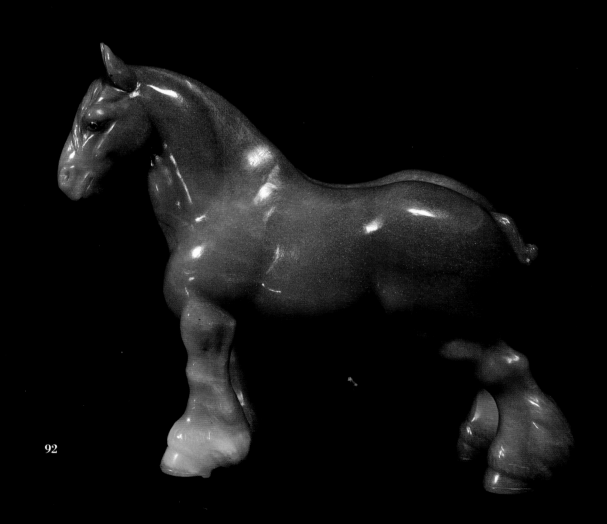

92

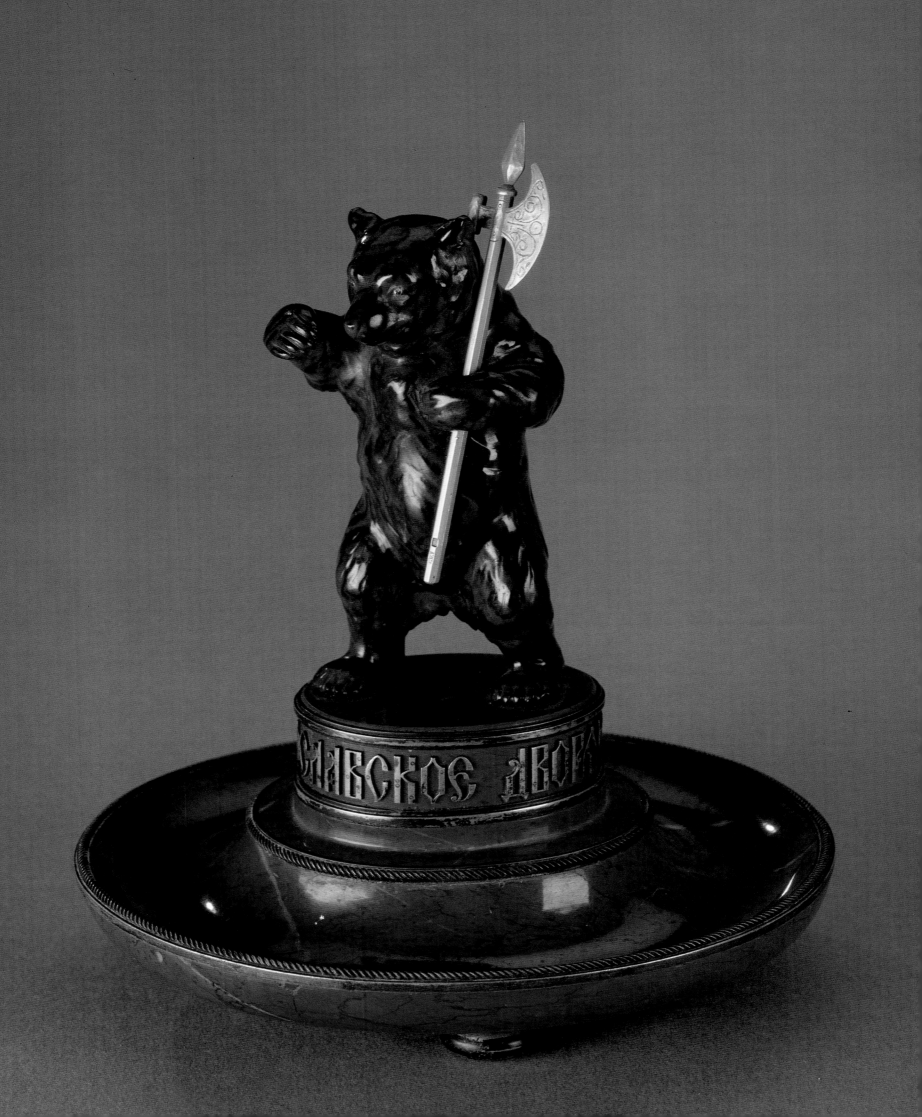

BOXES AND CASES

Boxes and cases were produced for a wide variety of purposes. There were cigar boxes to be kept on the table, as well as cigarette cases to be carried in the pocket. Compacts and visiting-card cases were also indispensable accessories. The most lavish boxes were made to be used as presentation pieces by the Czar and either carry his miniature portrait or bear his cipher in diamonds on the cover. These imperial presentation boxes follow in the tradition of the eighteenth-century French and German snuffboxes that were given by the sovereign as an expression of appreciation. Boxes did not need a specific utilitarian purpose in order to justify their existence. Handling a flawlessly made box of gold or silver is a source of great pleasure, possibly because of the apparently perfect enclosure of space by means of an invisible hinge and a tightly closing cover.

94. Fabergé. **Gold and Translucent Enamel Small Box.** Workmaster Henrik Wigström, St. Petersburg. ca. 1900. Length 1½″ (3.7 cm). *This small box is enameled translucent pale pink over an engine-turned wavy pattern. The top is fitted with a moss agate panel bordered by half-pearls.* **Small Gold-mounted Rock Crystal Box.** Workmaster Michael Perchin, St. Petersburg. ca. 1900. Length 2¼″ (5.5 cm). *Carved in the form of an egg, this box has red- and green-gold mounts set with rose diamonds.* **Small Carved Carnelian Box.** ca. 1890. Length 1½″ (3.6 cm). *Carved in the shape of a pumpkin, this box is made of reddish-brown carnelian with mounts of yellow gold. The removable segment has an opaque white enameled border that is set with rose diamonds.* **Gold and Translucent Enamel Small Circular Box.** Workmaster Henrik Wigström, St. Petersburg. ca. 1900. Diameter 1½″ (3.8 cm). *This box is enameled translucent dark blue over a guilloché ground. The cover is mounted by a jewel-set basket of flowers.* **Gold-mounted Rock Crystal Box.** Workmaster Michael Perchin, St. Petersburg. ca. 1890. Length 2½″ (6.4 cm). *The cover, in two sections, has gold mounts, ruby-set hinges, and a diagonal of diamonds.* **Gold-mounted Nephrite Small Box.** Workmaster Michael Perchin, St. Petersburg. ca. 1890. Length 1⅜″ (3.6 cm). *The gold mounts are set with diamonds and a cabochon ruby.* The Royal Collection, London.

95. Fabergé. **Gold Cigarette Case.** ca. 1890. Height 3½″ (8.8 cm). *White translucent enamel over a minute basket-weave guilloché ground forms the background for various sized roundels enameled translucent pink, aquamarine, sepia, gold, sea green, and red. Each roundel has a diamond center, and the clasp of this case is set with a cabochon sapphire.* The Forbes Magazine Collection, New York.

96. Fabergé. **Tortoise Shell Cigarette Case.** 1899–1908. Height 3¹⁄₁₆″ (7.7 cm). *Carved of highly polished tortoise shell, this cigarette case is overlaid with a gold and diamond-set flowering vine.* The Forbes Magazine Collection, New York.

97. Fabergé. Moscow. **Gold, Translucent Enamel, and Jeweled Cigarette Case.** ca. 1900. Length 3¹¹⁄₁₆″ (9.4 cm). *This case is enameled translucent royal blue over a guilloché ground. The cover and the base are set with a serpent studded with diamonds.* The Royal Collection, London. Collection of H.M. Queen Elizabeth II.

98. Fabergé. **Gold and Mother-of-Pearl Cigarette Case.** Workmaster Michael Perchin, St. Petersburg. ca. 1890. Length 3½″ (9 cm). *The mother-of-pearl case is overlaid with neo-rococo gold scrolls and diaper.* **Gold and Mother-of-Pearl Cigarette Holder.** Workmaster Alexander Wäkevä, St. Petersburg. ca. 1900. Length 2⅞″ (7.2 cm). *The holder is entwined with a gold snake, the head of which is set with a ruby.* The State Historical Museum, Moscow.

136

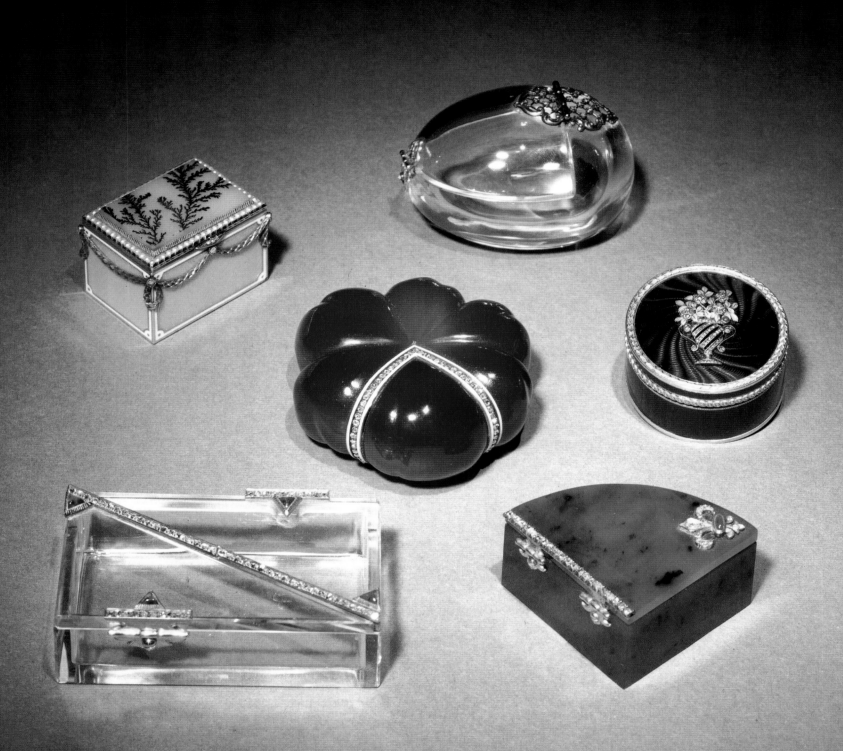

99. Fabergé. Workmaster August Hollming. **Silver, Gold, and Translucent Enamel Cigarette Case.** ca. 1910. Length 3¼″ (8 cm). *This curved case is enameled translucent steel gray on a guilloché ground. The gold borders are chased with leaf tips. The State Historical Museum, Moscow.*

100. Fabergé. **Gun-metal Cigarette Case.** ca. 1890. Length 3¼″ (8.5 cm). *This cigarette case, created from gun-metal, is inscribed "Lady Haig from Queen Alexandra" on the inside rim. The Forbes Magazine Collection, New York.*

101. Various makers. Moscow. **Group of Silver-gilt and Enamel Cigarette Cases.** ca. 1890–1910. Lengths 3¾″ to 5″ (9.5 cm to 12.7 cm). *This is a representative group of enameled cigarette cases that were popular at the turn of the century. These cases are enameled with various foliate motifs. Copyright 1989, Sotheby's, Inc., New York.*

102. **Silver-gilt and Shaded Enamel Two-handled Bowl.** Maria Semyonova. Moscow. ca. 1910. Length 7¾″ (19.6 cm). *The bowl has Art Nouveau harp-shaped handles which are hung with pendants. The body of the bowl is enameled with swans, fish, and exotic sea creatures.* **Silver-gilt and Shaded Enamel Easter Egg.** Maker unknown. Moscow. ca. 1910. Length 2½″ (6.4 cm). *Enameled "X.B." for "Christ Is Risen," the surround of the egg is enameled with colorful foliage on a pale green ground. The borders are enameled aubergine. The interior has fittings for conversion to egg cups. The egg has the maker's mark M.Ch. in Cyrillic.* **Silver-gilt and Shaded Enamel Pictorial Casket.** Maker unknown. Moscow. ca. 1900. Length 5″ (12.7 cm). *The cover is applied with an en plein enameled plaque depicting a medieval scene of an old man at the gate of a grand house presenting his daughters to a richly attired young nobleman. This plaque is counter-enameled on the interior with tulips.* **Silver-gilt and Shaded Enamel Trunk-form Casket.** Eleventh Artel. Moscow. ca. 1910. Length 4¼″ (10.8 cm). *This small box has a carrying handle at each end and is enameled with multicolored scrolling foliage. The corners have geometric designs.* **Silver-gilt and Shaded Enamel Small Casket.** Nicholai Zverev. Moscow. ca. 1910. Length 4⅛″ (10.5 cm). *With a stepped top and raised on four bracket feet, this box is enameled with stylized foliage.* **Silver-gilt and Shaded Enamel Table Cigar Box.** Eleventh Artel. Moscow. ca. 1910. Length 6¾″ (17 cm). *This cigar box is enameled with flowering foliage on a gilded stippled ground and is raised on four bracket feet. Copyright 1989, Sotheby's, Inc., New York.*

103. Khlebnikov. Moscow. **Large Silver-gilt and Shaded Enamel Table Cigar Box.** ca. 1910. Length 8⅝″ (22 cm). *This impressive casket is enameled on the cover with a large en plein scene after Repin's The Zaporozh Cossacks Write a Mocking Letter to the Sultan. The sides are enameled with stylized representations of an ancient kremlin and are set on each side with two chrysoprase cabochons. Each end has a hinged carrying handle. Private collection, U.S.A.*

104. Fabergé. Workmaster Feodor Rückert, Moscow. **Large Silver-gilt and Shaded Enamel Casket.** ca. 1910. Length 8⅜″ (21.2 cm). *The rectangular casket is raised on four bracket feet and has a carrying handle at each end. The hinged cover has two oval reserves enameled en plein, one with Alexander I, the other with Napoleon Bonaparte, each surmounted by their respective imperial monograms. Between the reserves, the casket is enameled with the Russian imperial eagle above an eagle with spread wings. The sides are enameled in the Old Russian style in muted tones of blue, brown, green, orange, and white. Copyright 1980, Sotheby's, Inc., New York.*

105. Fabergé. Workmaster Carl Gustav Hjalmar Armfelt, St. Petersburg. **Silver and Translucent Enamel Table Cigar Box.** ca. 1910. Length 6¾″ (17 cm). *This cigar box is enameled translucent steel blue over a guilloché ground. Both the front and the back of the box are applied with anthemion and laurel wreaths. The hinged cover has a reserve containing a miniature of a palace with a border enameled translucent sky blue over a guilloché ground. Four paw feet support the casket. Copyright 1987, Sotheby's, Inc., New York.*

106. Ovchinnikov. Moscow. **Silver, Enamel, and Jeweled Casket.** ca. 1894. 2¼ × 14⅞ × 9½″ (13.2 × 37.7 × 24.3 cm). *Decorated in the Old Russian style, this box was a presentation to Grand Duke Alexander Mikhailovich and Grand Duchess Kenia Alexandrovna from the city of Moscow on 25 July 1894, as indicated by the inscription. Their ciphers are applied to the cover of the box and are set in diamonds below an imperial crown. The front of the cover is enameled with a depiction of St. George slaying the dragon (the coat of arms of the city of Moscow). The State Historical Museum, Moscow.*

107. **Silver-gilt and Enamel Presentation Jewel Casket.** Ovchinnikov. Moscow. ca. 1893. Length 12¼″ (31 cm). *This casket is enameled all over with multicolored scrolling foliage and with geometric borders. The cover has a shield which is enameled with the coat of arms of Riazan. The sides are applied with shields enameled with the coats of arms of the various towns of the governorship of Riazan, including Zaraisk, Pronsk, Sapojok, and Skopin. This impressive presentation box was apparently a gift from the governorship of Riazan, possibly a presentation to Czar Nicholas II upon his accession in 1894.* **Silver-gilt and Shaded Enamel Cake Basket.** Maker unknown. Moscow. ca. 1890. Length 10½″ (26.7 cm). *The center and inner border of this basket are enameled with stylized flowers and foliage. The scalloped outer border is enameled similarly on a turquoise ground with filigree scrolls.* **Silver-gilt and Shaded Enamel Casket.** Vasiliy Agafonov. Moscow. ca. 1900. Length 8½″ (21.4 cm). *This box is enameled all over with colorful flowers and scrolling foliage on grounds of pink, olive green, avocado, and sky blue. It is raised on four petal-form feet enameled with flowers. The interior of the cover is inscribed with the date 10 November 1912 in Cyrillic.* Copyright 1989, Sotheby's, Inc., New York.

108. Khlebnikov. Moscow. **Silver-gilt and Shaded Enamel Rectangular Casket.** ca. 1910. Length 5½″ (14 cm). *The casket has a carrying handle at each end and is enameled all over with flowering foliage on grounds of sea green and blue.* Copyright 1989, Sotheby's, Inc., New York.

109. Ovchinnikov. Moscow. **Silver-gilt and Champlevé Enamel Casket.** ca. 1877. Length 7½″ (19 cm). *The hinged cover of this box is decorated with a deck of finely enameled playing cards. Each side of the casket is enameled in the Old Russian style with an architectural design incorporating roosters.* Copyright 1989, Sotheby's, Inc., New York.

110. **Silver-gilt and Shaded Enamel Pictorial Table Cigarette Box.** Eleventh Artel. Moscow. ca. 1910. Length 5⅝″ (14.4 cm). *The cover is enameled en plein with a boy and a girl of a noble family in a snowy landscape. They are warmly dressed in fur-trimmed coats. The sides of this box are enameled with foliate motifs on a gilded stippled ground.* **Silver-gilt and Shaded Enamel Letter Rack.** Feodor Rückert. Moscow. ca. 1900. Height 6⅜″ (16.4 cm). *The front of this letter rack is enameled with a castle door with simulated hinges and lock. The surround is enameled with colorful foliage on a pale green ground.* Private collection, U.S.A.

111. **Silver-gilt and Shaded Enamel Pictorial Card Case.** Feodor Rückert. Moscow. ca. 1900. Height 4″ (10 cm). *Each side of this case is enameled with a playing card, one side with the Queen of Hearts, the other with the King of Clubs. The surround is finely enameled with flowers on an avocado ground, and the sides are enameled with flowers and colorfully plumed birds on a sky-blue ground. The hinged cover is enameled with a hunting trophy centered by a roundel enclosing a black enamel spade.* **Silver-gilt and Shaded Enamel Pictorial Jeweled Casket.** Eleventh Artel. Moscow. ca. 1910. Length 6″ (15.2 cm). *This rectangular box with slightly tapering sides is raised on four bracket feet. The hinged cover is finely enameled en plein with a young bride and her groom within a border of entwining vine. The surround is enameled with paterae and leafage, and the sides are enameled with colorful scrolling foliage on a gilded stippled ground. Each end has a hinged carrying handle.* Private collection, U.S.A.

112. Marshak. Kiev. **Silver-gilt and Shaded Enamel Table Cigarette Box.** ca. 1910. Length 4¼″ (10.9 cm). *The cover has an en plein enamel scene of Czarevich Ivan and the Gray Wolf after the painting by Victor Vasnetzov. The surround of the cover and the sides of the box are enameled in muted tones in the Old Russian style. This Russian fairy tale concerns the young Czarevich Ivan who carries his wife-to-be, Princess Ellena, on a gray wolf whom he has befriended. The subject was painted by Vasnetzov in 1889.* Copyright 1989, Sotheby's, Inc., New York.

113. Fabergé. Workmaster Feodor Afanassiev, St. Petersburg. **Silver-gilt and Translucent Enamel Casket.** ca. 1900. Length 5⅜″ (13.6 cm). *Raised on four paw feet, with a hinged cover, this casket is entirely enameled in translucent pale purple over a guilloché ground. The sides are applied with ribbon-tied swags of laurel which pend from ribbon bows. The cover is applied with a laurel wreath, and the border is chased with acanthus leaves.* Copyright 1980, Sotheby's, Inc., New York.

114. Ovchinnikov. Moscow. **Silver-gilt and Enamel Photograph Album.** 1879. Length 24⅜″ (62 cm). *Lavishly enameled with foliate motifs, this album is decorated with the Dolgoruky (Dolgorukov) coat of arms and was a presentation to Prince Vladimir Andreyevich Dolgorukov (1810–1891) who became Governor-General of Moscow in 1865. It is inscribed in Cyrillic, "1865. To the Governor-General of Moscow, Prince Vladimir Andreyevich Dolgorukov from those working in the department of which he is in charge." The State Historical Museum, Moscow.*

115. Fabergé. Workmaster Michael Perchin, St. Petersburg. **Gold Carnet de Bal.** ca. 1890. Height 3⅞″ (9.7 cm). *The cover of this notepad, which is in the form of a book, is enameled translucent, opalescent pink over a sun-ray ground and mounted with a miniature of Alexandra Feodorovna within a diamond border. The edges of the carnet are enameled with green leafage. The accompanying gold pencil has a cabochon emerald finial. Courtesy of Hillwood Museum.*

116. Fabergé. Workmaster Michael Perchin, St. Petersburg. **Gold and Enamel Imperial Presentation Box.** ca. 1890. Width 3¼″ (8.3 cm). *Mounted with a miniature of Nicholas II within a diamond border, this presentation box is studded with diamonds, enameled translucent ivory over a sunburst field, and applied with swags of two-color gold foliage. The corners are enameled translucent strawberry red. Each side is mounted with an imperial crown. Copyright 1989, Sotheby's, Inc., New York.*

117. Fabergé. Workmaster Michael Perchin, St. Petersburg. **Rocaille Box.** 1886–1899. Length 3¾″ (9.5 cm). *Royal blue enamel forms the background for this small box with gold, neo-rococo scrolls on the lid. A small, oval gold door opens to reveal a miniature of Czar Nicholas II. The Forbes Magazine Collection, New York.*

118. Fabergé. Workmaster Henrik Wigström, St. Petersburg. **Nicholas II Nephrite Box.** 1915–1917. Length 3¾″ (9.5 cm). *This box is made from carved, deep green-colored nephrite with a trellis of gold and diamonds. In the center is a miniature of Nicholas II painted on ivory by Zuiev, a miniaturist whose work is incorporated in many of the imperial Easter eggs. The Forbes Magazine Collection, New York.*

119. Fabergé. Workmaster Henrik Wigström, St. Petersburg. **Gold, Enamel, and Jeweled Imperial Presentation Box.** ca. 1910. Length 3¾″ (9.5 cm). *Enameled translucent blue-gray over an engine-turned ground, this box has diamond-set borders. The border of the cover is enameled opalescent oyster. The box is mounted with a miniature of Czar Nicholas II within a diamond border and is surmounted by a diamond-set crown.* **Gold and Enamel Presentation Box.** Workmaster Michael Perchin, St. Petersburg. ca. 1890. Length 3¼″ (8.2 cm). *This box is enameled translucent yellow over a sun-ray ground. The border of the cover is enameled with stylized leaves, and the center is chased with the imperial eagle within a border of diamonds. The Royal Collection, London.*

120. Fabergé. Workmaster August Holmström, St. Petersburg. **Coronation Box.** 1896–1899. Length 3¾″ (9.5 cm). *This was given by Czarina Alexandra Feodorovna to Czar Nicholas II the same year he gave her the Imperial Coronation Easter Egg. The ground is gold-colored enamel with a gold trellis-work design on top. Within each diamond-shaped section is a black enamel imperial eagle set with a center diamond. The Forbes Magazine Collection, New York.*

121. Fabergé. Workmaster Michael Perchin, St. Petersburg. **Gold, Enameled, and Jeweled Imperial Presentation Box.** ca. 1900. Width 3¼″ (8.2 cm). *This box is enameled translucent yellow over a guilloché ground and is applied on the cover with four imperial eagles enameled black and set with diamonds. The center lozenge is enameled translucent oyster over a sun-ray ground and is set with the cipher of Nicholas II in diamonds within a diamond-set oval. Victoria & Albert Museum, London.*

122. Fabergé. Workmaster Henrik Wigström, St. Petersburg. **Gold, Enameled, and Jeweled Imperial Presentation Compact.** ca. 1910. Length 3⅝″ (9.2 cm). *This rectangular case is decorated with opaque white enamel stripes with borders of black enamel. The edges of the cover and base have bead and reel lines executed in opaque white enamel. The cover is mounted with a miniature of Alexandra Feodorovna below a diamond-set crown and within diamond-set borders. The miniature is flanked by two diamond-*

set patera. The base of the compact is mounted with a diamond-set basket of flowers on a black enamel ground bordered by diamonds. The interior is fitted with two hinged compartments, one of which is mirrored. Copyright 1988, Sotheby's, Inc., New York.

123. Fabergé. Workmaster Henrik Wigström, St. Petersburg. **Gold, Enameled, and Jeweled Lady's Cigarette Case.** ca. 1910. *This case is enameled with black stripes, and its borders are enameled with berried foliage. The cover has an oval reserve bordered by diamonds enclosing a basket of flowers executed in* champlevé *enamel simulating a micromosaic. The base is applied with an oval reserve bordered by diamonds engraved with the royal cipher for Queen Alexandra of Great Britain. The interior is inscribed "Just Love 1915." Alexandra (1844–1925), daughter of Christian IX of Denmark, married Edward, Prince of Wales (later Edward VII) in 1863. Copyright 1988, Sotheby's, Inc., New York.*

124. Fabergé. Workmaster August Hollming, St. Petersburg. **Gold and Enamel Imperial Presentation Box.** ca. 1900. Diameter 3½″ (8.9 cm). *This round box is enameled translucent pale blue over a guilloché ground. The hinged cover has an oval reserve, which is enameled translucent ivory over a sun-ray ground and applied with the imperial cipher of Nicholas II in diamonds. The cover is also applied with diamond-set crossed branches of oak and laurel. Copyright 1979, Sotheby's, Inc., New York.*

125. Fabergé. Workmaster Henrik Wigström, St. Petersburg. **Carved Agate, Gold, and Diamond-set Bonbonnière.** ca. 1900. Diameter 2″ (5.1 cm). *This bonbonnière, carved of mottled purple agate and lined with gold, is wrapped in diamond-set ribbons tied with bows. It has a* bombé *base and a hinged cover which is set with a panel of moss agate. Copyright 1980, Sotheby's, Inc., New York.*

126. Fabergé. Workmaster Michael Perchin, St. Petersburg. **Carved Nephrite Bonbonnière.** ca. 1890. Diameter 2½″ (6.3 cm). *This Chinese influenced bonbonnière is carved with neo-rococo scrolls and shellwork. It has a ruby thumbpiece and a gold mount set with diamonds. Courtesy of Hillwood Museum.*

127. Fabergé. Workmaster Michael Perchin, St. Petersburg. **Louis XVI–style Snuffbox.** 1886–1899. Length 3¼″ (8.2 cm). *This box was created when Czar Alexander III challenged Fabergé to copy an eighteenth-century French snuffbox. Allegedly, the Czar was impressed with the result and was unable to distinguish the copy from the original. The Forbes Magazine Collection, New York.*

128. Fabergé. Workmaster Michael Perchin, St. Petersburg. **Gold-mounted Enamel Imperial Presentation Box.** ca. 1885. Height 1″ (2.4 cm). *The top of the circular box is inset with a gold coronation jeton which is inscribed, "Emperor Alexander III and Empress Marie Feodorovna, Coronation in Moscow, 1883." The reverse bears the Russian imperial eagle and the inscription "God With Us." The sides of the box are applied with eight gold Russian imperial eagles, and the whole is enameled gray-green over a guilloché ground. Copyright 1979, Sotheby's, Inc., New York.*

129. Fabergé. Moscow. **Carved Nephrite and Gold Box.** ca. 1900. Length 3⅜″ (8.5 cm). *This box is carved in the form of a parcel that is tied with ribbons of gold. The borders are enameled opaque white, and the thumbpiece is set with diamonds. The Metropolitan Museum of Art, New York. Bequest of Vladimir M. Eitingon, in memory of his wife, Nadine (Nadia) Eitingon, 1982.*

130. Fabergé. Workmaster Henrik Wigström, St. Petersburg. **Youssoupov Gold Music Box.** ca. 1907. Length 3½″ (8.9 cm). *This box of sepia enamel has a gold frame, bordered in opaque enamel, with leaves and white flowers in relief. The thumbpiece is of gold, silver, and tiny diamonds and contains the number XXV in diamonds for the twenty-fifth wedding anniversary of Prince Felix Youssoupov and his wife, Zenaida, whose initials appear on the front corners. The box was given to them by their sons Nikolai and Felix whose initials appear on the back two corners. The box bears images, in sepia enamel over a guilloché ground, of six of the Youssoupov residences: (top) Archangelskoe, outside Moscow; (Front) Palace on the Moika; (Bottom) Palace of Koreiz in the Crimea; (Back) Youssoupov Palace at Tsarskoe Selo; (Left end) Palace of Rakitnoe in the government of Kursk; (Right end) Residence originally used as a hunting lodge by Ivan the Terrible. Courtesy of Hillwood Museum.*

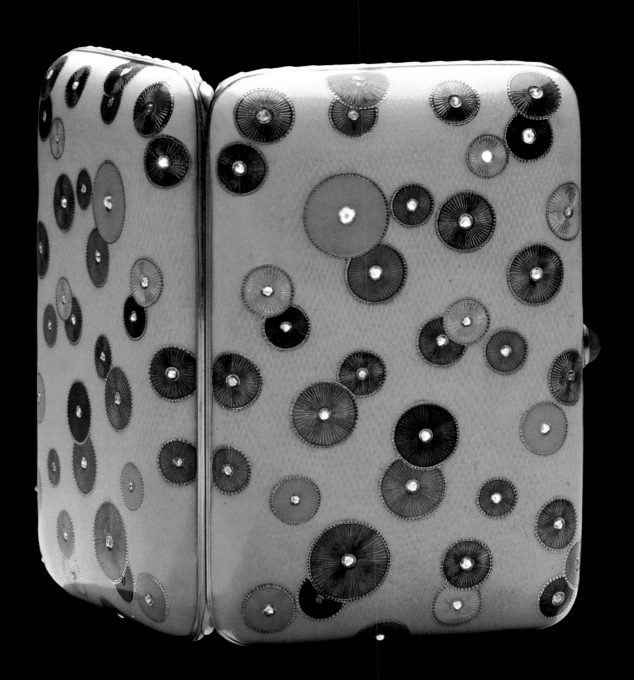

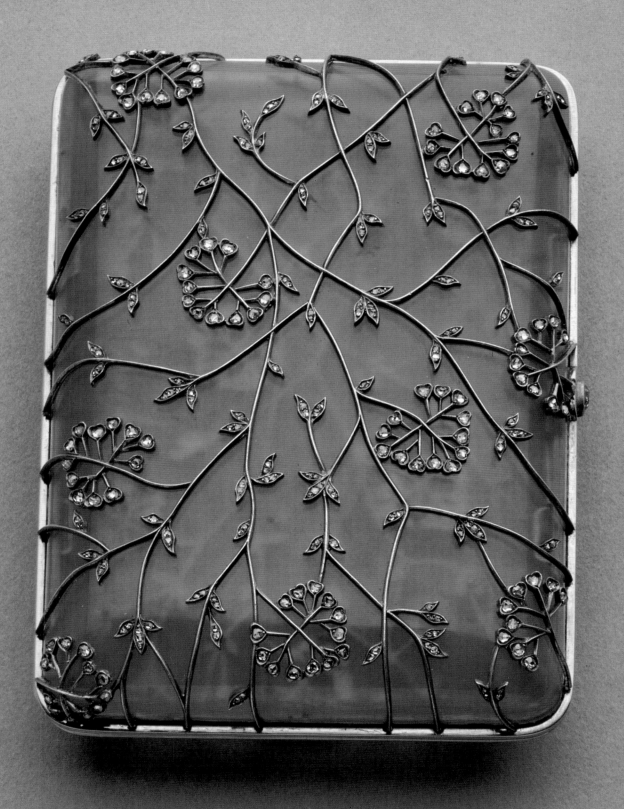

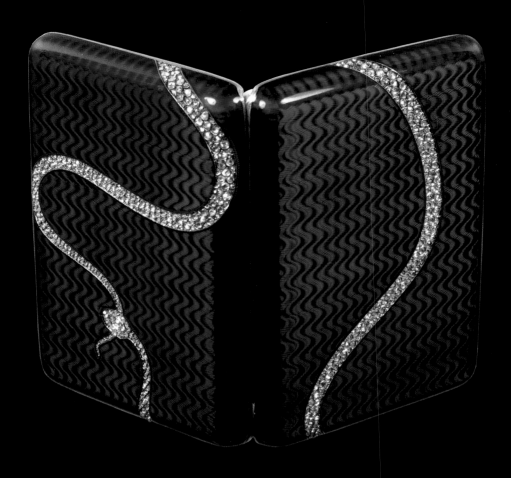

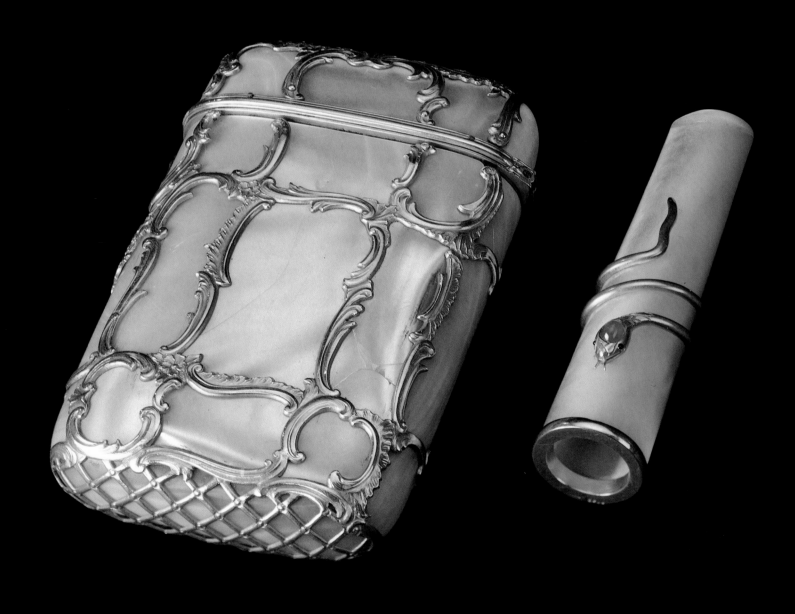

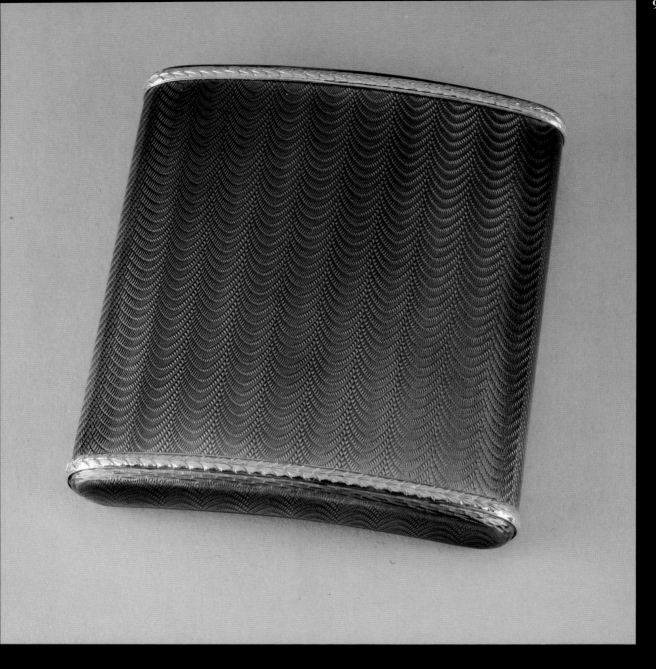

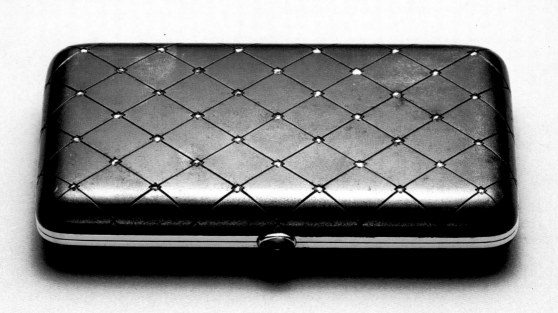

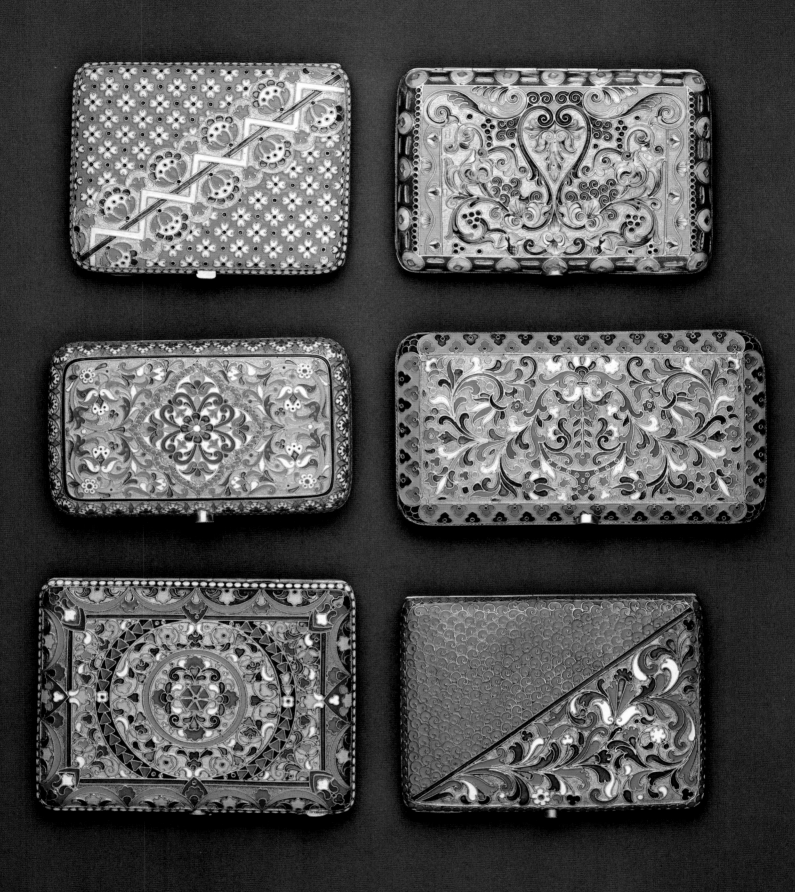

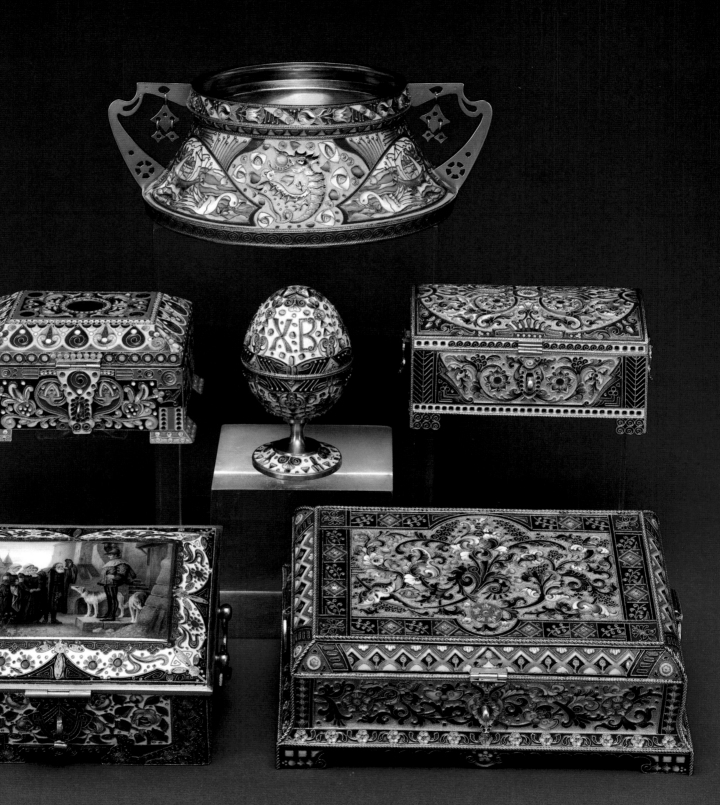

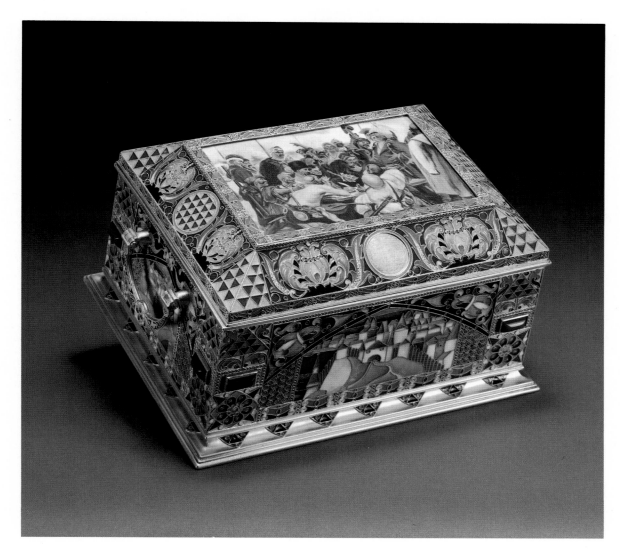

103

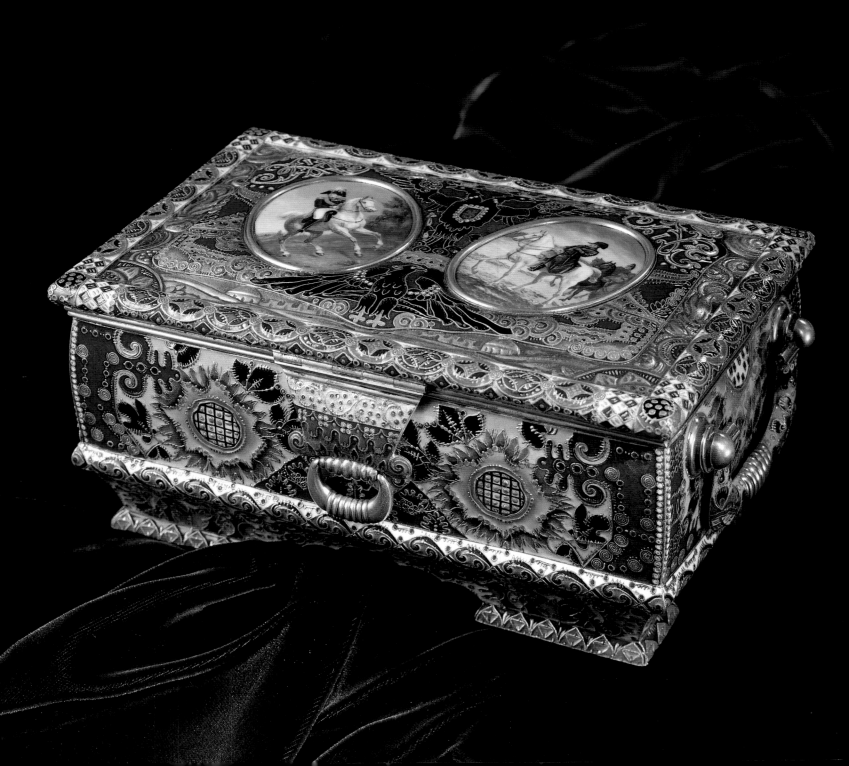

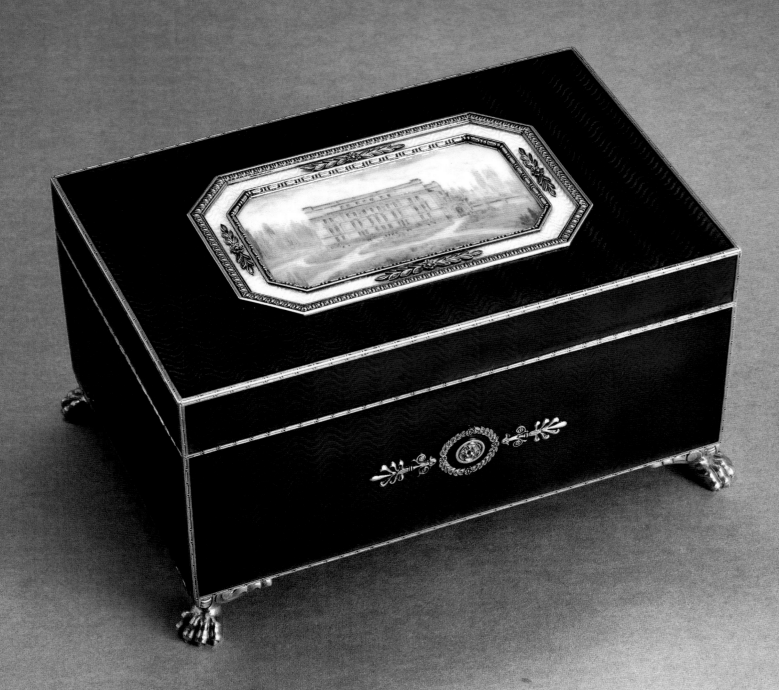

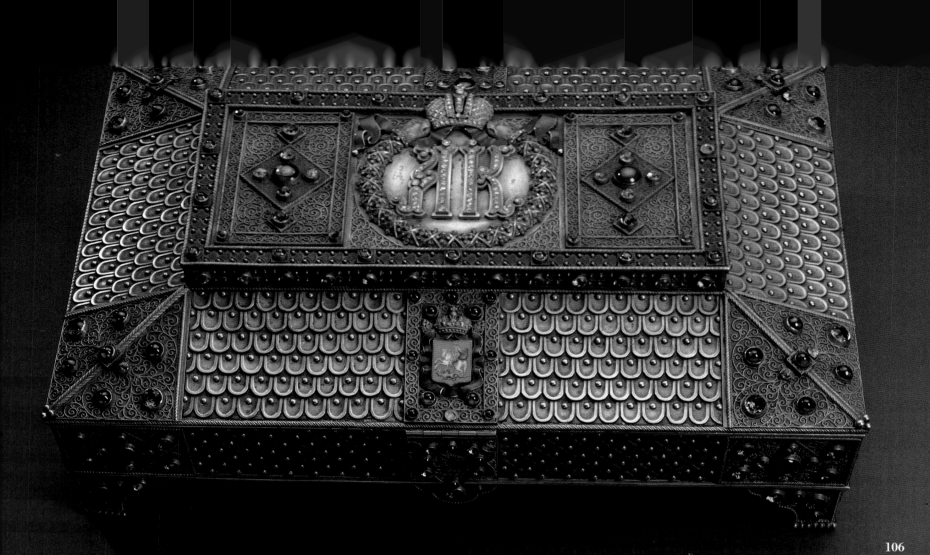

106

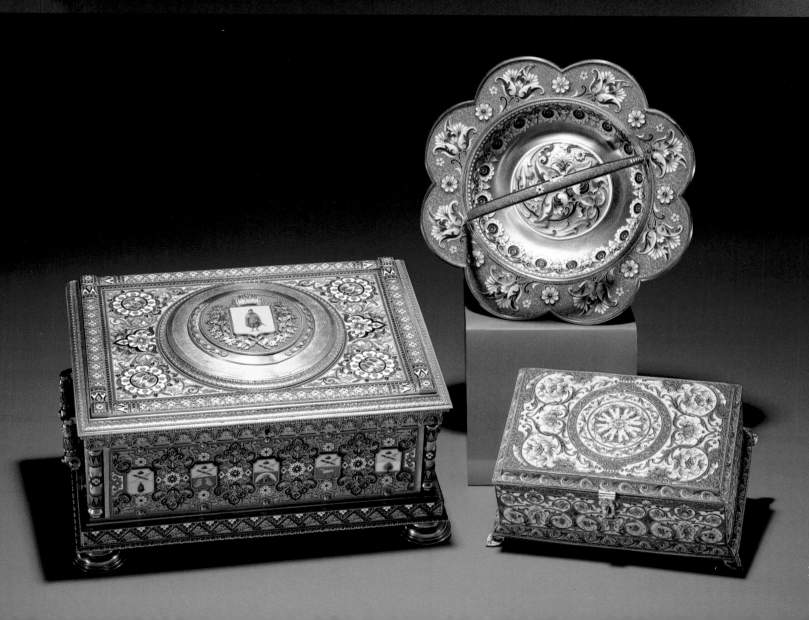

107

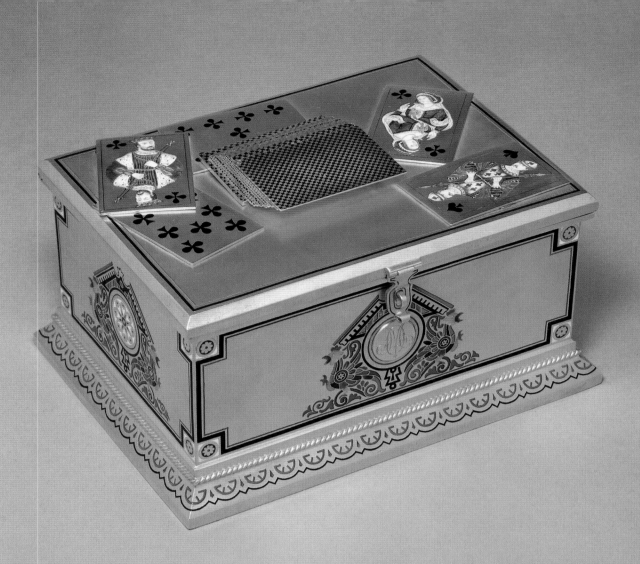

108

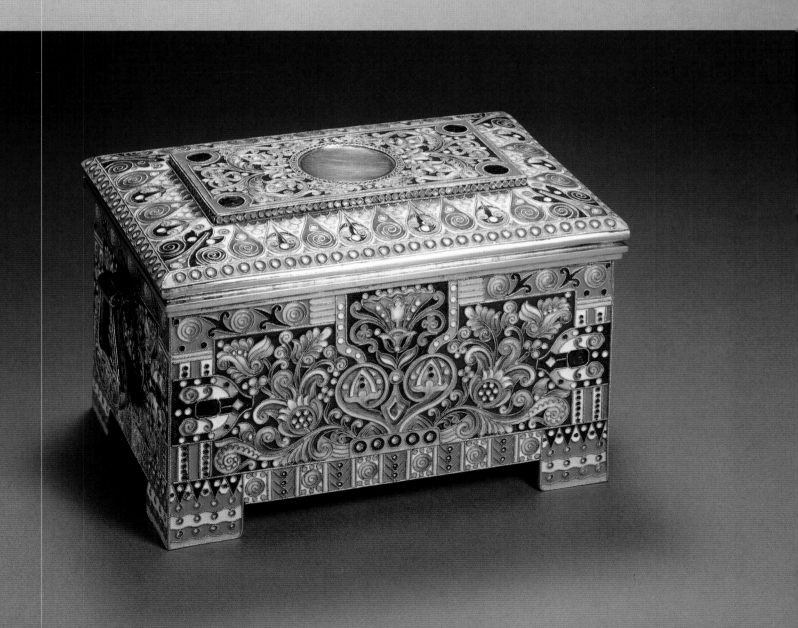

109

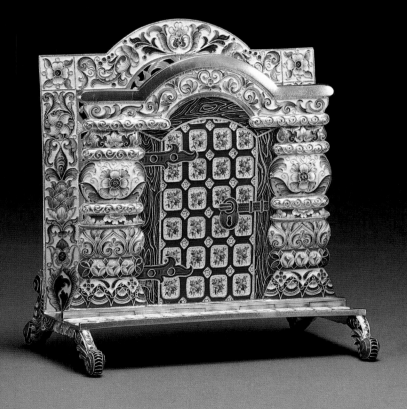
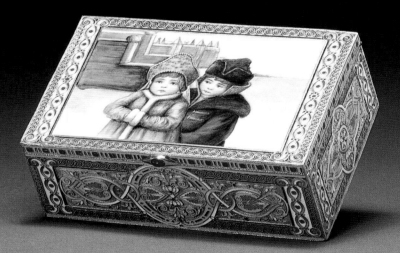

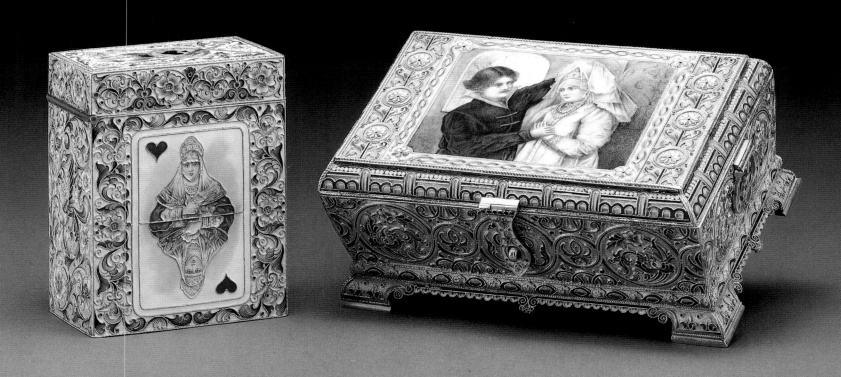

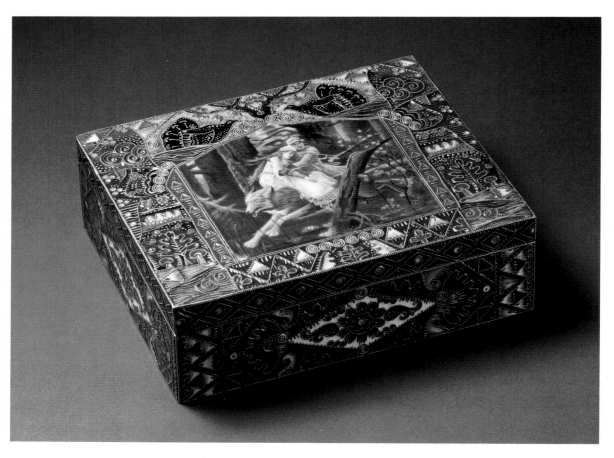

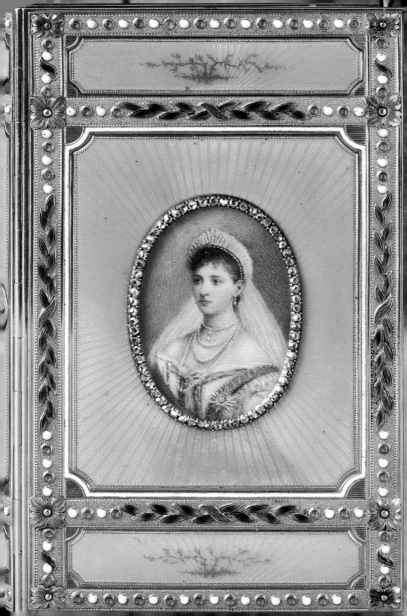

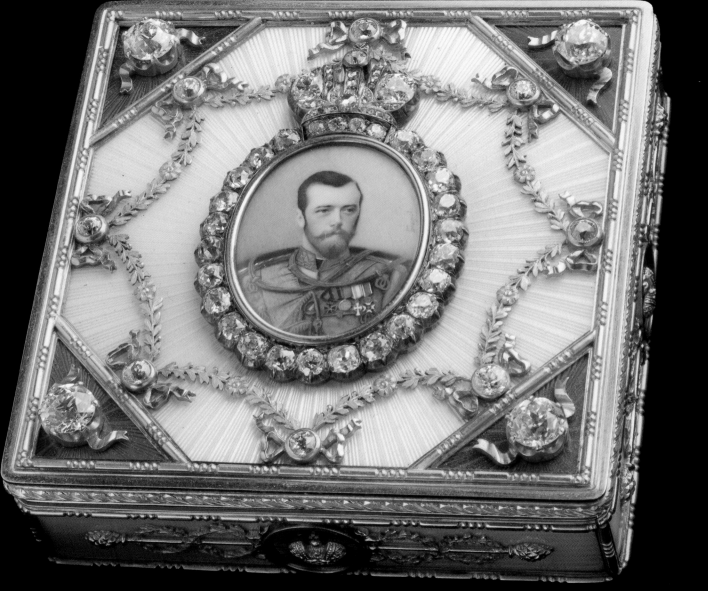

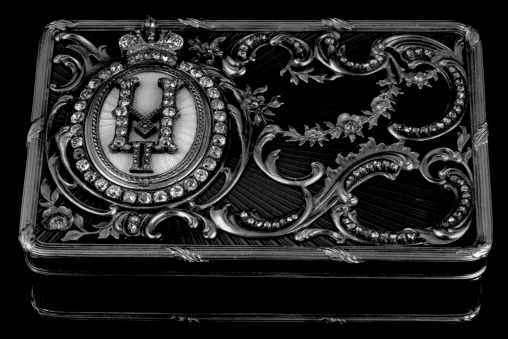

117

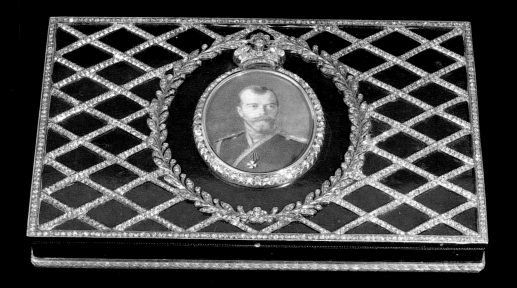

118

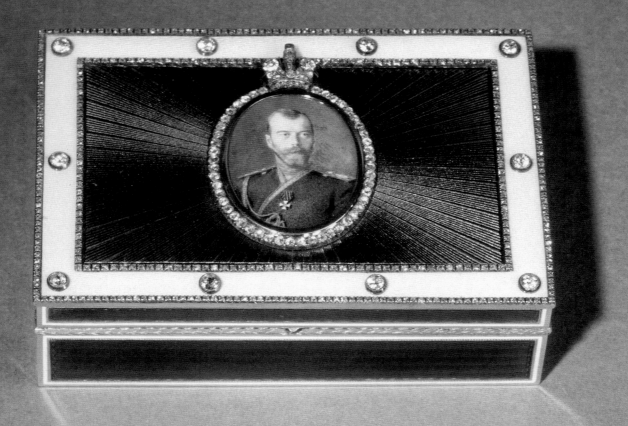

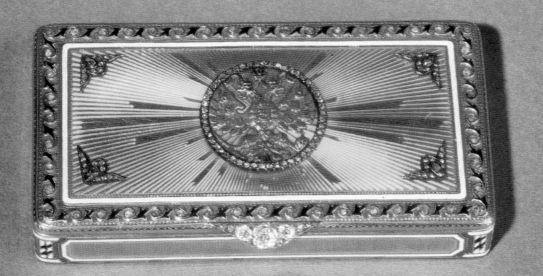

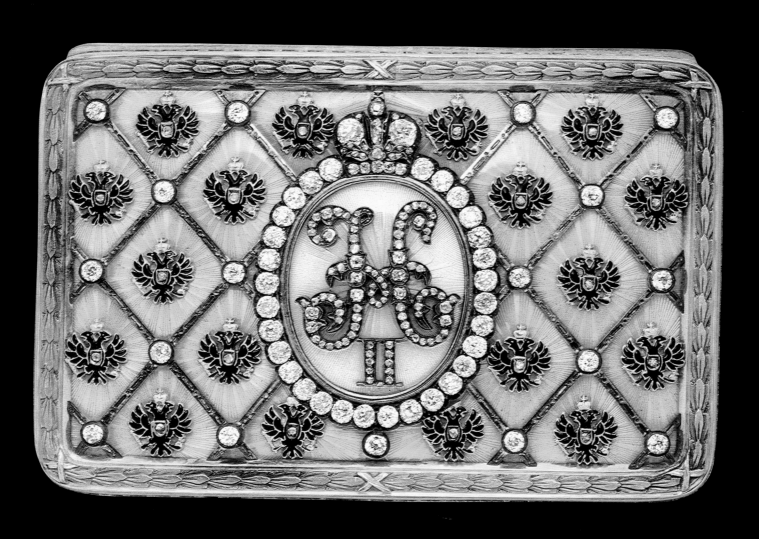

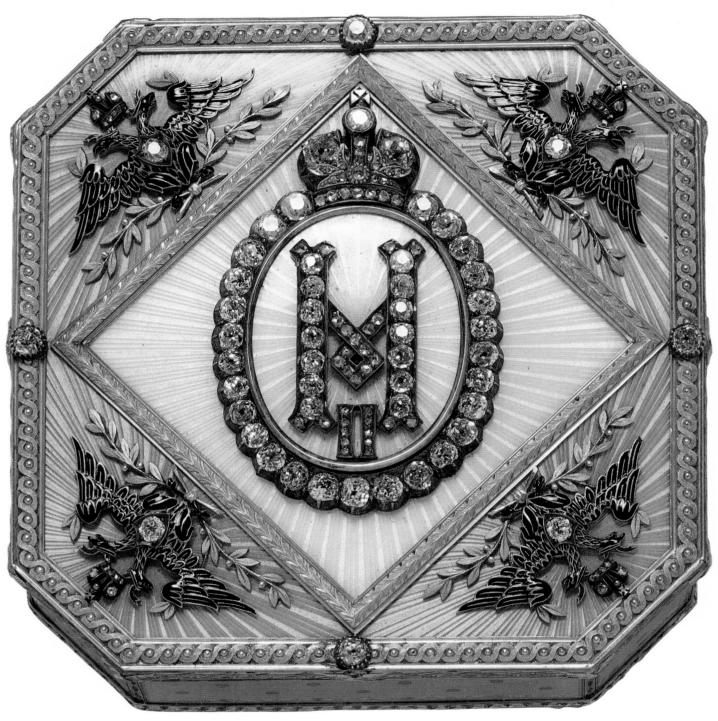

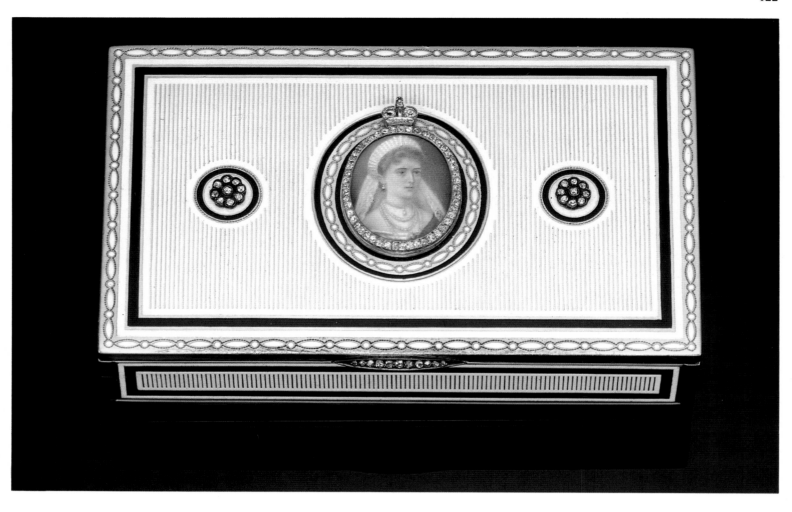

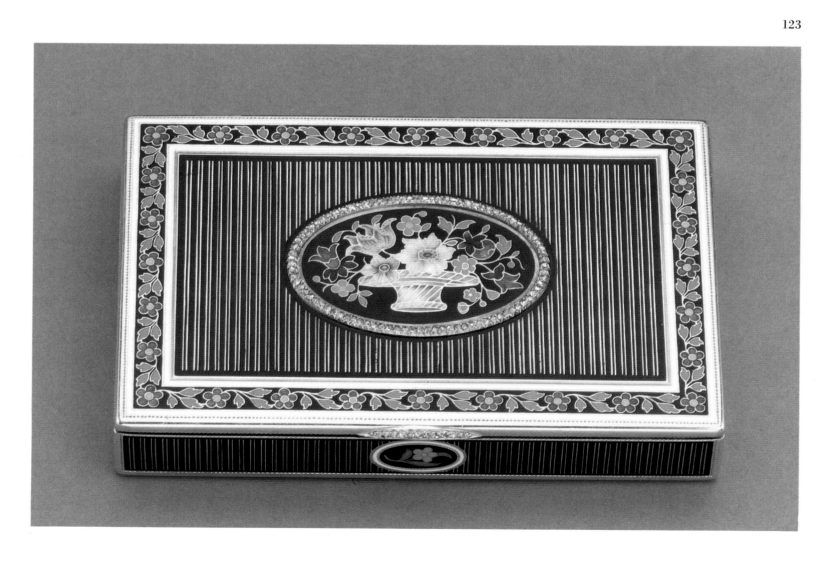

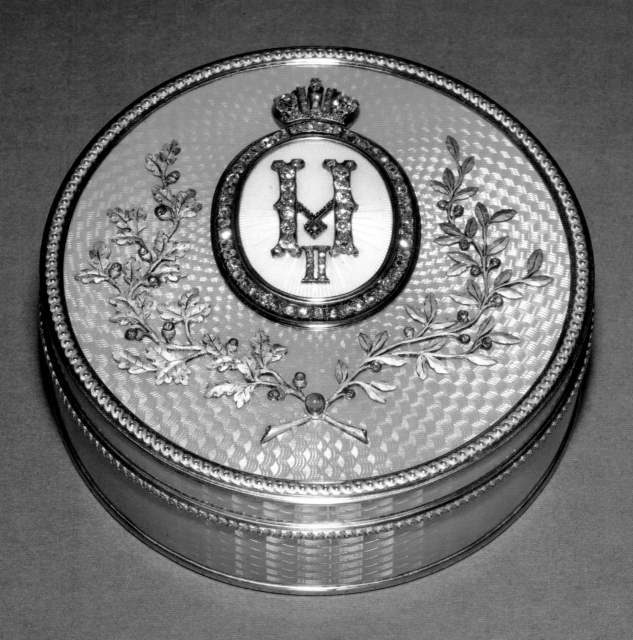

125

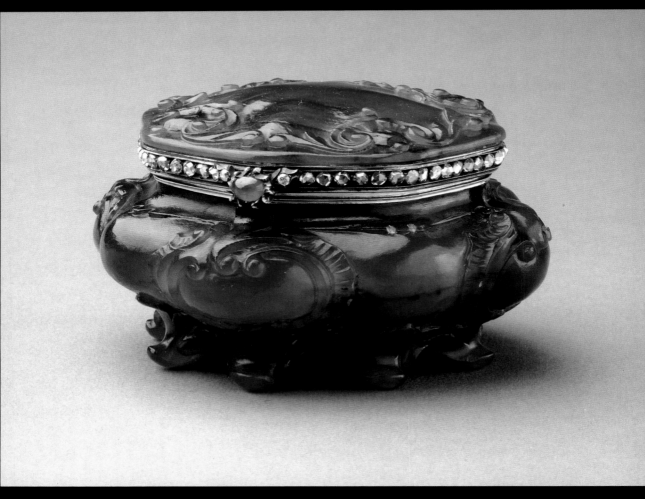

126

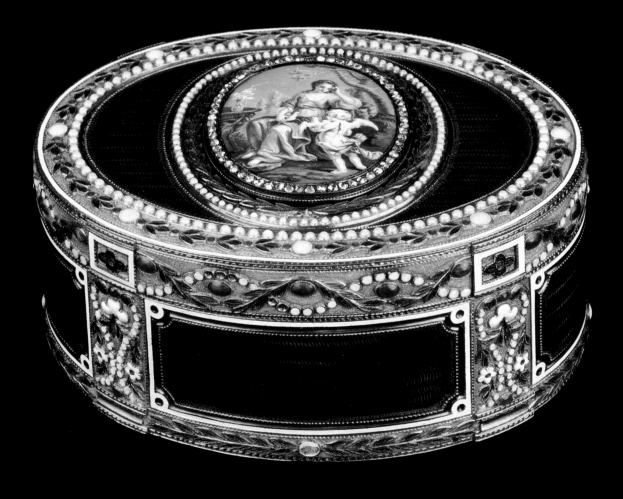

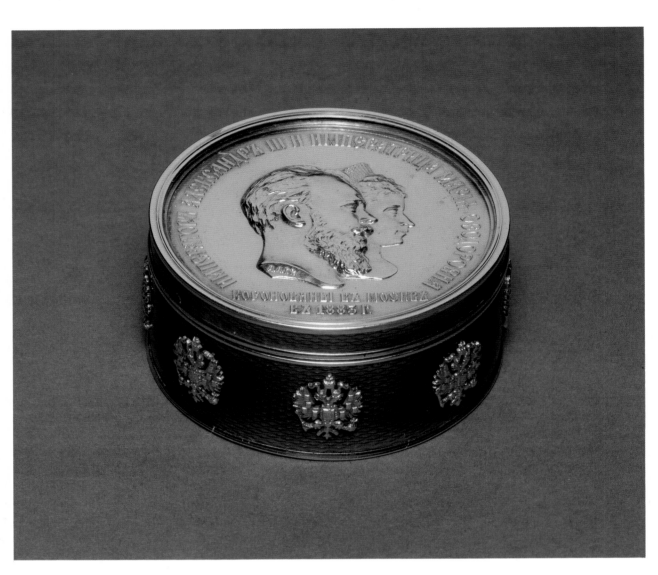

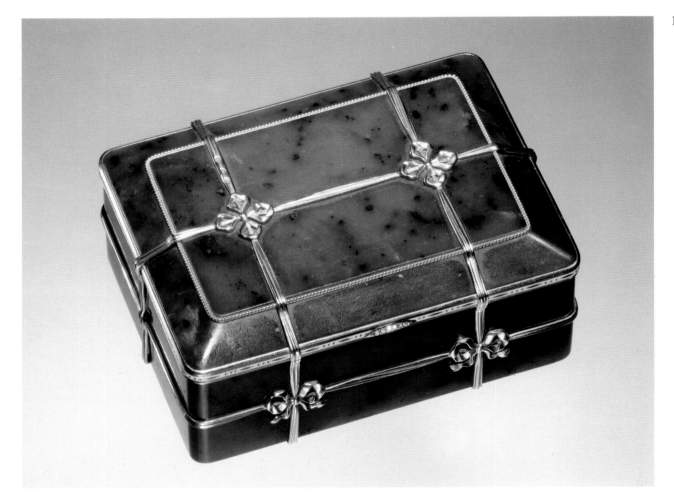

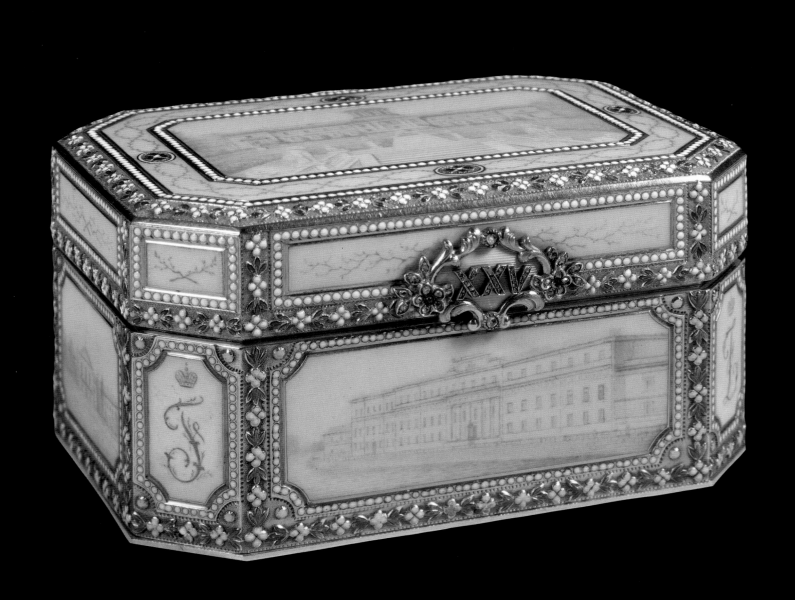

FRAMES AND CLOCKS

Most frequently, frames and clocks were produced in the neo-classical Louis XVI or Empire styles, and less frequently in the neo-rococo manner. Often rather severe forms were used (for example, circular or rectangular), and the attractive result was attained purely by the expert enameling of the patterned surfaces in translucent colors.

Imperial desks, in addition to accommodating a Fabergé clock, were laden with photographs of imperial relatives, mostly contained within enameled or jeweled frames of silver or gold. The fire-screen frame, now in the Forbes collection, demonstrates the highly accomplished use of vari-colored gold. Red, yellow, green, and white gold were used in the applied foliate swags to produce a lavish effect. The different shades were achieved by mixing pure gold with other metals such as copper, for red gold and silver, for white. Pure gold is in any case too soft to be used without the addition of a hardening metal.

Clocks were among the rarest of the goldsmith's productions. Some display a highly skilled execution of a whimsical and imaginative idea, such as the "man in the moon clock." Hardstones were also used to great effect. Nephrite was the stone most often chosen, although a simple cube-form clock of lapis-lazuli was perhaps one of Fabergé's most elegant creations. The movements were supplied from Switzerland by the firm of Henry Moser & Cie. Some imperial Easter eggs also took the form of clocks—as, for example, the Cuckoo Egg. At least one clock was made in the form of a miniature table.

131. Fabergé. Workmaster Johan Victor Aarne. **Lattice-work Frame.** ca. 1891–1899. Height 4¼″ (11.5 cm). *This is one of the most lavish of Fabergé's decorative frames. Four different colors of gold intertwine to create the background for Nicholas II's photograph. The lattice work of white enamel is bordered by sheaths of gold topped with scarlet enameled finials. The flowers themselves are tiny seed pearls that also encircle the portrait. The Forbes Magazine Collection, New York.*

132. Fabergé. Workmaster Johan Victor Aarne, St. Petersburg. **Revolving Photograph Frame.** 1891– 1899. Height 9″ (22.8 cm). *Mounted on a pale green bowenite stand, a central silver-gilt stand holds eight double-sided frames containing photographs of the British, Danish, Russian, and Greek royal families. The Forbes Magazine Collection, New York.*

133. Fabergé. Workmaster Carl Gustav Hjalmar Armfelt, St. Petersburg. **Gold-mounted, Enameled, and Jeweled Double Frame.** ca. 1900. Height 3¼″ (8.3 cm). *Each gilded silver frame is enameled translucent pale blue and is surmounted by a gold bow-knot centered by a cabochon ruby. The upper part is applied with two four-color gold floral garlands above an oval aperture which contains photographs of Alexandra Feodorovna and Nicholas II. The frame is raised on* toupie *feet, and the corners are set with cabochon rubies. Copyright 1979, Sotheby's, Inc., New York.*

134. Fabergé. Workmaster Carl Gustav Hjalmar Armfelt, St. Petersburg. **Silver-gilt and Translucent Enamel Photograph Frame.** ca. 1900. Length 11″ (28 cm). *This rectangular frame is enameled*

170

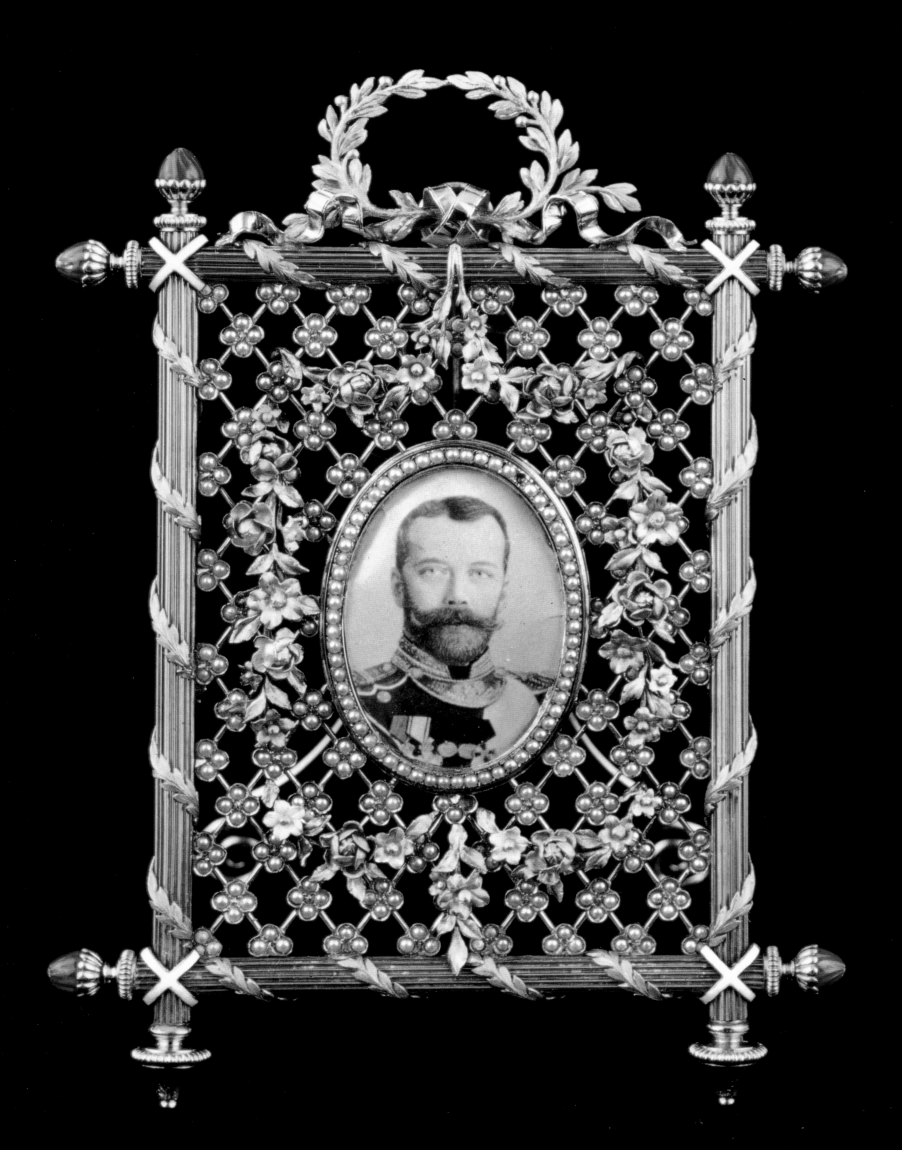

translucent pale blue over a guilloché ground. The outer border is reeded and ribbon-tied, and the inner border is reeded. The frame is applied with ribbon-tied swags of acanthus leaves which are pendent from a ribbon bow. It contains a photograph of Nicholas II and sixteen of his relatives, as follows: (Standing) Grand Duchess Tatiana, daughter of Nicholas II; a lady-in-waiting to the Czarina; Grand Duchess Victoria Feodorovna, wife of Grand Duke Cyril; Grand Duchess Olga, daughter of Nicholas II; Grand Duke Cyril, son of Grand Duke Vladimir; Marina, daughter of Grand Duchess Elena and future Duchess of Kent; Olga, daughter of Grand Duchess Elena and future Prince Paul of Yugoslavia; Grand Duchess Anastasia, daughter of Nicholas II; Elizabeth, daughter of Grand Duchess Elena; Grand Duchess Marie, daughter of Nicholas II; (Seated) Grand Duchess Marie, mother of Grand Duke Cyril, Boris, and Andrew, and wife of Grand Duke Vladimir, brother of Alexandra III; Czarina Alexandra Feodorovna; Nicholas II; Grand Duchess Elena, wife of Prince Nicholas of Greece; Grand Duke Boris, son of Grand Duke Vladimir; "Bobtail" the dog belonging to Grand Duchess Olga, sister of Nicholas II; Grand Duke Andrew, son of Grand Duke Vladimir. Courtesy of Hillwood Museum.

135. Fabergé. Workmaster Carl Gustav Hjalmar Armfelt, St. Petersburg. **Double-sided Pivot Frame.** ca. 1900. Height 10″ (25.4 cm). *Czar Nicholas II and King George V are pictured arm in arm in this simple wooden frame. Fluted wooden columns form the supports, with silver bands lashing them together. The frame is topped by the crowned double-headed imperial eagle.* The Forbes *Magazine Collection, New York.*

136. Fabergé. **Heart-shaped Surprise Frame.** 1897. Height 3¼″ (8.2 cm). *This was a gift from Czar Nicholas II to the Czarina Alexandra Feodorovna to celebrate the birth of their daughter the Grand Duchess Tatiana. The small frames, when closed, form a heart enameled translucent red over a guilloché ground with the date 1897 in diamonds. When opened, they reveal heart-shaped green frames producing a clover-like shape. Each miniature, of Grand Duchess Tatiana, Nicholas II, and Alexandra Feodorovna, is surrounded by an oval of diamonds. The base of the frame is red enamel adorned with small gold laurel bands and pearls.* The Forbes *Magazine Collection, New York.*

137. Fabergé. Workmaster Michael Perchin, St. Petersburg. **Gold, Enamel, and Jeweled Flower-form Miniature Frame.** ca. 1903. Height 6⅛″ (15.5 cm). *This frame, in the form of a pansy, contains miniatures of the five children of Nicholas II and Alexandra Feodorovna. They are the Grand Duchesses Maria, Olga, Tatiana, and Anastasia, and the Czarevich Alexei. The miniatures are mounted within diamond-set borders. The gold stem is set in a rock crystal vase engraved with the Roman numeral X. The frame was a gift from Nicholas II to Alexandra Feodorovna on their tenth wedding anniversary, 26 November 1904. The Armory Museum, Moscow.*

138, 139. Fabergé. Workmaster Henrik Wigström, St. Petersburg. **Fire Screen Frame.** 1914–1917. Height 7⅛″ (18 cm). *Four-color gold and white enamel combine to make this one of the most innovative of all of Fabergé's frames. The oval aperture is surrounded by seed pearls, a pattern of gold husks, and garlands of four-color gold flowers. The stand, resembling a fire screen, is held by thin white columns around which flower garlands are entwined. It is raised by scroll supports and is crowned with an imperial wreath. The frame contains photos of Nicholas II and Alexandra Feodorovna.* The Forbes *Magazine Collection, New York.*

140. Fabergé. Workmaster Johan Victor Aarne, St. Petersburg. **Silver and Translucent Enamel Photograph Frame.** ca. 1900. Height 2″ (5 cm). *This frame, of rectangular shape, has a lozenge-form inset that is enameled translucent pale blue over a guilloché ground. The surround is enameled translucent pale green over a guilloché ground and is applied with reeds of laurel. Chronological Collection of the Danish Queen, Rosenborg Castle, Copenhagen.*

141. Fabergé. Workmaster Michael Perchin, St. Petersburg. **Rock Crystal Frame.** 1899–1903. Height 4″ (10.2 cm). *This transparent rock crystal frame, etched with an inner border, is interlaced with four-color gold swags suspended from a delicate flower basket at the top of the frame. Diamonds form the*

center of some of the flowers as well as the bottom tassle, which is knotted with a ruby. A row of tiny diamonds borders the photograph of the Grand Duchess Marie, third daughter of Czar Nicholas II. The Forbes *Magazine Collection, New York.*

142. Fabergé. **Gold and Enamel Miniature Frame.** Workmaster Johan Victor Aarne, St. Petersburg. ca. 1900. Height 1⅞″ (4.9 cm). *The frame, enameled translucent pink over a guilloché ground, has borders formed by enameled rods with pearl finials. The photograph is of Princess Louise (later Princess Royal), Duchess of Fife.* **Gold and Enamel Miniature Frame.** ca. 1890. Height 2½″ (6.2 cm). *A photograph of Princess Maud of Wales is contained in this oval frame, which is enameled translucent blue over a guilloché ground.* **Gold and Translucent Enamel Miniature Frame.** Workmaster Johan Victor Aarne, St. Petersburg. ca. 1900. Height 1⅝″ (4.2 cm). *This frame is enameled translucent pale green over a sun-ray ground and is set with diamonds and pearls. The photograph is of Maud, Princess Charles of Denmark. The Royal Collection, London.*

143. Fabergé. Workmaster Johan Victor Aarne, St. Petersburg. **Silver-gilt and Translucent Enamel Photograph Frame.** ca. 1890. Height 3½″ (9 cm). *This triangular frame is enameled translucent orange over a guilloché ground and contains a photograph of Queen Louise of Denmark. The aperture is bordered by pearls. Chronological Collection of the Danish Queen, Rosenborg Castle, Copenhagen.*

144. Fabergé. Workmaster Michael Perchin, St. Petersburg. **Silver-gilt and Translucent Enamel Photograph Frame.** ca. 1890. Height 3⅞″ (9.8 cm). *Enameled translucent orange over a moiré ground and is surrounded by a ribbon bow, the frame contains a photograph of Queen Alexandrine of Denmark. Chronological Collection of the Danish Queen, Rosenborg Castle, Copenhagen.*

145. Fabergé. Workmaster Henrik Wigström, St. Petersburg. **Gold, Nephrite, Enameled, and Jeweled Imperial Presentation Miniature Frame.** ca. 1910. Height 4⅞″ (12.5 cm). *This frame is mounted with a miniature of Nicholas II, bordered by diamonds, and surmounted by a diamond-set crown. The ground is enameled translucent ivory over a sun-ray field and applied with diamond-set wreaths in the corners. The outer nephrite border has a gold edge chased with acanthus leaves. The ivory back has a gold strut. Copyright 1980, Sotheby's, Inc., New York.*

146. Fabergé. **Gold, Silver, and Translucent Enamel Desk Clock.** Workmaster Michael Perchin, St. Petersburg. ca. 1890. Height 4⅜″ (11 cm). *This octagonal clock is enameled translucent purple over an engine-turned sunburst ground. It is applied with garlands of gold flowers.* **Silver and Translucent Enamel Desk Clock.** Workmaster Michael Perchin, St. Petersburg. ca. 1900. Height 8⅛″ (20.5 cm). *This rococo-style clock is enameled translucent rose pink over a guilloché ground. It is applied with foliate scrolls, which also form the borders.* **Gold, Silver, Enameled, and Jeweled Cigarette Case.** Workmaster Michael Perchin, St. Petersburg. ca. 1890. Length 4″ (10.2 cm). *This case is enameled translucent apricot over a guilloché ground. The cover is applied with gold leafy scrolls set with diamonds. It has a molded gold mount and a diamond thumbpiece.* **Nephrite, Gold, Jeweled, and Enameled Imperial Presentation Box.** Workmaster Henrik Wigström, St. Petersburg. ca. 1900. Width 3⅛″ (8 cm). *The cover of this carved nephrite box is applied with a trellis of diamonds and ruby-set flowers. The center is set with the diamond-set monogram of Nicholas II mounted on a translucent oyster enamel ground and bordered by diamonds. The cabochon ruby thumbpiece is flanked by a jewel-set flower spray. Copyright 1985, Sotheby's, Inc., New York.*

147. Fabergé. **Gold-mounted, Silver-gilt, and Translucent Enamel Cigarette Case.** Workmaster Henrik Wigström, St. Petersburg. ca. 1900. Length 4″ (10.2 cm). *This case is of oval section and enameled translucent oyster over a guilloché ground. The gold border is chased with acanthus leaves, and the thumbpiece is set with a cabochon ruby. The lower border of the hinged cover is set with seed pearls.* **Silver-gilt and Translucent Enamel Desk Clock.** Workmaster Michael Perchin, St. Petersburg. ca. 1890. Diameter 4¼″ (11 cm). *This clock is enameled translucent steel gray over a guilloché ground. The outer border of the clock is reeded and chased with leaves, and the inner gold border is chased with acanthus leaves. Copyright 1984, Sotheby's, Inc., New York.*

148. Fabergé. **Silver and Translucent Enamel Desk Clock.** Workmaster Michael Perchin, St. Petersburg. ca. 1900. Height 4″ (10.2 cm). *This square clock is enameled translucent red over a sun-ray ground and is raised on two toupie feet. The border of the clock is reeded and applied with ribbon bows between crossed arrows. The outer border is chased with leaf tips.* **Lyre-form Table Clock.** Workmaster Michael Perchin, St. Petersburg. ca. 1890. Height 7″ (17.8 cm). *The circular dial is mounted within a lyre-form, flanked by berried foliage and surmounted by a female mask on a sunburst ground. The outline is set with brilliants. The oval rose-quartz base is applied with swags of foliage and a band of grapevine above a beaded base. The top is hung with swags of flowers.* **Silver, Enamel, and Jeweled Table Cigarette Box.** Moscow. ca. 1910. Length 5⅛″ (13 cm). *The hinged cover of this casket is enameled en plein by the enameler A. Borozoin, after Vasnetsov's The Prophecy to Oleg, and it is signed by Borozoin. The sides are repoussé and chased in the Old Russian style with architectural ornament. Each arched panel is set with a faceted colored stone. The supports of each corner of the base are in the form of winged lions. Copyright 1983, Sotheby's, Inc., New York.*

149. Fabergé. **Gold and Translucent Enamel Frame.** Workmaster Michael Perchin, St. Petersburg. ca. 1890. Height 4⅜″ (11.3 cm). *The oval is beaded and the border chased with green-gold acanthus leaves.* **Silver and Translucent Enamel Triangular Dish.** Workmaster Anders Nevalainen, Moscow. ca. 1900. Length 4⅜″ (11.3 cm). *Enameled pink over a sun-ray ground, the dish has a ribbon-tied laurel handle.* **Silver and Translucent Enamel Frame.** Moscow. ca. 1890. Height 5¼″ (13.5 cm). *Silver scrolls, flowers, and a ribbon-tied oval surround a gentleman's miniature.* **Bloodstone, Gold, and Enamel Cigarette Case.** Workmaster Michael Perchin, St. Petersburg. ca. 1890. Length 3¾″ (9.7 cm). *The border is white enamel with gold stripes.* **Two-color Gold, Enamel, and Diamond Cigarette Case.** Workmaster Henrik Wigström, St. Petersburg. ca. 1910. Length 3¾″ (9.7 cm). *The rose-gold ground has yellow-gold sprays of foliage.* **Two-color Gold and Translucent Enamel Carnet de Bal.** ca. 1900. Length 3½″ (9 cm). *The center is mounted with a diamond in a gold wreath.* **Four-color Gold and Translucent Enamel Carnet de Bal.** Workmaster Michael Perchin, St. Petersburg. ca. 1900. Length 3½″ (9 cm). *The cover is applied with a wreath and a trophy of love.* **Silver-gilt and Translucent Enamel Desk Clock.** Workmaster Henrik Wigström, St. Petersburg. ca. 1900. *The inner border is chased with acanthus leaves.* **Silver-gilt, Translucent Enamel, and Diamond Cigarette Case.** Workmaster August Hollming, St. Petersburg. ca. 1910. Length 3⅞″ (10 cm). *The sun-ray patterned cover is applied with a diamond-set imperial eagle. Copyright 1982, Sotheby's, Inc., New York.*

150. Fabergé. **Silver and Enamel Table Cigar Box.** Workmaster Julius Rappoport, Moscow. ca. 1900. Length 8¾″ (22 cm). *This box is raised on four paw feet, and the sides of this box are applied with gryphons. The hinged cover is enameled en plein after the painting by Ilya Repin (1844–1930), The Zaporozh Cossacks Writing a Mocking Letter to the Turkish Sultan.* **Silver-gilt and Translucent Enamel Photograph Frame.** Workmaster Anders Nevalainen, St. Petersburg. ca. 1900. Height 6¾″ (17 cm). *This photograph frame is enameled translucent strawberry red over a guilloché ground. It is applied with rosettes and anthemion and is surmounted by a ribbon-tied laurel wreath. The aperture has a band of beading.* **Silver-gilt and Shaded Enamel Cigarette Case.** Moscow. ca. 1910. Length 4¼″ (10.8 cm). *This case is enameled front and back in the Old Russian style with stylized fruit and foliage in muted colors. The cover has a square reserve which is enameled en plein with an interior scene depicting a fortune teller with three young ladies.* **Icon of the Mother of God Smolenskaya.** Moscow. ca. 1910. Height 6⅝″ (17 cm). *This icon has an oklad which is finely enameled in the Old Russian style in shades of blue, green, and gray.* **Silver, Translucent Enamel, Gold, and Wood Photograph Frame.** Workmaster Carl Gustav Hjalmar Armfelt, St. Petersburg. ca. 1910. Height 11¼″ (28.7 cm). *The border of the aperture is enameled translucent lavender over a guilloché ground. The sides are applied with gold rosettes, and each corner has a gold Russian imperial eagle with a pink hardstone cabochon in the center. The silver borders are chased with leaf tips. Copyright 1983, Sotheby's, Inc., New York.*

151. Fabergé. Workmaster Henrik Wigström, St. Petersburg. **Hardstone and Jeweled Table Clock.** ca. 1900. Height 2″ (5 cm). *This clock is carved of a block of lapis-lazuli. The dial is enameled translucent, opalescent white over a guilloché, or engine-turned, ground. The border of the dial is a laurel wreath, which is carved of nephrite and mounted with emeralds with diamond-set ribbons at the top and bottom. The Brooklyn Museum, Brooklyn, New York. Bequest of Mrs. Helen B. Saunders.*

152. Fabergé. Workmaster Henrik Wigström, St. Petersburg. **Lapis-lazuli, Gold, Silver, and Enamel Desk Clock.** ca. 1900. Height 2⅝″ (6.7 cm). *This small, almost cube-shaped clock has a circular dial which is enameled translucent oyster over a sunburst ground. The border of the dial is chased with two-color gold leaf tips and flower heads. Each side of the clock is applied with a two-colored gold wreath of leaf tips and flower heads. Copyright 1985, Sotheby's, Inc., New York.*

153. Bolin. Moscow. **Silver, Onyx, and Enamel Combination Clock and Thermometer.** ca. 1900. Height 9½″ (24 cm). *In the form of a miniature long case clock, the front is applied with a panel of onyx and set with a thermometer. The white enamel dial of the clock is surmounted by a chased silver laurel wreath. The clock has a presentation inscription, "To the Highly Respected Pavel Davidovich Ettinger." The State Historical Museum, Moscow.*

154. Fabergé. Workmaster Michael Perchin, St. Petersburg. **Serpent Clock Egg.** ca. 1885–1890. Height 7¼″ (18.4 cm). *This clock, designed in the Sèvres tradition, is enameled translucent royal blue with opalescent white on the base. Each side of the trilateral base is applied with vari-colored gold decorative devices. A coiled diamond-set serpent indicates the hour with its head and tongue. This egg was probably presented to Marie Feodorovna by Alexander III. Courtesy Wartski, London.*

155. Fabergé. Workmaster Julius Rappoport, Moscow. **Silver and Nephrite Mantel Clock.** ca. 1900. Height 14″ (36 cm). *The oval nephrite base is applied with silver swags of berried foliage. The free-standing gryphon clasps a sword with one arm and a shield in the form of a clock with the other. Copyright 1979, Sotheby's, Inc., New York.*

156. Fabergé. **Table Clock.** ca. 1900. Height 3⅜″ (8.5 cm). *This tiny clock is in the form of a round table, enameled translucent pink over a guilloche ground. The white enamel dial is surrounded by foliate swags. The supports are fluted columns with lion's-paw feet. Between the supports are crossed arrows with central laurel wreaths. The Forbes Magazine Collection, New York.*

157. Fabergé. Workmaster Michael Perchin, St. Petersburg. **Carved Nephrite Table Clock.** ca. 1900. Height 4⅛″ (10.5 cm). *This trapezoidal clock tapers from top to bottom. The white enameled dial is bordered by diamonds. Floral swags, pendent from rubies, are applied above the dial, and below is a vari-colored gold trophy of love. Chronological Collection of the Danish Queen, Rosenborg Castle, Copenhagen.*

158. Fabergé. Workmaster Henrik Wigström, St. Petersburg. **Gold and Translucent Enamel Desk Clock.** ca. 1900. Height 4¾″ (12 cm). *This clock of grenade form is enameled translucent blue-gray over a sun-ray ground. The white enamel dial is bordered by seed pearls and surrounded by a wreath of leaves and berries. Courtesy Wartski, London.*

159. Fabergé. Workmaster Michael Perchin, St. Petersburg. **Silver and Translucent Enamel Table Clock.** ca. 1890. Height 4¾″ (11.9 cm). *The white enameled dial is edged by pearls on this triangular clock. Enameled with translucent oyster over a sun-ray ground, the clock has an enameled blue border. The State Historical Museum, Moscow.*

160. Fabergé. Workmaster Henrik Wigström, St. Petersburg. **Gold, Silver, and Translucent Enamel Table Clock.** ca. 1900. Height 6⅜″ (16.1 cm). *The clock is enameled translucent oyster over a sun-ray ground, and the border is enameled translucent blue. The edge of the dial is chased with laurel, and ribbon-tied swags are applied to the upper sections and secured by ribbon bows. The State Historical Museum, Moscow.*

161. Fabergé. Workmaster Julius Rappoport, St. Petersburg. **Bowenite and Silver-gilt Table Clock.** ca. 1890. Height 11¼″ (28.5 cm). *The body of this clock, in the form of an eighteenth-century commode with silver-mounted drawers, is raised on four lizard-like supports. Two cupids support the dial of the clock, which is surmounted by a bouquet of flowers set with emeralds, rubies, and pearls. On the back of the*

lower part is the monogram, in Cyrillic, of Marie Feodorovna below an imperial crown. On each side of the clock case is an oval panel which opens to reveal miniatures of Nicholas II and his wife, Alexandra Feodorovna. The clock was a gift from Nicholas and Alexandra to the Dowager Empress Marie Feodorovna. Courtesy of Hillwood Museum.

162. Fabergé. Workmaster Michael Perchin, St. Petersburg. *Polar Star* **Clock.** ca. 1890. Width 5¼" (13.5 cm). *This gold, nephrite, and enamel eight-pointed table clock is in the form of a compass rose. The white enamel dial has black Arabic numerals. The border of the dial is enameled translucent white with diamond-set ties, and the nephrite surround is set with gold spokes in the form of phyrsi. The points of the star are enameled translucent pink with dendritic motifs over an engine-turned ground with a sunburst design. This clock was designed for use aboard the imperial yacht,* Polar Star. *Copyright 1983, Sotheby's, Inc., New York.*

163. Fabergé. Workmaster Michael Perchin, St. Petersburg. **Silver Desk Clock in the Form of a Rose.** ca. 1885. Width 5⅛" (13 cm). *This rose, realistically modeled, is in full bloom. It has leaves on the stem and a white enamel dial bordered by brilliants. Copyright 1979, Sotheby's, Inc., New York.*

164. Fabergé. Workmaster Henrik Wigström, St. Petersburg. **Globe Clock.** ca. 1900. Height 8½" (21.5 cm). *This nephrite desk clock has a white enamel face and gold hands. On top is a rock crystal globe etched with the shapes of the seven continents. It is held in a gold bracket with gold crossbars. The globe is motorized and tilts and turns as the hours pass. Private collection.*

165. Fabergé. Workmaster Henrik Wigström, St. Petersburg. **Silver-gilt and Translucent Enamel Desk Clock.** ca. 1910. Height 4¼" (10.5 cm). *The Man in the Moon panel in the center of the dial is carved of rock crystal bordered by seed pearls. The surround is enameled translucent dark blue over a guilloché ground and is set with diamond stars. Courtesy Wartski, London.*

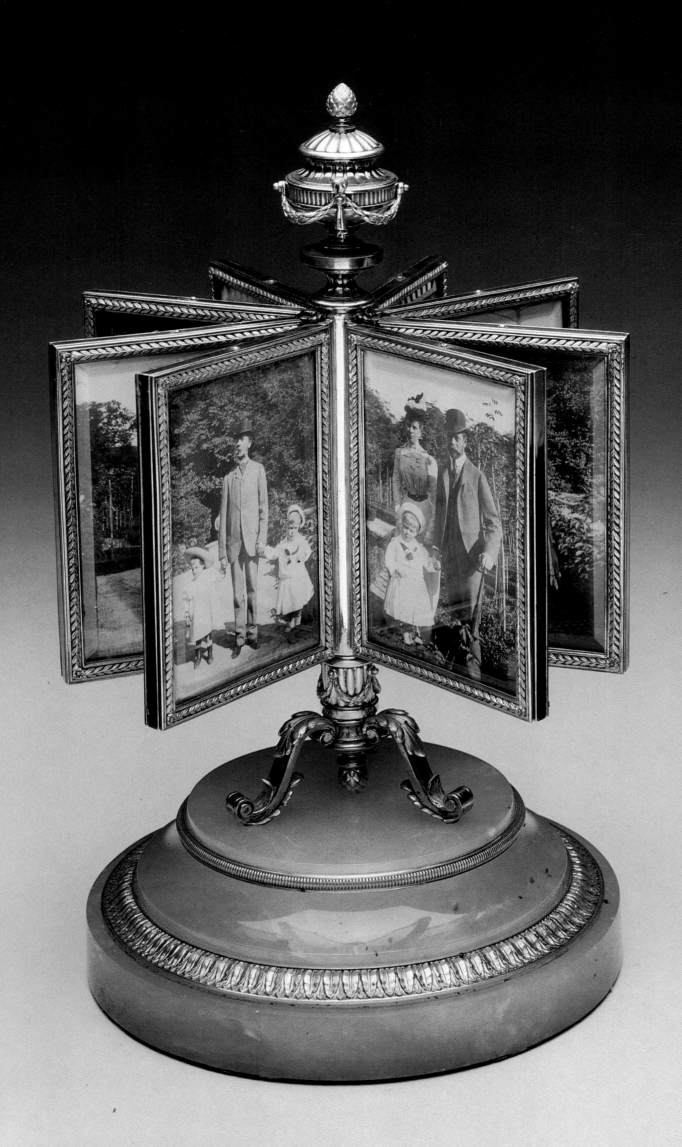

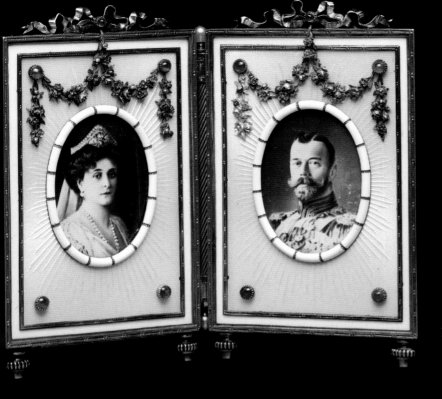

133

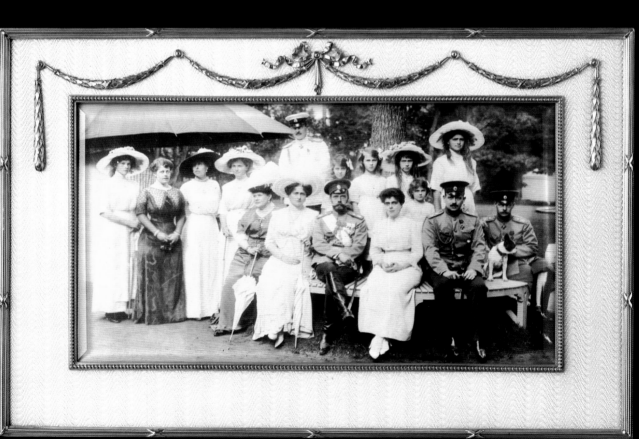

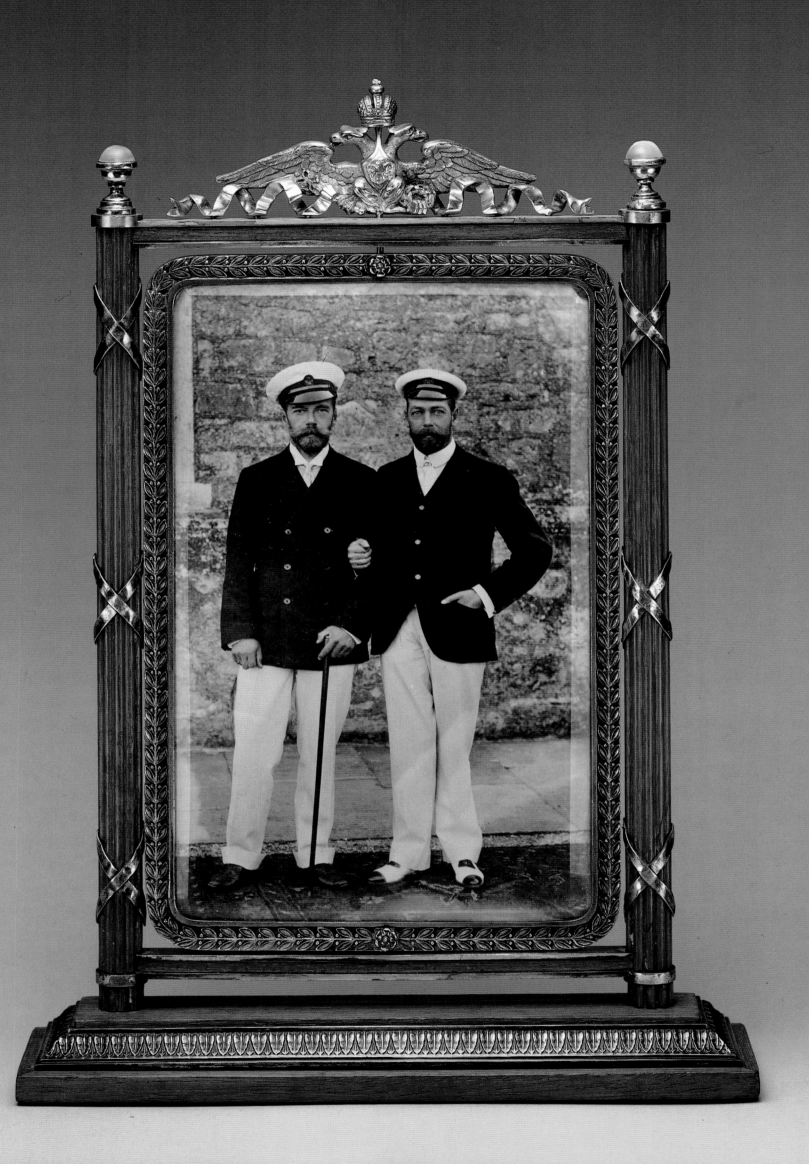

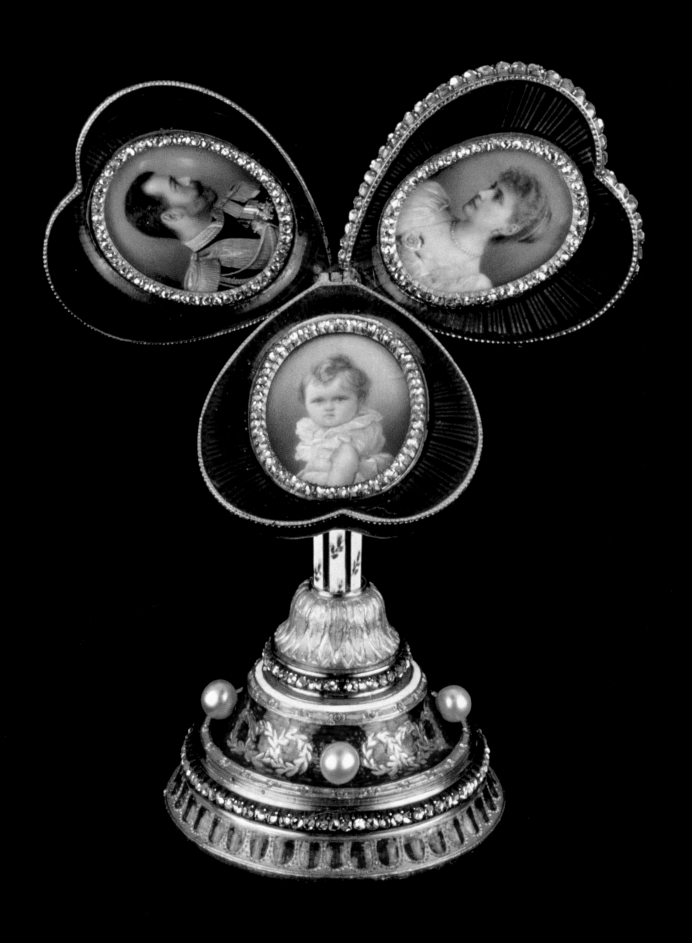

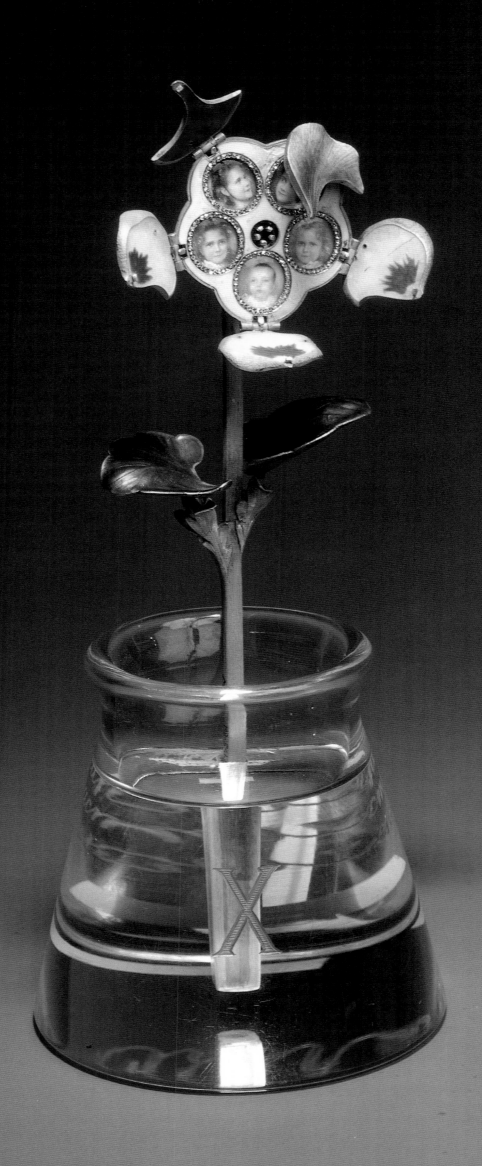

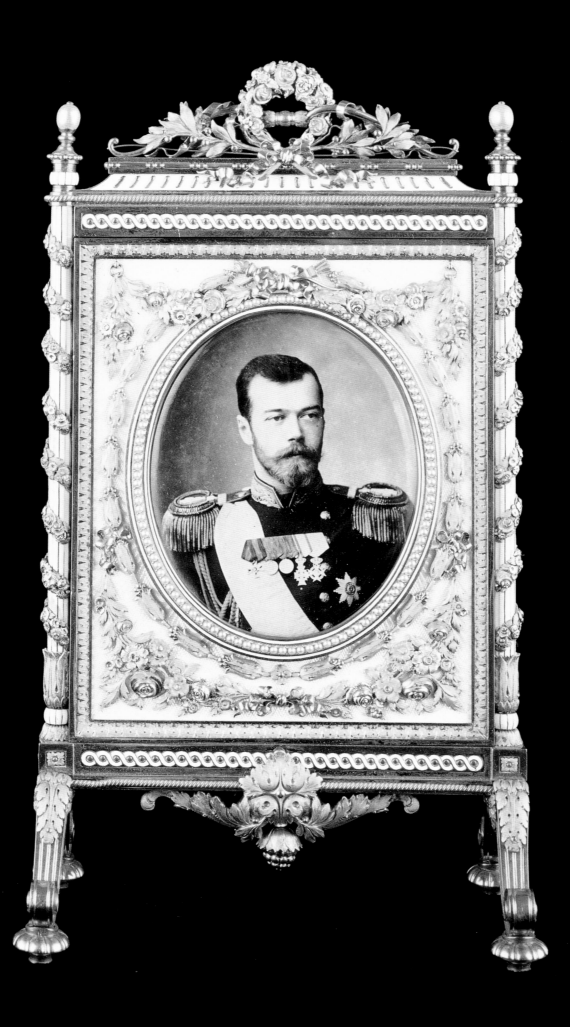

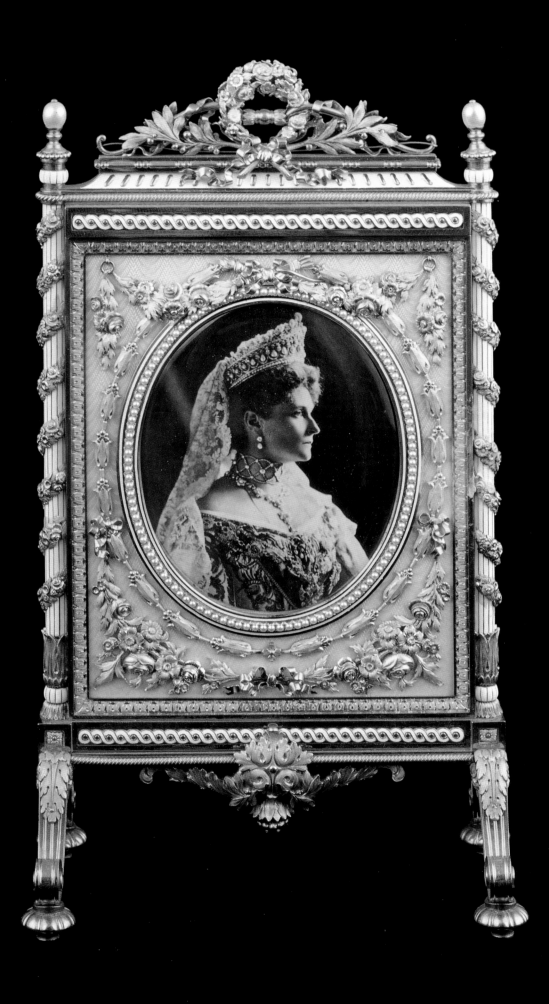

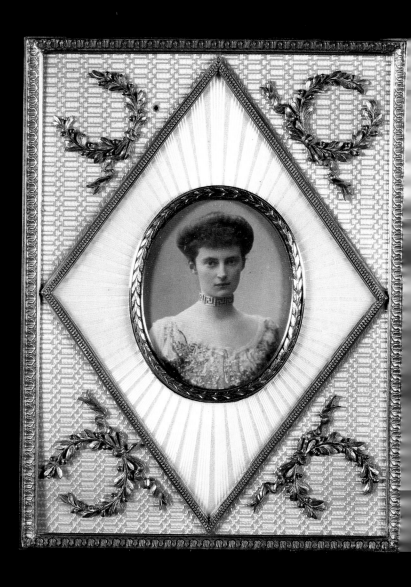

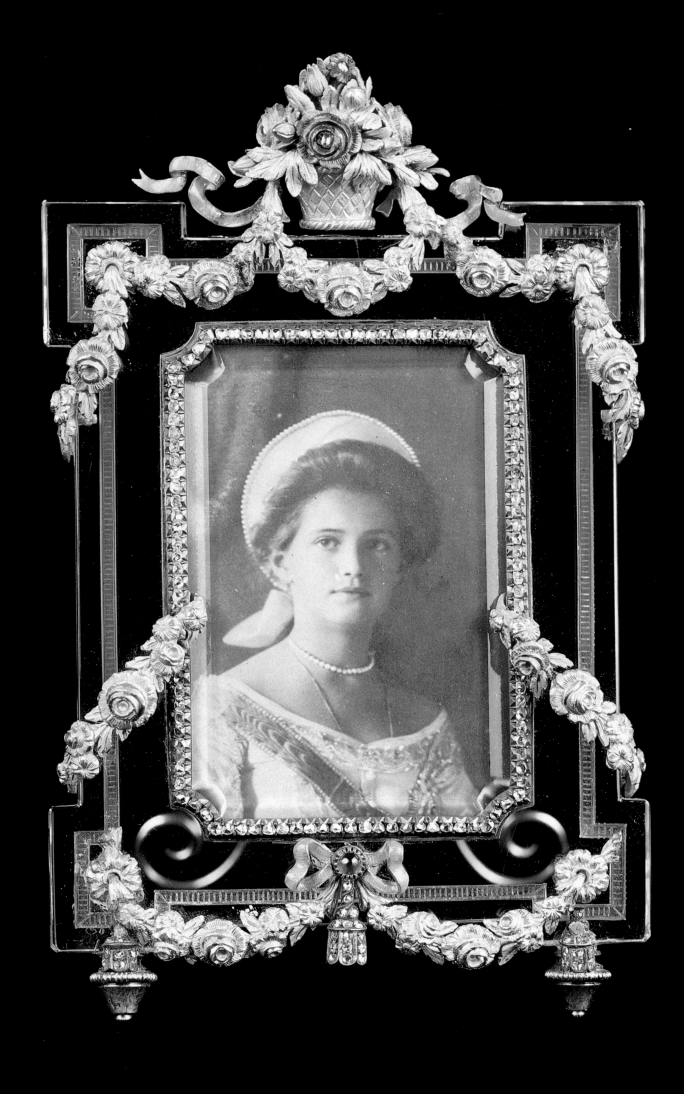

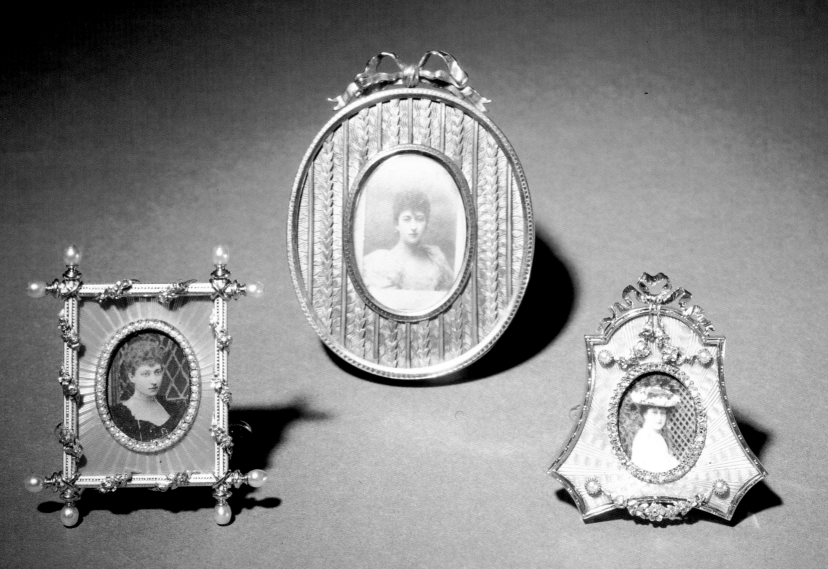

142

145

147

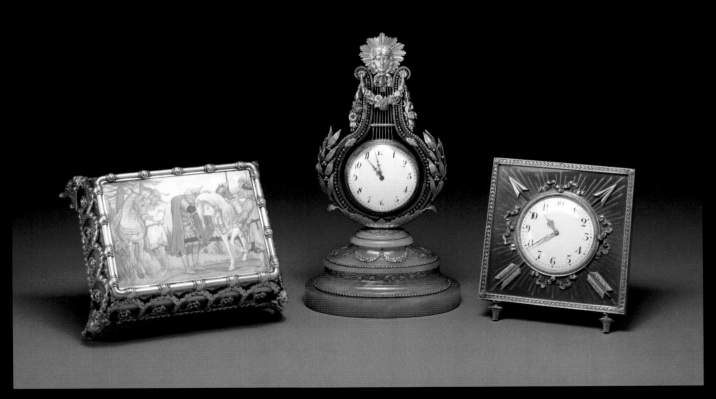

148

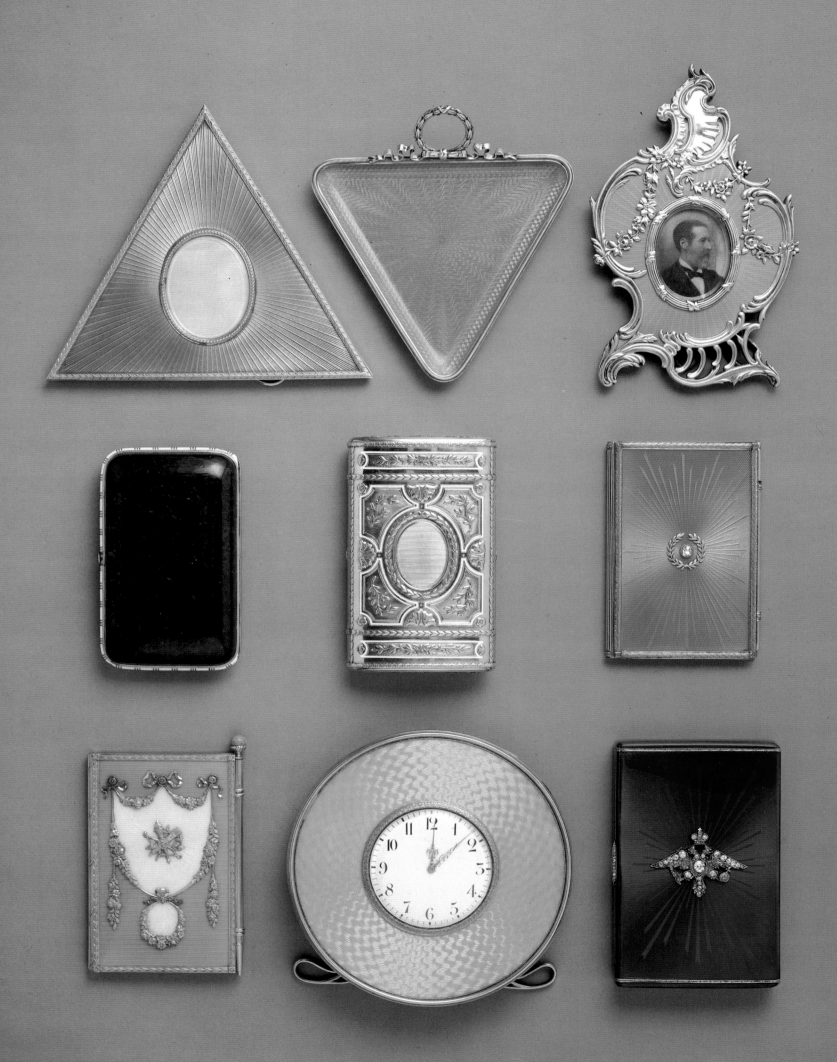

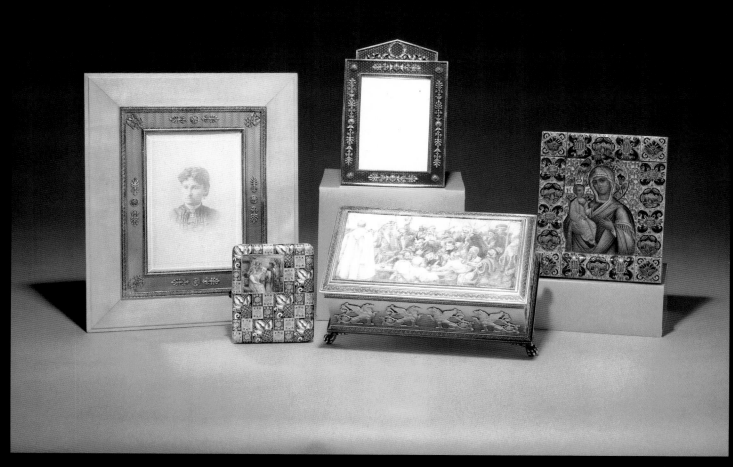

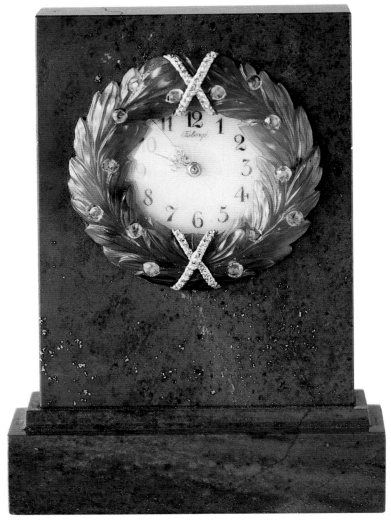

151

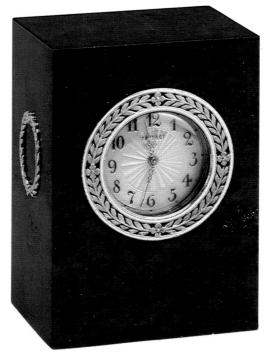

152

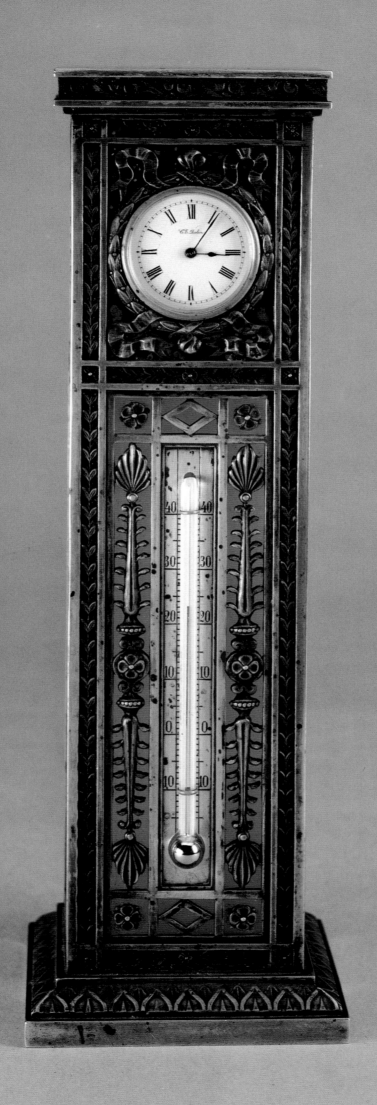

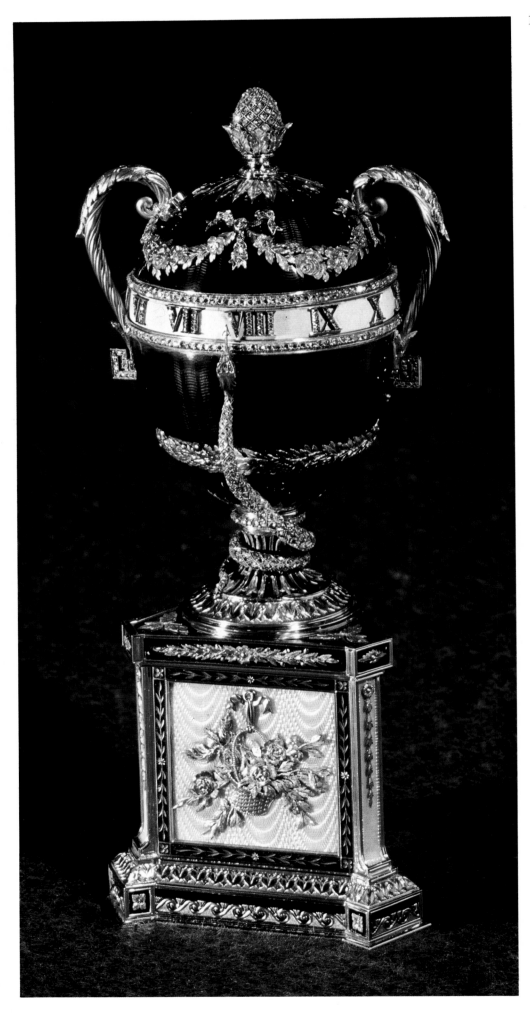

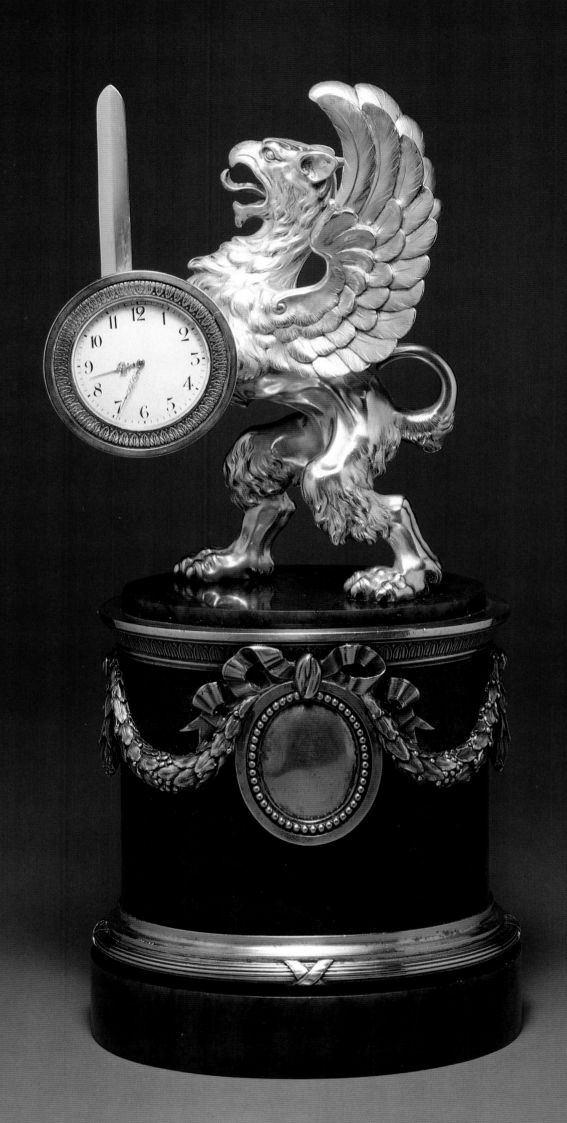

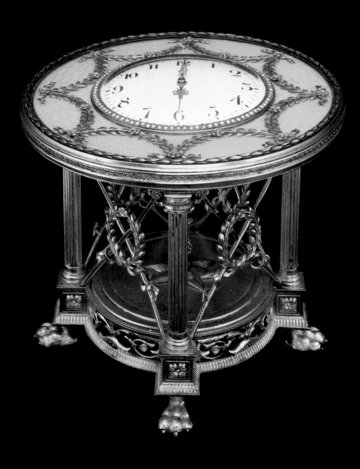

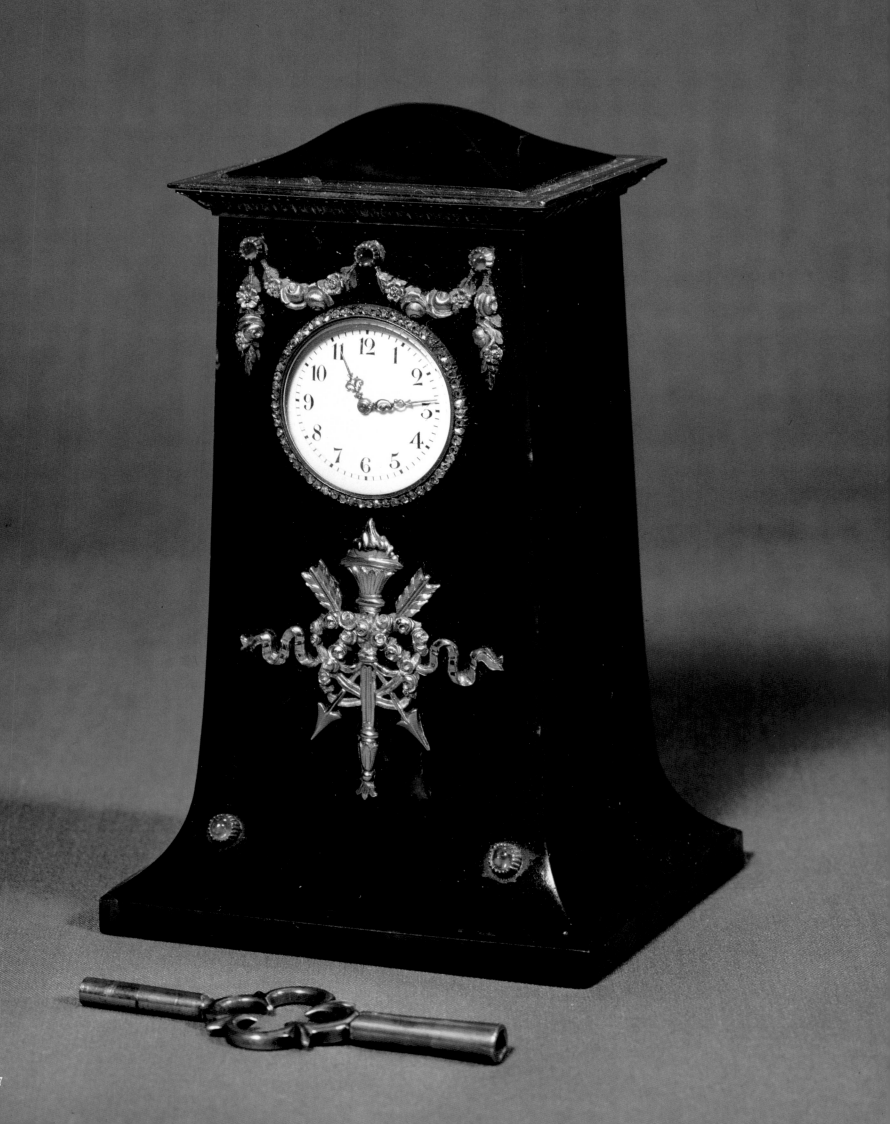

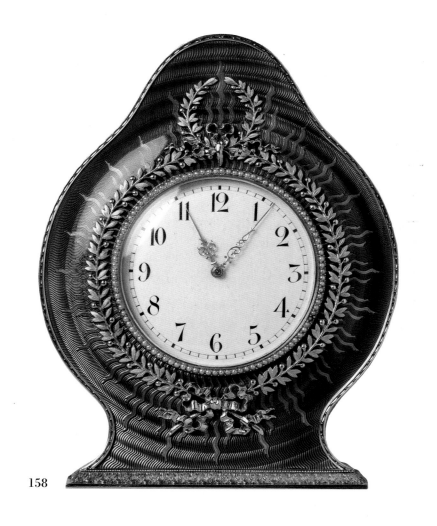

158

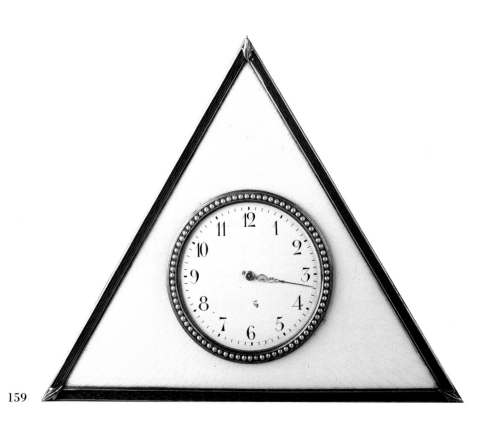

159

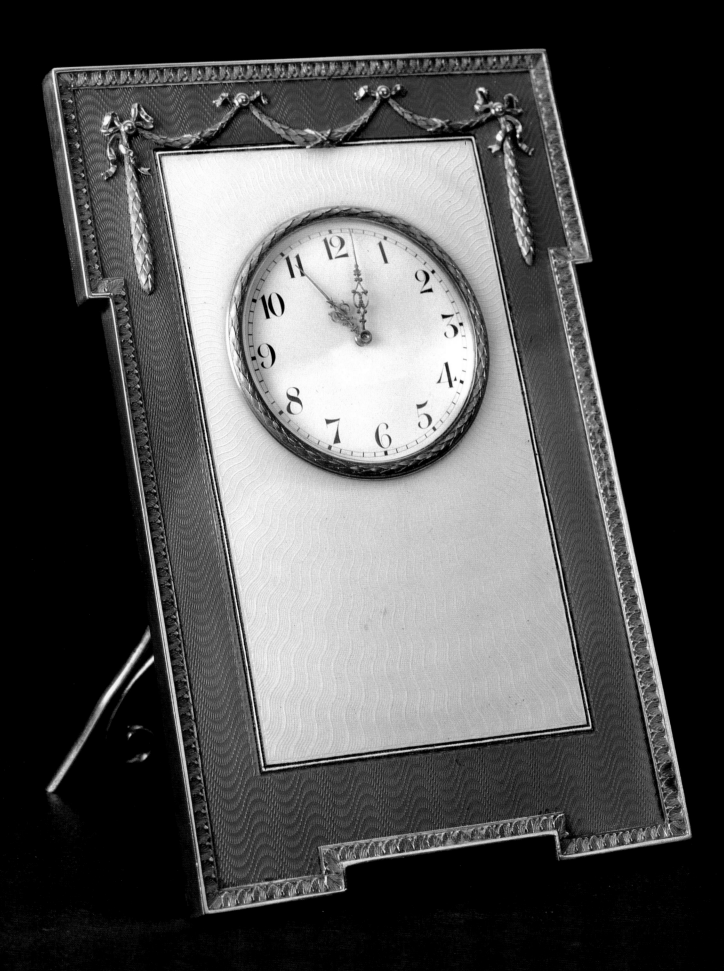

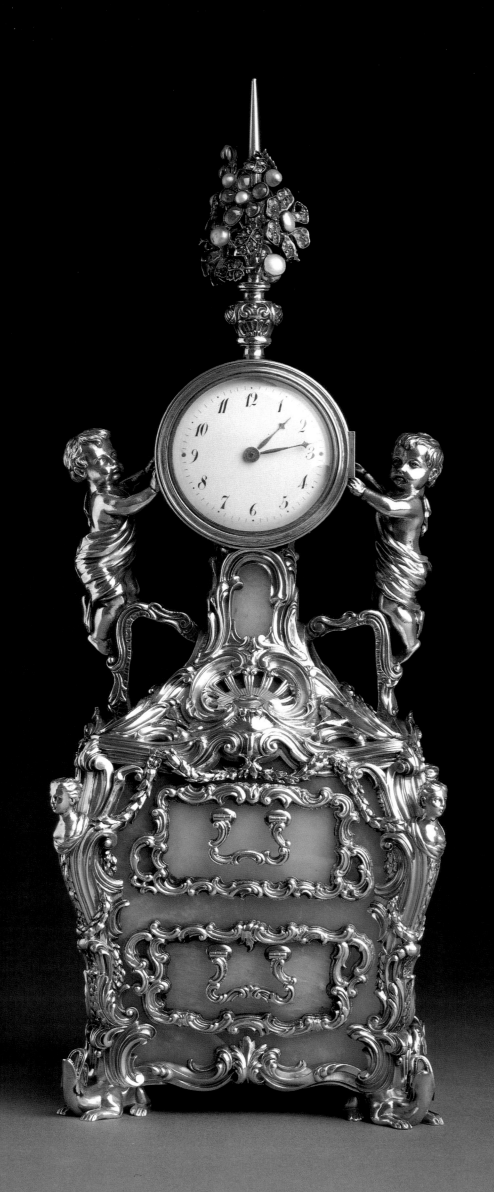

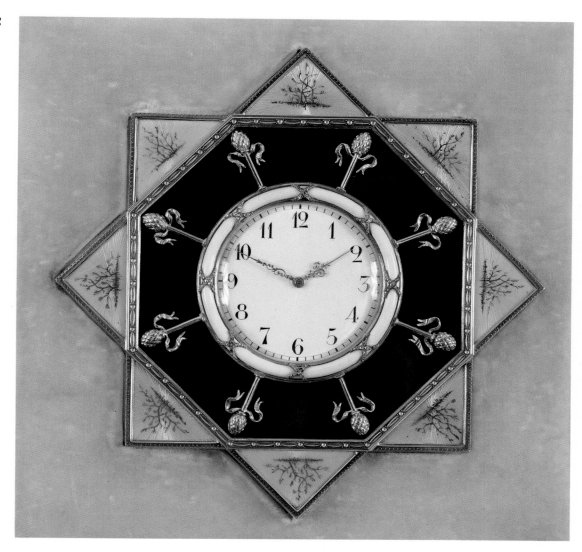

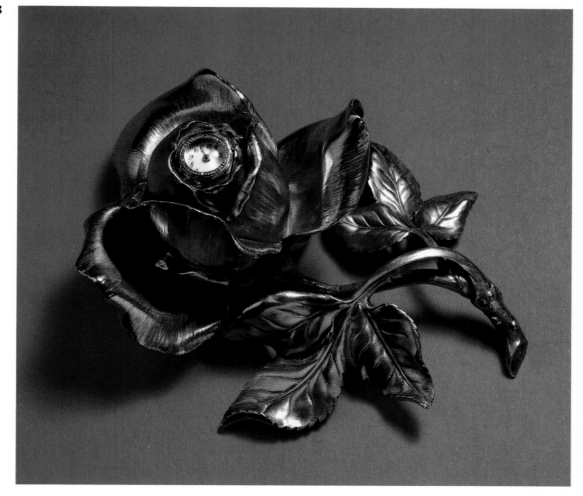

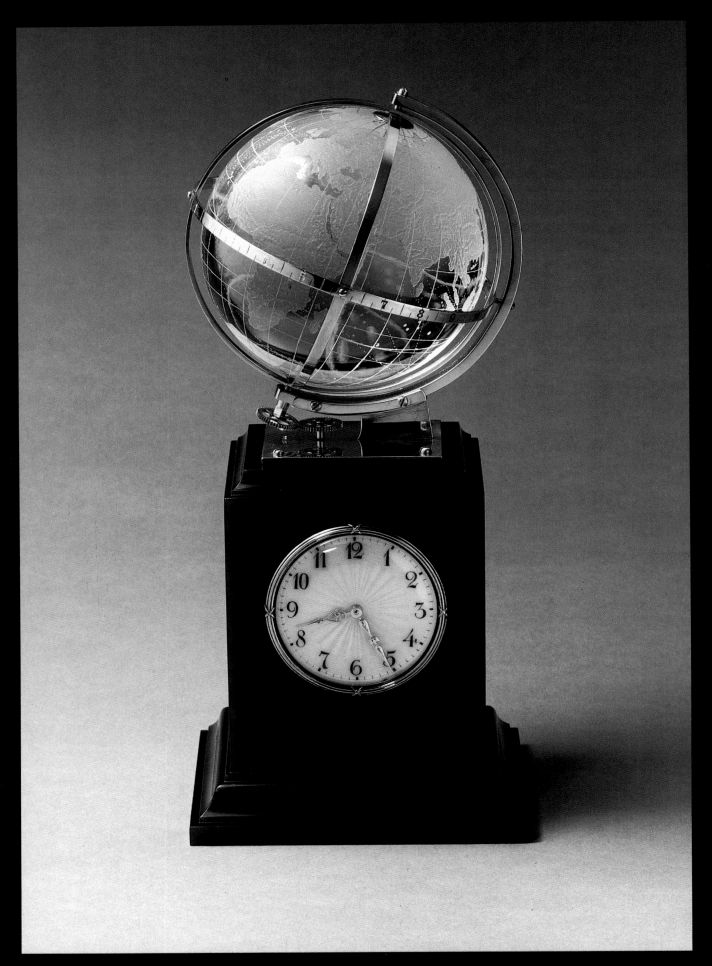

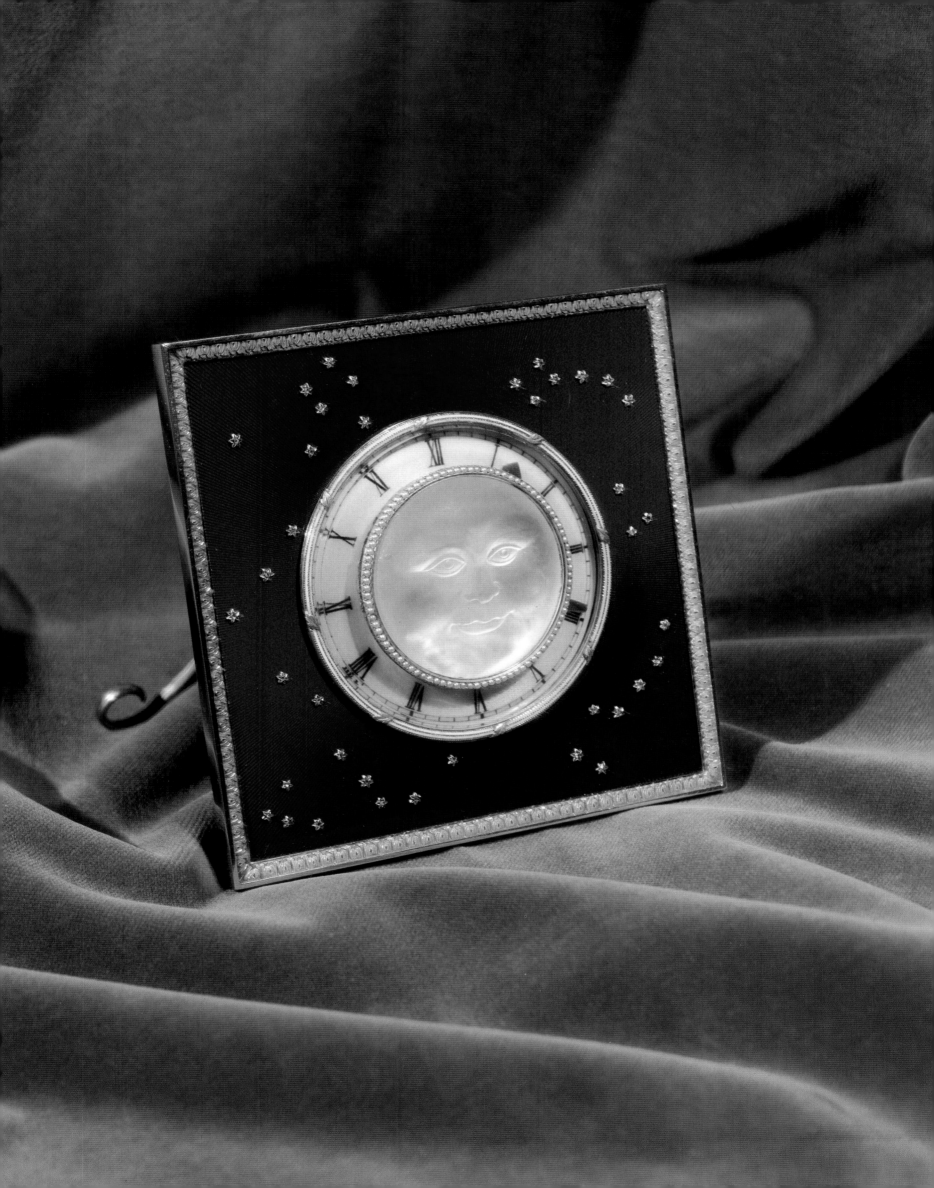

RELIGIOUS OBJECTS

Following the fall of Constantinople, the center of Christian Orthodoxy moved to Russia, and for hundreds of years of Russian history the state was inseparably linked with the Christian Church. The Russian goldsmiths made liturgical plate for the altar as well as covers for icons. The tradition of commissioning silver or gold and jeweled *oklads*, or covers, for revered icons dates back centuries. In 1657, Patriarch Nikon ordered a gold oklad for the twelfth-century icon of the Vladimir Mother of God, the palladium of the Russian state. By the nineteenth century, icons and their covers of silver were being produced contemporaneously. Chalices of silver or gold were applied with enameled plaques of the Saviour and the Mother of God, and similar enamels are to be found on bishops' mitres.

166. Olovyanishnikov. Moscow. **Bishops Mitre.** ca. 1910. Height 7⅝″ (19.5 cm). *This velvet mitre is embroidered with a floral design with mother-of-pearl beads and gold threads. It is mounted with eight silver-gilt plaques enameled with Christ's crucifixion and the Deesis and with cherubim. The top has a circular plaque engraved with a dove, a symbol of the holy spirit. The State Historical Museum, Moscow.*

167. Maker unknown. Moscow. **Silver and Enamel Wedding Crown.** ca. 1900. Height 7¾″ (19.7 cm). *This crown is chased with icons of the Mother of God, Saints Constantin and Helena, and the Archangel Michael. The State Historical Museum, Moscow.*

168. Fabergé. Moscow. **Icon of the Odigitria Mother of God with Silver-gilt and Jeweled Oklad.** ca. 1910. Height 11⅞″ (30 cm). *This piece is a companion to the icon of Christ Pantocrator, and the oklad is similarly decorated. Virginia Museum of Fine Arts, Richmond, Virginia, the Bequest from the Estate of Lillian Thomas Pratt.*

169. Olovyanishnikov. Moscow. **Icon of the Virgin of Tenderness.** ca. 1910. 12¼ × 10⅝″ (31 × 27 cm). *This icon has a colorful enamel oklad. The State Historical Museum, Moscow.*

170. Ovchinnikov. Moscow. **Icon of the Virgin Lactans.** 1884. 12½ × 10¼″ (32 × 26 cm). *The silver-gilt oklad is enameled with colorful foliate borders, while the robes of the Mother of God and Christ are woven with pearls. The State Historical Museum, Moscow.*

171. Alexander Mukhin. Moscow. **Icon of the Kazan Mother of God.** 1896. 12¼ × 10½″ (31.3 × 26.8 cm). *The silver-gilt oklad is fitted with enameled halos, and the robes are sewn with pearls. The State Historical Museum, Moscow.*

172. Ivan Alexeyev. Moscow. **Presentation Icon of St. Alexander Nevsky and Lydia: A Wedding Icon.** ca. 1900. 12¼ × 10½″ (31 × 26 cm). *The halos, canopy, and spandrels are decorated with scrolls and flowers executed in multicolored shaded enamel on opaque white enamel grounds. The sides and base are bordered by enamel columns. The halos are set with red stones, and the back has a silver plaque which is*

206

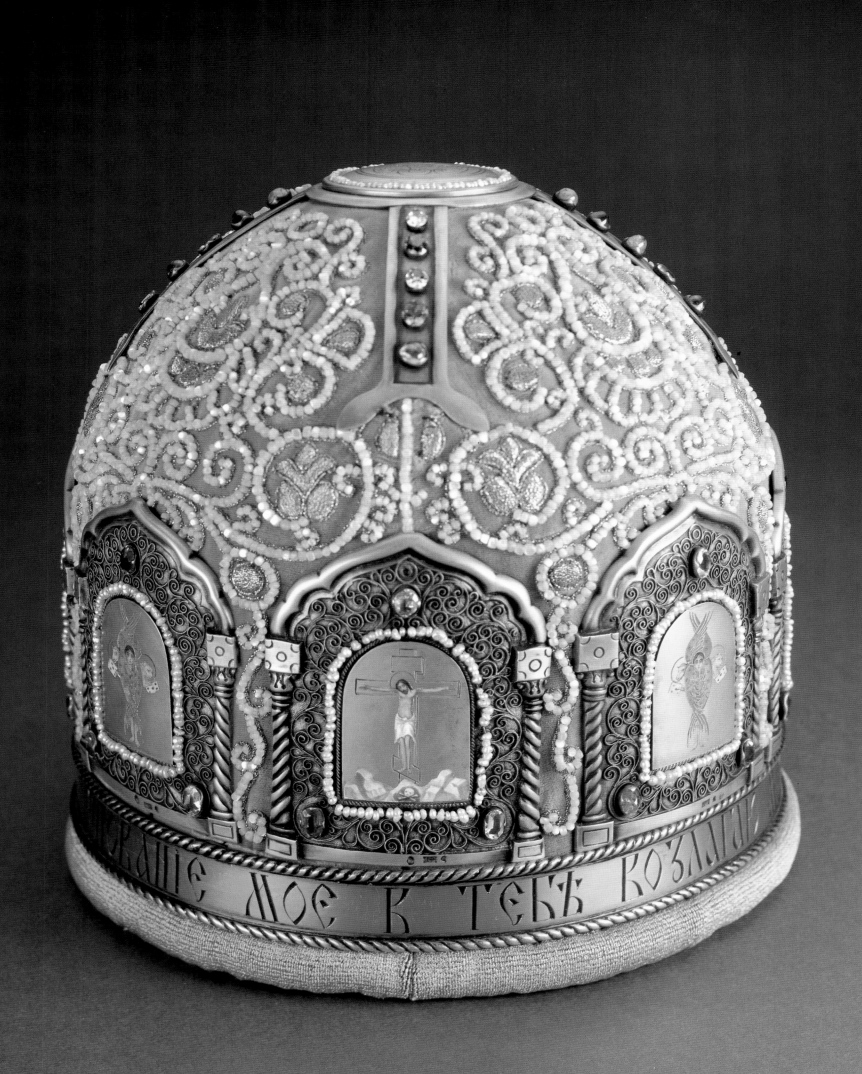

inscribed, "To the esteemed Alexander Petrovich and Lydia Vasilievna Sorokoumovsky from the grateful Moscow employees to commemorate their wedding, 6 June 1905." Copyright 1989, Sotheby's, Inc., New York.

173. Fabergé. Moscow. **Icon of Christ Pantocrator with Silver-gilt and Jeweled Oklad.** ca. 1910. Height 12″ (30 cm). The border is applied with filigree scrollwork and is mounted with colored stones, seed pearls, and diamonds. Virginia Museum of Fine Arts, Richmond, Virginia, Bequest from the Estate of Lillian Thomas Pratt.

174, 175. Ovchinnikov. Moscow. **Icon Triptych.** 1889. 9 × 15½″, open (22.8 × 39.6 cm). The center panel is painted with the Transfiguration of Christ, and the wings are painted with St. Peter and St. Paul on one side, and St. Vladimir on the other side. The central panel is inscribed, in Cyrillic, "For Great Deeds Performed at the Battle of Kulm, 17 August 1813." The exterior of this triptych is enameled with colorful foliage within borders of white beads. This icon was a presentation to Vladimir Vasilyevich Pensky from his comrades of the Preobrazhensky regiment, including the Czarevich Nicolai Alexandrovich, and is so inscribed on the reverse. The State Historical Museum, Moscow.

176. Grachev Brothers. St. Petersburg. **Silver-gilt and Enamel Chalice.** ca. 1910. Height 11½″ (29.3 cm). This chalice is inscribed in blue enamel, "To Those Who Have Received Communion, From Their Former Commander Grand Duke Constantin Constantinovich." It is enameled with multicolored foliage on a gilded silver ground and is mounted with four medallions enameled with images of Christ, the Holy Virgin, St. John the Baptist, and the Resurrection. The State Historical Museum, Moscow.

177. Verkhovtsev. St. Petersburg. **Silver Chalice.** 1853. Height 11¾″ (30 cm). The bowl has four medallions bordered with pearls depicting the Deesis and the Crucifixion. The bowl and foot are overlaid with vines and grasses set with pastes simulating jewels. The State Historical Museum, Moscow.

178. Ivan Dmitrovich Chichelev. Moscow. **Pair of Silver, Enamel, and Jeweled Wedding Crowns.** 1881. Height 5¾″ (14.6 cm). Each crown has an enameled band of multicolored foliage bordered by a line of blue paterae. The lower parts have bands of simulated rubies and emeralds which are edged by simulated pearls. The front of each crown is set with three icons. One crown has St. Constantin and St. Helena flanking the Mother of God. The other crown has the Mother of God and St. John the Baptist flanking Christ. Copyright 1989, Sotheby's, Inc., New York.

179. Vasiliy Sikachev. Moscow. **Silver-gilt and Enamel Altar Cross.** 1904. Height 20½″ (52 cm). This cross is decorated in multicolored shaded enamel with foliate motifs on a blue ground and is set with a radiating design mounted with simulated diamonds, rubies, and emeralds. The State Historical Museum, Moscow.

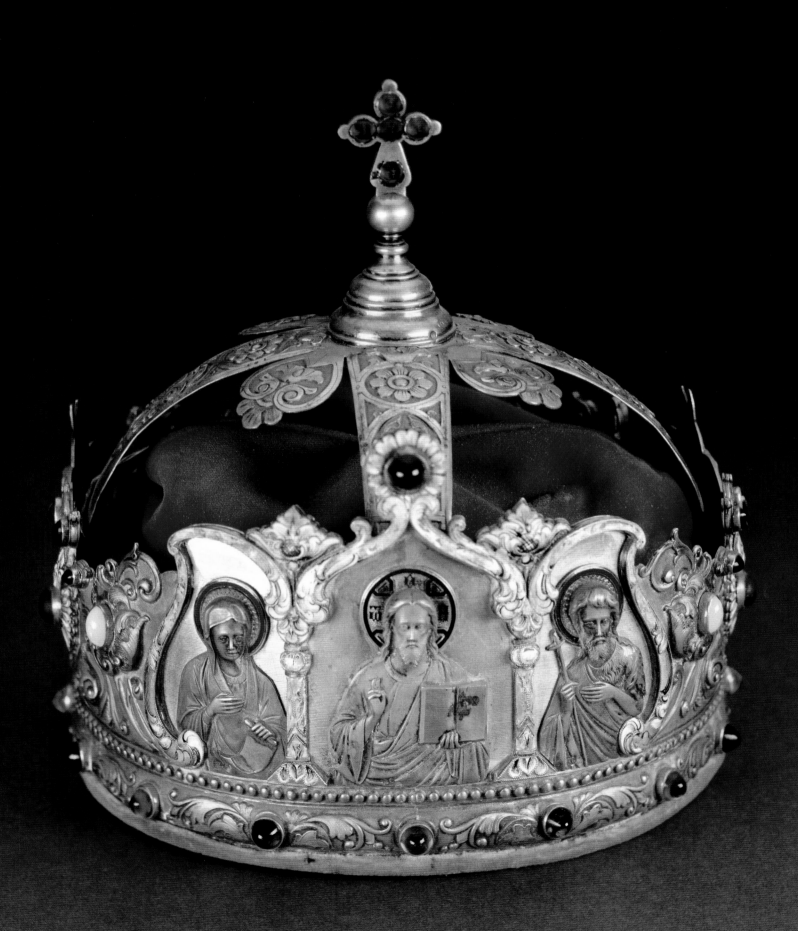

168

169

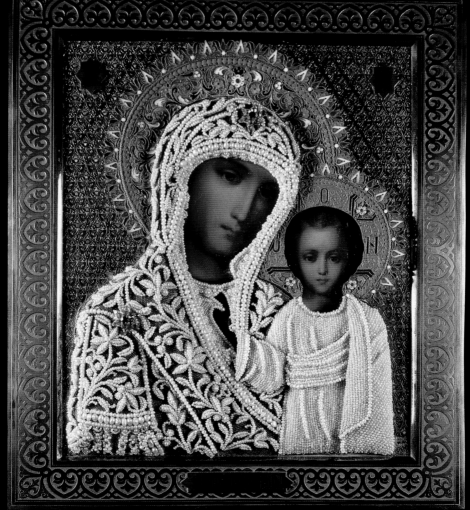

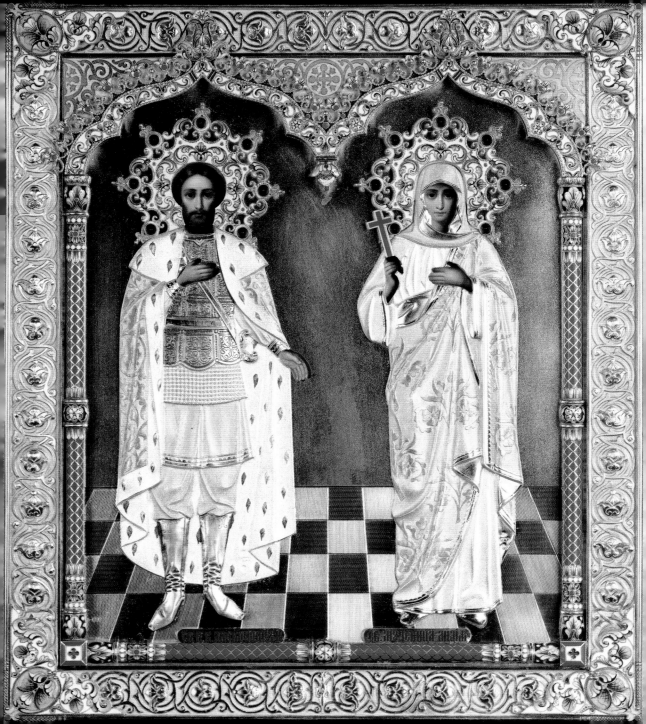

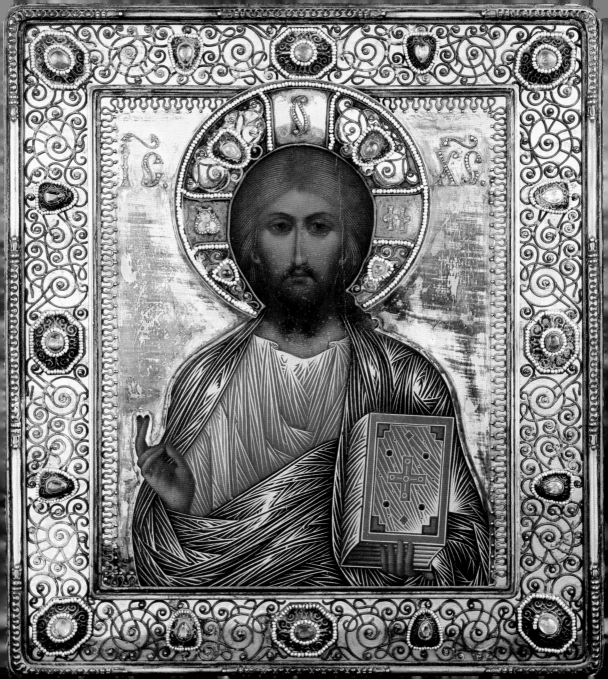

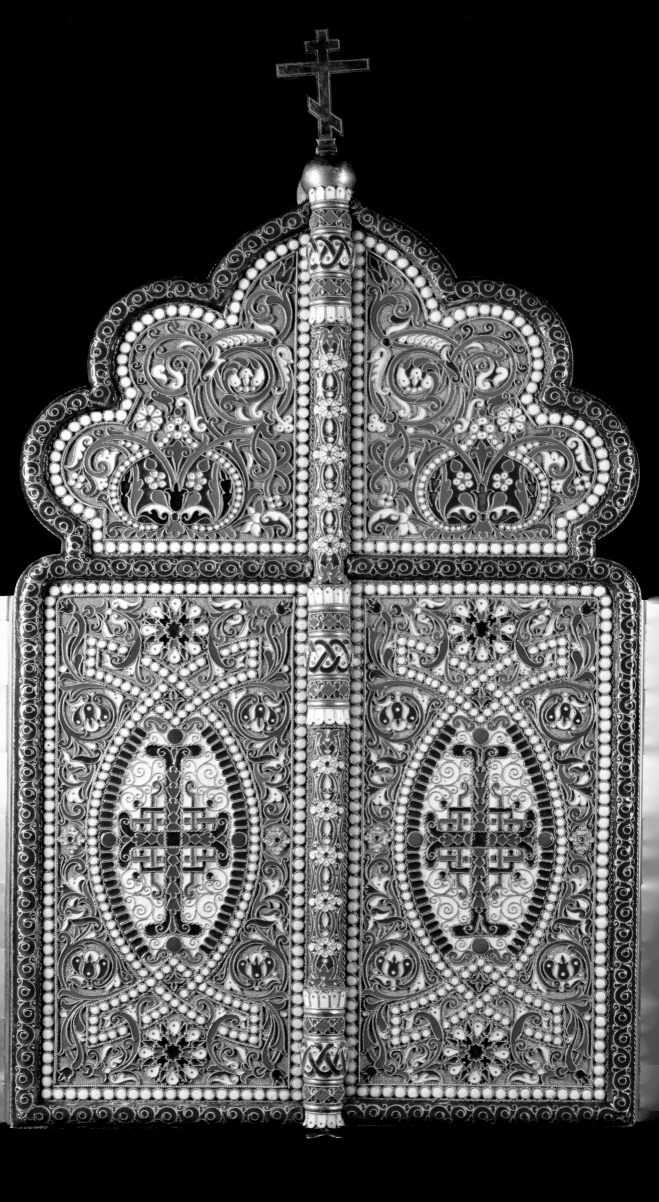

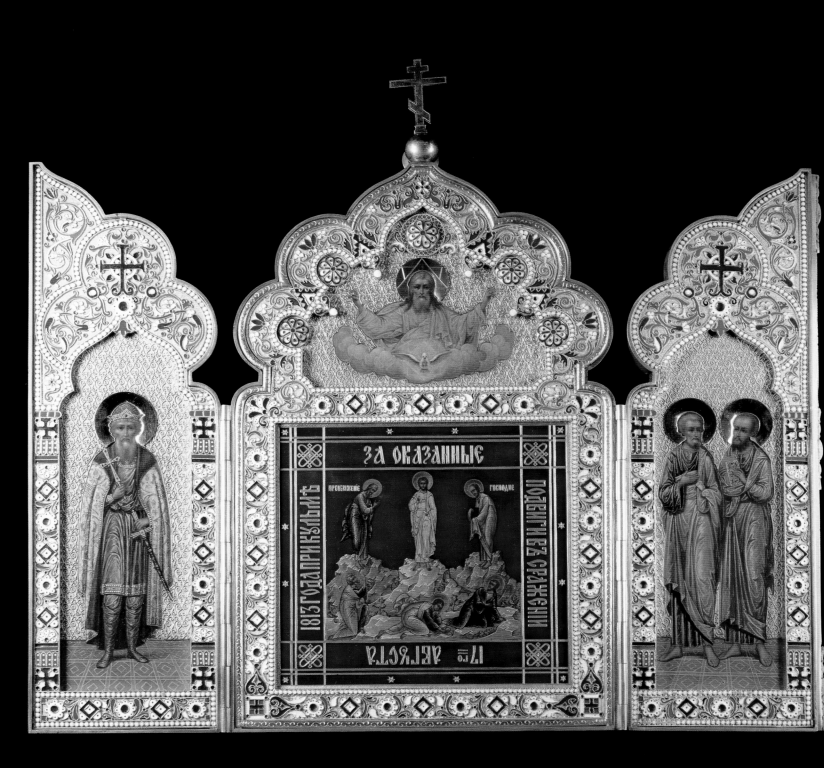

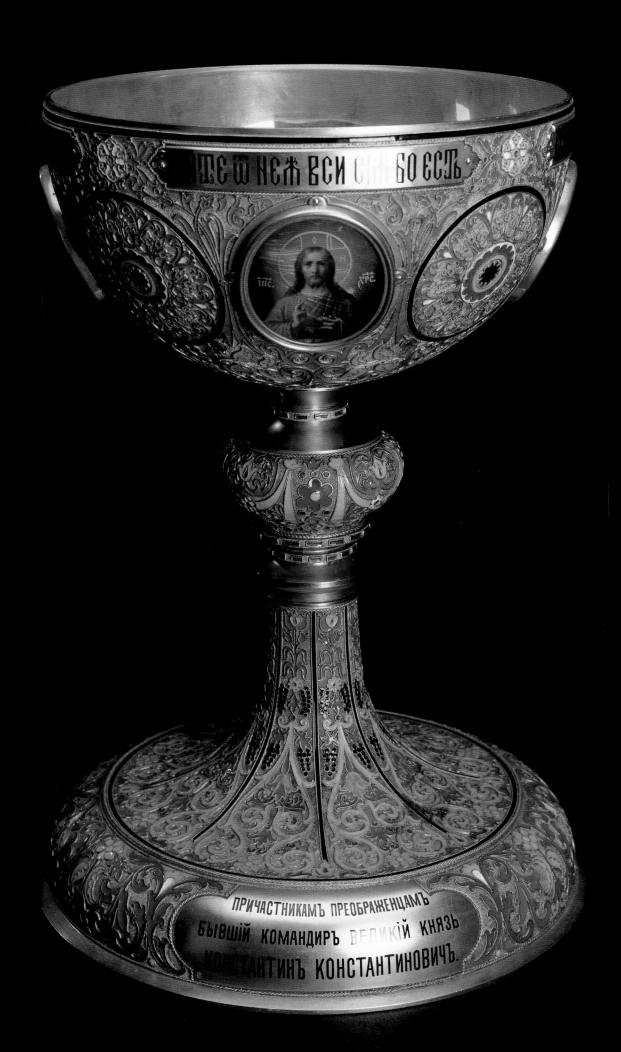

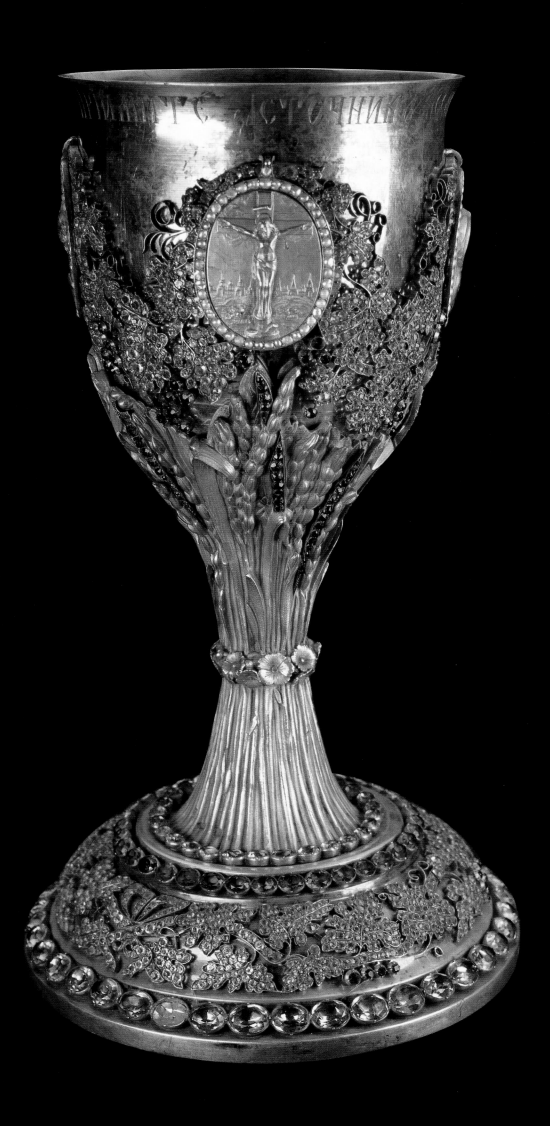

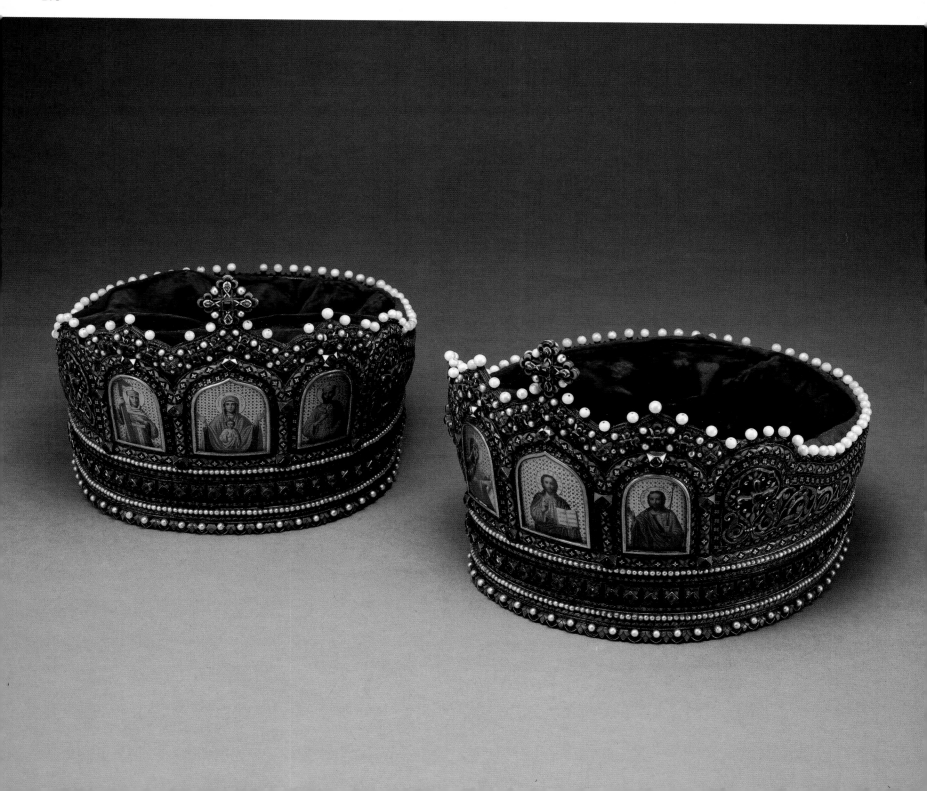

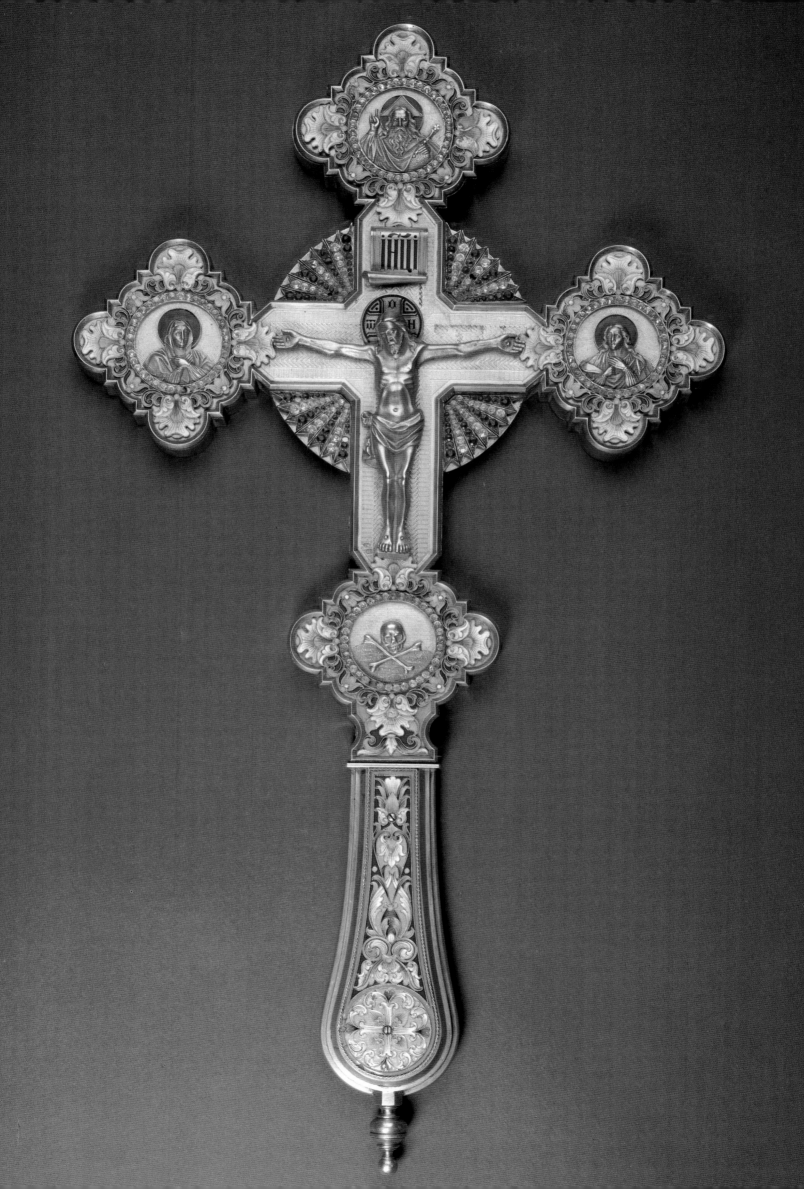

TABLE ORNAMENTS AND *OBJETS DE VITRINE*

Throughout the centuries in Russia, as in Europe, the display of silver has always been an indicator of the wealth of a household. Silver tea sets of heavy gauge silver, richly gilded or sumptuously enameled, could be displayed to great advantage on the sideboard of a rich Moscow merchant. A samovar, necessary for supplying hot water for tea, could be found in every household. Most families owned samovars of base metal such as pewter or brass, but samovars of silver were owned by the wealthy.

One of the most popular forms upon which the goldsmiths and enamelers lavished their talents was the kovsh. The kovsh is a peculiarly Russian object that can be traced back in origin to the sixteenth century when it was made of wood and took the more distinguishable form of a bird. It was originally used as a dipper, but came to be used by the Czar or Czarina, when it was made of silver as a presentation object, much in the same way that snuffboxes were used as presentation pieces in eighteenth-century France. These imperial presentation kovshes were chased with the cipher of the reigning emperor or empress as well as with the imperial eagle. By the latter part of the nineteenth century, the kovsh had become lavishly enameled and a showpiece *par excellence*.

180. Ovchinnikov. Moscow. **Silver-gilt and *Plique-à-Jour* Enamel Footed Cup.** ca. 1899. Height 4½″ (11.2 cm). *The almost hemispherical cup is decorated in multicolored* plique-à-jour *enamel with stylized foliage. It has a flat circular foot and a tubular stem.* **Silver-gilt and *Plique-à-Jour* Enamel Cigarette Case.** ca. 1890. Length 4″ (10.2 cm). *This rectangular case is enameled front and back with peacocks inhabiting foliage. Copyright 1989, Sotheby's, Inc., New York.*

181. Ovchinnikov. Moscow. **Large Silver-gilt and Enamel Presentation Duck-form Kovsh.** ca. 1900. Length 19½″ (49.7 cm). *In the form of a mallard with a wide fan-shaped tail and long beak, this kovsh is enameled with pastel-colored stylized flowers and foliage. The neck is enameled to simulate feathers, and the base is engraved with signatures and, inscribed in Cyrillic, "Petrograd," with the date 27 July 1917. Copyright 1989, Sotheby's, Inc., New York.*

182. Fabergé. Moscow. **Silver-gilt and Shaded Enamel Kovsh.** ca. 1910. Length 9¼″ (23.5 cm). *The globular body is enameled with multicolored foliage and geometric forms in the Old Russian style.* **Large Silver-gilt and Shaded Enamel Kovsh.** ca. 1900. Length 11″ (28 cm). *This kovsh is enameled with colorful flowers on black enamel reserves and bordered by scrolling foliage on a sea-green ground. Copyright 1989, Sotheby's, Inc., New York.*

220

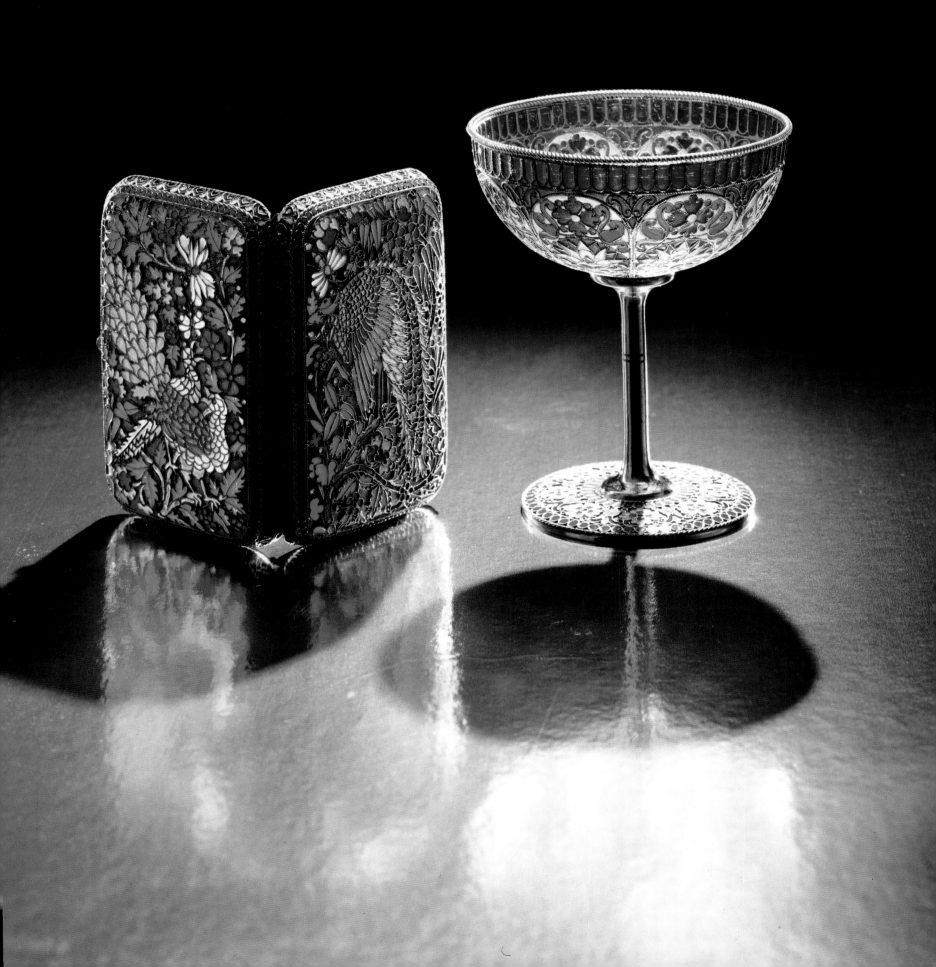

183. Ovchinnikov. Moscow. **Large Silver-gilt and Enamel Two-handled Bowl.** ca. 1910. Length 22″ (55.9 cm). *This bowl, in the shape of a boat, is enameled with multicolored foliage and borders mounted with colored hardstone cabochons. The handles are set with faceted amethyst quartz reserves and are supported on the heads of gryphons. Copyright 1989, Sotheby's, Inc., New York.*

184. Fabergé. Workmaster Michael Perchin, St. Petersburg. **"Fish" Charka.** ca. 1890. Height 3½″ (8.8 cm). *Ruby-eyed fish of red and white gold swim against a background of yellow gold. The base of the cup is decorated with scallop shells, and the handle holds a gold, one-ruble Empress Elizabeth coin from 1756. A cabochon sapphire is mounted at the tip of the handle. The* Forbes *Magazine Collection, New York.*

185. **Silver-gilt and Shaded Enamel Two-handled Sugar Bowl.** Sixth Artel. Moscow. ca. 1910. Length across handles 7⅜″ (18.9 cm). *The upper border of this bowl is comprised of eight ovals which are enameled with multicolored stylized foliage. The central oval on each side is enameled with a swan floating on a pond. Each handle is in the form of a colorful siren.* **Large Silver-gilt and Shaded Enamel Kovsh.** Maria Semyonova. Moscow. ca. 1900. Length 9″ (23 cm). *The body of the kovsh is colorfully enameled with flowers and foliate motifs, and the border is set with red hardstone cabochons.* **Silver-gilt and Enamel Kovsh.** Ovchinnikov. Moscow. ca. 1910. Length 6⅜″ (16.3 cm). *Of stylized bird form, this kovsh is finely enameled with multicolored, pastel, stylized flowers and foliage between geometric borders. The triangular head and the geometric tail are set with cabochon amethysts. It was presented to Dr. Jens Schou, personal surgeon to Christian IX, by the Empress Marie Feodorovna, daughter of the Danish King. The inscription on the base indicates this exchange and is dated 2 February 1910. Copyright 1989, Sotheby's, Inc., New York.*

186. Feodor Rückert. Moscow. **Silver-gilt and Shaded Enamel Pictorial Kovsh.** ca. 1900. Length 13½″ (34.4 cm). *The body of this Kovsh is finely enameled on one side with a scene of a boyar wedding and is inscribed in Cyrillic, "Honorable Wedding." The other side is enameled with a wedding feast and is inscribed in Cyrillic, "Celebration Banquet." The front of the kovsh is enameled with the imperial eagle on a sea green ground. The back of the body flanking the handle is enameled with winged horses ridden by finely robed young nobles. This piece is marked by Ovchinnikov, as retailer. Copyright 1989, Sotheby's, Inc., New York.*

187. Maria Semyonova. Moscow. **Large Silver-gilt and Shaded Enamel Kovsh with Matching Ladle.** ca. 1900. Length of kovsh 9½″ (24 cm). *Finely enameled with colorful flowering foliage on a Chinese-red ground, the front of this kovsh is enameled with the Russian imperial eagle. Copyright 1989, Sotheby's, Inc., New York.*

188. **Pair of Silver-gilt and Shaded Enamel Beakers.** Grigori Sbitnev. Moscow. ca. 1910. Height 4¾″ (12 cm). *These beakers are of tapered cylindrical form and are colorfully enameled with flowers and geometric forms.* **Silver-gilt and *Plique-à-Jour* Enamel Beaker.** Ovchinnikov. Moscow. ca. 1900. Height 5⅛″ (13.1 cm). *This piece is enameled in the* plique-à-jour *technique with panels of birds and foliage and with a chinoiserie figure. The circular foot is engraved underneath with the Cyrillic signature, "P. Ovchinnikov & Son."* **Silver and Champlevé Enamel Bird-form Carafe.** Khlebnikov. Moscow. ca. 1874. Height 8¾″ (22.2 cm). *In the form of a stylized cockerel, this carafe has a stylized slavonic inscription encircling it which reads, "To Drink Is No Hindrance, but Youth's Diversion."* **Silver and Enamel Casket.** Khlebnikov. Moscow. ca. 1900. Length 6¾″ (17.3 cm). *Raised on bracket feet, this rectangular box is enameled with multicolored stylized foliage, flowers, and geometric forms. It has a green hardstone cabochon thumbpiece. Copyright 1989, Sotheby's, Inc., New York.*

189. Fabergé. Workmaster August Hollming, St. Petersburg. **Carved Nephrite and Silver-gilt Small Cup.** ca. 1915. Height 3⅞″ (9.8 cm). *This cylindrical, carved nephrite cup is simply tapered and is applied with a silver-gilt medallion of the imperial eagle. It is inscribed "War 1914–1915. K. Fabergé." The State Historical Museum, Moscow.*

190. Fabergé. Workmaster Erik Kollin, St. Petersburg. **Miniature Gold Coin Tankard.** ca. 1880. Height 3⅜″ (8.6 cm). *This is based on a seventeenth-century tankard. The lid carries a gold ruble of Catherine the Great and is dated 1783. Smaller rubles are set into the barrel. Two cabochon sapphires decorate the handle.* The Forbes *Magazine Collection, New York.*

191. Fabergé. Workmaster Anders Johann Nevalainen, St. Petersburg. **Silver-gilt and Enamel Small Cup.** ca. 1900. Height 1⅝″ (4.2 cm). *The cylindrical body is enameled pale green over a guilloché ground. The lower part of the body is enameled translucent red; the handle is in the form of a serpent.* The Forbes *Magazine Collection, New York.*

192. Ovchinnikov. Moscow. **Silver Tankard.** 1873. Height 7¼″ (18.5 cm). *The barrel of this tankard is chased with peasants returning from hay-making. The Armory Museum, Moscow.*

193. Fabergé. Moscow. **Monumental Bogatyr Silver Kovsh.** ca. 1900. Height 23″ (58.2 cm). *This is very different from most of Fabergé's work for its folkloric quality. Bogatyrs, or medieval warriors, crowd together to form the handle of this kovsh. Bearded, fierce-looking, and dressed with mail tunics, they form a contrast to the simple silver bowl, with gilded interior, to which they are attached. Imaginatively modeled, this kovsh has a semiprecious blue cabochon stone at the front which acts as a balance.* The Forbes *Magazine Collection, New York.*

194. Fabergé. Moscow. **Ivan Kalita Bowl.** ca. 1900. Height 6¼″ (15.8 cm). *Created in the Old Russian style, this bears a caricature of Ivan, Prince of Moscow (1325) and later Grand Duke of Russia (1339–1341), who was famous for his miserliness, earning him the nickname "Kalita" (moneybags). The bowl is made of silver and silver-gilt and is set with cabochon rubies and emeralds.* The Forbes *Magazine Collection, New York.*

195. Ovchinnikov. Moscow. **Silver-gilt, Cloisonné Enamel, and *Plique-à-Jour* Enamel Punch Set.** ca. 1890. Diameter of tray 15″ (38 cm). *This large circular tray is raised on four ball feet. The surface is enameled with panels of multicolored stylized foliage on a gilded stippled ground. The tray's center is fitted with a punch bowl in the form of a bucket, enameled en suite, and engraved in French and Cyrillic, "Souvenir of Pavlovsk, 2 July 1891." Each side of the bucket has a roundel inscribed in champlevé enamel, "J.M. Charcot." The border of the tray has six polished circular reserves to hold six plique-à-jour enamel footed cups. The imperial residence of Pavlovsk was begun in 1777 and was virtually completed by 1825. The initial residence was begun for Paul, and, upon Paul's accession to the throne in 1796, Pavlovsk was given the status of a town. Copyright 1989, Sotheby's, Inc., New York.*

196. Ovchinnikov. Moscow. **Silver-gilt and Enamel Punch Set.** ca. 1885. Diameter of tray 12½″ (31.9 cm). *This set includes a punch bowl, tray, eight cups with hook handles, and a kovsh. All pieces are enameled with multicolored flowers and scrolling foliage on gilded stippled grounds. The tray has eight reserves for the cups and a wide colorfully enameled apron. Copyright 1989, Sotheby's, Inc., New York.*

197. **Twelve Silver-gilt and Shaded Enamel Vodka Cups.** Grachev Brothers. St. Petersburg. ca. 1890. Height 1⅝″ (4.2 cm). *The tapered cylindrical cups are enameled with multicolored scrolling foliage with reserves of yellow, midnight blue, sky blue, royal blue, Chinese red, turquoise, mauve, and ivory.* **Silver-gilt and Shaded Enamel Strawberry Spoon.** Maker unknown. Moscow. ca. 1910. Length 7½″ (19 cm). *The back of this spoon is finely enameled with multicolored flowers on a pale green ground. It has a twist and knop stem.* **Silver-gilt and Shaded Enamel Dish.** Fabergé. Moscow. ca. 1910. Diameter 4″ (10.2 cm). *With incurved corners and a foot of conforming shape, this dish is enameled in muted tones in the Old Russian style with a design of stylized foliage.* **Silver-gilt and Shaded Enamel Cigarette Case.** Fabergé. Moscow. ca. 1916. Length 4⅛″ (11 cm). *This case is finely enameled, in the Old Russian style, with stylized foliage in shades of brown, green, and blue. It has a gold-mounted cabochon sapphire thumbpiece. Copyright 1989, Sotheby's, Inc., New York.*

198. Khlebnikov. Moscow. **Silver-gilt and Champlevé Enamel Wine Set.** ca. 1880. Height of decanter 15¼″ (38.5 cm). *Brightly enameled in many colors, the decanter is in the form of a cock and the charkas are shaped as chickens. The State Historical Museum, Moscow.*

199. Maker unknown. Moscow. **Silver (Partly Gilded) and Enamel Punch Set.** ca. 1910. Diameter of tray 19¼″ (49 cm). *This set, initialed N.I.T. in Cyrillic includes a punch bowl, a circular stand, twelve cups, and a ladle. All pieces are repoussé and chased in the Old Russian style with fruit and foliage. The punch bowl has a plaque enameled with two bogatyrs after Vasnetsov, and its handles are chased with gryphons and have openwork pendants. The stand is raised on six bun feet. Copyright 1989, Sotheby's, Inc., New York.*

200. Feodor Rückert. Moscow. **Silver-gilt and Shaded Enamel Pictorial Punch Bowl and Ladle.** ca. 1910. Diameter 12″ (30.5 cm). *This extraordinary object, which is virtually without parallel, is repoussé in high relief with legendary bogatyrs and female portrait busts in the Old Russian style, with flying eagles encircling the base. The bogatyrs hold aloft mugs of frothing ale, all exquisitely enameled in a multitude of colors. The gilded ground has a matted finish. The shoulder of the bowl is repoussé with pear-shaped lobes, each of which is enameled with a flowering plant or vegetable. The rim is enameled with black bears in snowy landscapes and with luminescent windows. The handles are in the forms of bear heads with eyes set with red stones. Copyright 1989, Sotheby's, Inc., New York.*

201. Twentieth Artel. Moscow. **Silver-gilt and Enameled Punch Set.** ca. 1910. Length 13⅜″ (34 cm). *This set includes a large kovsh, three smaller kovshes, and a ladle, all enameled with multicolored foliage and set with colorful hardstone cabochons. The State Historical Museum, Moscow.*

202. Grigori Sbitnev. Moscow. **Silver-gilt and Shaded Enamel Eight-piece Punch Set.** ca. 1900. Height of bowl 9⅜″ (24 cm). *This set includes a two-handled punch bowl, six punch cups, and a ladle. The bowl is of tapered circular form with four curved panels and four angular panels. The lower parts of the bodies are lobed. The set is enameled with multicolored flowers and scrolling foliage on grounds of pale yellow, purple, gray, emerald, and olive green. Copyright 1989, Sotheby's, Inc., New York.*

203. Fabergé. Moscow. **Silver, Enamel, and Cut-glass Punch Bowl with Ladle.** ca. 1910. Length across handles 14″ (35.7 cm). *The cut-glass bowl has a silver rim-mount which is enameled with green squares. The alternating squares are chased with circles and paterae. Copyright 1989, Sotheby's, Inc., New York.*

204. Fabergé. Moscow. **Silver and Enameled Art Nouveau Seven-piece Tea and Coffee Set.** ca. 1895. Height of coffee pot 5¾″ (14.5 cm). *This set includes a teapot, a coffee pot, a covered sugar bowl, a sugar shovel, tongs, a lemon fork, and a strainer spoon. The pots and the sugar bowl are of tapered circular form and have handles in the form of conjoined scrolls. All pieces are enameled with purple flowers arising from green leaves. The tops are enameled with stylized red berries. Copyright 1985, Sotheby's, Inc., New York.*

205. Nicholai Alexeyev. Moscow. **Silver-gilt and Shaded Enamel Four-piece Tea Set.** ca. 1900. Height of teapot 7¾″ (19.6 cm). *Executed in the Chinese style, this tea set includes a teapot, covered sugar bowl, waste bowl, and cream jug. Each piece is in the form of a Chinese pagoda and is enameled with colorful foliage on alternating Chinese-red and sky-blue grounds. Private collection, U.S.A.*

206. Ovchinnikov. Moscow. **Silver, Partly Gilded Samovar, Tray, and Bowl.** 1879. Height 22″ (56 cm). *This samovar is chased to simulate wood grain. It has pierced aprons and angular handles rising from roosters. The spigot is in the form of the head and neck of a cock. Copyright 1989, Sotheby's, Inc., New York.*

207. Nicholai Alexeyev. Moscow. **Set of Twelve Silver-gilt and Enamel Demitasse Cups, Saucers, and Spoons.** ca. 1910. Diameter of saucer 4¼″ (11 cm). *These objects have borders of plique-à-jour enamel stylized foliage and bands of translucent enamel over guilloché grounds in six pairs of colors. The centers of the saucers and bases of the cups are decorated with champlevé enamel stylized foliage. The fitted porcelain liners are by Kornilov. Copyright 1989, Sotheby's, Inc., New York.*

208. Eleventh Artel. Moscow. **Set of Six Silver-gilt and Enamel Demitasse Cups, Saucers, and Spoons.** ca. 1910. Diameter of saucer 4⅛″ (10.4 cm). *These cups and saucers combine three techniques of enameling. The outer borders are executed in* plique-à-jour *enamel, while the inner borders are decorated in translucent enamel. The centers of the saucers and bases of the cups are enameled in the* champlevé *technique. Copyright 1989, Sotheby's, Inc., New York.*

209. Khlebnikov. Moscow. **Silver and Champlevé Enamel Four-piece Tea Set.** ca. 1884. Length of basket 8⅞″ (22.2 cm). *The set includes a teapot, a covered sugar bowl, a cream jug, and a cake basket, all of which are finely enameled with brightly plumed birds among colorful foliage on a pale green ground. Copyright 1989, Sotheby's, Inc., New York.*

210. Lubavin. St. Petersburg. **Silver-gilt and Enamel Eleven-piece Tea Set.** ca. 1900. Height of teapot 5½″ (14 cm). *The set includes a teapot, a covered sugar bowl, a cream jug, two glass tea holders, two teaspoons, a caddy shovel, a lemon fork, sugar tongs, and a straining spoon. All pieces are enameled with multicolored scrolling foliage and with exotic birds flanking a monogram. Copyright 1989, Sotheby's, Inc., New York.*

211. Feodor Rückert. Moscow. **Silver-gilt and Shaded Enamel Three-piece Tea Set.** ca. 1900. Height of teapot 8¼″ (21 cm). *This set, including a teapot, a covered sugar bowl, and a cream jug, is enameled with colorful foliage. The baluster bodies have multiple lobes which are enameled with flowers on grounds of aubergine, royal blue, and sea green. The teapot and the bowl have acorn finials which are enameled with swirls. Copyright 1989, Sotheby's, Inc., New York.*

212. Ovchinnikov. Moscow. **Silver-gilt and Enamel Imperial Presentation Tea Set.** ca. 1900. Height of teapot 5⅞″ (15 cm). *The set comprises a teapot and a two-handled sugar bowl, both with slip-on covers, and a cream jug, all of bulbous form with shaped rims and enameled with multicolored flowers and scrolling foliage. The sugar shovel, lemon fork, tea strainer, and sugar tongs are similarly enameled. The base of the teapot is inscribed, "Cannes Golf Club, 1910. Presented by H.I.H. Grand Duke Michael of Russia. Won by Lady M. Hamilton-Russell." Copyright 1989, Sotheby's, Inc., New York.*

213. Kurlyukov. Moscow. **Silver and Shaded Enamel Tea Caddy.** ca. 1900. Height 6¾″ (17.2 cm). *In a fine example of Kurlyukov's spectacular enameling, the bulbous caddy is enameled with colorful foliage on a blue ground, and the handles have borders of white beads. Copyright 1989, Sotheby's, Inc., New York.*

214. Kurlyukov. Moscow. **Silver-gilt and Shaded Enamel Three-piece Tea Set.** ca. 1900. Height of teapot 6¾″ (17.2 cm). *This set includes a teapot, a covered two-handled sugar bowl, and a cream jug. They are pear-shaped with lobed bases and are enameled with multicolored flowers and scrolling foliage. Copyright 1989, Sotheby's, Inc., New York.*

215. Fabergé. Moscow. **Seven-piece Silver Tea and Coffee Set.** ca. 1900. Height of coffee pot 9⅜″ (24 cm). *This set includes a hot-water kettle on a lamp stand, a teapot, a coffee pot, a covered sugar bowl, a cream jug, a waste bowl, and a cake basket. All pieces are repoussé and chased with neo-rococo scrolls and shellwork. Each piece is applied with armorials. Copyright 1979, Sotheby's, Inc., New York.*

216. Ovchinnikov. Moscow. **Silver-gilt and Shaded Enamel Seven-piece Tea Set.** ca. 1900. Height of teapot 6½″ (16.5 cm). *This set comprises a teapot, a sugar basket, and a cream jug, lobed and enameled with gryphons and flowering foliage on grounds of shades of blue, green, pink, and cream. The caddy spoon, sugar tongs, straining spoons, and lemon fork are enameled en suite. Although this set is marked by Ovchinnikov, it is almost certainly the work of Feodor Rückert, whose enamels were sometimes retailed by Ovchinnikov and Fabergé. Copyright 1989, Sotheby's, Inc., New York.*

217. **Silver-gilt and Enamel Cigar Case.** Feodor Rückert, Moscow. ca. 1910. Length 6⅜″ (16.3 cm). The moonlit scene with legendary hero copies a work by Victor Vasnetsov (1848–1926) and is signed A.B. in Cyrillic. Rückert's mark is overstruck with Bolin's. **Silver-gilt and Shaded Enamel Card Tray.** Feodor

Rückert. Moscow. ca. 1900. Diameter 4¾″ (12.2 cm). *The center is enameled with a gryphon. The border is enameled with scrolling foliage on a Chinese-red ground.* **Silver-gilt and Shaded Enamel Vodka Beaker.** Feodor Rückert. Moscow. ca. 1900. Height 2¾″ (7 cm). *This beaker, enameled with flowers and foliage on blue and peach panels, is marked by Tiffany & Co., New York, as retailer.* **Silver-gilt and Shaded Enamel Pictorial Spoon.** Feodor Rückert. Moscow. ca. 1910. Length 8″ (20.3 cm). *The back of the bowl is enameled with a boyarina.* **Silver-gilt and Shaded Enamel Oval Box.** Feodor Rückert. Moscow. ca. 1900. Length 2¼″ (5.9 cm). *The cover is enameled with a farmer, his dog, and three cows.* **Silver-gilt and Shaded Enamel Salt Throne.** Feodor Rückert. Moscow. ca. 1910. Height 2½″ (6.4 cm). *The shaped back is enameled with caryatids.* **Silver-gilt and Shaded Enamel Easter Egg.** Ivan Alexeyev. Moscow. ca. 1900. Height 3½″ (8.9 cm). *This egg has doors hinged at the sides and enameled with the Cyrillic initials "X.B." for "Christ Is Risen." Within is an icon of the Resurrection painted on mother-of-pearl; outside is enameled foliage on a brick-red ground; and on the back are seraphim.* Copyright 1989, Sotheby's, Inc., New York.

218. Khlebnikov. Moscow. **Silver-mounted Wood Presentation Dish.** ca. 1913. Diameter 25¼″ (64.5 cm). *The central silver roundel is chased with the coronation of Mikhail I, the first Romanov ruler. On one side of this roundel is a scene of Minin addressing the people of Nizhny-Novgorod, and the other side depicts Prince Pozharsky's entry into Moscow. The Cyrillic inscription on the top of this dish reads, "To the Royal Highnesses." The bottom is applied with the coat of arms for Nizhny-Novgorod and is inscribed in Cyrillic, "The Nizhny-Novgorod Nobility." This dish was given in recognition of the three hundredth anniversary of Romanov rule.* The State Historical Museum, Moscow.

219, 220. Feodor Rückert. Moscow. **Silver-gilt and Shaded Enamel Pictorial Compote.** ca. 1900. Diameter 10½″ (26.6 cm). *A tour de force of enameling, this lobed hexafoil-form compote is richly enameled with birds and foliage on grounds of avocado, pink, and cream. The inner lobes are enameled with flowers on grounds of Chinese red and deep green. The central boss is enameled with a finely attired young boyarina offering a tray with a carafe and a cup to a suitor, inscribed in Cyrillic, "Dear Guest."* Private collection, U.S.A.

221. Fabergé. Workmaster Henrik Wigström, St. Petersburg. **Moss Agate and Enamel Oval Dish.** ca. 1900. Length 6⅞″ (17.4 cm). *The wide border of the silver-gilt mount is enameled translucent royal blue over a guilloché ground. The outer edge is chased with acanthus leaves, and the inner edge is beaded. It is raised on four toupie feet.* Copyright 1979, Sotheby's, Inc., New York.

222. Ovchinnikov. Moscow. **Silver and Champlevé Enamel Dessert Serving Set.** ca. 1878. Diameter of stand 15⅛″ (38.4 cm). *This set comprises a bowl with a stand and a large spoon. All pieces are enameled with multicolored roosters and geometric designs. The borders are decorated with alternating translucent red and royal-blue enamel ribbons.* Copyright 1989, Sotheby's, Inc., New York.

223. **Silver-gilt and Shaded Enamel Basket.** Maker unknown. Moscow. ca. 1910. Diameter 4″ (10.2 cm). *The basket has a swing handle and is colorfully enameled with stylized foliage on grounds of avocado, blue, and olive green.* **Silver-gilt and Shaded Enamel Jeweled Oval Dish.** Kurlyukov. Moscow. ca. 1900. Length 10⅝″ (27 cm). *This oval-shaped dish has pierced handles and is raised on four bun feet. It is enameled with swans and with white doves amongst violets, lilies-of-the-valley, lilacs, and various other flowering foliage. The dish is mounted with colored hardstone cabochons.* **Silver-gilt and Shaded Enamel Kovsh.** Maria Semyonova. Moscow. ca. 1900. Length 6½″ (16.7 cm). *This kovsh is enameled with colorful foliage on grounds of Chinese red, sea green, and cream.* Copyright 1989, Sotheby's, Inc., New York.

224. **Silver-gilt, Shaded Enamel, and *Plique-à-Jour* Enamel Sugar Basket.** Sixth Artel. Moscow. ca. 1910. Diameter at lip 3¼″ (9.6 cm). *The basket, with a swing handle, has lobed sides enameled with multicolored flowers on a gilded stippled ground within cable borders. The upper section of plique-à-jour enamel is decorated with multicolored stylized foliate designs.* **Silver-gilt and Shaded Enamel Bird-form Kovsh.** Ovchinnikov. Moscow. ca. 1900. Length 9½″ (24 cm). *This kovsh is shaped as a peacock with colorfully enameled feathers and a crested head.* Copyright 1978, Sotheby's, Inc., New York.

225. **Silver-gilt and Enamel Vase and Stand.** Grachev Brothers. St. Petersburg. ca. 1890. Height of vase 8⅞″ (22.5 cm). *Enameled with bunches of flowers and with scrolling stylized foliage on a gilded stippled ground, this vase, like its stand, has a border of blue and white beads.* **Pair of Silver-gilt and Shaded Enamel Vases.** Ovchinnikov. Moscow. ca. 1900. Height 6¼″ (16 cm). *These vases of slightly bulbous, tapered, cylindrical shape have angular handles and wavy rims. They are enameled with colorful stylized flowering plants, and the lower section is enameled brown, simulating earth. Copyright 1989, Sotheby's, Inc., New York.*

226. Fabergé. Workmaster Michael Perchin, St. Petersburg. **Gold-mounted Smoky Quartz Vase.** ca. 1900. Height 7⅞″ (19.6 cm). *Of tapered cylindrical shape with flared rim, this vase has a gold foot mount that is reeded and has a ribbon-tied acanthus leaf border. The vase was presented to Prima Ballerina, Madame Elizabeth Balletta. The Brooklyn Museum, Brooklyn, New York. Bequest of Mrs. Helen B. Saunders.*

227. Fabergé. Workmaster Michael Perchin, St. Petersburg. **Carved Rock Crystal Vase Mounted in Gold and Enamel.** ca. 1900. Height 6½″ (16.5 cm). *The rock crystal body is carved with scrolling foliage and with the date 22 June 1911 in Roman numerals. The gold mounts are enameled with multicolored scrolling foliage and are set with jewels. This vase was bought at Fabergé's shop in London by Leopold de Rothschild and was given to King George V and Queen Mary as a coronation gift. The Royal Collection, London. Collection of H.M. Queen Elizabeth II.*

228. Ovchinnikov. Moscow. **Pair of Silver-gilt and Shaded Enamel Covered Vases.** ca. 1900. Height 20″ (50.7 cm). *The lobed bodies have six panels alternately enameled with imperial eagles and with flowering foliage. The bodies also have six lobes enameled with swans floating on ponds against Chinese-red grounds. The borders are mounted with colored hardstone cabochons. Copyright 1989, Sotheby's, Inc., New York.*

229. Grachev Brothers. St. Petersburg. **Pair of Silver-gilt, *Plique-à-Jour*, and Cloisonné Enamel Vases.** ca. 1890. Height 11½″ (29.2 cm). *The bulbous bodies, each on a dome foot, have plique-à-jour enameled, tulip-shaped necks and plique-à-jour enameled handles. The bodies are decorated with reserves of stylized flowers on cream-colored grounds, and the surrounds are enameled with flowers on deep blue grounds. Copyright 1989, Sotheby's, Inc., New York.*

230. Feodor Rückert. Moscow. **Silver-gilt and Shaded Enamel Standing Cup and Cover.** ca. 1900. Height 13½″ (34.2 cm). *The foot, bowl, and cover are lobed and enameled with colorful flowers on grounds of brick red, pink, pale green, sea green, sky blue, deep blue, and purple. The shaft has a square knop, and the finial is in the form of the Russian imperial eagle. Copyright 1989, Sotheby's, Inc., New York.*

231. Ovchinnikov. Moscow. **Pair of Silver-gilt and Shaded Enamel Vases.** Height 14⅛″ (35.8 cm). *The lobed cylindrical bodies of these monumental vases are enameled with colorful flowering foliage on a blue ground. Each vase is enameled on one side with a warrior battling a dragon and on the other side with an archer. The lobes around the base of each vase are enameled with swans alternating with bears. The flared rims and angular handles are set with hardstone cabochons. These superb vases represent the height of the enameler's art. Private collection, U.S.A.*

232. Maria Semyonova. Moscow. **Silver-gilt and Shaded Enamel Two-handled Vase.** ca. 1900. Height 8″ (20.4 cm). *Lobed and colorfully enameled with sprays of flowering foliage, this superb example of Maria Semyonova's work has two harp-shaped handles and a spreading foot. Copyright 1989, Sotheby's, Inc., New York.*

233. Fabergé. Moscow. **Silver Cruet Set.** ca. 1900. Height 12¾″ (32.5 cm). *This silver cruet has a central handle in the form of two entwined stalks. It is fitted with four glass containers. The Armory Museum, Moscow.*

234. Fabergé. Workmaster Carl Gustav Hjalmar Armfelt, St. Petersburg. **Set of Six Gold, Enameled, and Bowenite Menu Holders.** ca. 1900. Length 2″ (5 cm). *The rectangular bowenite bases of these menu holders have stepped tops. The demi-lune faces, each with a ribbon-bow top, are enameled translucent lilac over sunburst grounds. Copyright 1985, Sotheby's, Inc., New York.*

235. Fabergé. **Silver and Enamel Kovsh.** Moscow. ca. 1910. Length 8½″ (21.7 cm). *This globular kovsh is enameled with multicolored foliage in the Old Russian style on an olive-green ground. The base of the handle is inscribed "Moscow, Russia, 1916."* **Pair of Silver Figural Table Candlesticks.** Workmaster Julius Rappoport, St. Petersburg. ca. 1910. Height 7⅞″ (20 cm). *Based on a design by the eighteenth-century French silversmith J. A. Meissonier, these candlesticks are executed in the rococo style. Each trilateral base is boldly chased with shellwork. The stems are formed by embracing nude infants. Copyright 1984, Sotheby's, Inc., New York.*

236. Fabergé. Workmaster Johan Victor Aarne, St. Petersburg. **Silver-gilt and Translucent Enamel Taperstick.** ca. 1900. Height 2½″ (6.4 cm). *This piece is enameled in translucent pale green over a guilloché ground and is raised on four bun feet. The State Historical Museum, Moscow.*

237. Fabergé. Workmaster Julius Rappoport, St. Petersburg. **Pair of Massive Silver Nine-light Table Lamps.** ca. 1910. Height 32½″ (82.5 cm). *These rare table lamps are executed in the rococo style. The domed bases and stems are boldly chased with scrolls in high relief and with shells and foliage. The branches are similarly chased, and the finials are formed as clusters of oak leaves. Copyright 1984, Sotheby's, Inc., New York.*

238. Fabergé. Workmaster Carl Gustav Hjalmar Armfelt, St. Petersburg. **Pair of Silver-gilt Table Candlesticks.** ca. 1910. Height 8″ (20.3 cm). *These candlesticks have tapered stems and square bases and are chased with swans, cornucopia, and crossed branches of laurel. The bases are chased with acanthus leaves and are applied on each side with a rosette. Copyright 1980, Sotheby's, Inc., New York.*

239. Fabergé. **Pair of Silver Table Candlesticks.** Workmaster Julius Rappoport, St. Petersburg. Late 19th century. Height 12″ (30.5 cm). *These candlesticks are boldly chased with scrolls, shellwork, and flowers in the style of Meissonier.* **Large Silver-gilt and Shaded Enamel Kovsh.** Fabergé. Moscow. ca. 1900. Length 12½″ (31.8 cm). *Decorated in the Old Russian style, this kovsh is enameled with colorful flowers and with stylized scrolling foliage on a ground of avocado. It has a high scrolling handle and domed foot. Copyright 1983, Sotheby's, Inc., New York.*

240. Khlebnikov. Moscow. **Silver and Leather Portfolio.** 1916. Height 19¼″ (49 cm). *The silver and enamel plaque on the cover is chased with a boyar and engraved with a presentation inscription. The State Historical Museum, Moscow.*

241. Maker unknown. St. Petersburg. **Silver (Partly Gilded) Sculpture of Peter the Great.** 1852. Height 19¼″ (49 cm). *This was presented as a yachting trophy. The back is applied with a shield inscribed in Cyrillic "Yacht Georgian, F.K. Bird, 24 June 1856." Peter the Great is depicted in full length wearing a crown of laurel. An open book rests on a pedestal by his side. The fluted plinth is applied at the front with the Russian imperial eagle. It is signed Vaillant. Copyright 1989, Sotheby's, Inc., New York.*

242. Sazikov. St. Petersburg. **Sculptural Group.** 1852. Height 22¾″ (58 cm). *This sculpture depicts a young warrior dressed in chain mail and wearing a helmet standing by his saddled horse. The base is chased with neo-rococo scrollwork. The Armory Museum, Moscow.*

243. Maker unknown. Moscow. **Silver Dish.** ca. 1910. Length 4⅞″ (12.5 cm). *In the form of a female bust, this small dish is formed by the hands and hair of the female figure. The State Historical Museum, Moscow.*

244. Fabergé. Workmaster Eduard Wilhelm Schramm, St. Petersburg. **Two-color Gold and Jeweled Dish.** ca. 1890. Diameter 4½″ (11.4 cm). *This dish has a hammered finish and is chased with a ribbon-*

tied bouquet of flowers. The flower heads are set with diamonds and cabochon sapphires. **Two-color Gold and Translucent Enamel Bell Push.** *Workmaster Feodor Afanassiev, St. Petersburg. ca. 1890. Diameter 1⅞″ (4.8 cm). The dome-shaped bell push is enameled translucent pale blue over a guilloché ground and is surmounted by a gold cap chased with leaves. The push is made of a cabochon moonstone, and the gold base is chased with leaves.* **Silver-gilt and Translucent Enamel Photograph Frame.** *Workmaster Michael Perchin, St. Petersburg. ca. 1900. Height 3⅞″ (9.8 cm). This frame is enameled translucent lilac over a guilloché ground with a border that is chased with entwined ribbon. The oval aperture is chased with leaf tips, and the surround is applied with swags of ribbon-tied laurel. It has an ivory back and strut support and contains a photograph of Alexander III.* **Gold-mounted Bowenite Kovsh.** *Workmaster Erik Kollin, St. Petersburg. ca. 1890. Length 4½″ (11 cm). The well-carved bowenite body has a ribbed prow, a molded gold rim, and a fluted gold handle that is bordered by diamonds and ends with a baroque pearl. The prow is mounted with a neo-classical bust of carved moonstone.* **Nephrite and Gold Stamp Moistener.** *Workmaster Michael Perchin, St. Petersburg. ca. 1900. Height 3¾″ (9.5 cm). The cylindrical nephrite body is applied with ribbon-tied swags of laurel which are hung between torches. The moistener, which has a blue stone finial, and the gold base are chased with acanthus leaves. Copyright 1979, Sotheby's, Inc., New York.*

245. Fabergé. Workmaster Julius Rappoport, Moscow. **Mahogany Silver-mounted Table.** *ca. 1900. Length 29½″ (75 cm), height 28⅜″ (72 cm). The four slender legs of this oval table terminate in silver paw feet. The apron is applied with silver swans which support baskets of flowers. The circular stretcher has a pierced gallery and beaded borders. The top has a border of acanthus leaves, and the glass liner is fitted with reeded silver handles. Copyright 1980, Sotheby's, Inc., New York.*

246. Fabergé. Workmaster Michael Perchin, St. Petersburg. **Gold Guéridon in the Louis XVI Style.** *ca. 1900. Height 3⅛″ (7.9 cm). This objet de vertu is made to resemble a wood table with legs enameled to simulate wood grain. The tabletop is of nephrite with a narrow gold latticework edge. Gold swags hang around the skirt of the table and from white enamel panels. An openwork gold basket sits in the center of four crossbars. The Forbes Magazine Collection, New York.*

247. Fabergé. **Gold and Enamel Miniature Desk.** *ca. 1900. Height 4⅜″ (11.1 cm). This desk, in the Louis XV style, is enameled translucent pale mauve and opalescent white. It is chased with gold neo-rococo scrolls and flowers. The Royal Collection, London. Collection of H.M. Queen Elizabeth II.*

248. Fabergé. Workmaster Michael Perchin, St. Petersburg. **Miniature Gold Guéridon Table.** *ca. 1900. Height 3¾₆″ (9 cm). This miniature table is enameled red to imitate wood grain. The top is of mother-of-pearl imitating a leather surface. The apron is hung with gold swags. The Royal Collection, London.*

249. Fabergé. Moscow. **Miniature Guéridon.** *Before 1899. Height 2¼″ (5.6 cm). Red and green gold are combined in the structure of this table. The tabletop is a checkerboard of fire opals surrounded by rock crystal, from which hang swags of green gold ending in red-gold bows. The Forbes Magazine Collection, New York.*

250. Fabergé. Workmaster Michael Perchin, St. Petersburg. **Gold and Eosite Sedan Chair.** *ca. 1890. Height 3¾″ (9.5 cm). This sedan chair is of rectangular bombé section. The eosite body has gold mounts which are chased with neo-rococo scrolls, foliate swags, flowers, and diaper. The rock crystal windows are etched with borders of scrolls, and the handles have hinged mounts on both sides. The top is also hinged, and the silver-gilt interior is engraved with flower sprays and scrolls. Copyright 1979, Sotheby's, Inc., New York.*

251. Fabergé. Workmaster Michael Perchin, St. Petersburg. **Miniature Sedan Chair.** *ca. 1900. Height 3½″ (8.5 cm). This remarkably ornate miniature chair is enameled translucent salmon over a sunburst pattern. The structure is of gold with etched rock crystal windows (resembling curtained doors), mother-of-pearl handles on the carrying rods, and brown, white, and green enamel designs (one showing an artist's palette and brushes). The Forbes Magazine Collection, New York.*

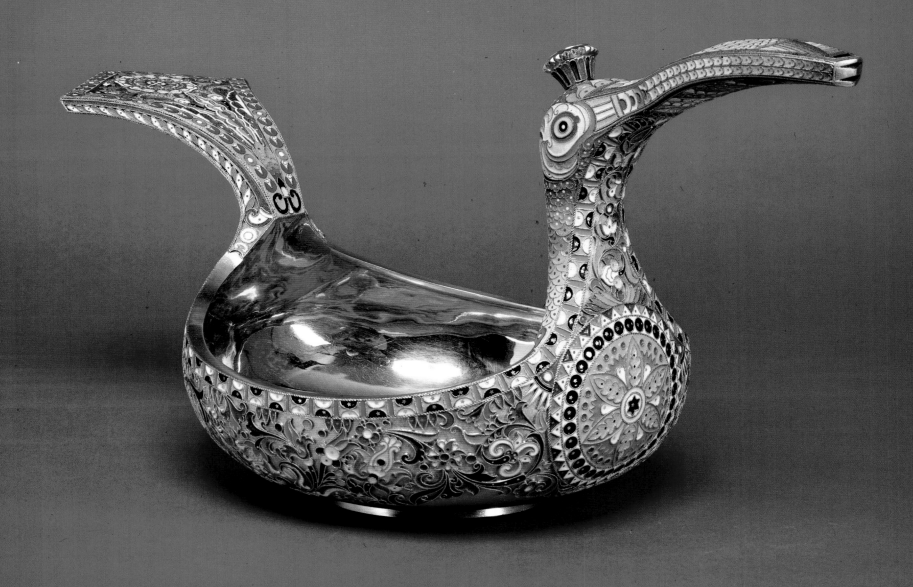

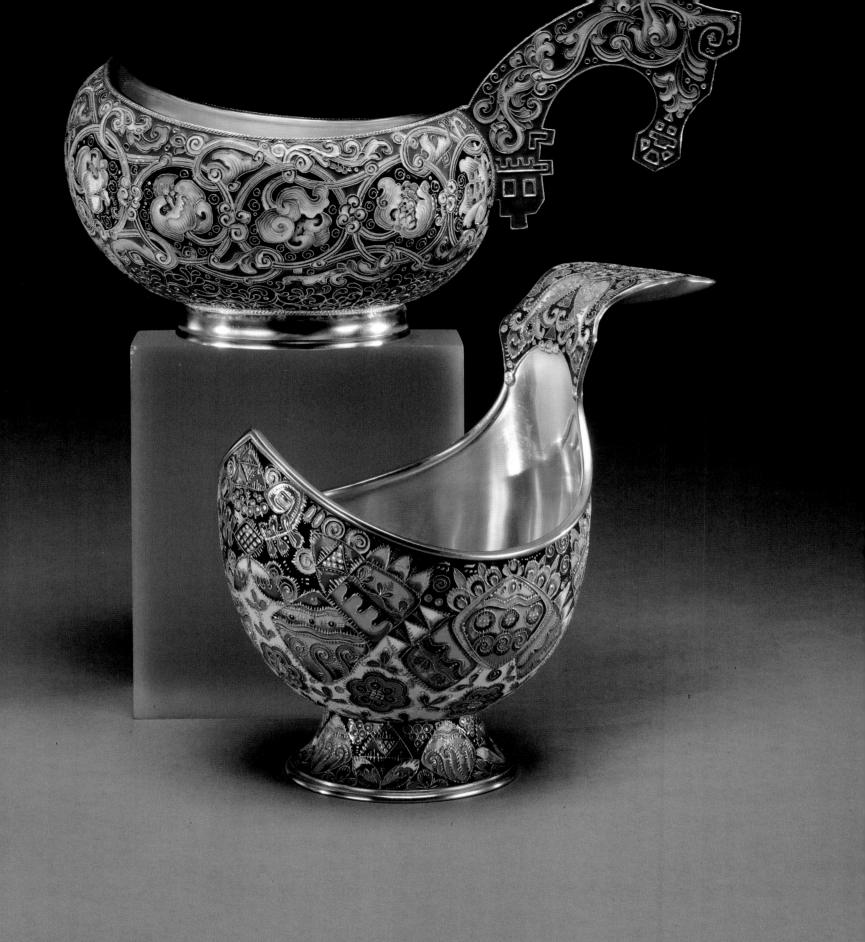

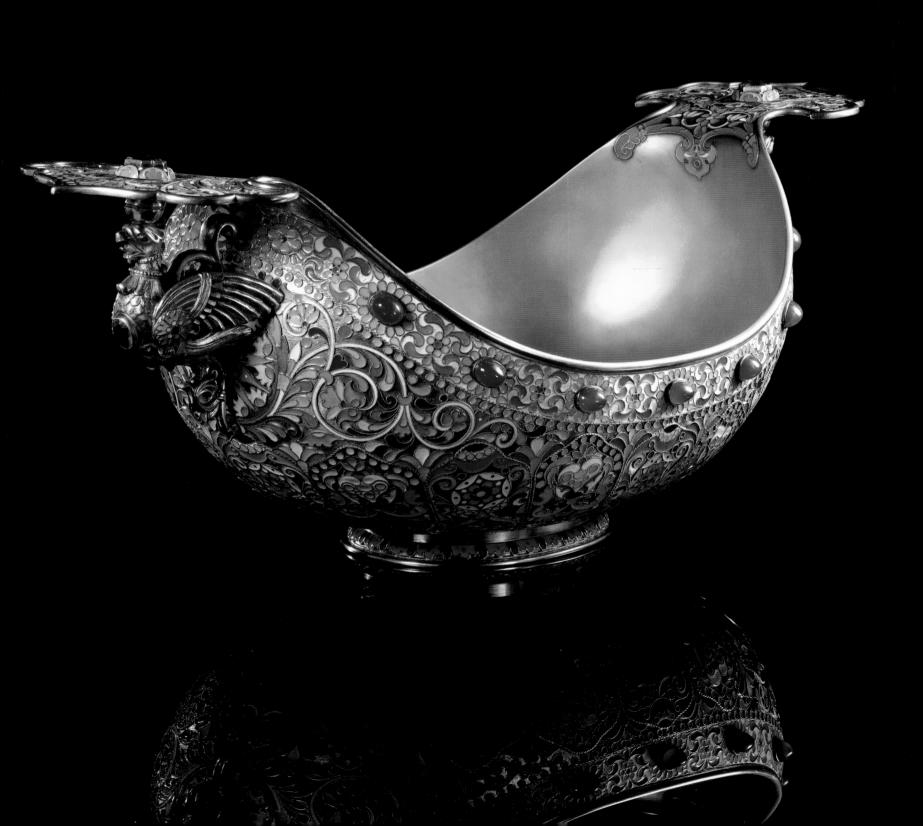

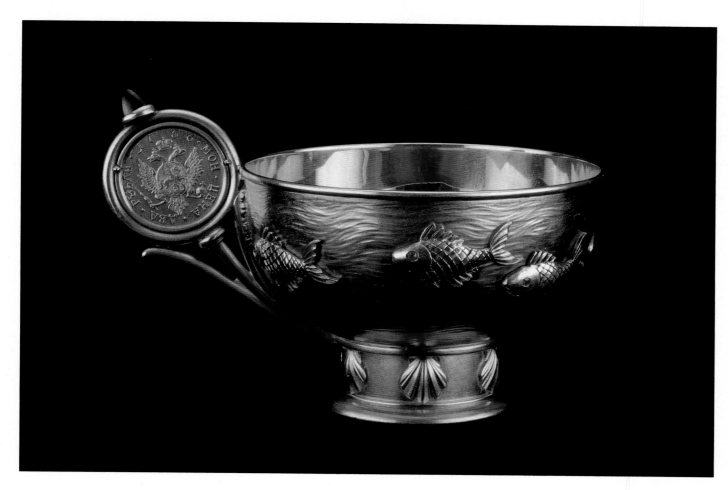

184

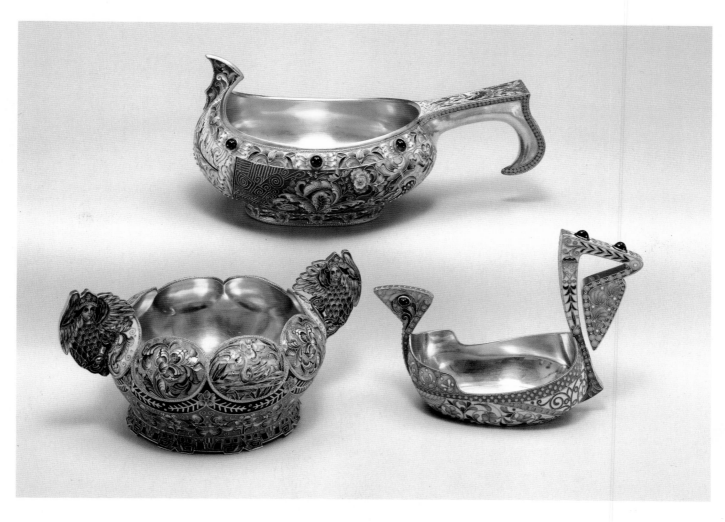

185

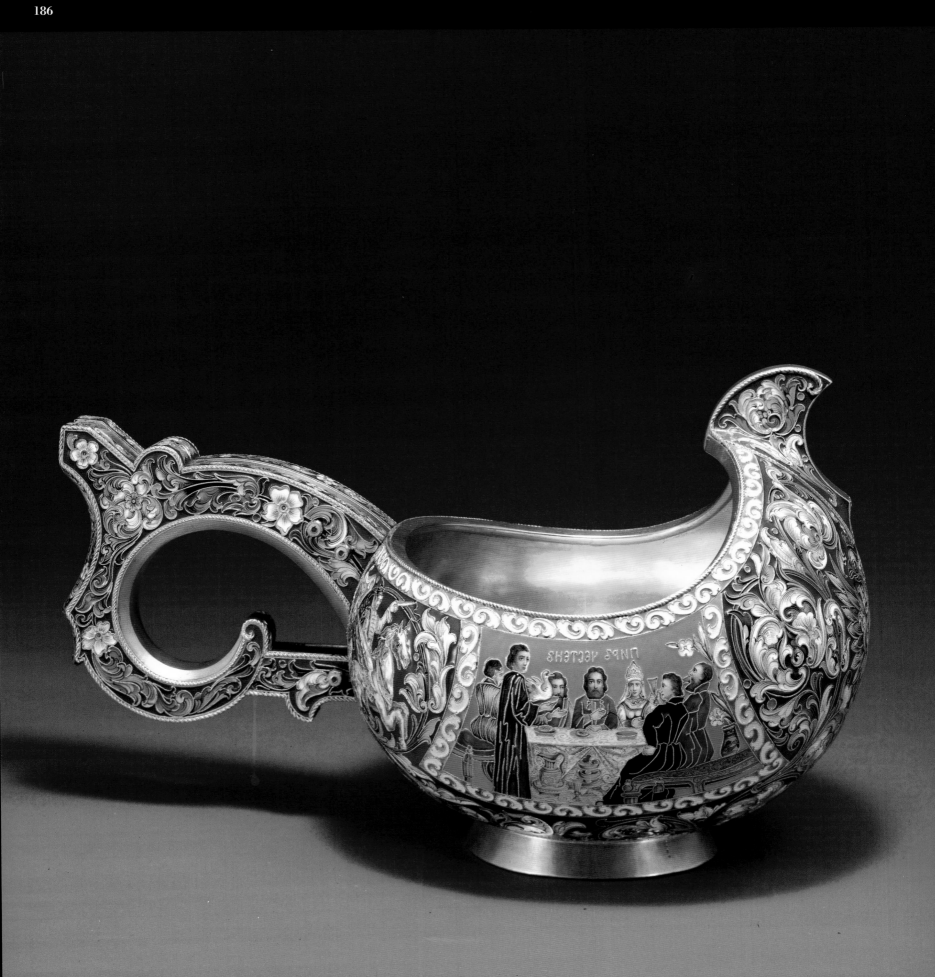

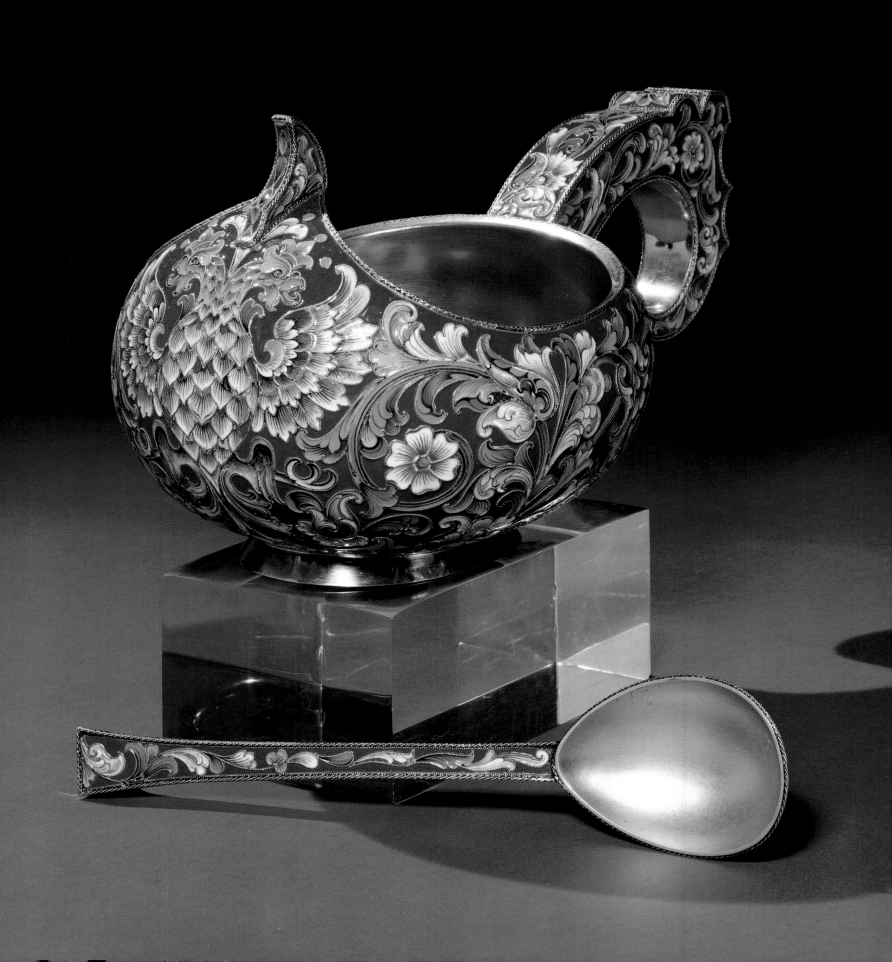

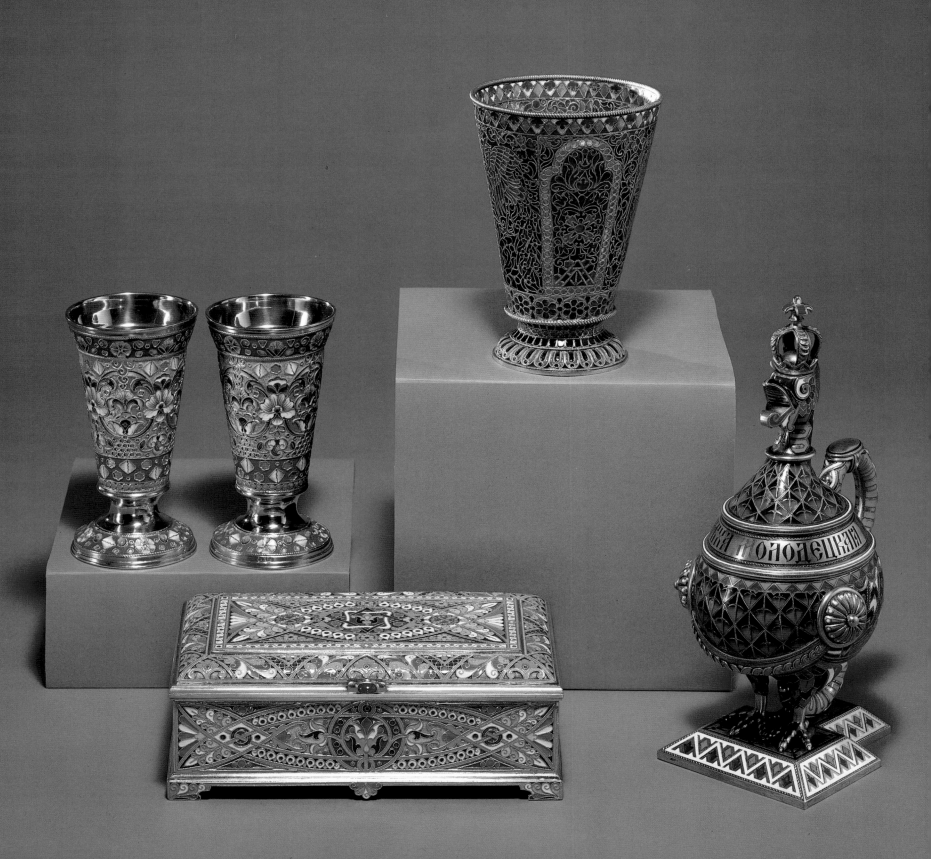

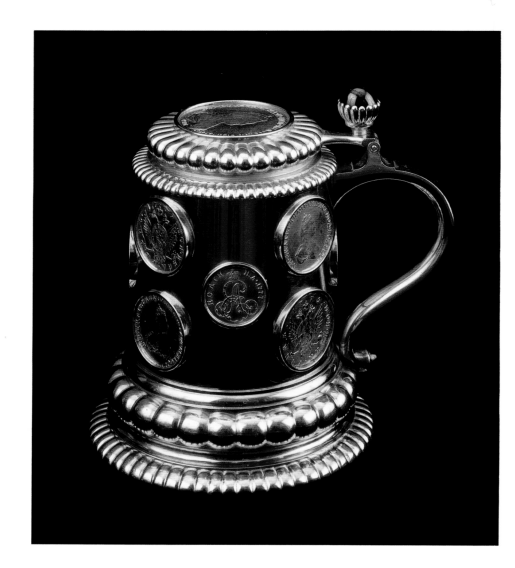

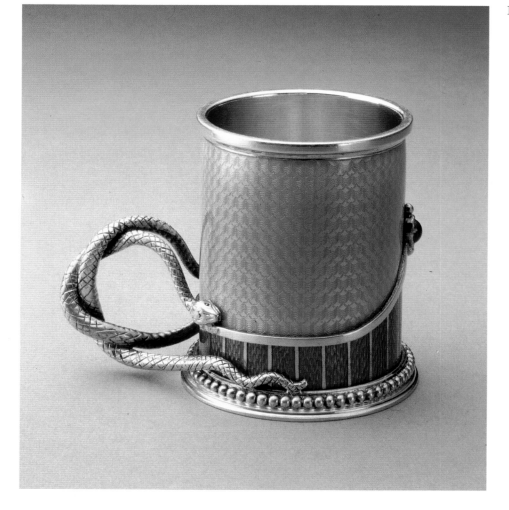

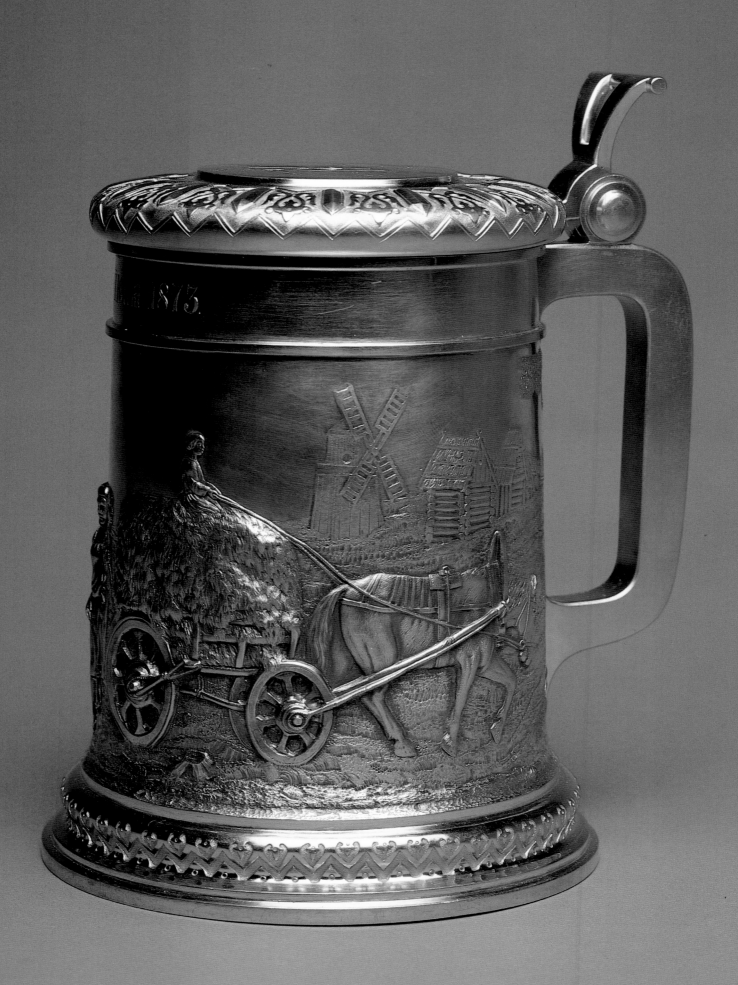

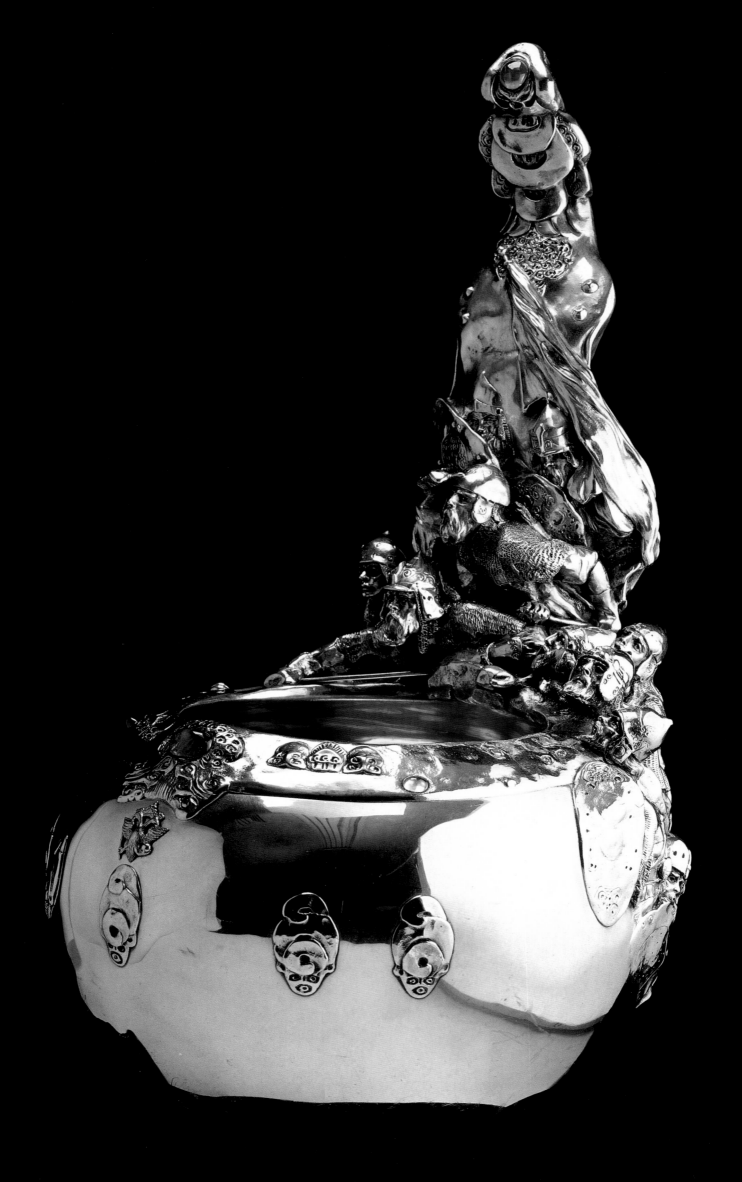

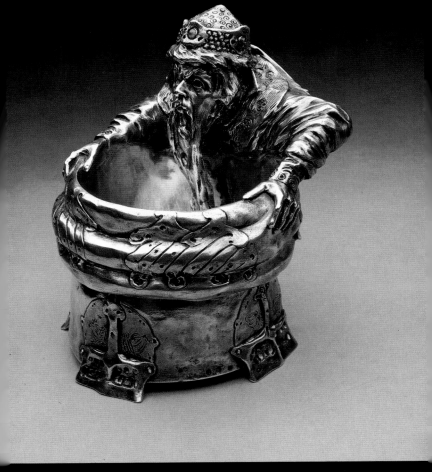

195

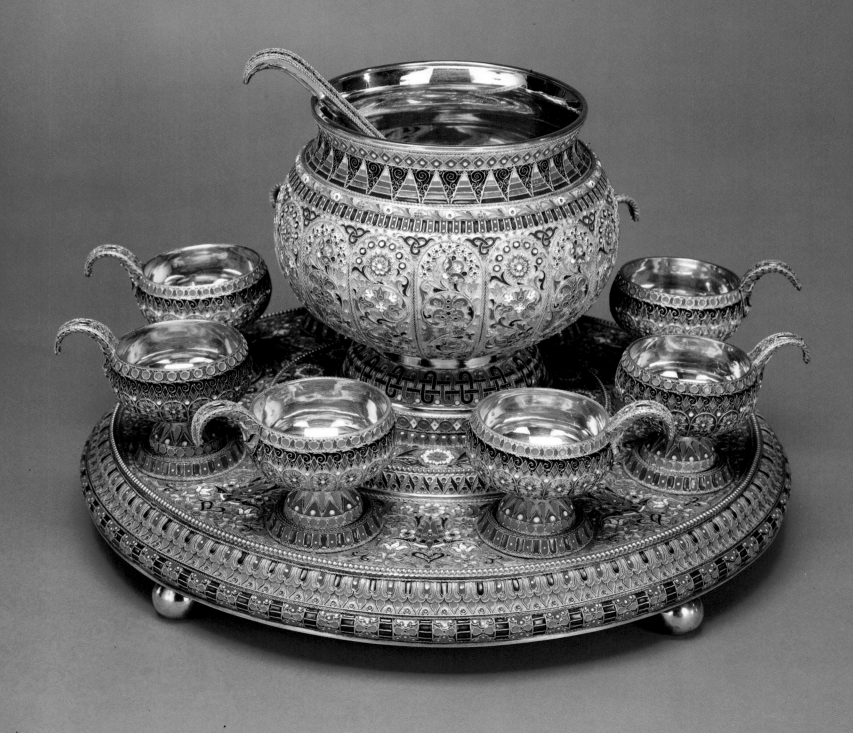

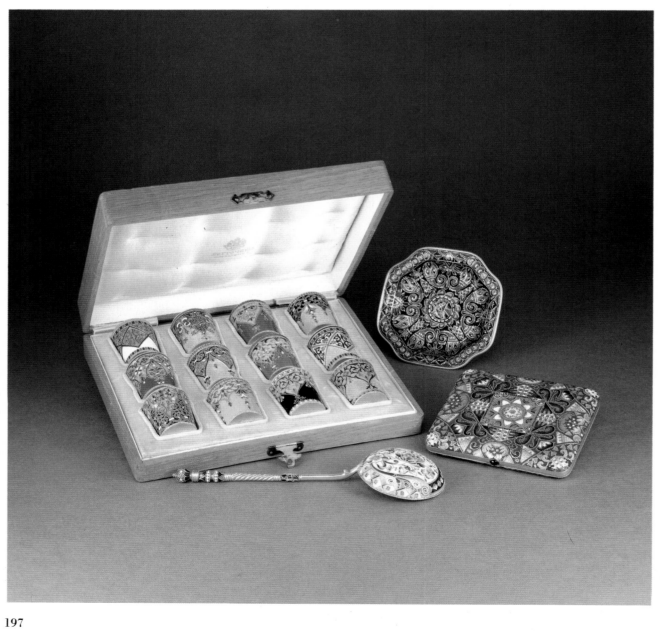

197

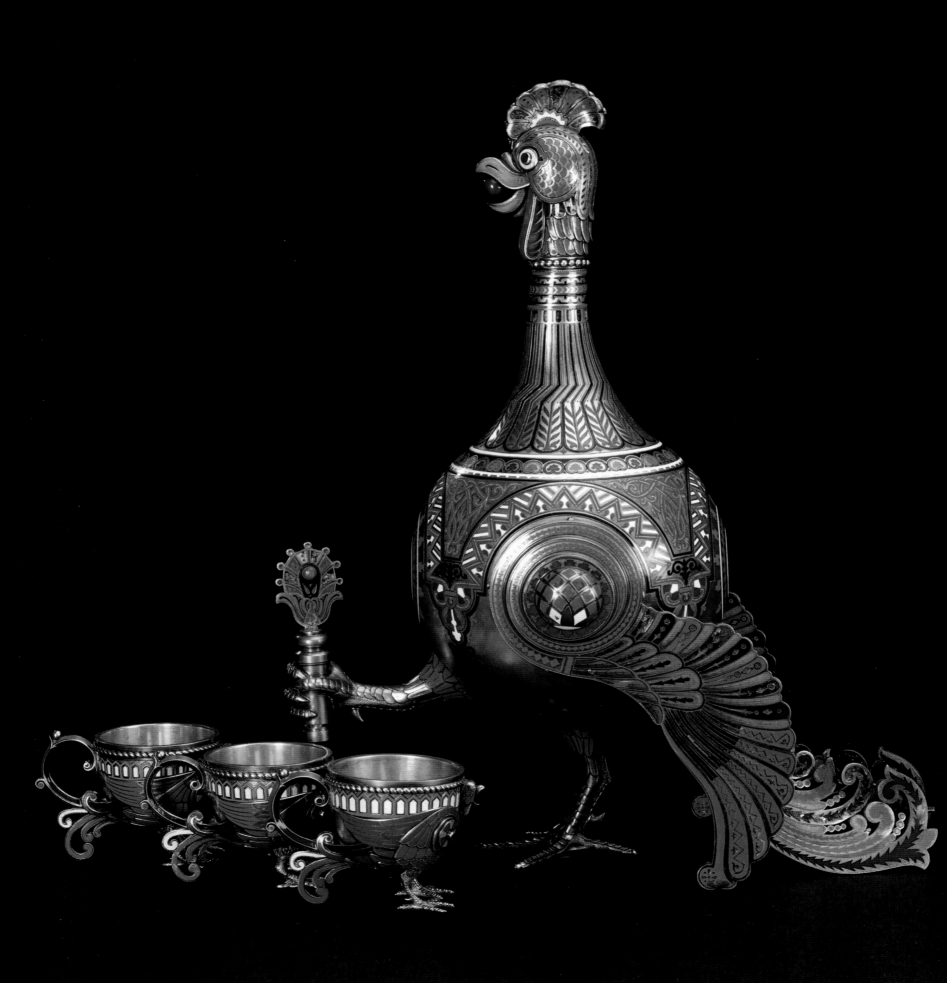

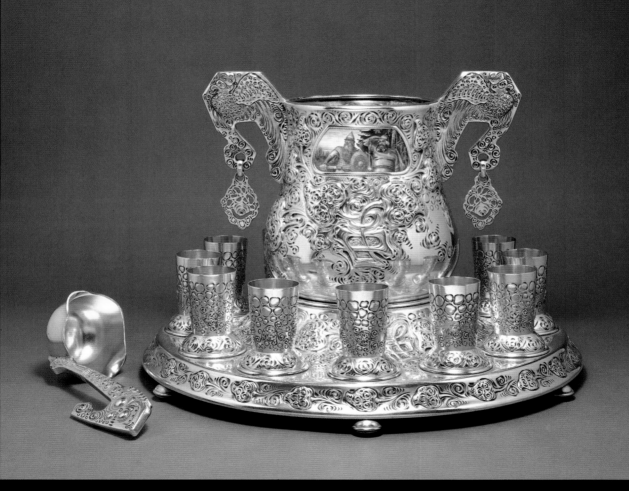

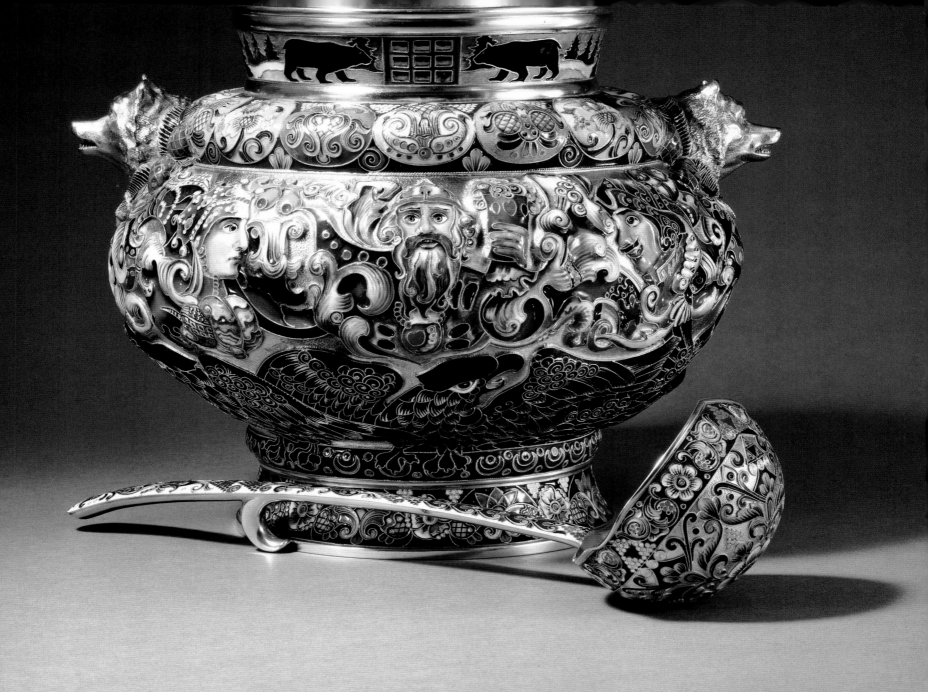

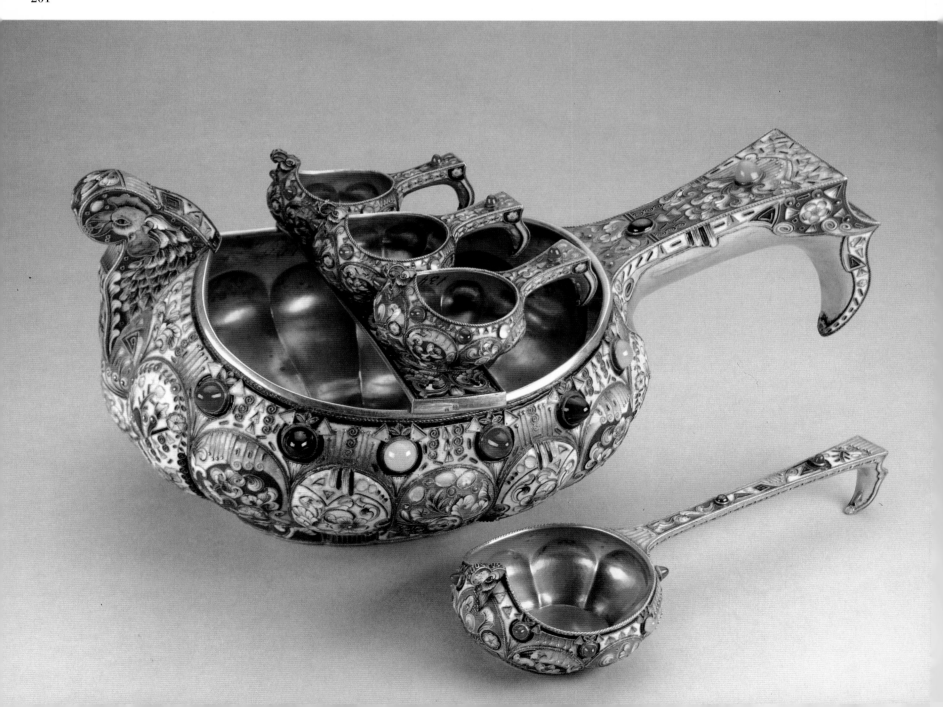

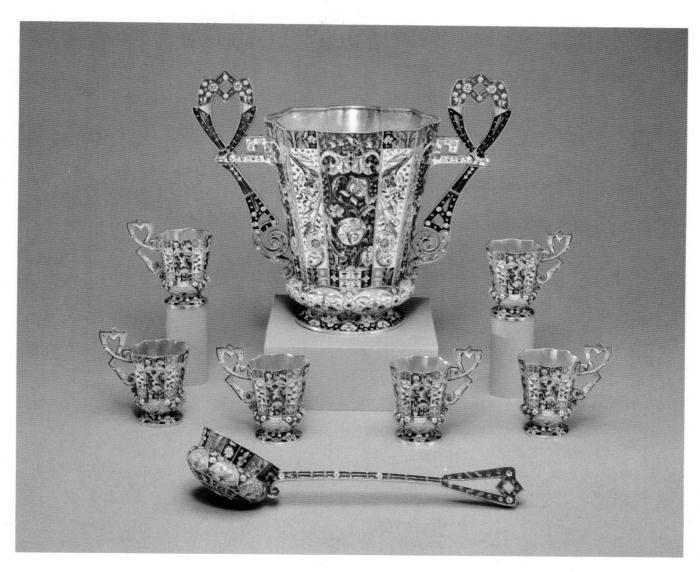

202

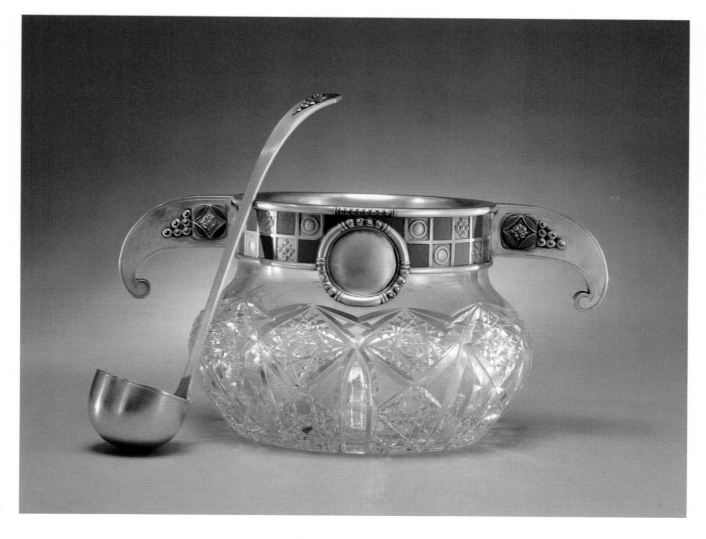

203

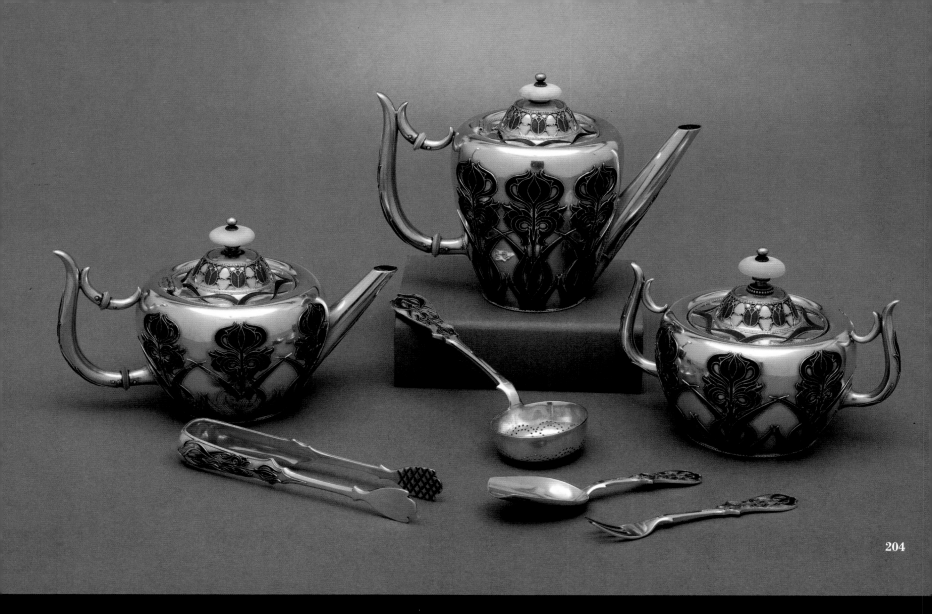

204

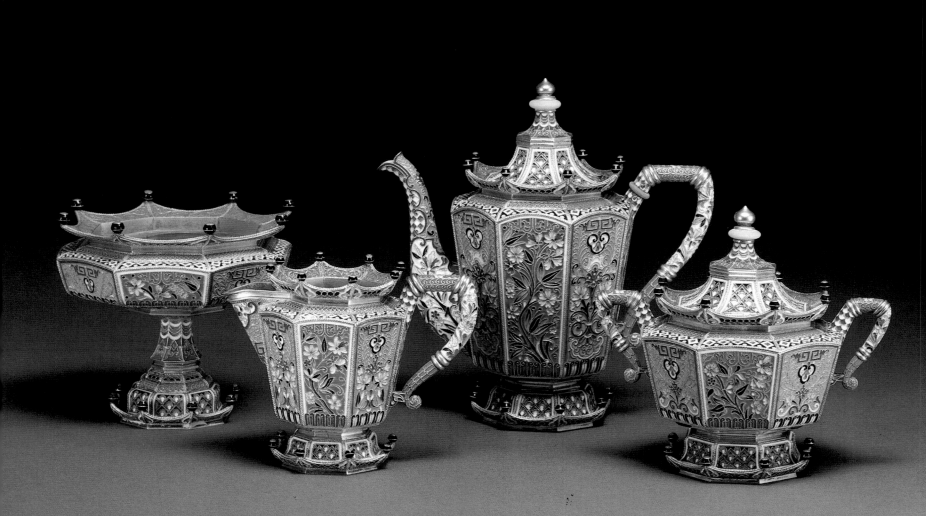

205

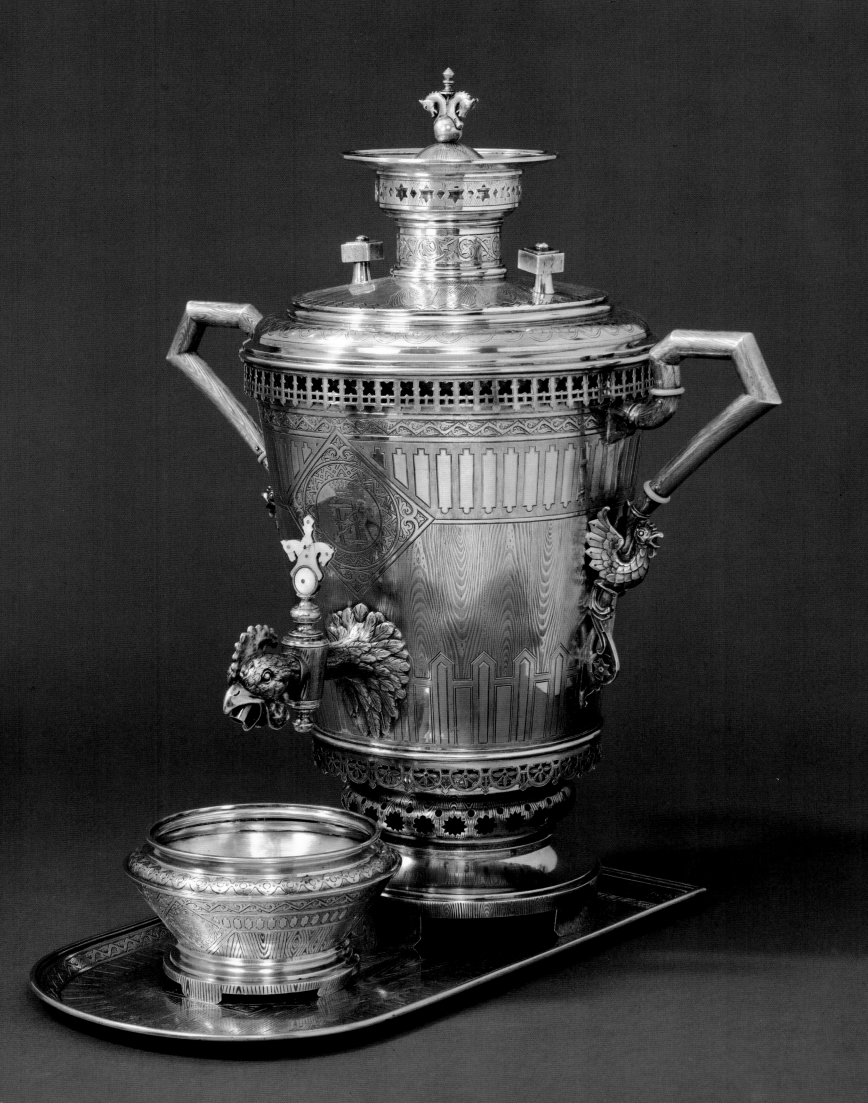

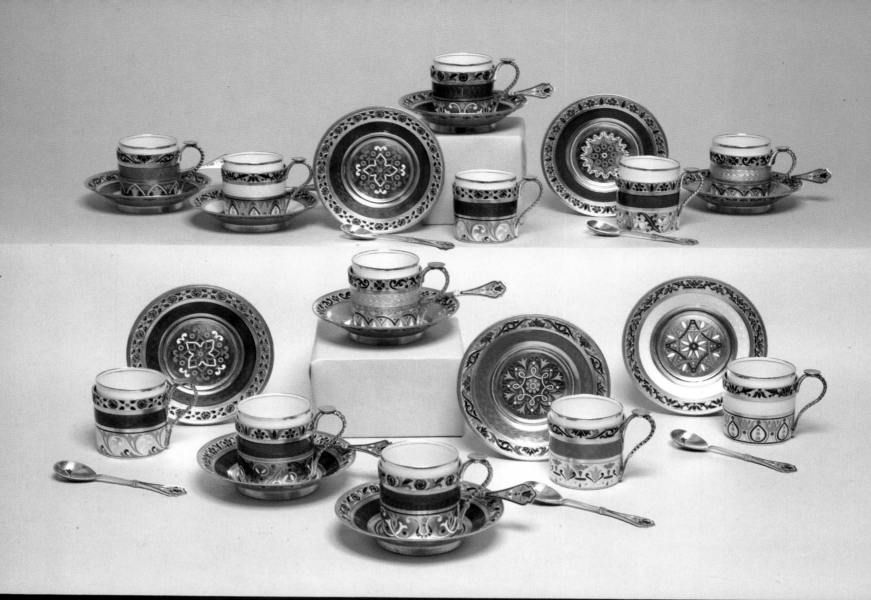

207

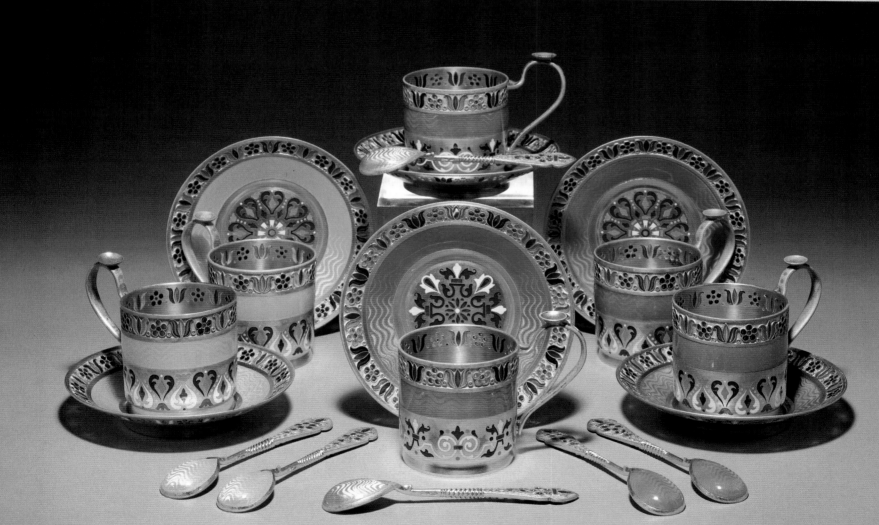

208

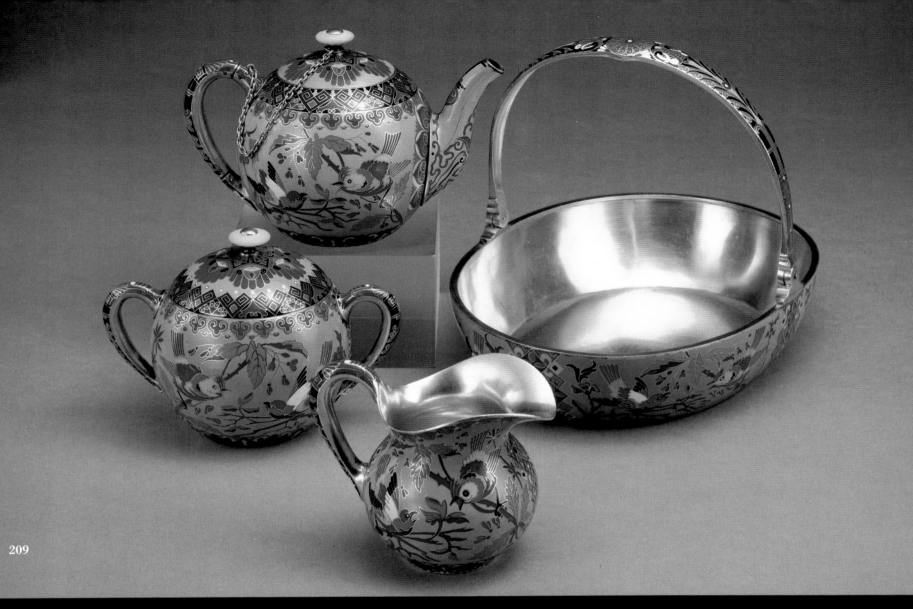

209

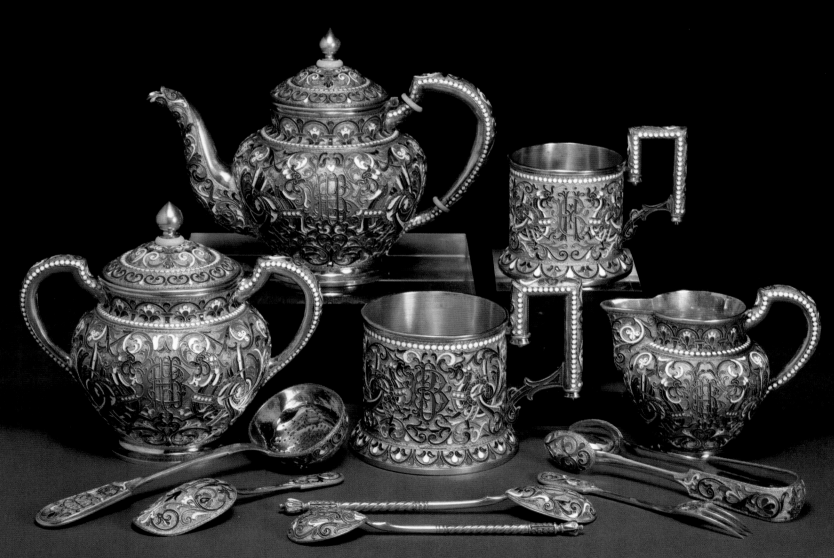

210

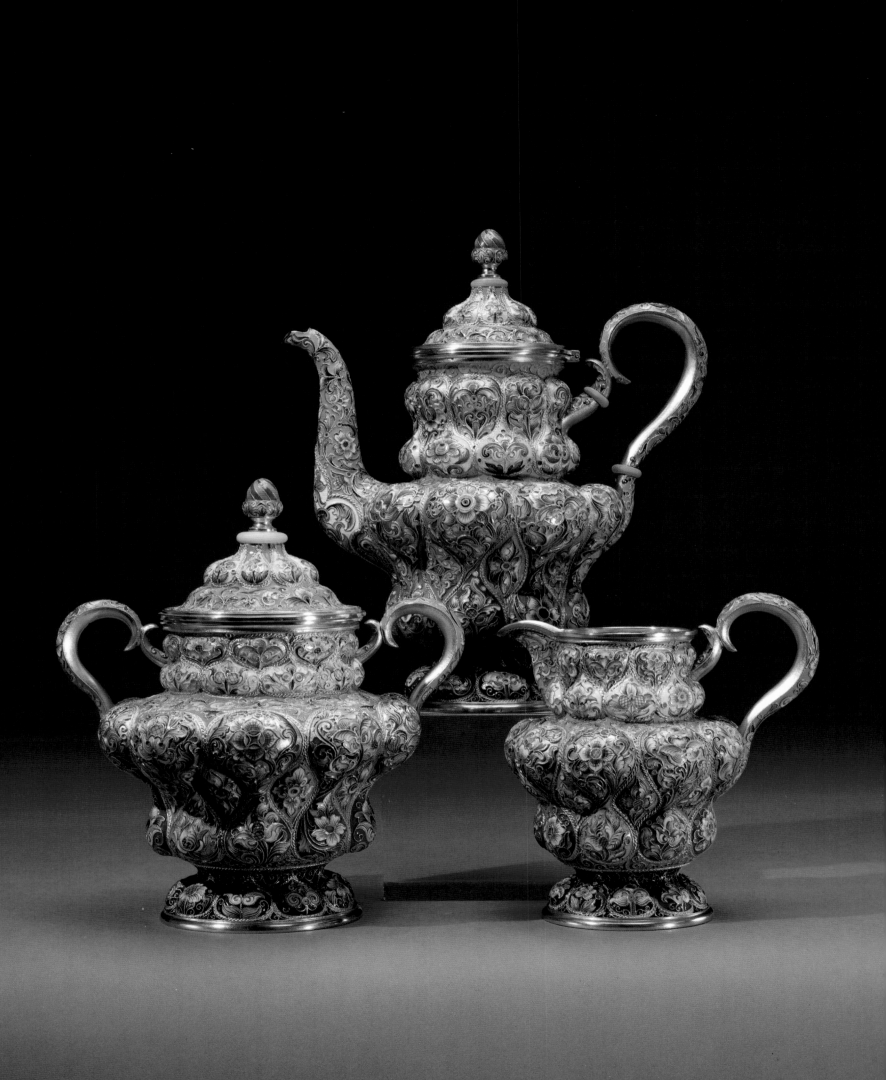

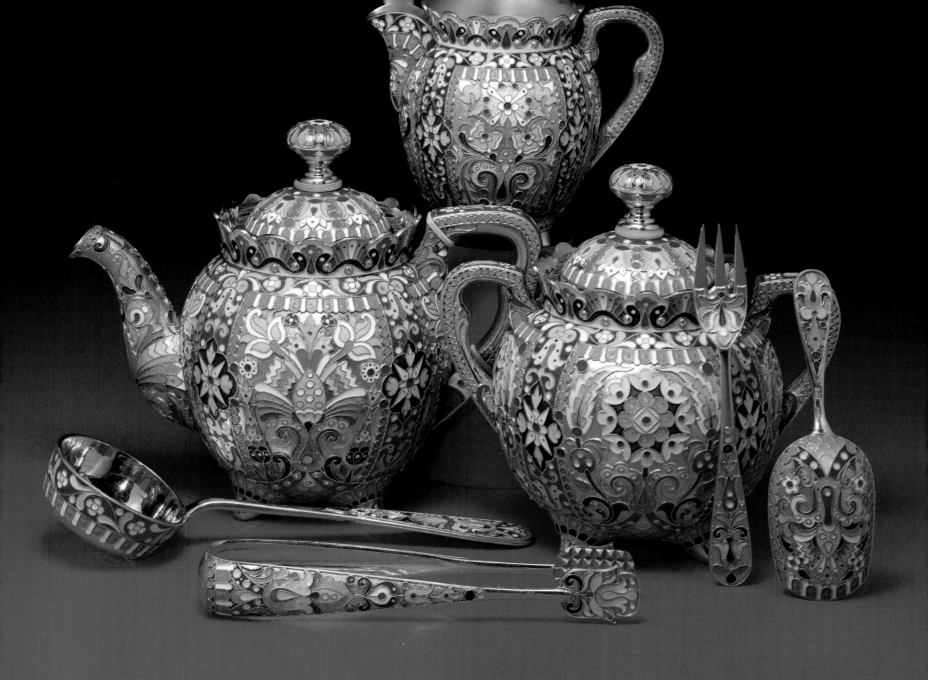

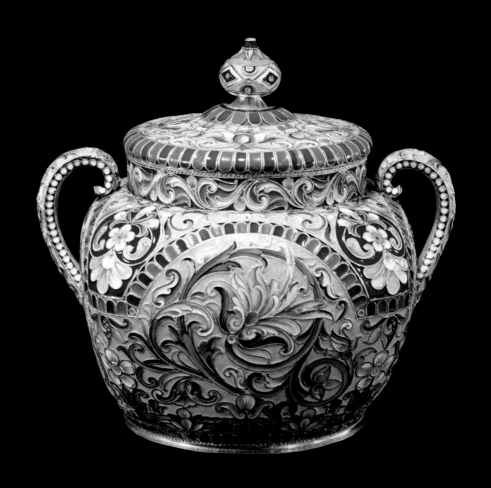

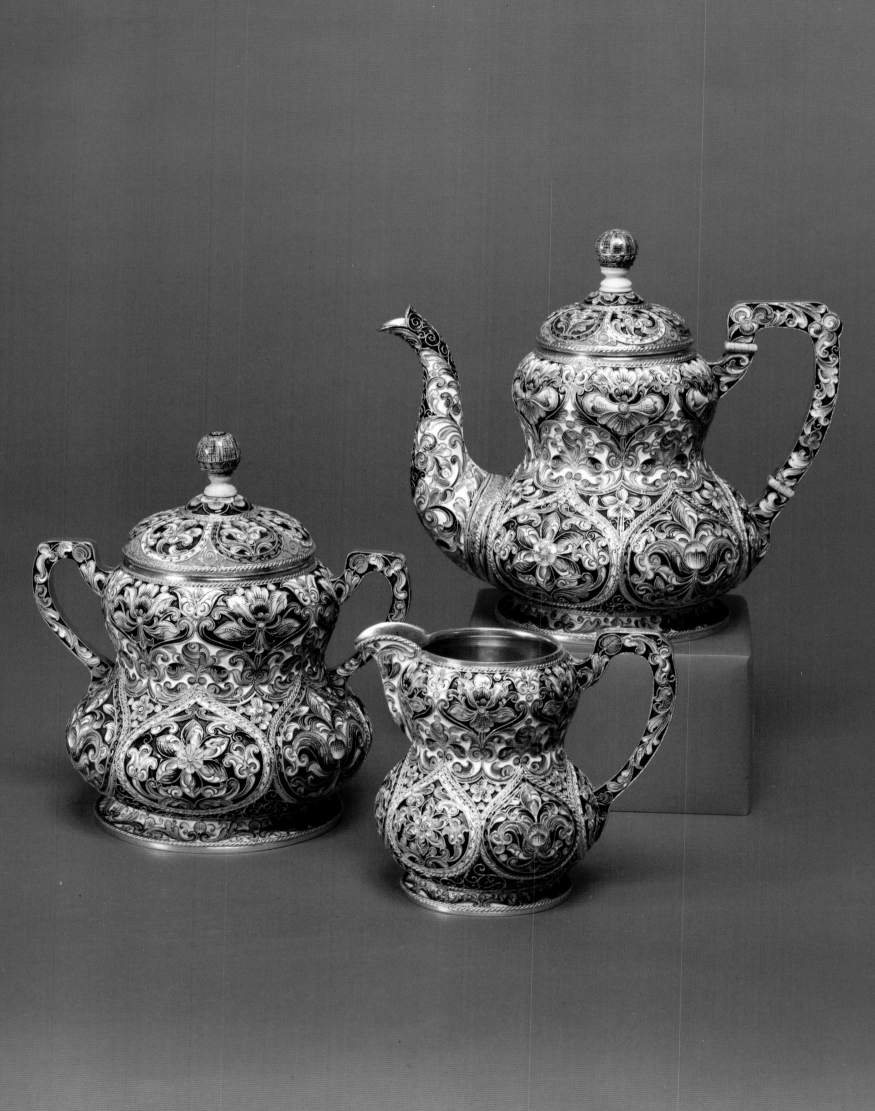

214

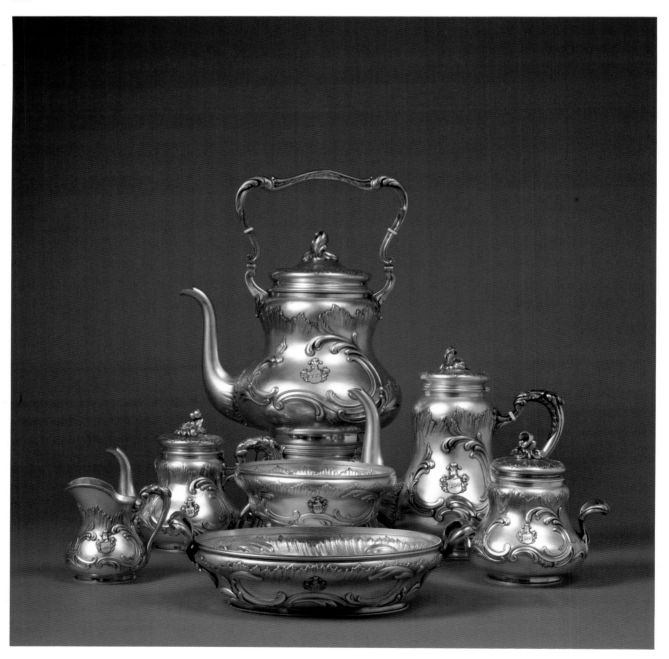

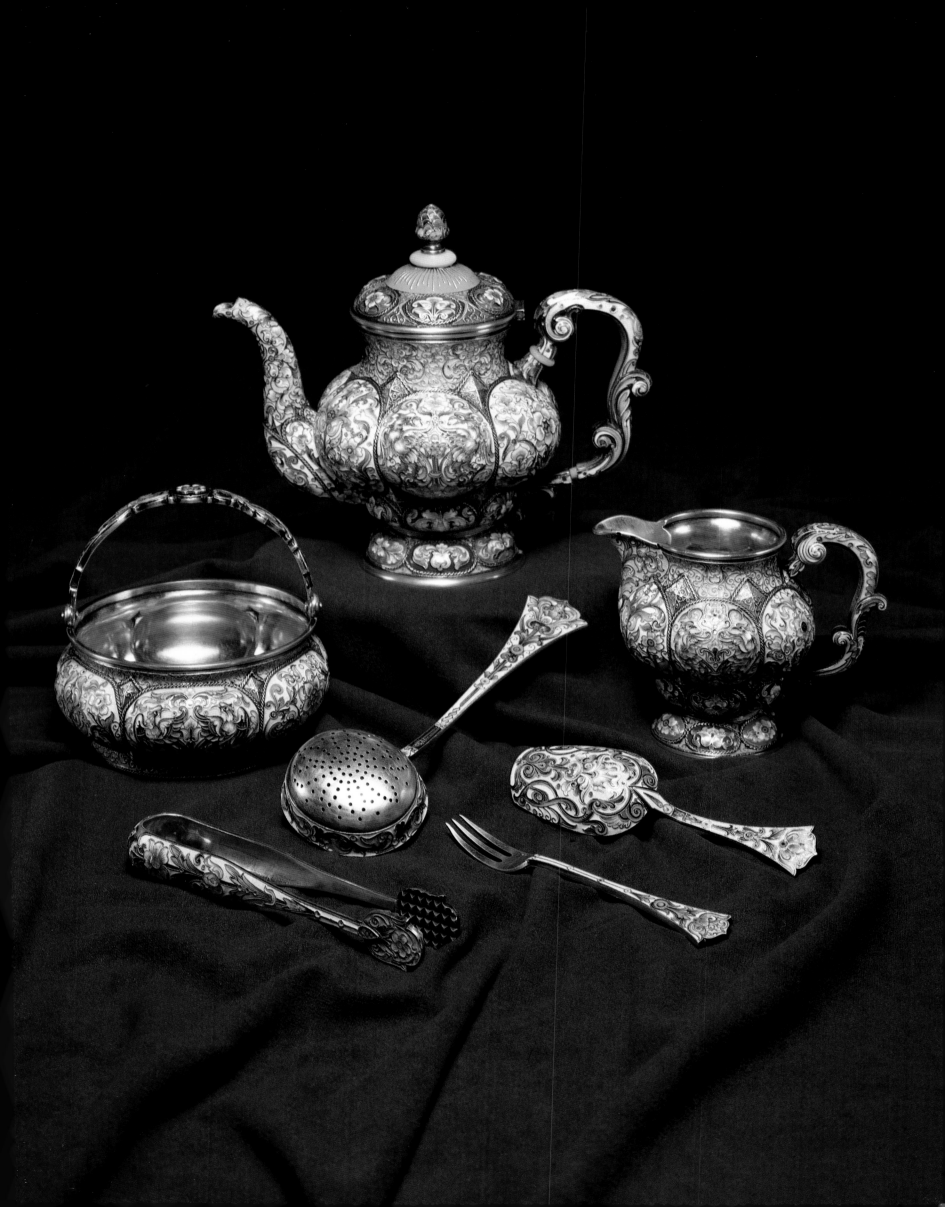

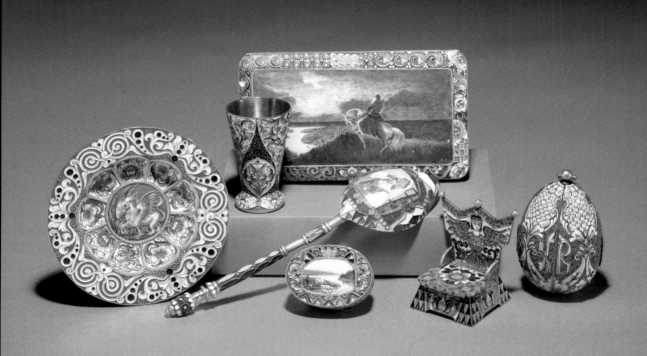

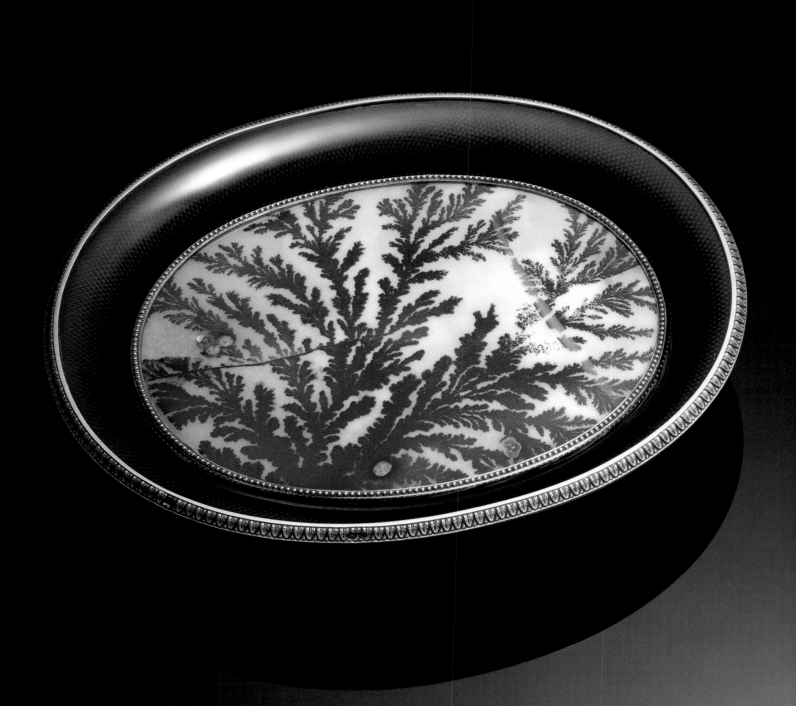

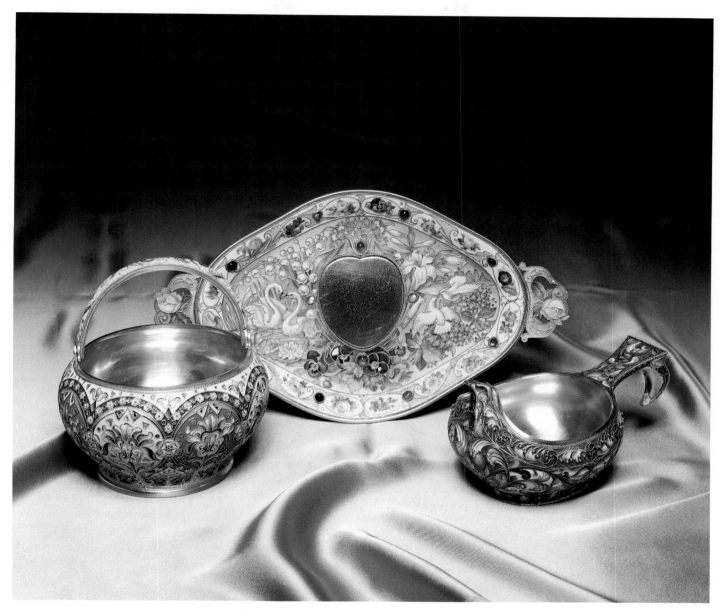

223

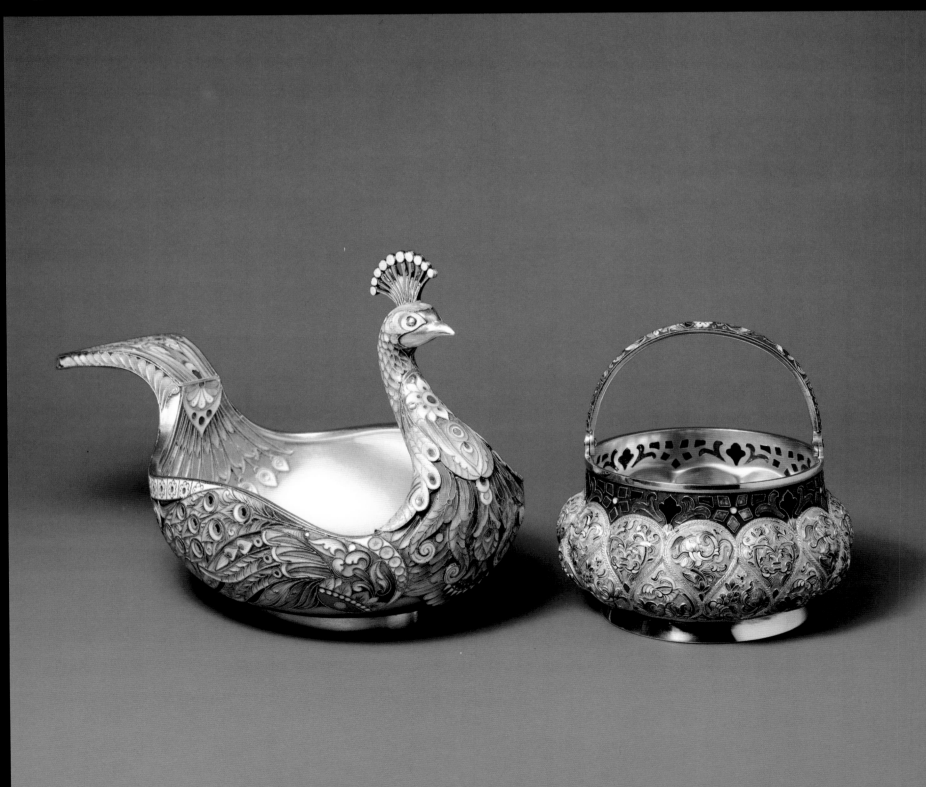

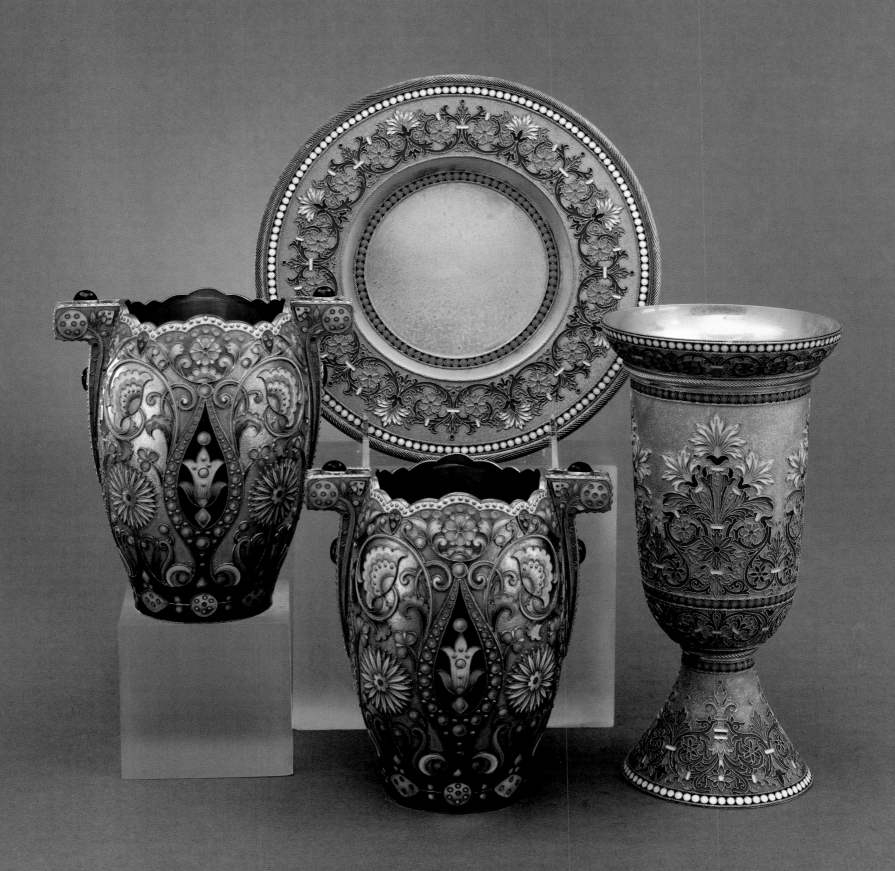

226

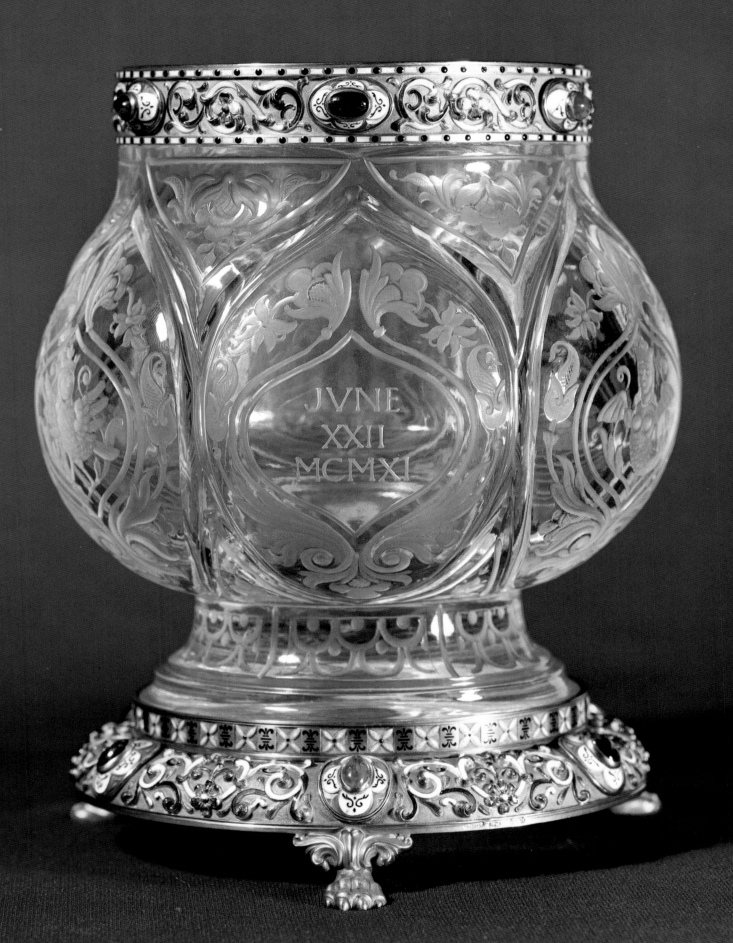

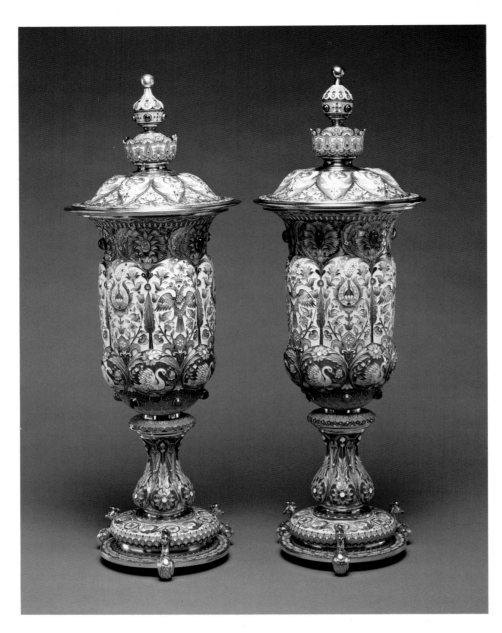

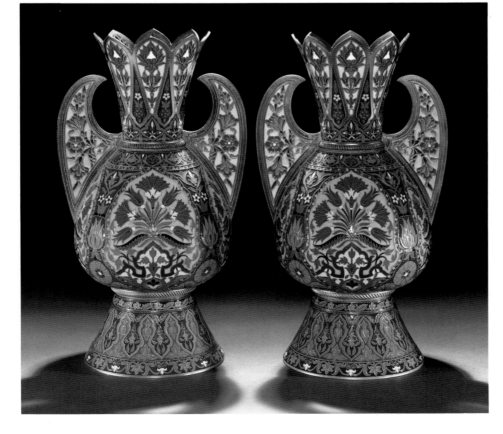

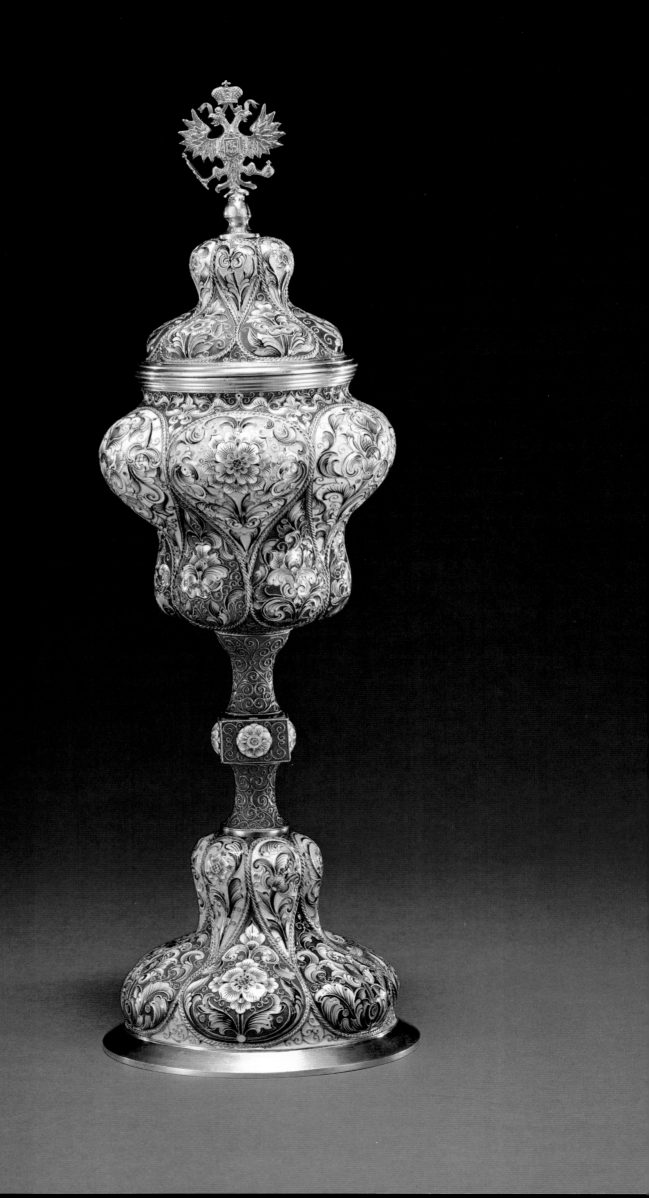

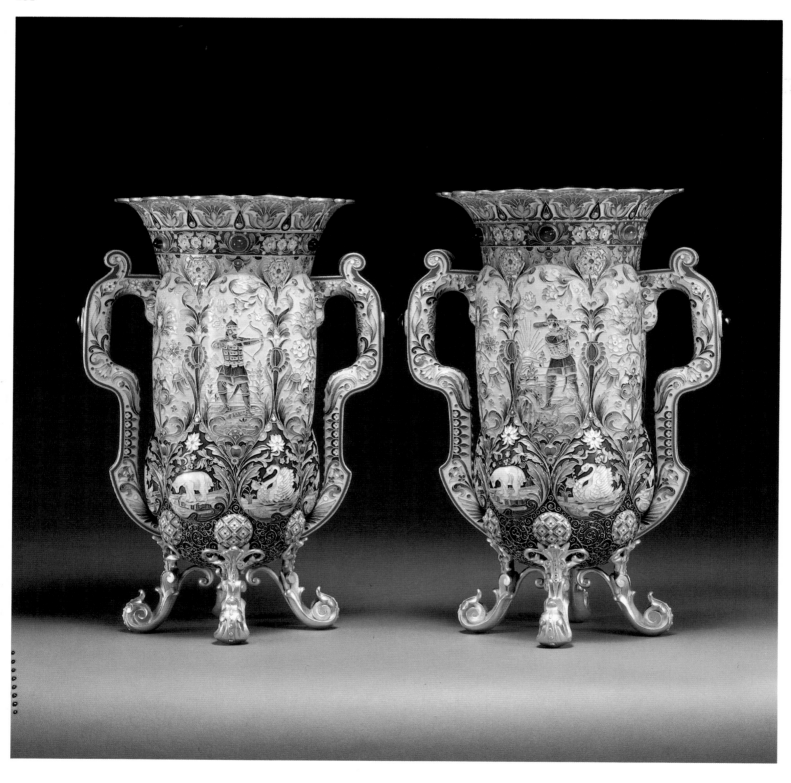

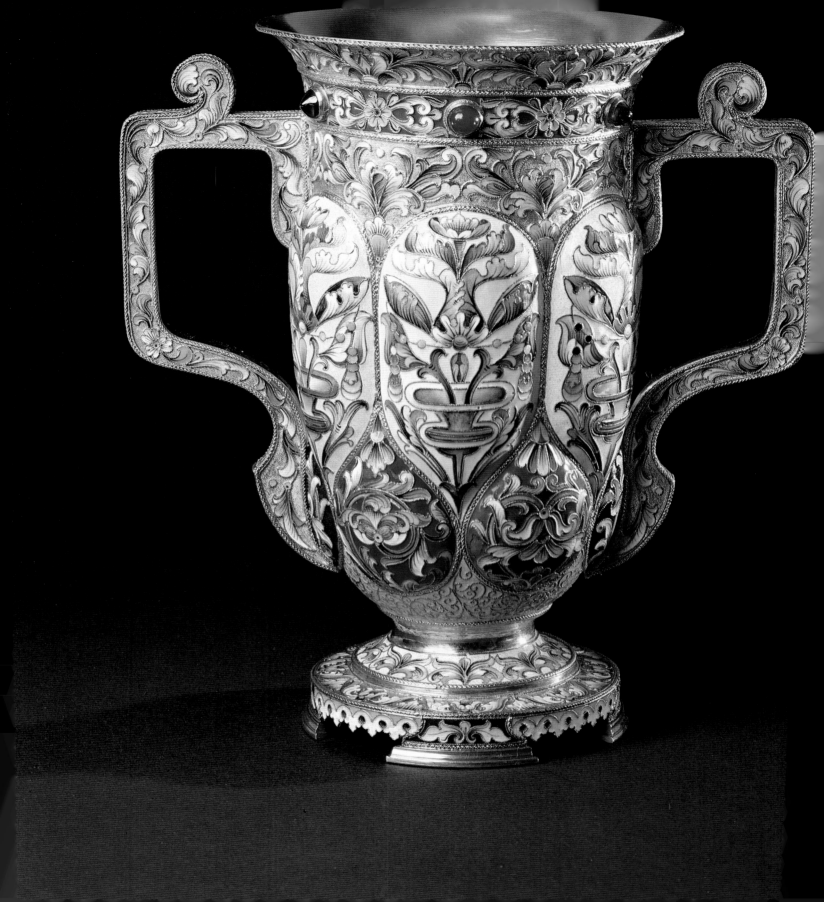

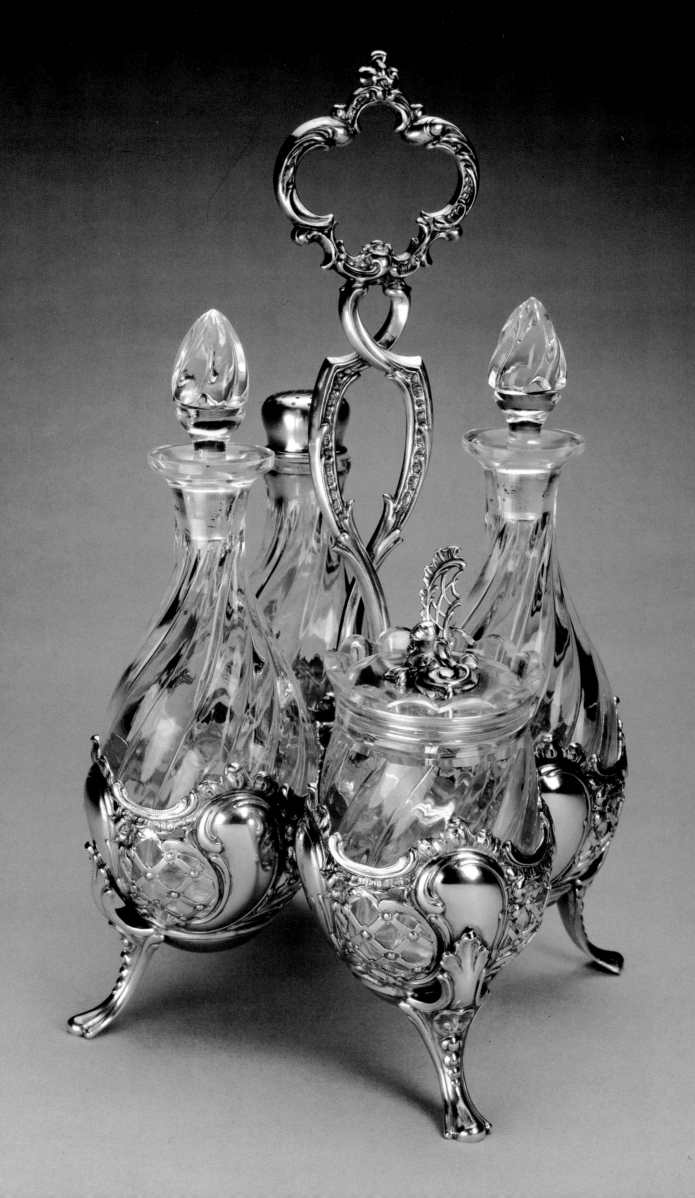

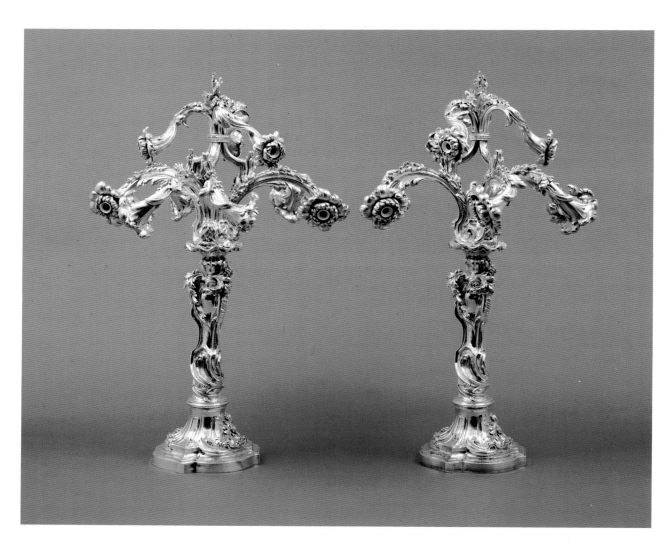

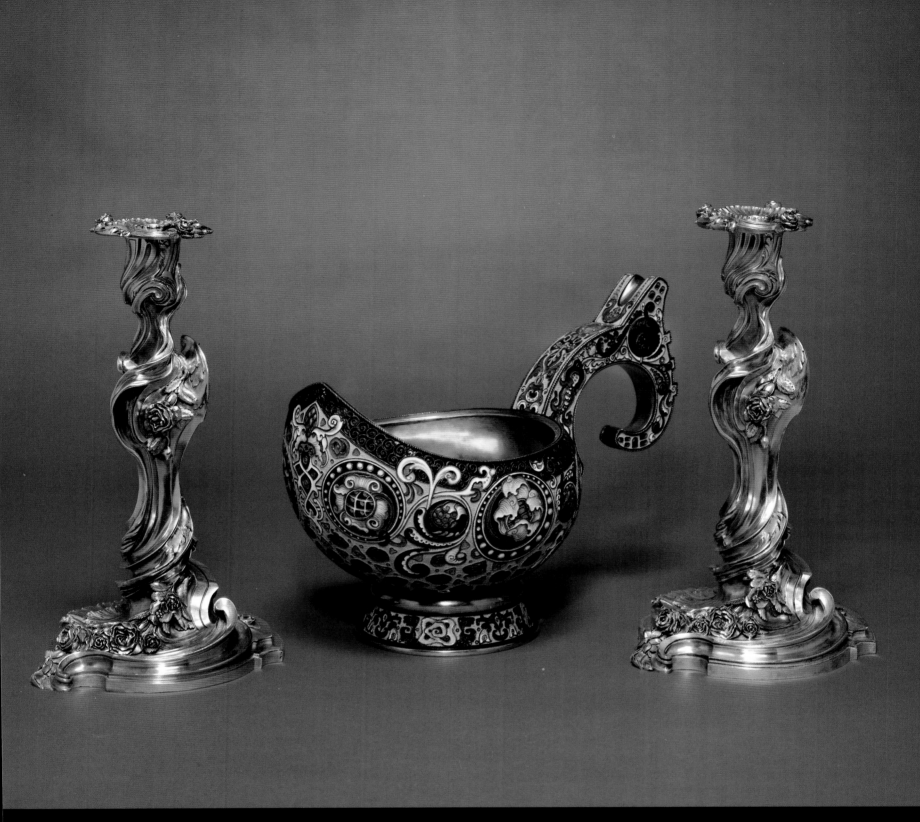

239

240

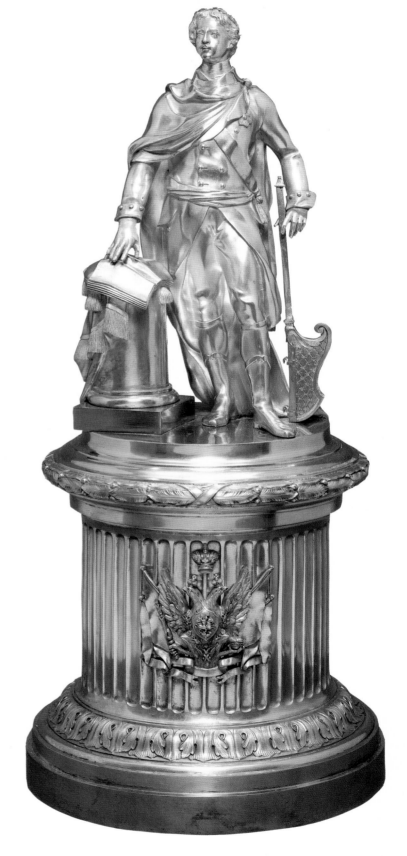

241

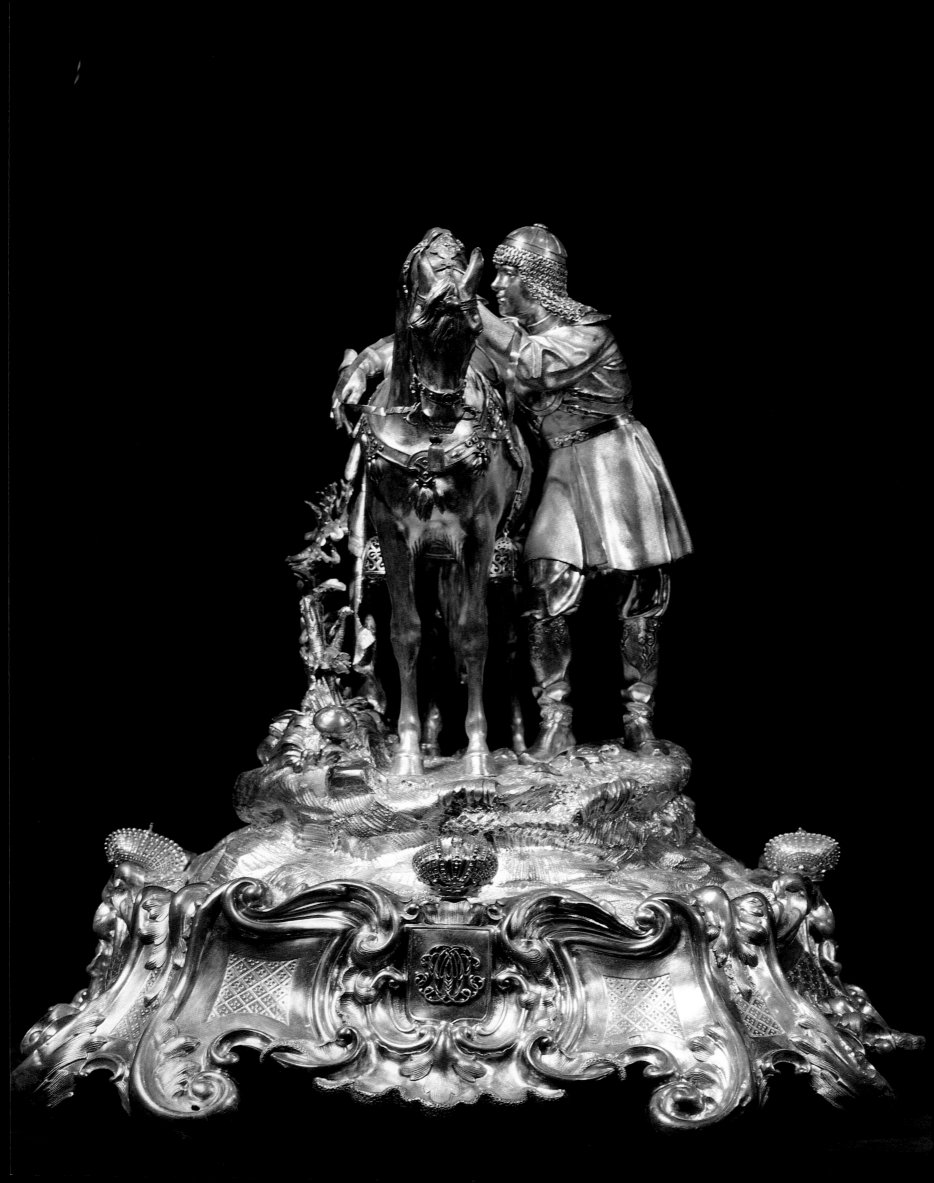

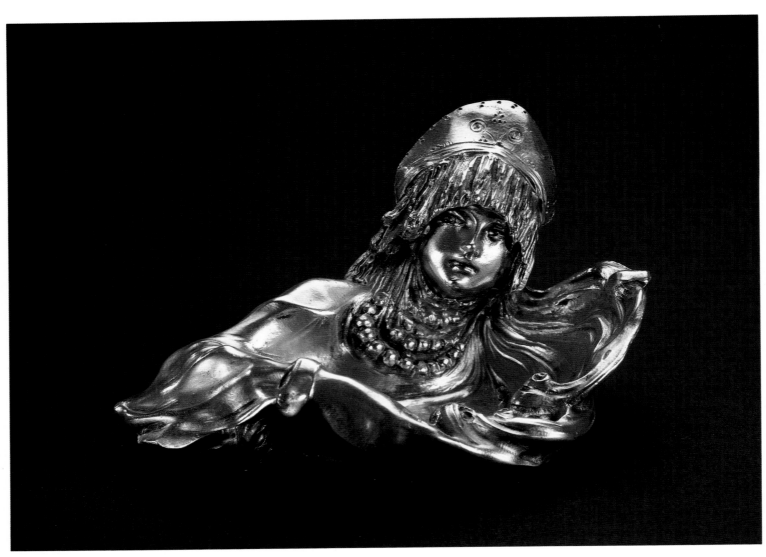

243

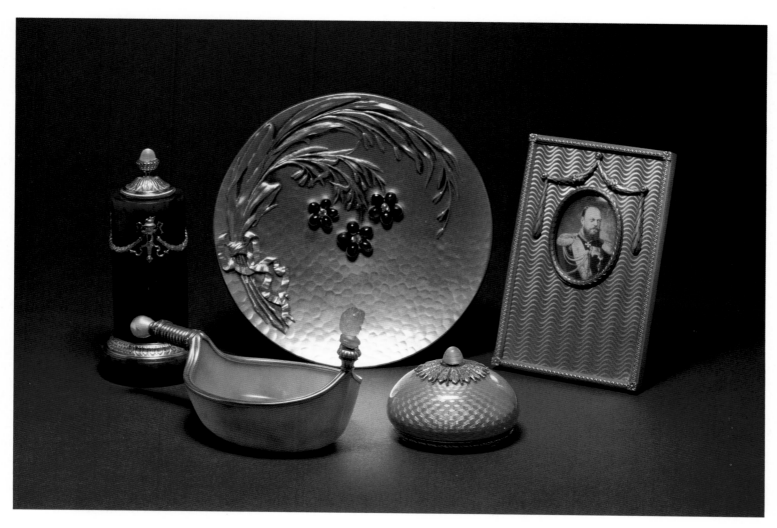

244

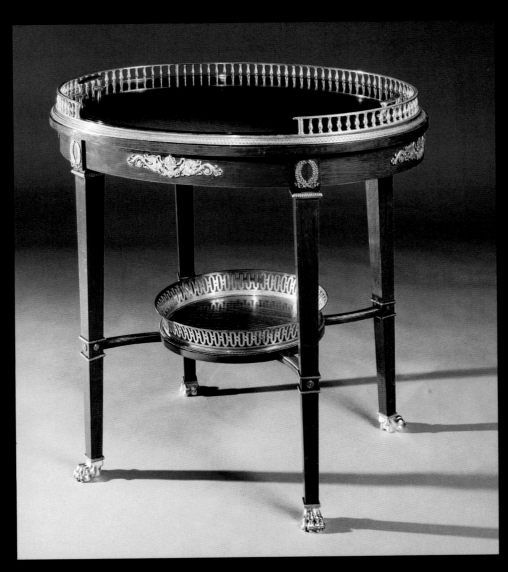

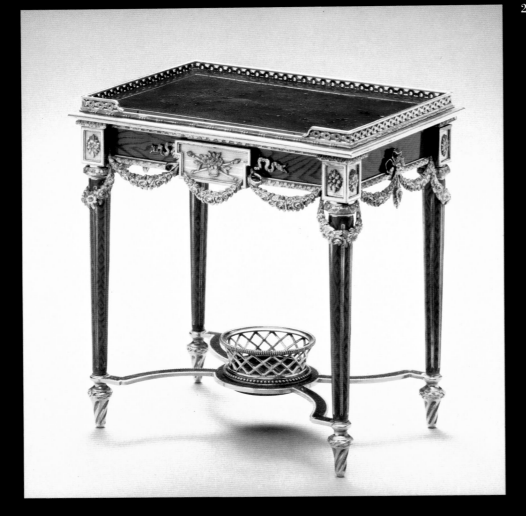

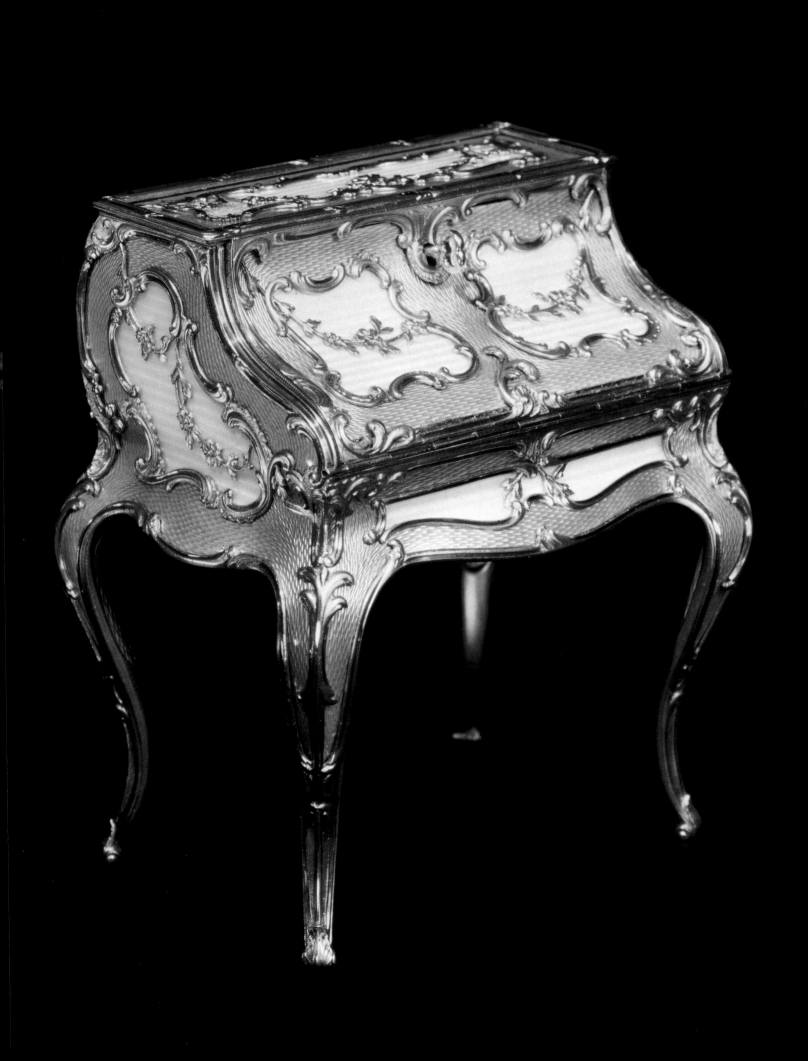

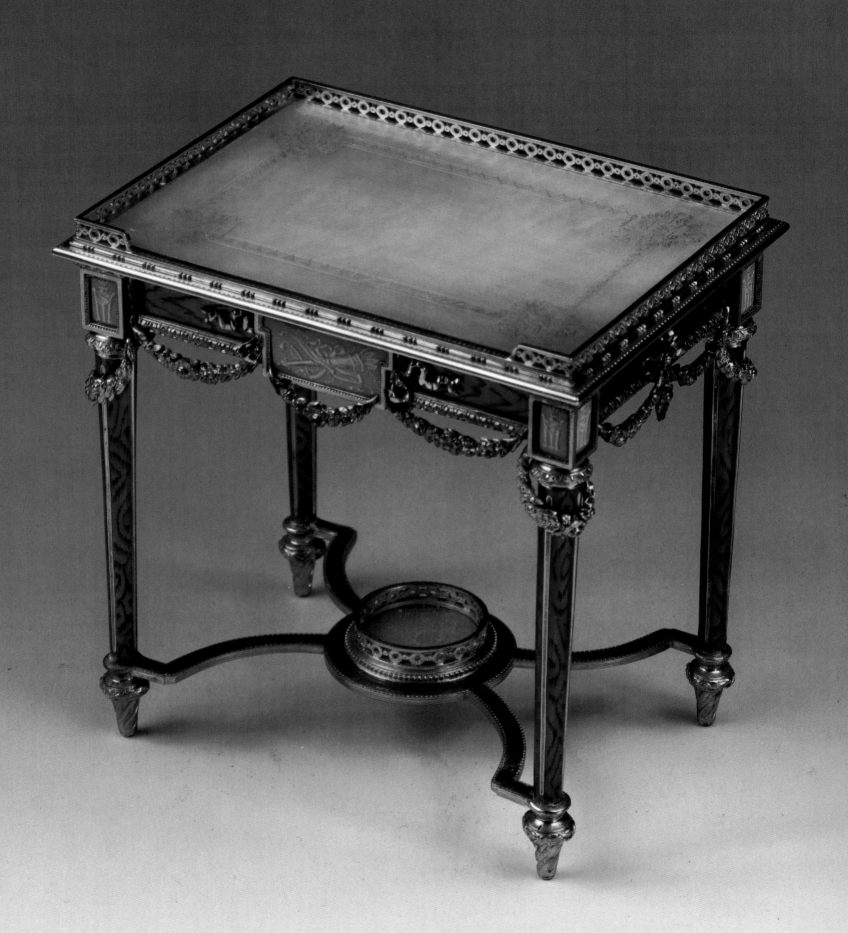

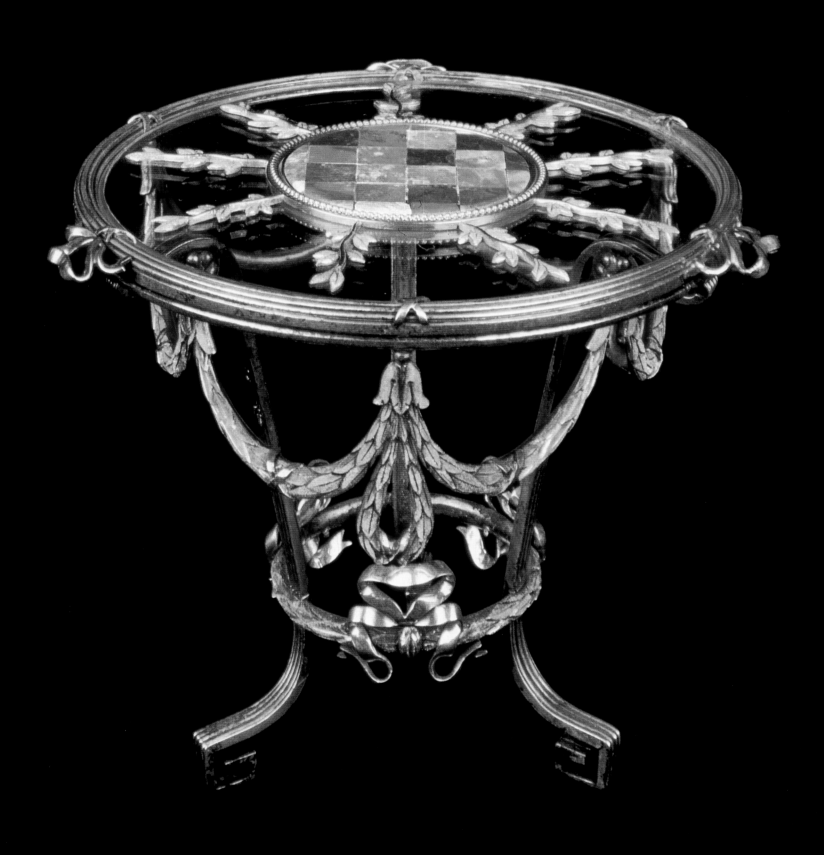

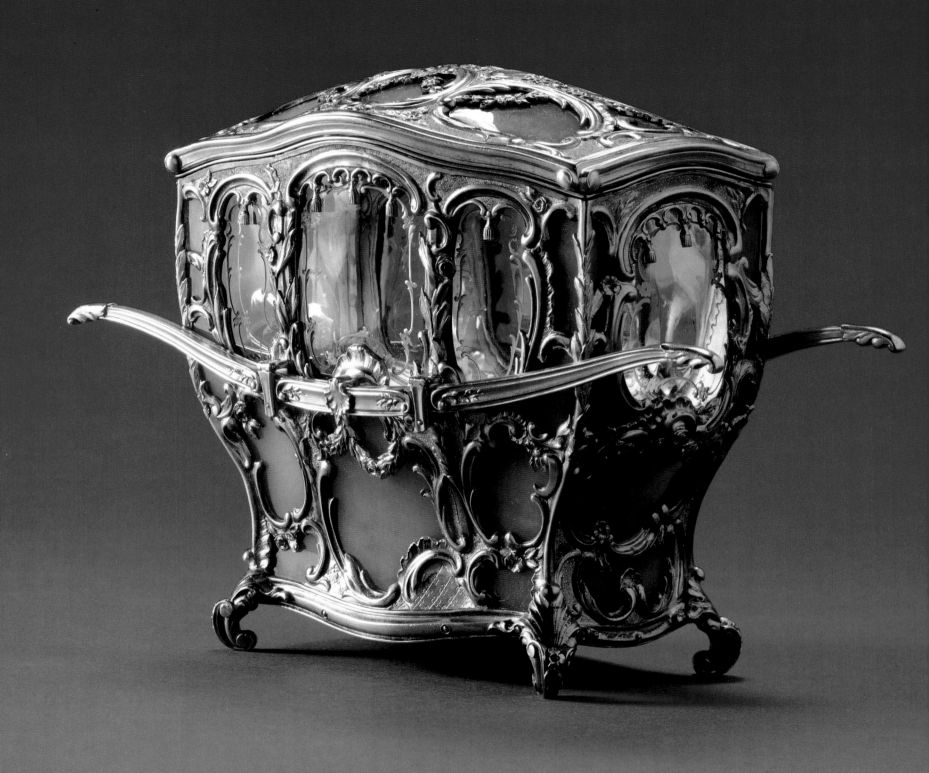

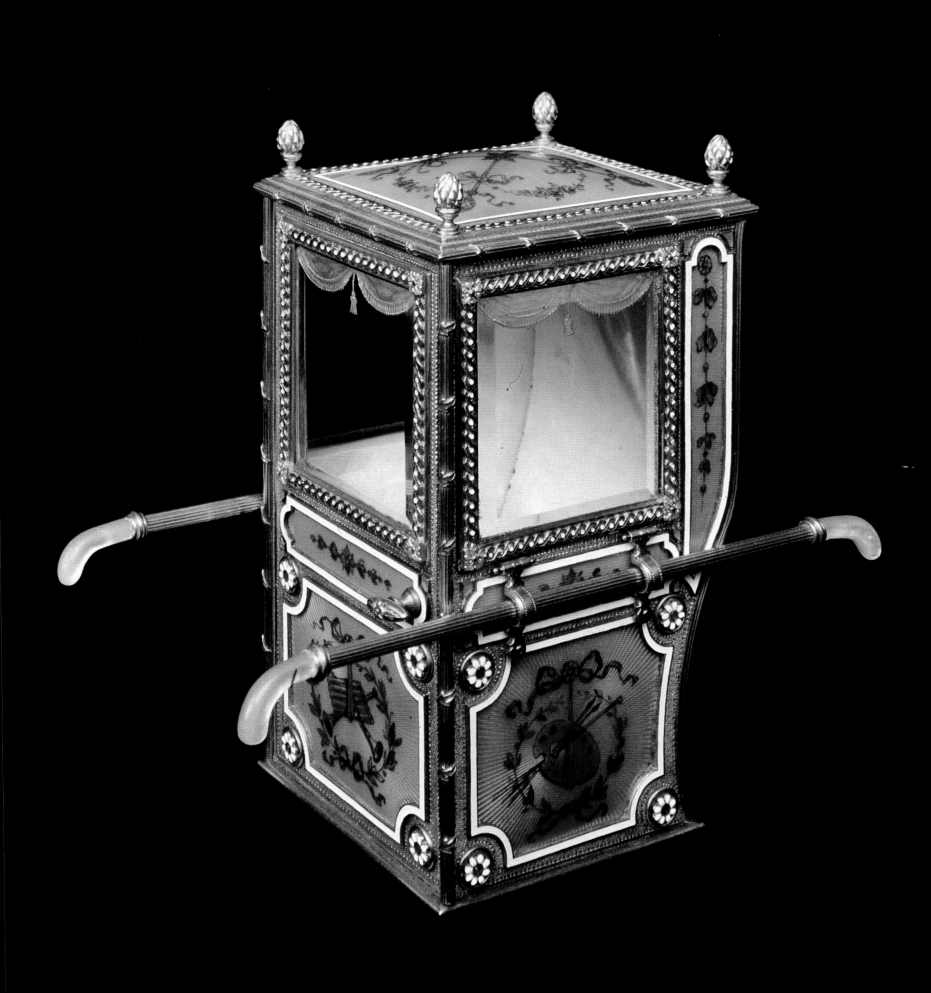

OBJETS DE LUXE

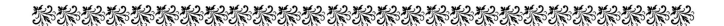

The era of great prosperity in Russia at the turn of the century brought the production of an almost endless array of *objets de luxe* by the goldsmiths and jewelers of Moscow and St. Petersburg. Such items as gold and silver cigarette cases, scent bottles, parasol handles, and fans were produced by Fabergé and his competitors, intended for practical use but even more so for the delight they gave when presented as a gift. Russian jewelry of this date is frequently marked by the use of semiprecious hardstones of Russian origin, or by the use of a particular motif such as an imperial eagle. This kind of nationalistic jewelry found great popularity in conjunction with the celebration of the Romanov Tercentenary in 1913. Jewelry made by Fabergé's workmaster Erik Kollin in the Scythian style brought the Fabergé firm recognition at the Nuremberg Fair in 1885.

252. Fabergé. **Gold and Enamel Frame.** Workmaster Henrik Wigström, St. Petersburg. ca. 1910. Height 2¾″ (7.1 cm). *This rectangular red gold frame is enameled opaque white and translucent emerald green over a guilloché ground. A view of the dairy at Sandringham is painted in opalescent rose-sepia enamel.* **Gold and Rock Crystal Hand Seal.** Height 1⅝″ (4.1 cm). *This rock crystal seal has mounts of red and matted green gold and is set with four carbuncles. This Fabergé work is unmarked.* **Gold and Carved Hardstone Miniature Elephant.** Height 1″ (2.5 cm). *Carved of sardonyx with rose diamond eyes, this tiny creature bears a gold rug and tower on its back enameled opaque white and translucent emerald green. Both the tower and rug are bordered by diamonds. This Fabergé work is unmarked.* **Rock Crystal and Gold Small Elephant.** Height 1″ (2.5 cm). *This carved rock crystal elephant has cabochon ruby eyes. It carries on its back a tower which is enameled translucent red and is bordered by diamonds. This Fabergé work is unmarked.* **Gold, Rock Crystal, and Enamel Miniature Wine Glass.** Workmaster Michael Perchin, St. Petersburg. ca. 1900. Height 3″ (7.6 cm). *The trumpet-shaped stem is enameled translucent opalescent pink over a guilloché ground. The gold foot has a reeded border. The Royal Collection, London.*

253. Fabergé. **Pink and Blue Whistles.** 1890–1917. Height 1⅜″ (3.4 cm). *Even an item as simple as a whistle became a luxurious object for the workshops of Fabergé. These two whistles, one of pink and one of blue enamel, are enameled over tiny guilloché basket-weave patterns and each has a gold ring to which a chain may have been attached. The Forbes Magazine Collection, New York.*

254. Fabergé. Workmaster Michael Perchin, St. Petersburg. **Opera Glasses.** 1899–1903. Height 4¼″ (10.5 cm). *These rococo opera glasses are enameled translucent pink over a moiré guilloché ground. The lattice design is set with diamonds. The Forbes Magazine Collection, New York.*

255. Fabergé. Workmaster Michael Perchin, St. Petersburg. **Gold and Translucent Enamel Opera Glasses.** ca. 1895. Length 4¼″ (10.5 cm). *These opera glasses are enameled in translucent cinnamon over a guilloché ground and are mounted with two-color gold chased spirals of laurel leaves. The borders are set with rose diamonds. Courtesy Wartski, London.*

290

256. Fabergé. Workmaster Henrik Wigström, St. Petersburg. **Fan.** ca. 1900. Height 8½" (21.8 cm). *Though Wigström is best known for magnificent imperial Easter eggs, he also worked on smaller objets de vertu, such as this delicate fan. The gold handle is enameled pink and is set with diamonds. The fan is made of silk and gauze and is painted with three tiny scenes, the central one of a* scène gallante, *signed A. E. Begnée. The two smaller scenes are depictions of idyllic landscapes. The* Forbes *Magazine Collection, New York.*

257. Fabergé. St. Petersburg. **Parasol Handle.** ca. 1900. Height 3" (7.5 cm). *Modeled in the Louis XVI style, this handle is enameled in pink, green, and white and is set with a moonstone, rubies, and diamonds. It is now mounted for use as a hand seal. The* Forbes *Magazine Collection, New York.*

258. Fabergé. **Imperial Parasol Handle.** 1896–1917. Height 2½" (6.5 cm). *Parasols were a necessary part of a lady's wardrobe and were usually decorated with ornate handles and lace and ruffle that matched the lady's dress. This gold parasol handle is mounted with a diamond monogram of the Czarina Alexandra Feodorovna. Pink and white enamel over guilloché grounds form the border, and a bowenite handle, molded to fit in the palm of the hand, completes the design. The* Forbes *Magazine Collection, New York.*

259. Fabergé. Moscow. **Pair of Toilet Bottles.** ca. 1900. Height 5⅛" (13 cm). *These delicate bell-shaped bottles are made of cut-glass with gold tops enameled translucent pale blue over a guilloché ground. The tops are quartered by four rows of diamonds and are surmounted by cabochon amethysts. The* Forbes *Magazine Collection, New York.*

260. Fabergé. **Gold and Translucent Enamel Desk Clock.** Workmaster Henrik Wigström, St. Petersburg. ca. 1910. Width 2½" (6.2 cm). *This square desk clock is enameled translucent oyster over a sun-ray ground.* **Rock Crystal, Gold, and Enamel Scent Bottle.** Workmaster Henrik Wigström, St. Petersburg. ca. 1900. Height 3¼" (8.3 cm). *Of square section, the hinged cover is enameled translucent pale blue.* **Rock Crystal, Gold, and Enamel Scent Bottle.** Workmaster Feodor Afanassiev, St. Petersburg. ca. 1910. Height 2⅛" (5.4 cm). *The domed cover is enameled translucent blue over a guilloché ground and has opaque white enamel stripes.* **Rock Crystal, Gold, and Translucent Enamel Scent Bottle.** Workmaster Feodor Afanassiev, St. Petersburg. ca. 1910. Height 2⅟₁₆" (5.2 cm). *The cover is enameled translucent pale blue over a guilloché ground and with opaque white enamel stripes.* **Silver and Translucent Enamel Powder Compact.** Workmaster August Hollming, St. Petersburg. ca. 1900. Length 4" (10.1 cm). *This narrow rectangular compact has three hinged covers. It is enameled translucent oyster over a guilloché ground. The three thumbpieces are set with diamonds. The Royal Collection, London.*

261. Fabergé. **Diamond Necklace.** ca. 1890. Length 15¾" (40 cm). *This necklace was commissioned by Sinebrikov, a brewing magnate. The large center bow, with pendent diamond, is detachable and wearable as a brooch. The* Forbes *Magazine Collection, New York.*

262. Fabergé. **Carved Nephrite, Gold, and Jeweled Necklace.** Moscow. ca. 1900. Length 17" (43 cm). *This necklace is formed of carved nephrite batons joined by diamond-set circles. The lozenge-shaped pendant is applied with a diamond-set arrow which pierces a diamond and ruby wreath.* **Gold, Enamel, and Jeweled Brooch.** Workmaster Michael Perchin, St. Petersburg. ca. 1890. Width 1⅜" (3.5 cm). *This brooch is in the form of conjoined scrolls with a latticework center. The scrolls are enameled translucent pink over a guilloché ground, and the borders are set with diamonds.* **Gold, Diamond, and Sapphire Brooch.** Workmaster August Holmström, St. Petersburg. ca. 1900. Length 1⅛" (3 cm). *Heart-shaped and surmounted by a diamond-set ribbon bow, this brooch at its center has a faceted sapphire pendant.* **Gold and Jeweled Miniature Easter Egg Pendant.** Workmaster August Holmström, St. Petersburg. ca. 1890. Length ⅝" (1.5 cm). *The egg is reeded and applied with gold loops centering a cabochon ruby on each side.* **Gold and Jeweled Miniature Easter Egg Pendant.** St. Petersburg. ca. 1890. Length ⅝" (1.5 cm). *This egg is stippled all over and is set with a faceted red stone. Copyright 1987, Sotheby's, Inc., New York.*

263. Maker unknown. Moscow. **Gold and Jeweled Cross on Gold and Enamel Chain.** 1867. Length of cross 2½" (6.2 cm). *The cross is mounted with diamonds, rubies, emeralds, and pearls. The ends of the arms are enameled blue.* The State Historical Museum, Moscow.

264. Fabergé. Workmaster Erik Kollin, St. Petersburg. **Scythian-style Bracelet.** ca. 1882. Height 2⁵⁄₁₆" (7.3 cm). *This is a replica of a Scythian gold bracelet found in the Crimea. The hinged armpiece is cast of twisted gold wrapped with thin filigree wire. The main decorative element is the two lion's heads, with ears pinned back, mouths open, and dropped tongues touching each other. Their manes are three rows of stylized leaf tips. Each wears an ornate collar of swirls and pyramid forms.*
 This bracelet was made at the suggestion of Count Sergei Stroganov who was President of the Archaeological Society in St. Petersburg. It was first shown at the Pan-Russian Exhibit in 1882. The Scythian-style jewelry subsequently brought Fabergé's firm their first international award when it was shown at the Nuremberg Fair in 1885. The Forbes Magazine Collection, New York.

265. Fabergé. Workmaster A. R. **Silver, Translucent Enamel and Glass Ink Pot and Pen.** ca. 1900. Height of ink pot 5⅛" (13 cm), length of pen 6½" (16.5 cm). *The base of the glass pot is deeply cut with geometric patterns. The hinged bulbous top is enameled translucent strawberry red over a guilloché ground and is inscribed, in Cyrillic, with "In Fond Memory of the Town of Mukden, Oct. 1904." The ivory pen has a silver band enameled en suite.* Copyright 1979, Sotheby's, Inc., New York.

266. Fabergé. Workmaster Henrik Wigström, St. Petersburg. **Gold and Rock Crystal Inkwell.** ca. 1910. Height 4⅝" (11.8 cm). *The rock crystal body is of octagonal shape and is raised on four bun feet. The conforming gold mount is fluted and applied with ribbon-tied swags of laurel, and the slip-on cover has a laurel-wreath finial.* Copyright 1979, Sotheby's, Inc., New York.

267. Fabergé. Workmaster Henrik Wigström, St. Petersburg. **Miniature Motorcar.** 1904–1905. Length 10¼" (26 cm). *This small silver and enamel motorcar is an exact representation of a 1904 motorcar with a few customized additions. A miniature, the car functions as a desk ornament and has practical uses: the driver's seat is a stamp box, the radiator is an inkwell, the steering wheel is a bell push, and a small receptor serves as a pen stand.* The Forbes Magazine Collection, New York.

268. Fabergé. Workmaster Michael Perchin, St. Petersburg. **Rock Crystal Stamp Dispenser.** ca. 1900. Height 4⁷⁄₁₆" (11.4 cm). *This twelve-sided rock crystal stamp dispenser is made of six compartments with striped red- and white-enamel, scallop-shaped gold hinges. It sits on a base of red-and-white striped enamel over a delicate basket-weave guilloché pattern and is raised on three ball feet. The gold fluted stem terminates at the top in a ring shaped as a serpent with a ruby head.* The Forbes Magazine Collection, New York.

269. Fabergé. Workmaster Henrik Wigström, St. Petersburg. **Art Nouveau Match Holder.** 1886–1917. Height 2⅝" (6.8 cm). *This match holder is carved of green jasper and is set into a gold naturalistic setting of cattails and other flora mounted with demantoids and rubies. Lion's heads with rings through their noses circle the base of the cup, and dolphins with their tails curved backwards form its stand.* The Forbes Magazine Collection, New York.

270. Fabergé. Workmaster Michael Perchin, St. Petersburg. **Two-color Gold Miniature Wastepaper Basket.** ca. 1890. Height 1¹³⁄₁₆" (4.6 cm). *Probably used as a match holder, this yellow- and red-gold object has four gold rubles of Catherine the Great and Empress Elizabeth enameled white.* The Forbes Magazine Collection, New York.

271. Fabergé. Workmaster Julius Rappoport, St. Petersburg. **Big Bad Wolf Lighter.** ca. 1900. Height 6½" (16.4 cm). *Never at a loss for making the commonplace interesting, this lighter is based on a character from a popular children's fairy tale. The silver wolf is dressed in a silver shawl, beneath which is its round, red-glazed ceramic body.* The Forbes Magazine Collection, New York.

272. **Silver-gilt and Shaded Enamel Large Tea Caddy.** Grigori Sbitnev. Moscow. ca. 1910. Height 5½″ (14 cm). *This caddy, with curved shoulders, is enameled all over with colorful foliage on a gilded stippled ground. The interior cork has a silver-gilt mount.* **Silver-gilt and Shaded Enamel Kovsh.** Feodor Rückert. Moscow. ca. 1900. Length 9¾″ (24.7 cm). *Marked by Ovchinnikov, as retailer, this kovsh is enameled with colorful foliage on grounds of two-tone green and is mounted with eight hardstone cabochons.* **Silver-gilt and Shaded Enamel Desk Set.** Maria Semyonova. Moscow. ca. 1910. Height of inkstand 5″ (12.7 cm). *The set includes an inkstand fitted with a glass inkwell, pen, and blotter. It is enameled with colorful foliage and flowers on grounds of cream, avocado, blue, and green.* **Silver-gilt and Shaded Enamel Small Easter Egg.** Maker unknown. Moscow. *Although lacking a maker's mark, this work is almost certainly the work of Feodor Rückert. It is enameled with colorful foliage on a pale green ground and has a gilded interior.* **Silver-gilt and Shaded Enamel Pictorial Box.** Eleventh Artel. Moscow. ca. 1910. Length 6″ (15.2 cm). *The cover is enameled en plein with a fairy tale scene, and the sides are decorated with colorful stylized foliage.* **Silver-gilt and Shaded Enamel Pictorial Bowl.** Feodor Rückert. Moscow. ca. 1900. Diameter 3¼″ (8.3 cm). *The interior of this bowl is enameled with an eagle with spread wings, perched on a branch of a tree. Copyright 1989, Sotheby's, Inc., New York.*

273. Fabergé. Moscow. **Ivan the Terrible Desk Set.** 1899–1917. *This desk set could possibly have been designed by the artist Nikolai Roerich (1874–1947). The set, created of silver, crystal, and gemstones in the Old Russian style, depicts Ivan the Terrible with the boyars. Included in the set are an inkwell, a pair of lamps with candles, a seal, a pen rest, and a dagger-shaped letter opener. The* Forbes *Magazine Collection, New York.*

274. Fabergé. **Group of Desk Ornaments.** *This group of desk ornaments, mostly made of gold-mounted carved nephrite, includes a fan-shaped miniature frame containing a photograph of the Honorable Julia Stonar, later Marquise d'Hautpoul. The letter opener is topped by a carved quartzite elephant with cabochon ruby eyes. The Royal Collection, London.*

275. Fabergé. Workmaster Michael Perchin, St. Petersburg. **Imperial Writing Portfolio.** ca. 1895. Height 12½″ (33.5 cm). *Fabergé was not only commissioned by the imperial family, but for them as well. This portfolio was commissioned by the City of St. Petersburg for Czar Nicholas II and Czarina Alexandra but was never actually presented to them. The initials of the imperial couple appear on the front cover in rose-cut diamonds. They are topped with a diamond-set imperial crown and are set inside a garland, tied with a delicate bow in which the words "From the City of St. Petersburg" are inscribed. This entire motif is circumscribed by a gilt oval. At the bottom is the coat of arms of the city of St. Petersburg. A thick gilt band frames the entire design with leaves at each of the four corners. The interior of the portfolio is lined with cream-colored moiré silk. The* Forbes *Magazine Collection, New York.*

254

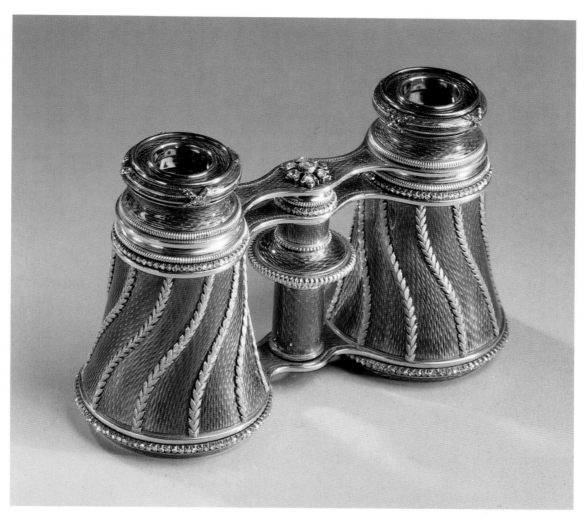

255

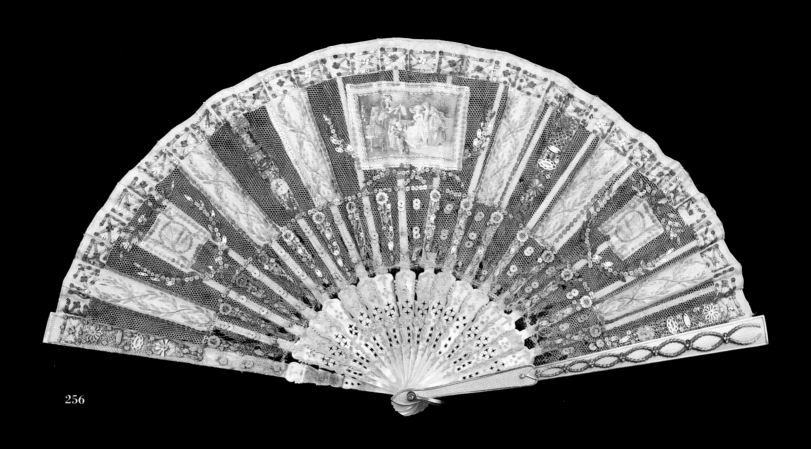

256

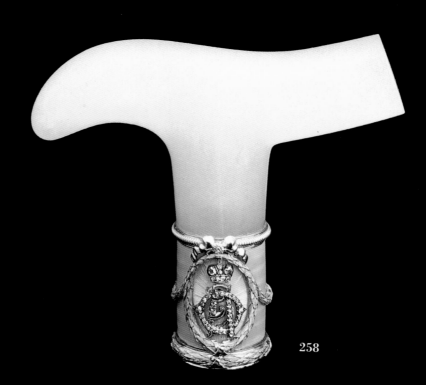

258

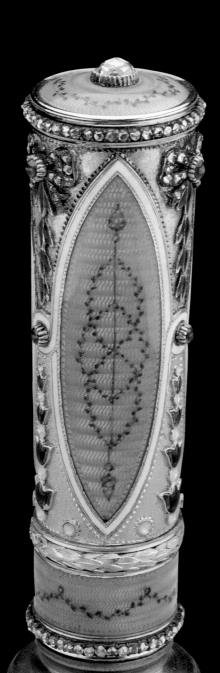

257

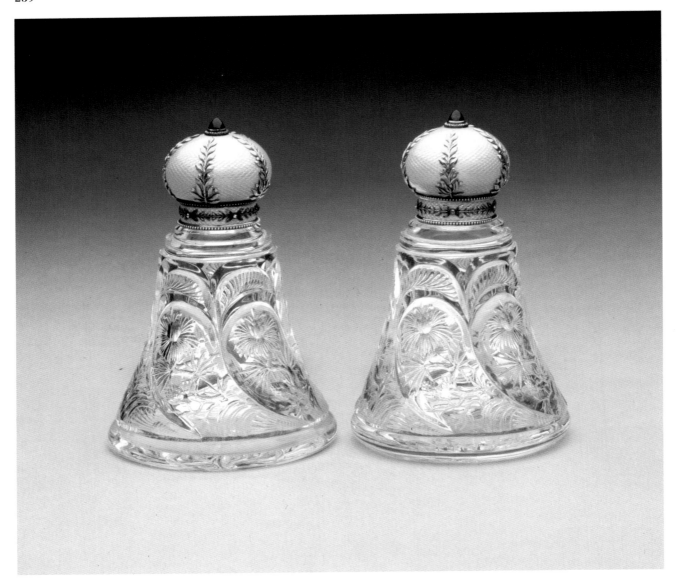

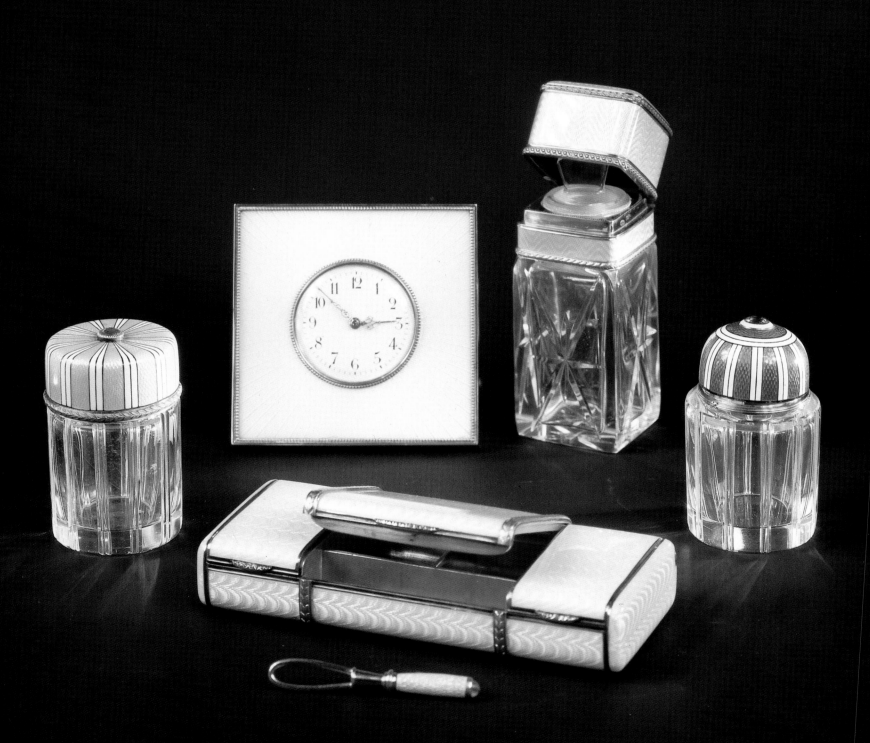

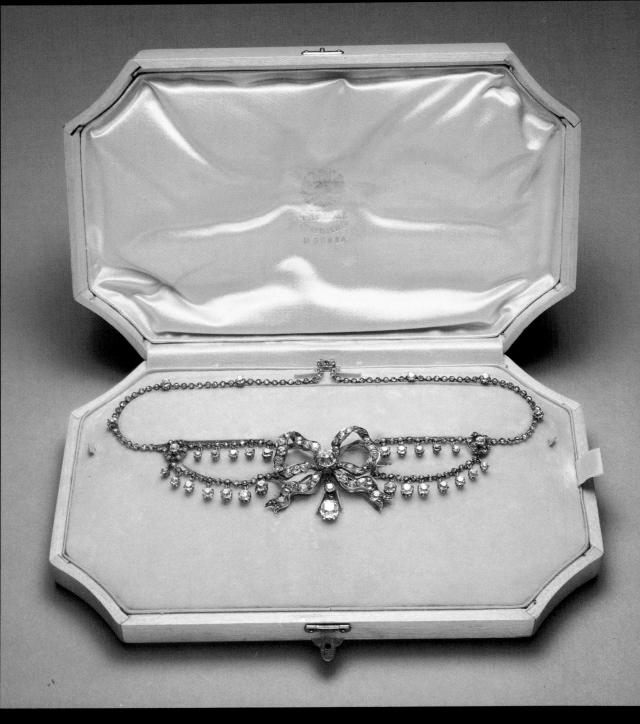

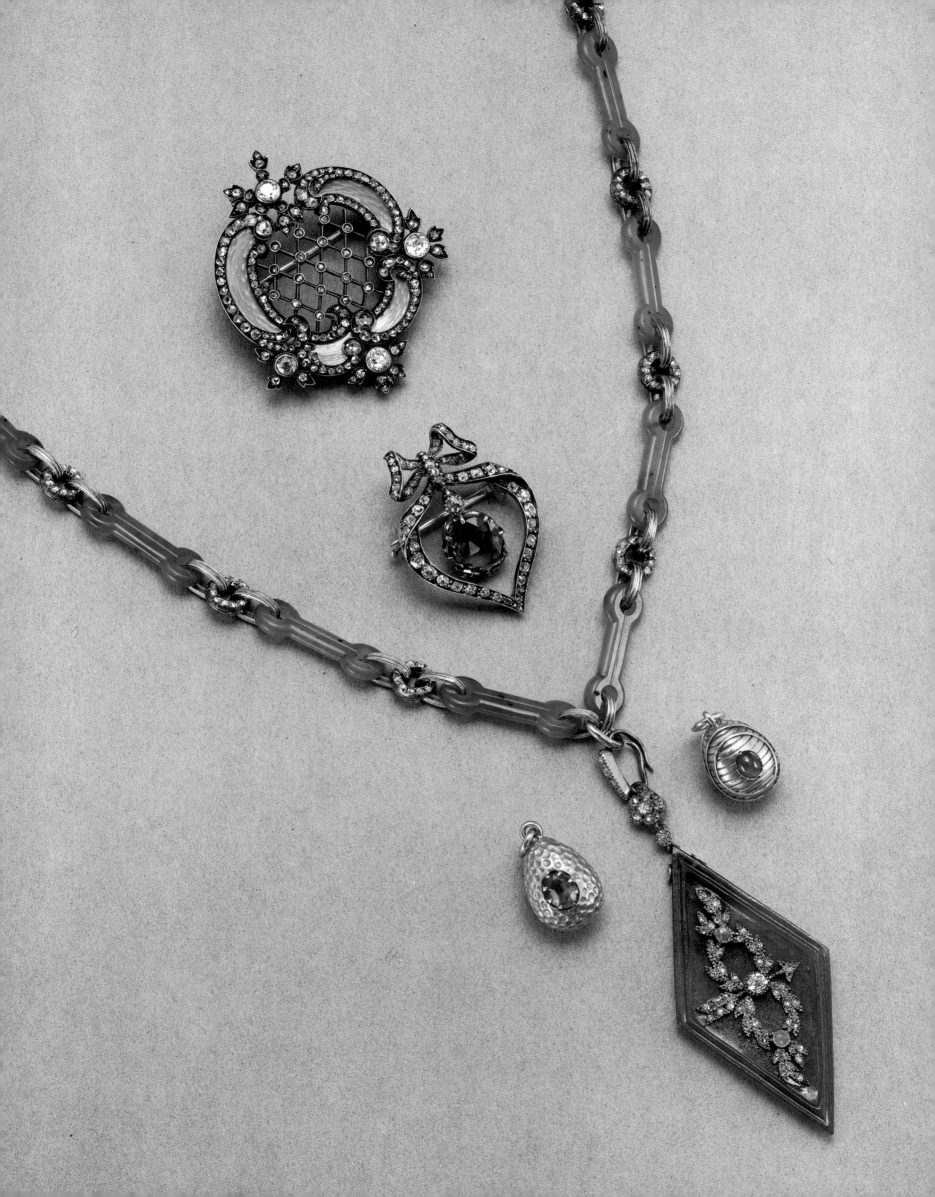

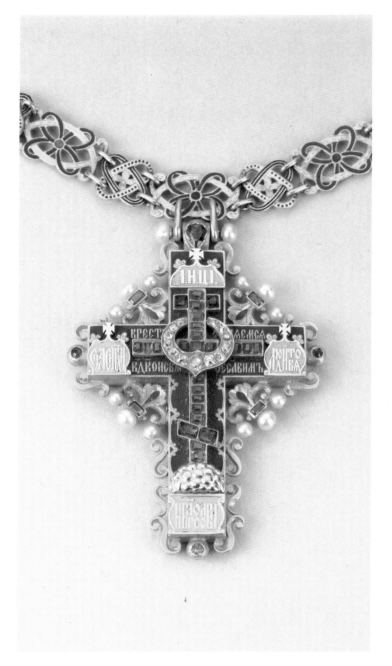

263

264

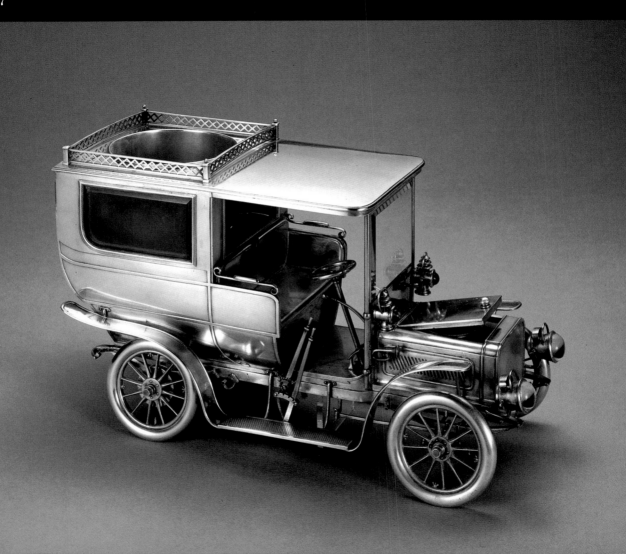

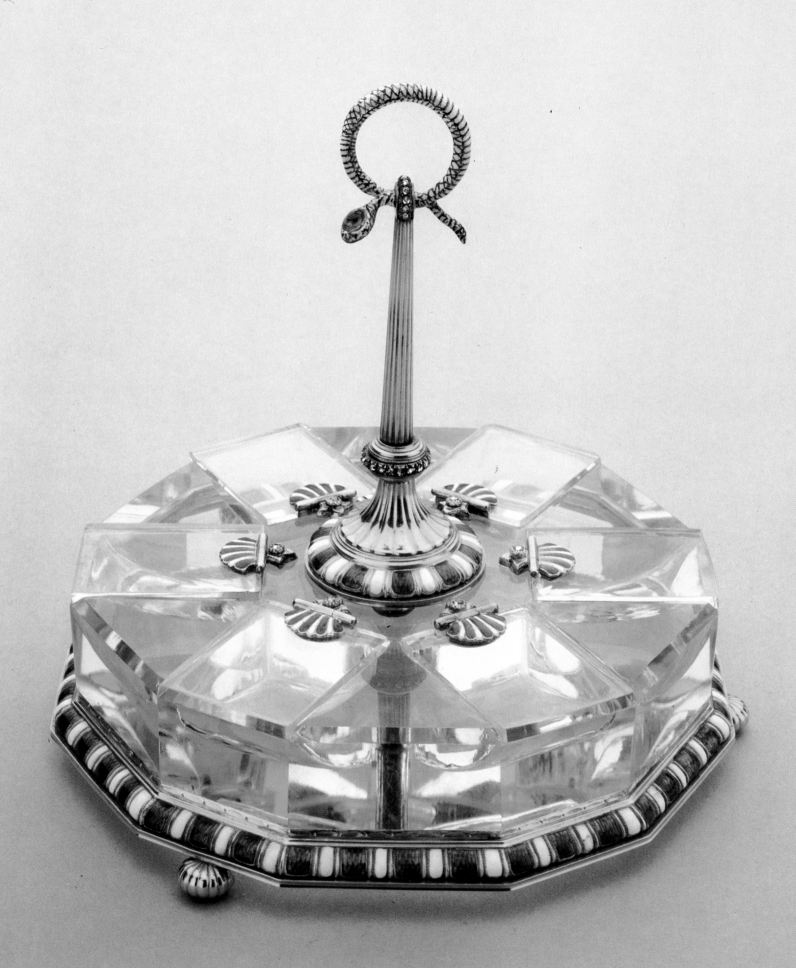

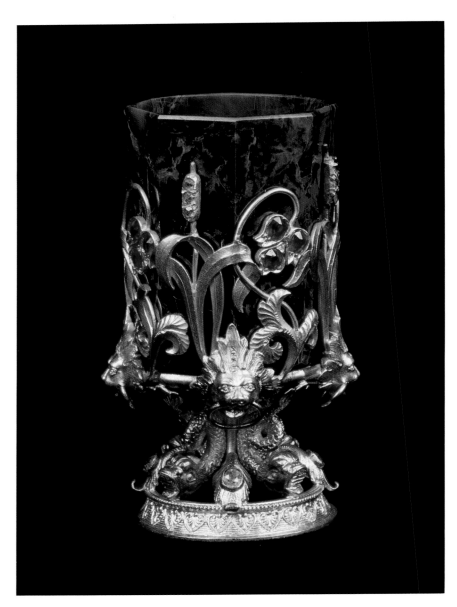

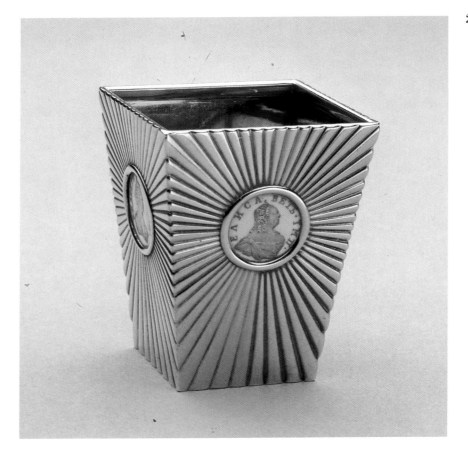

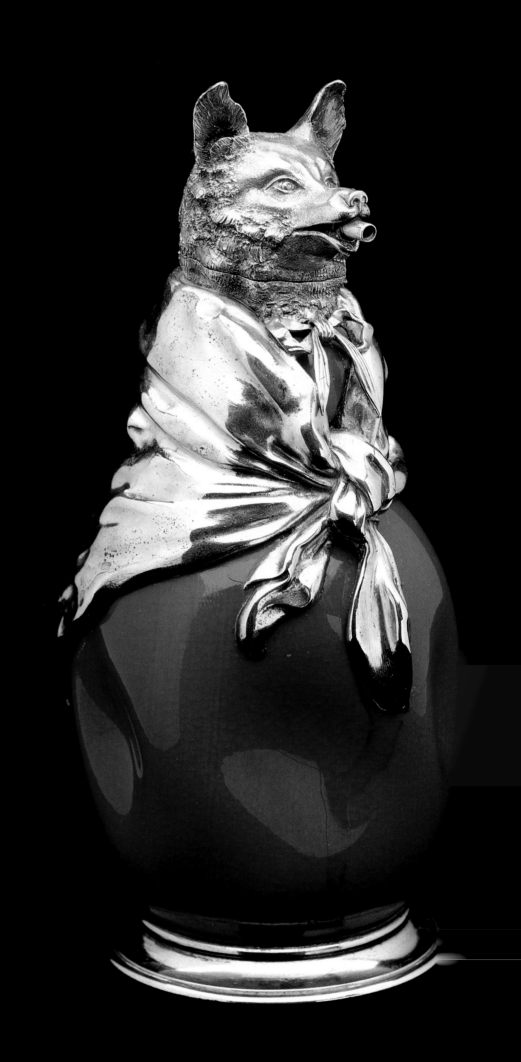

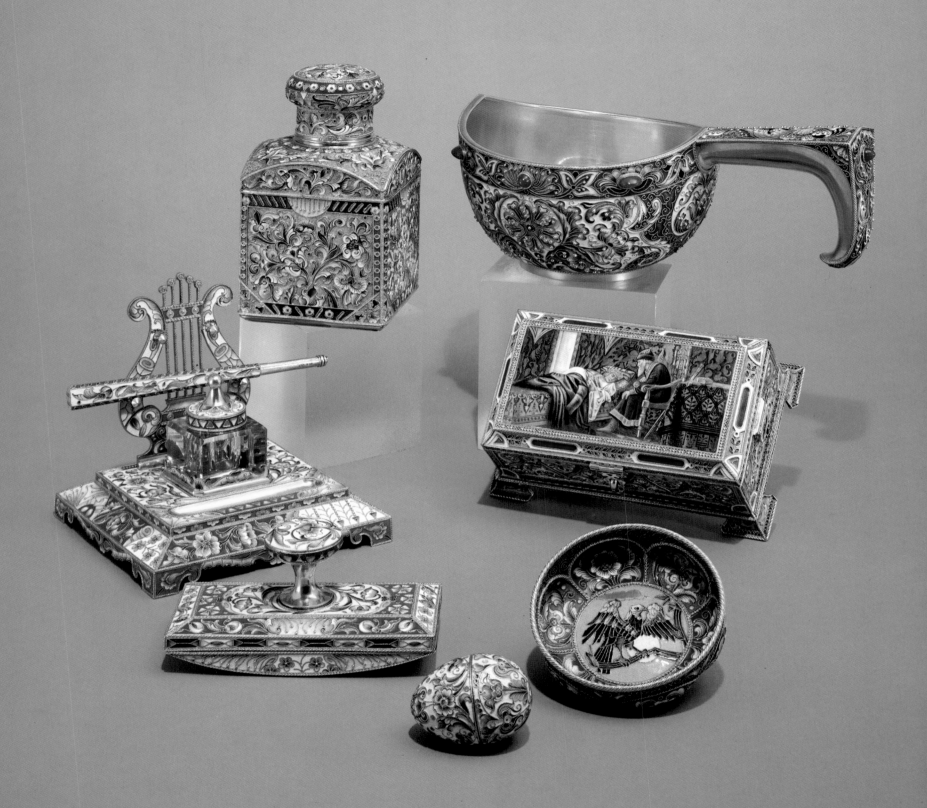

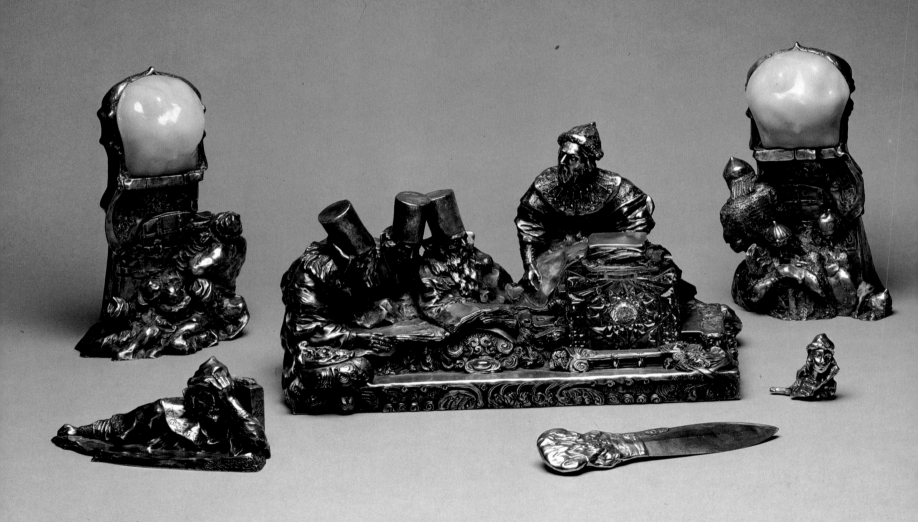

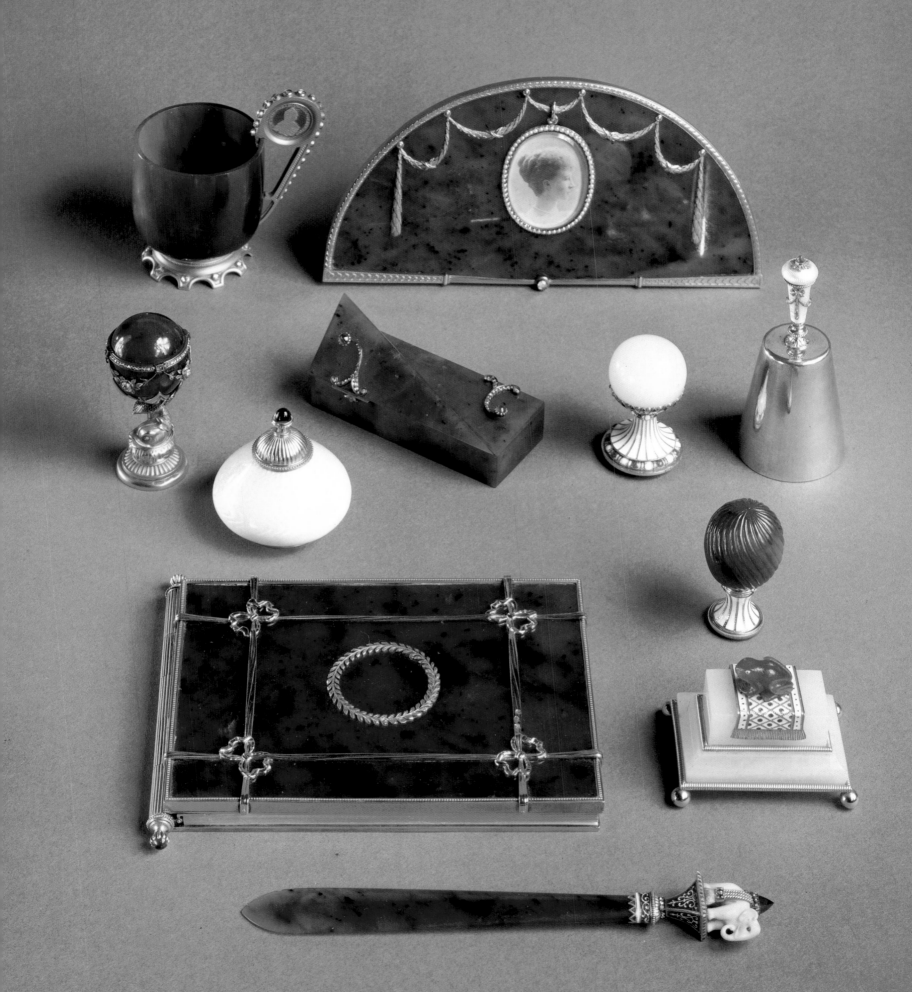

INDEX

Illustrations are indicated by the abbreviation "pl.," followed by the plate number.

Aarne, Johan Victor, 11
Adler, Maria, 23, 30
Ador, Jean-Pierre, 10
Afanassiev, Feodor, 11
Alexander III, 13, 15, 16, 19, 37, 40, 44
Alexandra Feodorovna, 13, 15, 18, 74
Armfelt, Carl Gustav Hjalmar, 11
The Art of Carl Fabergé, 14, 22
Artels, 12, 23, 49

Bainbridge, Henry C., 9, 16, 22, 44
Bakst, Leon, 16
Baskets, pl. 12, pl. 107, pl. 223, pl. 224
Baylin and Son, 24, 51
Beakers, pl. 13, pl. 188, pl. 217
Bell push, pl. 244
Benois, Alexandre, 16, 43, 44
Birbaum, François, 44
Bolin, C., 23, 51
Bornikov, I., 34–35, 36
Bottles, pl. 259, pl. 260
Bowe brothers, 16, 42, 44
Bowls:
 Ivan Kalita bowl, pl. 194
 pictorial bowl, pl. 272
 two-handled bowl, pl. 16, pl. 102, pl. 183, pl. 185
Boxes and cases, 16, 18, 42, 136–169
 bonbonnières, pl. 67, pl. 68, pl. 71, pl. 125, pl. 126
 card case, pl. 111
 carnelian box, pl. 94
 carnet de bal, pl. 115
 caskets, pl. 102, pl. 104, pl. 106, pl. 107, pl. 108, pl. 109, pl. 111, pl. 113, pl. 188
 cigar boxes, pl. 102, pl. 103, pl. 105, pl. 150, pl. 217
 cigarette cases, 16, 17, 50, pl. 95, pl. 96, pl. 97, pl. 98, pl. 99, pl. 100, pl. 101,

pl. 110, pl. 112, pl. 123, pl. 146, pl. 147, pl. 148, pl. 149, pl. 150, pl. 180, pl. 197
 cigarette holder, pl. 98
 coronation box, *title page*, 22, pl. 120
 enamel circular box, pl. 94
 enamel oval box, pl. 16, pl. 217
 enamel pictorial box, pl. 272
 enamel small box, pl. 94
 imperial presentation boxes, pl. 116, pl. 119, pl. 121, pl. 124, pl. 128, pl. 146
 imperial presentation compact, pl. 122
 music box, pl. 130
 nephrite boxes, 22, pl. 94, pl. 118, pl. 129
 presentation box, pl. 119
 rocaille box, pl. 117
 rock crystal boxes, pl. 94
 snuffbox, 16, pl. 127
 travelling boxes, pl. 73
Bragin, Andrei Stepanovich, 49
Britzin, 28, 43, 48
Buhré, Paul, 24

Candlesticks, pl. 235, pl. 238, pl. 239
 taperstick, pl. 236
Carafe, pl. 188
Carving precious-metal objects, 29
Cases. *See* Boxes and cases
Casting techniques, 27, 49
Champlevé, 17, 29
Chanticleer Egg, 22
Charka, pl. 184
Chasing techniques, 27, 49
Chichelyov, I., 23, 51
Cigarette cases. *See* Boxes and cases
Clocks, 170, 173–176, 190–192, 194–205
 clock eggs, 14, 21, pl. 4, pl. 39, 170, pl. 154
 combination clock and

thermometer, pl. 153
 desk clocks, pl. 146, pl. 147, pl. 149, pl. 152, pl. 158, pl. 163, pl. 165, pl. 260
 globe clock, pl. 164
 mantle clocks, pl. 14, pl. 155
 Polar Star clock, pl. 162
 table clocks, pl. 148, pl. 151, pl. 156, pl. 157, pl. 159, pl. 160, pl. 161
Cloisonné, 11–12, 28–29
Compacts:
 imperial presentation compact, pl. 122
 powder compact, pl. 260
Compote, pl. 219, pl. 220
Cruet set, pl. 233
Cuff links, imperial crown, *title page*
Cups:
 coconut cup, pl. 178
 demitasse cups, saucers, and spoons, pl. 207, pl. 208
 enamel footed cup, pl. 180
 small cups, pl. 189, pl. 191
 standing cups, pl. 10, pl. 230
 three-handled cup, pl. 16
 vodka cups, pl. 197

Desk ornaments, pl. 274
Desk sets, pl. 272, pl. 273
Dessert serving set, pl. 222
Dinglinger, Johann Melchior, 10, 14
Dishes, pl. 10, pl. 149, pl. 197, pl. 218, pl. 221, pl. 223, pl. 243, pl. 244
Duchess of Marlborough Egg, 14, 21

Eggs, 22, 54, 61–63, 105–115
 bonbonnière eggs, pl. 67, pl. 68, pl. 71
 clock eggs, 14, 21, pl. 4, pl. 39, 170, pl. 154

Easter eggs, *endpapers*, 43,
 pl. 2, pl. 62, pl. 63, pl. 64,
 pl. 66, pl. 67, pl. 69, pl. 70,
 pl. 71, pl. 102, pl. 217,
 pl. 272
hoof egg, pl. 61
icon Easter egg, pl. 217
imperial Easter eggs, 12–14, 20,
 21, 44, 54–61, 64–104. *See
 also specific imperial Easter
 eggs*
Kelch hen egg, pl. 65
pendants, Easter egg,
 endpapers, pl. 262
pine cone egg, pl. 72
Elephant, rock crystal and gold,
 pl. 252. *See also* Hardstone
 carvings
Enameling, 27–29, 38, 39
 by Fabergé firm, 16–17, 44
 en ronde bosse, 17

Fabergé, Agathon (brother), 10,
 44
Fabergé, Agathon (son), 20, 44
Fabergé, Alexander, 20
Fabergé, Eugene, 20, 44
Fabergé, Gustav, 9, 11
Fabergé, Nicholas, 16, 20, 44
Fabergé, Peter Carl, 9–22, 44
 background, 9–10
 contests, 31, 44
 eggs, imperial, 12–14
 fame, international, 14–16
 firm of, products from, 23, 41,
 42–48, 51, 116
 shops of, 10–11, 16, 42
 sources of inspiration for, 10
 workmasters under, 11–12
Fakes, categories of, 20
Fan, pl. 256
Figurines. *See* Hardstone carvings
Filigree, 27
Flatware service, pl. 9
Flowers, hardstone, 46–47,
 116–118, 120–121
 cherry sprig, pl. 74
 group of three flowers, pl. 77
 hawthorn, spray of, pl. 75
 lilies-of-the-valley, imperial
 flower arrangement of, 18,
 22, pl. 76
Forbes, Malcolm, 14, 21–22
Frames, 170–173, 177–189
 double frame, pl. 133
 double-sided pivot frame,
 pl. 135

fire screen frame, 22, 170,
 pl. 138, pl. 139
flower-form frame, pl. 137
heart-shaped surprise frame,
 pl. 136
imperial presentation frame,
 pl. 145
lattice-work frame, pl. 131
miniature frames, pl. 137,
 pl. 142, pl. 145, pl. 149,
 pl. 252
photograph frames, pl. 132,
 pl. 134, pl. 140, pl. 143,
 pl. 144, pl. 149, pl. 150,
 pl. 244
rock crystal frame, pl. 141
Fuld, A., 29

Galkin Brothers, 24, 27
Galvanic gilding, 26
Gibson, Allan, 44
Gold. *See* Precious metals
Goldsmiths, the Russian master,
 23–52
 artisans, the making of, 30–32
 the beginnings of, 23–25
 developments in works with
 precious metals by, 25–30
 and gold and silver work in
 Moscow, 35–43
 and gold and silver work in St.
 Petersburg, 43–49
 and the new century, 49–52
 and style, aspects of, 32–35
Gorianov, Andrei, 11
Grachev Brothers, 26, 27, 28, 48
Gray, Matilda Geddings, 18, 20
Gubkin family, 23, 30, 34, 35
Guilloché patterning, 16–17,
 26–28

Hahn, Carl, 12, 28, 43, 48
Hallmarking, 18–20
Hammer, Armand, 20
Hand seal, pl. 252
Hardstone carvings, 12, 14, 18,
 45, 46–47, 116, 118–119,
 122–135
 bear, pl. 93
 birds, pl. 89
 Captain of the Fourth
 Harkovsky Lancers, pl. 79
 cats, pl. 83, pl. 86
 Chelsea pensioner, pl. 78
 chick, pl. 88

Dancing Moujik, *title page*, 22,
 pl. 80
 elephants, pl. 86, pl. 252
 flowers. *See* Flowers, hardstone
 frogs, pl. 86, pl. 90
 hippopotamuses, pl. 15, pl. 86
 horse, pl. 92
 izvoshchik, pl. 82
 mandril, pl. 91
 mice, pl. 84, pl. 86
 owl, pl. 87
 peasant woman, pl. 81
 pig miniatures, pl. 85
 rabbits, pl. 86
 table seal, pl. 90
Hen Egg, 22
Hollming, August, 11, 43
Holmström, August, 11, 44

Icons. *See* Religious objects
Imperial Alexander Palace Egg, 14
Imperial Alexander III Equestrian
 Egg, 14, pl. 49
Imperial Blue Enamel Ribbed
 Egg, pl. 19
Imperial Cameo Egg, 14, pl. 57
Imperial Caucasus Egg, 14, pl. 23
Imperial Clover Egg, 14, pl. 40
Imperial Colonnade Egg, 14,
 pl. 46
Imperial Coronation Egg, 14,
 pl. 31, pl. 32
Imperial Cross of St. George Egg,
 14, 20, pl. 60
Imperial Cuckoo Egg, 13, 14, 22,
 pl. 39, 170
Imperial Czarevich Egg, 14, pl. 53
Imperial Danish Palace Egg, 14,
 pl. 28
Imperial Egg with Revolving
 Miniatures, 14, pl. 30
Imperial Fifteenth-Anniversary
 Egg, *title page*, 14, pl. 50,
 pl. 51
Imperial Gatchina Palace Egg, 14,
 pl. 41, pl. 42
Imperial Hen Egg, first, 13, 14,
 22, pl. 17
Imperial Lilies-of-the-Valley Egg,
 14, pl. 35
Imperial Madonna Lily Egg, 14,
 pl. 36
Imperial Monogram Egg, pl. 29
Imperial Mosaic Egg, 14, pl. 56
Imperial Napoleonic Egg, 14,
 pl. 54

Imperial Orange Tree Egg, *title page*, 14, 54, pl. 52
Imperial *Pamiat Azova* Egg, 14, pl. 22
Imperial Pansy Egg, pl. 37
Imperial Peacock Egg, 14
Imperial Pelican Egg, 14, pl. 33, pl. 34
Imperial Peter the Great Egg, 14, pl. 43, pl. 44
Imperial Red Cross Egg with Portraits, 13, 14, pl. 59
Imperial Red Cross Egg with Resurrection Triptych, 14, pl. 58
Imperial Renaissance Egg, *title page*, 14, pl. 24, pl. 25
Imperial Resurrection Egg, 14, pl. 18
Imperial Romanov Tercentenary Egg, 14, pl. 55
Imperial Rose Trellis Egg, 14, pl. 47
Imperial Rosebud Egg, 14, pl. 26, pl. 27
Imperial Silver Anniversary Egg, 14
Imperial Spring Flowers Egg, *title page*, 14, pl. 20, pl. 21
Imperial Standart Egg, 14, pl. 48
Imperial Steel Military Egg, 14
Imperial Swan Egg, 14
Imperial Trans-Siberian Railway Egg, 13, 14, pl. 38
Imperial Uspensky Cathedral Egg, 14, pl. 45
Ink pot and pen, pl. 265
Inkwell, pl. 266

Jewelry, 23, 27, 50–52, 290
 bracelet, pl. 264
 brooches, pl. 262
 cameos, 51–52
 cross on gold-and-enamel chain, pl. 263
 Easter egg pendants, *endpapers*, pl. 262
 necklaces, pl. 261, pl. 262

Kelch, Alexander, 14
Khlebnikov, Ivan Petrovich, 19, 23, 24, 27, 28, 29, 30, 32, 36, 39, 40, 54
Klingert, 23, 29
Köchli family, 24, 43, 48, 51
Kolbe family, 10

Kollin, Erik, 11, 43, 290
Kovshes, 220, pl. 10, pl. 181, pl. 182, pl. 185, pl. 186, pl. 187, pl. 193, pl. 223, pl. 224, pl. 235, pl. 239, pl. 244, pl. 272
Kurlyukov, Orest, 24, 28, 40–41

Lapidary art, 45
Lighter, pl. 271
Linden, Nicholas, 51
Lundell, Gustav, 44
Lundell, Karl, 11

Marie Feodorovna, 13, 15, 18, 20, 44
Marlborough, Duchess of, 14
Match holder, pl. 269
Menu holders, pl. 234
Mickelson, Anders, 11
Mir Iskusstva ("World of Art") movement, 16, 43, 44
Mishukov, Y. F., 40
Morgan, J. P., Jr., 14
Mother-of-pearl, 47
Motorcar, miniature, pl. 267

Nemirov-Kolodkin, N., 24, 40
Nevalainen, Anders, 11
Nicholas II, 13, 15
Nicholls and Plincke, 10, 27, 43
Niello, 29–30
Niukkanen, Gabriel, 11, 44
Nobel, Emmanuel, Dr., 14

Objets de luxe, 18, 290–315. See *also specific* objets de luxe
Objets de vitrine. See Table ornaments and *objets de vitrine; specific* objets de vitrine
Olovyanishnikov, P. I., 24, 28, 41
Opera glasses, pl. 254, pl. 255
Ovchinnikov, Pavel Akimovich, 10, 12, 19, 23, 27–30, 32, 36–40, 54
 factory school of, 30

Parasol handles, pl. 257, pl. 258
Pauzie, Jeremie, 10, 116
Pendin, Hiskias, 9
Perchin, Michael, 10, 11, 16, 44, 47

workshop, photograph of, pl. 3
Peter Carl Fabergé, His Life and Work, 22
Petrov, Nicolai, pl. 5
Photograph album, pl. 114
Pihl, Knut Oskar, 11
Plique-à-jour enameling, 39, pl. 8
Portfolios:
 imperial writing portfolio, pl. 275
 silver and leather portfolio, pl. 240
Post, Marjorie Merriweather, 14, 21
Postnikov, A. M., 24, 28, 30, 40
Pratt, Lillian Thomas, 20
Precious metals:
 development in work with, 25–30, 49
 gold and silver work in Moscow, 35–43
 gold and silver work in St. Petersburg, 43–49
 hallmarking silver and gold, 18–20
Punch sets, pl. 1, pl. 195, pl. 196, pl. 199, pl. 201, pl. 202
 punch bowls and ladles, pl. 200, pl. 203

Rabbit Egg, 22
Rappoport, Julius, 11, 45
Reiman, Jan, 51
Reimer, Wilhelm, 11, 32
Religious objects:
 altar cross, pl. 179
 bishop's mitre, pl. 166
 chalices, pl. 176, pl. 177
 icons, 24, pl. 11, pl. 150, pl. 168, pl. 169, pl. 170, pl. 171, pl. 172, pl. 173, pl. 174, pl. 175, pl. 217
 oklads, 24, 206
 wedding crowns, pl. 167, pl. 178
Rimmer, Yakov, 51
Ringe, Philipp Theodore, 11
Romanov family:
 Alexander III, 13, 15, 16, 19, 37, 40, 44
 Alexandra Feodorovna, 13, 15, 18, 74
 Marie Feodorovna, 13, 15, 18, 20, 44
 Nicholas II, 13, 15
 Prince Vasili, 20
de Rothschild, Leopold, 16

Rückert, Feodor, 11–12, 28, 29, 41, 42, 54

Salt throne, pl. 217
Saltykov, I., 29
Samovars, 220, pl. 206
Sazikov family, 10, 23, 27, 30, 32, 33–34, 36
Schaffer, Alexander, 20
Schramm, Eduard, 11
Sculptural group, pl. 242
Sculpture, decorative, 49
Sculpture of Peter the Great, pl. 241
Scythian-style jewelry, 11, 290
bracelet, pl. 264
Sedan chairs, miniature, pl. 250, pl. 251
Semyonov, Vasiliy, 23, 30
Serpent Clock Egg, 14
Silver. *See* Precious metals
Silverware and *le style moderne*, 49
Sitwell, Sacheverell, 9
Snowman, A. Kenneth, 14, 22
Snowman, Emanuel, 20
Soloviev, Vladimir, 11
Spoons, pl. 197, pl. 207, pl. 208, pl. 217
Stamp dispenser, pl. 268
Stamp moistener, pl. 244

Stone carvings. *See* Flowers, hardstone; Hardstone carvings
Stroganov School of Industrial Art, 25, 30, 31, 33, 49, 51
Style:
aspects of, 32–35
naturalistic style in decorative applied art, 51
neo-Russian style, 33, 39, 40, 41, 42, 43
Old Russian style, 10, 12
le style moderne, 29, 33, 41, 43, 49–51

Table lamps, pl. 237
Table ornaments and *objets de vitrine*, 220–289. *See also specific table ornaments and objets de vitrine*
Tables and desks, pl. 245
guéridon, pl. 246
miniature desk, pl. 247
miniature guéridons, pl. 248, pl. 249
Tankards, pl. 190, pl. 192
Tea caddies, pl. 213, pl. 272
Tea and coffee sets, pl. 204, pl. 205, pl. 209, pl. 210, pl. 211, pl. 212, pl. 214, pl. 215, pl. 216

Thielemann, Alfred, 11, 12
Tillander, Alexander, 12, 28, 43, 48
Training schools for artisans, 30–31
Trays, pl. 206
card tray, pl. 217

Vanderbilt, Consuelo, 14
Vases, pl. 225, pl. 226, pl. 227, pl. 228, pl. 229, pl. 231, pl. 232
Vashkov, S., 41

Wäkevä, Alexander, 11
Wäkevä, Stephan, 11, 43
Walters, Henry, 14
Wastepaper basket, miniature, pl. 270
Whistles, pl. 253
Wigström, Henrik, 10, 11, 43, 44
Wine glass, miniature, pl. 252
Wine set, pl. 198
Woerffel, Carl, 12, 45

Yachting trophy, pl. 6
Yakovlevich, Feodor, 40

PHOTOGRAPHY CREDITS

The Forbes *Magazine Collection, New York*: Murray Alcosser (Coronation Egg), H. Peter Curran, Larry Stein.
The Brooklyn Museum: Scott Hyde.

DATE DUE

K.E.			